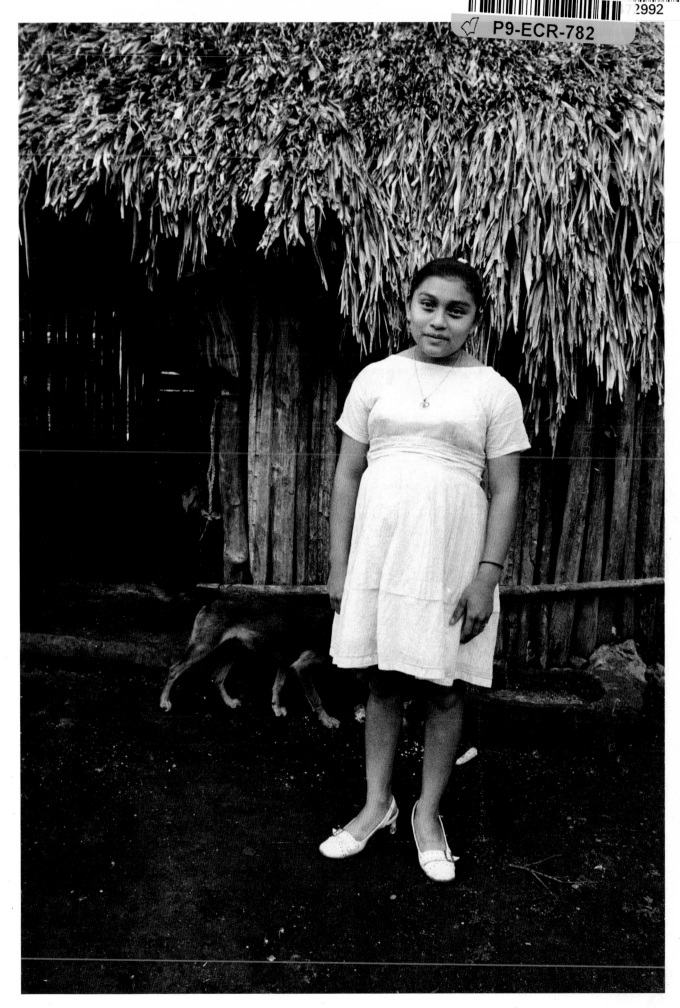

The Modern Maya

@@@@@@@@@@@@@@@@@@@@@@@@

A Culture in

TRANSITION

Macduff Everton

Edited by Ulrich Keller and Charles Demangate

Essays by Ulrich Keller and Dorie Reents-Budet

University of New Mexico Press

Albuquerque

Library of Congress Cataloging-in-Publication Data
Everton, Macduff.
The modern Maya: a culture in transition/Macduff Everton:
edited by Ulrich Keller and Charles Demangate;
essays by Ulrich Keller and Dorie Reents-Budet.—1st ed.
p. cm.
Includes bibliographical references (p.)
ISBN 0-8263-1240-3 (cloth).—ISBN 0-8263-1241-1 (paper)
1. Mayas. 2. Mayas—Pictorial works. I. Keller, Ulrich, 1944–
II. Demangate, Charles. III. Reents-Budet, Dorie. IV. Title.
F1435.E89 1991 *90-40730*
972.81'016—dc20 *CIP*

Frontispiece: A woman proudly wears shoes for the second time in her life.
She bought them for her wedding. Monte Cristo, 1971.

This book accompanies a traveling exhibit of the same
title. At press time, the venues were as follows:

University Art Museum
University of California, Santa Barbara
6 March–28 April 1991

Mexican Fine Arts Center Museum
Chicago, Illinois
28 June–22 September 1991

Lehigh University Art Galleries
Bethlehem, Pennsylvania
1 November 1991–1 January 1992

Art Galleries
California State University, Northridge
24 February–28 March 1992

Contents

Acknowledgments

In 1969 I was deciding if I could start this project. It would mean giving up security and several interesting job opportunities. One evening my parents visited me. They explained they felt it was better to follow a dream than never to try, and forever wonder what might have been. So I am dedicating this book to my parents for showing me, teaching me, and allowing me to dream.

There are many, many people to thank in a project that has continued for over twenty years. Some of these people you will meet in the book—Charles Demangate, Hilario Hiler, Don Dario and Doña Herculena, Don Diego and Doña Margarita, Don Cornelio and Doña Veva, Don Juan and Doña Alicia, Don Chucho and Doña Eleodora, Don Elut and Doña Juliana, Don Pablo, Don Marcelino, Don Roque, Doña Chole and Don Antonio Negro Aguilar—but there are many more who aren't mentioned who have helped and/or shared in the adventures. They include Abeba and Semira Abraha, Joann Andrews, Bonnie Bishop, Janet Borden, Anne Bronstein, Dorie Reents-Budet, Annette Burden, Albert Chiang, Scott and Ora Clayton, Skip Cole, Teen Conlon, Steven Cortright, Connellan Coxwell, Sienna Craig, Neila Danelius, Dale and Doris Davis, Howard Dean, Ben and Robilee Deane, Rickey and Donald Demangate, Patricia, Josef, and Djamila Demangate, Dolores DeSilver, Nancy Doll, Doug and Ann Edge, Mario and Lupe Escalante, Jon Everton, Pat Everton, Robert Everton, Don and Grace Ewing, David Farmer, Rosy Fitzgerald, Leanord Foote, Lydia Freeman, Alice Rose George, Arturo Gómez-Pompa, Lillian Harris, Morris Hughes (the former American vice-consul in Mérida), Tracey Garet, Linda Girvin, Roger and Vicki Gregorich, Carolyn Gressman, Andy Grundberg, Walt and Claire Heebner, Sharon Hicks, Beate Hoffman, Corrine Horrowitz, Kahn Ivey, Patricia James, John (from Vancouver), Andy Johnson, Vernon and Anne Johnson, Mark Johnstone, Ulrich Keller, Avery, Carol, and Fred Kenyon, Kathleen Klech, Judy Klinge, Richard Mansfield, Katy McCormick, Mary McGinnis, Kevin McKiernan, Neil and Trish Mietus, Felipe Montoya of The Resource Center, Larry and Janet Ogden, Guillermo and Mari Olguin, Katie Peake, Phyllis Plous, James, Binina, and Aida Puc-Hiler, the Ramirez family and El Circo Magico Modelo,

Russ Rappa, Harry and Sandra Reese, Pat Ripley, Jim Risser, Tico Raul Rivas, David Roberts, Richard Ross, Joe Russell (who was instrumental in organizing the Maya Hurricane Benefit), Jeremy Sabloff, Janice Sadler, Afif and Amanda Samaha, Wendy Sanford, Linda Schele, Kornel Schlorlé, Kate and Shannon Schott, Dewey Schurman, Ruth Shaffner, Bill and Stevie Sheatsley, Michael Shnayerson, Martina Sternfeld, Joan Tapper, Rosalind Thomas, Barbara Voorhies, Roger Welch, Marion Woodham, Stephen and Mus White, Roger and Margaret Woods, and Noel Young. I appreciate that the County of Santa Barbara has rented me very economic studio space since 1973—without their help this project would have been even harder to complete. The Mexican Government Tourism Office has been very helpful, especially Mr. Carlos Hampe.

This list seems so neat and concise but doesn't give any idea of the effort many of these people made in helping this project. For example, there were many people who helped wade through the first draft of the manuscript; Annette Burden helped me early on with comments such as "the next eight lines are the worst I've ever read in my life." It is the sort of criticism that is very hard to give to a friend, so I appreciated her honesty. And there is really no way to thank my lovely wife, Mary Heebner. Mary actively listened, made suggestions, and inspired me, in addition to slapping mosquitoes, sleeping in hammocks, and exploring back roads and trails. I also want to thank my son, Robert, who accompanied me several times to Yucatán and is a fabulous traveler. I especially want to thank Charles Demangate who was so intimately involved in the project that he knew what I was trying to say even when I wasn't doing it. Alice George, then picture editor at Fortune Magazine, gave me my first assignments which let me break into editorial photographic work and made it possible for me to give up mule-skinning, river-running, and carpentry as a way to make a living in between trips to Mexico. I appreciate working with Dana Asbury and Tina Kachele at UNM Press who embody everything one thinks an editor and graphic designer should be. Ulrich Keller was the impetus behind this project becoming a traveling exhibition and book, and Stephen White suggested I contact UNM Press. *¡Millón gracias a todos. Hach Dios bo'tik! Andele pues.*

I would like to thank Kodak who donated film for this project in 1988, Apple Computers Inc., who donated a Macintosh computer for writing the manuscript, Richard Armstrong Color Labs in Santa Barbara who made the necessary internegatives, and Freestyle Sales Co. in Los Angeles who donated the Orwo 111 paper for making the final photographic prints.

There are many variations to writing spoken Maya. I have chosen to follow *Diccionario Maya Cordemex* (Mérida: Ediciones Cordemex, 1980).

Macduff Everton
Santa Barbara, 1990

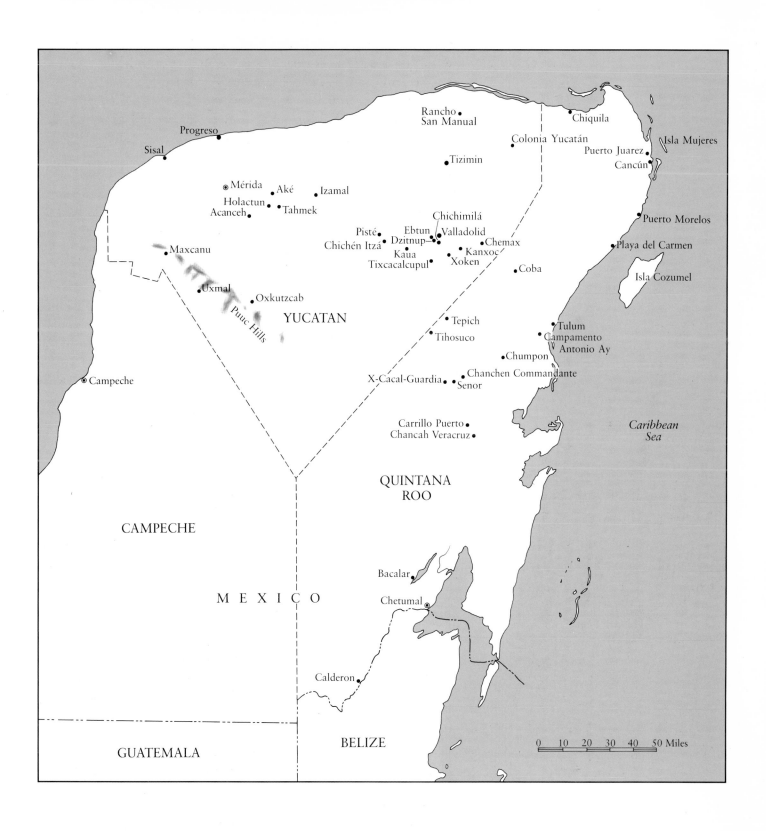

Rancho
San Manual

Chiquila

Progreso

Colonia Yucatán

Isla Mujeres

Sisal

Tizimin

Puerto Juarez

Cancún

Mérida Aké

Izamal

Holactun

Tahmek

Puerto Morelos

Acanceh

Chichimilá

Pisté Ebtun Valladolid

Playa del Carmen

Chichén Itzá Dzitnup

Chemax

Maxcanu

Kaua Kanxoc

Tixcacalcupul Xoken

Isla Cozumel

Coba

Uxmal

Oxkutzcab

Puuc Hills

YUCATAN

Campeche

Tepich

Tulum

Tihosuco

Campamento

Antonio Ay

Chumpon

X-Cacal-Guardia

Chanchen Commandante

Senor

Caribbean
Sea

Carrillo Puerto

Chancah Veracruz

QUINTANA
ROO

CAMPECHE

Bacalar

MEXICO

Chetumal

Calderon

BELIZE

0 10 20 30 40 50 Miles

GUATEMALA

The Modern Maya

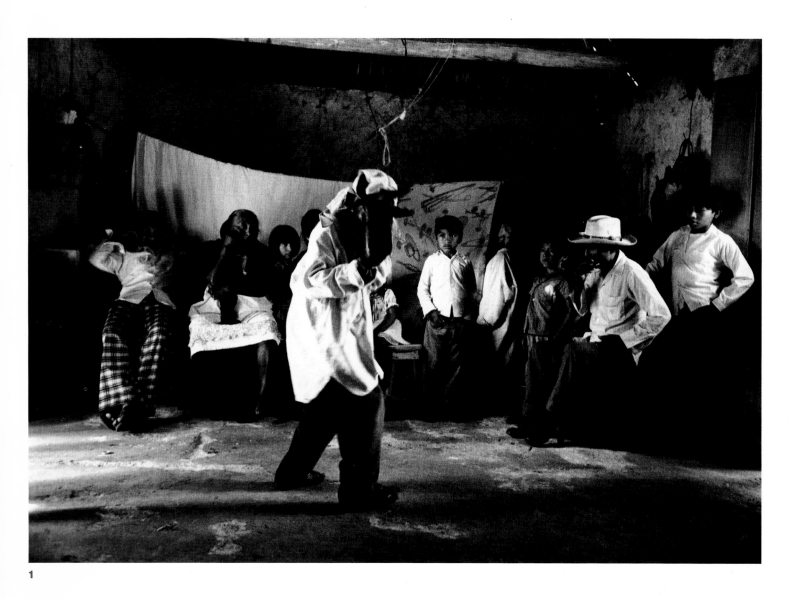

1 *In the village of Dzitnup, Christmas day is celebrated with the devil sweeping through town stealing something from every household. Abraham and Isaac follow the devil to recover the loot and give it to the church. Small boys play the masked roles, which helps assure that the villagers can control the amount the devil takes. Tribute is usually paid in corn. Dzitnup, December 25, 1975.*

Introduction

Anthropology
Photography
Society

ULRICH KELLER

The Otherness of the Maya

This is a book about Maya culture, seen by an American photographer. Its publication necessarily rests on the familiar assumption that every culture other than our own has exemplary aspects which we cannot afford to ignore. Certainly it is no accident that during the past few decades ever-increasing resources have been devoted to the study of a great variety of non-Western ways of life, down to the minutest details. Apparently, what the Kwakiutl or Yoruba do to spear an animal or to celebrate a marriage holds in some way or other great importance for the conduct of our own economic and private lives.

During the nineteenth century, adventurous travelers and early anthropologists defined this exemplariness in no uncertain terms. "Primitive" tribes, seen from the heights of Victorian civilization, were, at best, taken for paradigms of our own state of evolutionary childhood. Many thousand years ago, white European men must have thought and acted in the same primitive manner still observable in present-day Zulus and Trobrianders. Primitive people marked the lowest section of the tree of human evolution in its many ethnic and geographic ramifications, a tree crowned, of course, by Western man who lived in big cities, traveled by railroad, and paid income tax.

The Maya—that is, the living Maya still encountered by modern explorers—faced remarkable difficulties in getting even the most humble place assigned to them in the Darwinian order of things. The problem

3

was, they stood in the shadow of the ancient Maya, who had produced such extraordinary architectural wonders and had therefore been given such a high evolutionary rank that their post-Columbian progeny, colonized into sullen misery, seemed to deserve little more than a contemptuous glance in passing.

John L. Stephens, for example, undertook in the early 1840s one of the first serious archeological explorations of the ruined Maya cities without paying the slightest attention to the habits and identity of the indigenous population. Only once, on occasion of a grand village fiesta, he acknowledged the presence of this population with a sense of puzzlement. While mingling with the white ruling class in the ballroom his eyes wandered and were suddenly struck by the fact that

> outside, leaning upon the railing, looking in, but not presuming to enter, were close files of Indians, and beyond, in the plaza, was a dense mass of them—natives of the land and lords of the soil, that strange people in whose ruined cities I had just been wandering, submitting quietly to the dominion of strangers, bound down and trained to the most abject submission and looking up to the white man as a superior being.[1]

Stephens seems to come close here to the recognition of the living Maya as a people in their own right, but in the end the memory of the ancient, the great and militarily mighty, Maya prevails. "Could these be the descendants of that fierce people who had made such bloody resistance to the Spanish conquerors?"

As long as culture and history were defined in terms of battle victories, monumental architecture, and the like, the living Maya could indeed lay hardly any claim to recognition. That they preserved a rich heritage in form of their language, mythology, rituals, and social organization became visible only to professional anthropologists in the course of the twentieth century. At the end of a long struggle with the fallacies of "ethnocentric" views of other cultures, the evolutionary model has fallen by the wayside, too. "Primitive" societies are now better known as "tribal" societies, and instead of being considered inferior to Western industrial civilization they are simply seen as *different*.

In *Another Place*, a study of the Highland Maya of Zinacantan, Frank Cancian has found persuasive words for this "pluralistic" concept of culture:

> Men wear colorful ribbons on their hats, red and white striped tops and short pants; they carry made-in-Hartford machetes when they go to their cornfields. Women pat out countless tortillas and always walk behind men. Chickens are sacrificed to Maya gods under crosses on a mountaintop overlooking the Catholic church. A proper meal is prepared by rinsing out the mouth as well as hand-washing and Zinacantecos die easily of measles, a European disease.[2]

2

3

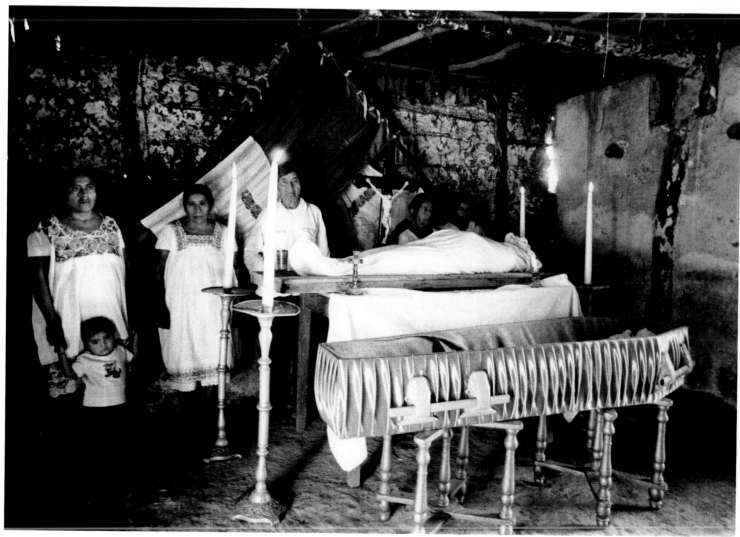

These and similar things, concludes Cancian, characterize the daily life of the highland Maya. But, he adds, "they make very little difference. Zinacantan is another place where people live."

But do they *really* make very little difference, one is tempted to ask, sixteen years (anthropologically speaking, a very long time) after the publication of Cancian's book? Is it that there are some people with white and some with black skins, some with cars and some with horses, some with one wife and some with many, and that it is just fine to be what we happen to be (because, ultimately, perhaps, we are the Family of Man?).

Cultural Pluralism is a beautiful concept, no doubt, but it presupposes some kind of balance between the world's countless cultures. To make this assumption confidently has become an impossibility—and as our optimism is fading the importance of the Maya is growing beyond anything foreseen by Cancian. Perhaps we are beginning to look at Maya culture not as a facet in a pluralistically structured world but as an alternative to, if not an indictment of, that Western culture which soon may be the only one left, on top of a heap of rubble. With the destruction of the rain forests 17,000 species of animals are cultivated out of existence each year. The textures of social life are hardly more resistant to the progress of industrial civilization.

Photographing Cultures

Ever since Columbus Europeans were drawn to the documentation and interpretation of Other cultures; the pursuit of this concern was, of course, greatly furthered by the invention of photography. Museums of ethnology are loaded with photographic collections which await discovery and will sooner or later permit the construction of some kind of history of ethnological/anthropological camera work (and its implications for the history of colonialism).

While there is at present insufficient research evidence to embark on the discussion of this very large topic, a few fragmentary comments are in order, and these can begin in Maya territory, two or three years after the invention of photography. In fact, Yucatán deserves to be recognized as one of the first colonial territories to be surveyed by the camera. As we know already, documenting the ancient Maya ruins was the main goal of John L. Stephens's Central American journeys. Consequently a daguerreotype outfit was included in his luggage primarily for archeological reasons. During a preliminary stay at Merida, however, Stephens decided to apply his photographic skills to human subjects, and some society ladies of the provincial capital seem to have been very pleased indeed with the "artistic effect" of the resulting images. Emboldened by his initial success Stephens proceeded to make a house visit to influential friends in town, but discovered that

> man is born to disappointment. I spare the reader the recital of our
> misfortunes that day. . . . Suffice it to say that we tried plate after

plate, sitting after sitting, varying light, time, and other points of the process, but it was all in vain. . . . What was the cause of our complete discomfiture we never ascertained, but we resolved to give up business as ladies' Daguerreotype portrait takers.[3]

Since the likenesses were apparently just meant to test the camera's performance under tropical conditions Stephens did not attach much importance to his momentary failure; at Uxmal and similar archeological sites the camera later rendered him excellent services. Still, as far as his stated intentions are concerned, his daguerreotype work at Merida marks the beginning of ethnological photography in Latin America; for, had the unsuccessful sitting produced the desired result, it would have included every family member "down to Indian servants."

Since Stephens's adventurous life came to a premature end we cannot answer the question whether his attitude toward the natives of Yucatán would have changed in later years. The example of his approximate contemporary Désiré Charnay suggests that a change of mind might very well have been triggered by the rise of professional anthropology toward the end of the century. Like Stephens, the French amateur archeologist and photographer Charnay was only interested in stones during his first visit to Yucatán in 1859–60, which resulted in the two-volume work *Cités et ruines americaines,* illustrated with purely architectural photographs.[4] When Charnay returned in the 1880s, however, his subject range expanded to include images of native "types," many of which were exposed both frontally and in profile in a demonstrative bid for scientific objectivity.

Charnay's picture pairs exemplify an attitude that permeates a great number of ethnological publications in the fifty years preceding and following the turn of the century—a neutral, scientific attitude, that is, which focused primarily on the physical, and more specifically "racial" characteristics of "primitive" tribes, as well as on material equipment, such as tools, huts, and costumes. During the heyday of Positivism this was perhaps an inevitable course to take for photography. How deeply the taking of indigenous portraits especially was influenced by this scientific ideology can be gathered from the advice a British handbook of anthropological field research offers in a chapter entitled "Photography and the Collection of Specimens":

> Where possible the subject should be given a metric staff to hold. Ideally a true front view, a profile and a three-quarter view should be taken. The subject should have a number attached to him, corresponding to the serial number of the anthropological record card (described on) p.11. A convenient numbering device consists of a strip of zinc, one side painted white. To the back of the strip two tags are soldered, pierced with holes through which a string is passed. The device can then be hung round the subject's neck.[5]

The pitfalls of such maximally scientific, accurate, unassailable photographic Positivism are readily apparent in retrospect. Anthropology is an academic discipline dealing with people who are different, but people nevertheless, and since people are not objects, any

"objective" photographic approach to the documentation of races and cultures was from the beginning fraught with the strange contradiction that what was represented as a thing was really a human being.

Freudian psychology, in conjunction with 35-mm film, led to more mobile photographic procedures during the 1930s. Instead of on physiognomic characteristics and tools, the emphasis was now placed on behavioral patterns, documented in thousands of quickly exposed frames which could be read sequentially much like slowed-down movies. Gregory Bateson's and Margaret Mead's *Balinese Character* is a classic and very persuasive example of this genre, which nevertheless remained committed to a problematic preoccupation with scientific rationality and quantitative accumulation. As anthropological photographers, Bateson and Mead were interested in the species, not individuals, in data, not experience.[6]

Around 1900 the obvious insufficiency of the anthropological illustration in the Positivist vein provoked an artistically inclined counter-movement which emphasized tonal mood as opposed to accurate detail, nostalgic feeling as opposed to scientific neutrality. Among American photographers this alternative attitude is most spendidly represented by Edward Curtis, whose photographs portray Indian chiefs as noble savages in manufactured stone-age costumes, as the real Indians were lingering in rural slums, clad in shredded U.S. Army uniforms or second-hand Sears & Roebuck apparel.

In Central America, moderate variants of this nostalgic approach were adopted by photographers such as Laura Gilpin and Gertrude Blom. While Curtis was personally satisfied that Indian culture was inevitably destined to be ground under the heels of progress, Blom especially was not willing to aquiesce and courageously fought throughout a lifetime for the preservation of Indian cultures and natural habitats which have since largely disappeared from the face of the earth.[7] However, with all her commitment to Indian culture and causes, Gertrude Blom remained very much an outside observer, a highly educated lady from Switzerland who used the camera to project an elegiac image of a pure, aboriginal race living in harmony with the aboriginal rain forest, both veiled in mysterious mists and shadows, belonging to a world irrefutably lost to modern civilization. Blom expressed deep sympathy for the highland Maya via her photographic work; but she never shared their lives which she herself had imbued with too much mystery.

In our own time, the most familiar approach to the photographic documentation of other cultures could be labeled the "National Geographic mode," one which has its origin in photojournalistic reporting in the *Life* tradition, but has largely been reduced to picturesque entertainment thanks to the perfection of color photography.

Seen through the *National Geographic* lens, Third World cultures acquire an air of eternal festiveness embedded in vibrant color. We are looking at wonderful people who lead a rich and creative life, and everyone of us can go there and experience their human warmth first hand. It is the Third World's tourist facade, staged and subventioned by ministries of tourism, which is brought home to us in this glamorous manner. The permanent Kodachrome celebration of Balinese trances and Zulu weddings mercifully covers up the acute political and economic

crisis of the developing countries. Awareness of these problems only could poison our enjoyment of the picture story and lessen the desire to embark on a photo safari of our own. Camera stars of international repute will personally guide groups of amateur photographers to Bombay's red-light district for moving portraits of prostitutes, perhaps with an optional side-trip to Mother Teresa's hospital in Calcultta thrown in.

Through a Special Publications Division, the National Geographic Society develops some of its picture articles into luxuriously illustrated books. In 1977, a volume of this kind was devoted to the Maya, ancient and new. Candlelight processions, exuberant market scenes, carnival festivities, and religious rituals combine to demonstrate the Maya's emergence from a mysterious past into a colorful "round of life" and "dynamic presence" in the modern world, apparently without serious adjustment problems.

A cheerful text makes only involuntary references to the bitter socioeconomic realities underlying the festive surface appearance. Take the introduction of tea cultivation, which *National Geographic* explains to its readers, in the words of a local plantation owner:

> There has been an amazing social change since tea harvesting began [the informant points out optimistically]. Women and children have more agile fingers than men. We pay by the pound, and often a child earns more than the father by picking tea. I call some of the children *maquinitas*—little machines, their hands go so fast. Whoever picks the most every day [i.e., over 100 pounds] gets 25 cents extra.[8]

The name of *National Geographic*'s informant is John Armstrong. How a man with a Yankee name came into possession of a Guatemalan plantation remains as enigmatic as the source of his right to use children in lieu of machines for harvesting his tea. In the United States of America the documentary photographer Jacob Riis crusaded against child labor one hundred years ago. In the vibrantly exotic culture of the highland Maya, however, human *maquinitas* still seem perfectly acceptable today, even cute. Possible second thoughts in the reader's mind are dispersed by the illustration contributed by *National Geographic*'s photographer: a boy rolling his hoop, picturesquely silhouetted against the misty shores of Lake Atitlan.

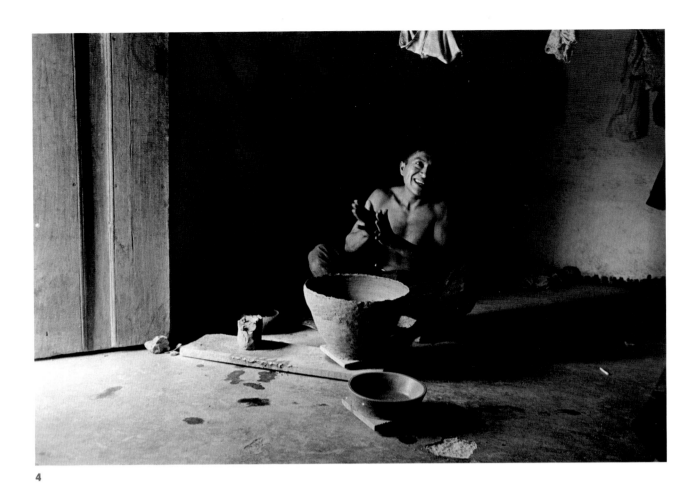

4

5

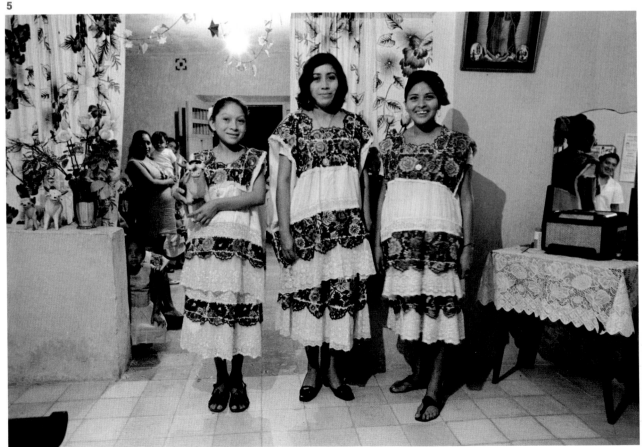

Macduff Everton,
Narrative Photographer

In a broad and perhaps not overly useful labeling attempt we might speak of the "narrative mode" as yet another approach to photographing cultures. It is the approach adopted by Macduff Everton, and the difficulty of describing it in clear academic terminology may have to do with the fact that Everton avoided all professional entrenchment in his camera work.

To be sure, he received degrees from art schools, had his share of group and one-man exhibitions, sold his work to respected art institutions, and made fine contributions to the publication genre known as "artists' books." In short, Everton has acquired all the credentials of a professional artist—but this is a recent development. For a long time, his documentary work in Yucatán was too absorbing to leave room for a career in the United States. Everton's inspirations and aspirations derived from the best camera work in art, social documentation and journalism. Essentially, however, he remained outside the respective professional networks, being content to work periodically at money-making jobs such as river rafting and mule training, as a practical means to finance further documentary campaigns in Yucatán. "Sometimes," he believes, "when you focus on something important you have to make certain decisions."[9] For many years his decision remained firm that continuing to take pictures in Tixcaculcupul was more important than pursuing a photographic career in New York where contacts to publishers fell victim to his frequent long absences.

4 *Fernando Uicab Pech, a potter who uses the coil technique. He can make a large pot in ten minutes. Ticul, 1971.* **5** *Fernando peeks in the mirror as his daughter poses with her cousins during the celebrations of the* gremios. *Ticul, 1971.*

Everton might never have exposed a roll of film in his life at all, had it not been for a brave American tourist who, in a lucid moment, put his camera down in the middle of a street on Bornholm, Denmark, and could not be persuaded to take it back. The man was tired of doing what tourists are supposed to do; Everton, freshly embarked on a tour of the world at age seventeen, was not and kept the camera. The pictures he sent back to his parents received critical scrutiny and encouragement. By the time he got to Asia he had become rather proficient at producing picture stories, some of which were bought by Asahi and published in Japanese magazines (1966).

His first, two-month visit to Yucatán came in 1967, on the payroll of the Tenth Muse Inc., a small California company specializing in manufacturing archeological film strips. The Tenth Muse went bankrupt in short order, but Everton kept returning to Yucatán to gather materials for a photo book on contemporary Maya culture. The project, which eventually grew into a twenty-year enterprise, was at first supported by Everton's parents with small monthly checks. Later he developed outside sources, including a brief and ill-fated association with *National Geographic*. Until 1976 so much of his life was spent among the Maya that he began to feel a sense of deprivation. Everton missed traveling and seeing the world—because going to Yucatán seemed more and more like "going home."

What was the book to be like? Everton never could reconcile the dry, didactic illustrations in anthropological volumes with his own travel experiences. Artistically ambitious photo books seemed even worse because they sacrificed documentary information to fancy design effects. Coffee table volumes on foreign countries were not the answer either; they put excessive emphasis on scenic beauty, architectural wonders, and exotic costumes while neglecting to portray individuals with full identity.

Finally there was the reportage genre, but photo essays for the magazines needed to be topical and exciting. There were editors in New York who could be persuaded to look at pictures taken in a part of Mexico which never made headlines. The editors even thought the photographs publishable—provided that sex and drug topics would be included, Castaneda style. "Except," says Everton, "this was not the way I wanted to represent my friends."

Still, the photo-essay format pioneered by *Life* magazine since the 1930s offered a model of persuasive narrative reporting after which his planned book could be fashioned. *Life's* editorial slant, the deadlines, the sensationalism, the slick packaging and similar commercial constraints could be avoided by a freelancer working with his own agenda, for his own satisfaction. What proved eminently useful for Everton, on the other hand, was the concept of a *narratively developed* photo story devoted to a person, or two or three, persons who were representative of a whole community and could serve to mirror general conditions in individual terms. Eugene Smith's "Country Doctor" and "Midwife" essays for *Life* magazine are still celebrated today as classical examples of what could be accomplished in this genre.[10] Everton was aware of Smith and found the "one day in the life" format still serviceable enough in the 1970s to be used as the basic structure

for his projected Maya book. It always had been his principal goal "to be specific about individuals"; moreover, he wanted to produce not an arcane scholarly treatise for a handful of experts but vivid reading (and viewing) for a general audience, something which would have its place in public libraries and schools. The eminently fluent and persuasive photo-essay approach permitted to accomplish just that.

It was a problematic approach nevertheless. While it seems natural to see an American country doctor's work featured in a photo story, as Eugene Smith had done, one might question whether such personal, narrative treatment is equally suitable for contemporary Maya culture. As an essentially anthropological subject (from *our* vantage point, at any rate) the latter seems to call for sound scientific examination, but a scientist Everton is not. Though he has read plenty of anthropological books, he would not lay claim to thorough scholarly grounding in Maya history, economy, society; nor is he abreast of the current, increasingly sophisticated strategies geared at avoiding ethnocentric fallacies, minimizing the observer's influence on the observed community's daily life, obtaining reliable data from informants, drawing legitimate conclusions from the accumulated data, and, above all, arriving at a halfway complete and balanced evaluation of a given culture. As an artist Everton cannot reasonably be expected to compete with professional anthropologists in these matters, and it is certainly a good thing that he made no such attempt. At the same time it is obvious that even the finest artistic sensitivity is liable to go astray at times without expert guidance where the nature of the subject requires it.

For example, the selection of the individuals to whom Everton's photo essays are devoted involved quite complex considerations—if it was to be a *representative* selection which accurately mirrored the structure of Maya society. Everton no doubt gave much thought to the matter, and the individuals chosen as his main protagonists certainly can stand for diverse and important facets of Maya life. Whether they are truly representative of their culture is a debatable question, however. Many indications point to the fact that this culture is perhaps more complex, more contradictory and less tranquil, less lovable than Everton's images suggest.

Specifically, one is tempted to ask: where are the mayors and policemen, the drug dealers and big land owners, the elected officials, the union organizers, the Yankee businessmen, and the rest of the post-Colonial social framework within which the Maya happen to exist and to be short-changed, Dario, Alicia, and Doña Veva not excluded. It could be argued that such marginal figures have no legitimate place in a photographic documentation of an authentic Maya core community, except that in anthropological contexts the isolation of some kind of authentic core always encompasses the danger of romantic fiction. In any event it can be said that the political dimension is all but absent from Everton's photo essays, though some telling passages are interspersed in his text. His photojournalistic procedure made this deficit all but unavoidable. Photo essays in the *Life* tradition routinely compressed the enormous complexity of historical processes and social conditions into the narrow scope of individual lives. The rise of *Life* magazine brought the apotheosis of the photograph as "human

document"; some of the limitations of this journalistic reification can still be felt in Everton's work.

But we should not dwell on this side observation. On the whole Everton was remarkably successful in surmounting the shortcomings inherent in journalistic or anthropological camera work. Press photographers, for example, never have time because of publication deadlines; anthropologists, on the other hand, never can get involved because neutrality is their scientific creed. The key to understanding Everton's work may well lie in the fact that contrary to accepted precedent he acts as a participant in, rather than a neutral, passing observer of social situations. The truthfulness of his photographic documentation is not guaranteed by scientific or any other professional procedure, but by the individual behind the camera, his intelligence, sensitivity, and tact. Even though, upon further reflection, we must correct this statement. Everton does not really remain behind the camera, where documentary photographers usually want to be, as invisible as possible. In a manner of speaking, he is always present before the camera—because the people in the picture include him in their circle; we can tell that they accept and trust him; and since they trust him, his pictures have credibility for us, too.

Everton's use of very wide wide-angle lenses is emblematic in this respect. He is close to those he photographs; he is permitted to see them in very personal, sometimes tender and intimate situations; clearly he and they are friends, and it is no wonder that from this very privileged perspective he is able to articulate things which are off limits to professional anthropologists or journalists.

When Margaret Mead returned from her first field trip it suddenly occurred to her "how starved for affection" her strictly scientific pursuits had left her. "As Gregory Bateson phrased it later, it is not frustrated sex, it is frustrated gentleness that is so hard to bear when one is working for long months alone in the field. . . . I realized now how lonely I had been, how much I wanted to be where someone else wanted me to be just because I was myself."[11]

Without talent for similar asceticism, Everton used close friendship as the basis of his photographic work. It is a relationship which permitted to bridge differences without disguising or denying them. Everton could be a Yankee wanderer with anthropological interests, romantically tinged, perhaps, and Don Chucho could be a Maya laborer trying to make a living, given to strange religious beliefs, perhaps. But they could genuinely like and respect each other, they could get drunk together, and they could have a quarrel and make up. It was a kind of interaction unlikely to lead to new theoretical insights concerning kinship systems and sex role definition, nor would it generate visual information as to how the Maya go about weaving a basket or skinning a pig. Some such data can be gathered from Everton's documentation, to be sure, but that is a side result.

In essence these pictures are nonscientific; they do not conform to anthropological or any other standards of what a picture ought to show, and how it should do so. Consequently, it is not overly important to try to decode these pictures in any professional sense. The secret of their extraordinary persuasiveness is that they go far beyond any standardized

knowledge within the confines of an academic discipline. Seen through Everton's eyes, the Maya preserve the full personal identities and the rich lives which scientific investigation always curtails in search of reliable data. Not only as a private visitor, but also as a photographer he has managed to relate to them as people, as friends, rather than as anthropological subjects, i.e., objects. This means that his viewers, too, must bring into play the whole range of their faculties and sensitivities, not just academically trained segments.

Perhaps, Everton comes closest to professional anthropological work in those sometimes quite extensive and painstakingly accumulated picture series which he devoted to the elaborate ritual operations accentuating significant moments and passages in the life of a traditional Maya community. Clearly, these ceremonial occasions held a special fascination for the photographer—and so they should for every observer coming from the impoverished commercial culture of modern industrial nations. The amount of labor and the complexity of the ritual procedures summoned by Maya villagers, for example, to prepare food for consecration on an altar is truly amazing. All these day-long exertions have nothing to do with the production of a marketable commodity, with "making" money, with material enrichment; no commercial or economic purpose is involved at all. This is a more important labor by which the Maya constitute the gods, the land, and themselves as a meaningfully structured world, both material and spiritual, one which has room for their hands, and also for their hopes and fears and dreams. In his ceremonial sequences, too, however—as close as they sometimes come to systematic professional inquiry— Everton ultimately fails to proceed in straight, linear fashion and to produce standardized, scientific picture results.

In all, his documentation thus stands in an unusual, though, upon further consideration, not at all negative relationship to anthropology. Scientists require "hard" visual data which can be unequivocally decoded, processed, and used in support of clearcut theoretical conclusions. By comparison, Everton's work is "soft" and open to many interpretations, making it vulnerable to legitimate criticism from the academic side, but providing a challenge to professional entrenchment as well. Against the generalizations of the anthropologists whose writings deal with classes of individuals and models of culture, Everton sets the concreteness of one person's life and one hamlet's rain ceremony. Strictly speaking, there can never be a reconciliation between the two modes of understanding, nor should there be. Everton's photo essays and the textbooks will never "jibe"; rather, their mutual validity will have to be tested against each other in an ongoing process. In slight modification of Hegel's famous dictum, it might be said that scientific concepts remain blind without concrete visual evidence, whereas the latter remains empty without the first. Quite possibly, the principal significance of Everton's work lies in the fact that, contrary to the prevailing pattern, it is strong enough to open a dialogue with academic scholarship, instead of just illustrating it.

Everton has photographed Maya culture with the intimate familiarity of a friend, but also with the curiosity of a foreign visitor, and this permitted him to give us an unusually clear picture of what we have called the "otherness" of the Maya. In looking through this comprehensive photographic record we are constantly made aware of the differences separating our culture from theirs—important differences which must not be misunderstood as merely decorative variations in the cultural facades lining the tourist trail.

6

6 A boy proudly shows off his family's new transistor radio in front of a store. Tulum, 1971. 7 This woman wanted her portrait taken in her house with her prize possession, her radio. Tixhualatun, 1971.

At the same time, however, it is difficult to ignore the countless traces pointing to the gradual erosion of the "otherness" of contemporary Maya society. Everton's work in Yucatán spans about twenty years, a negligible slice of history in the existence of tribal communities before the advent of colonialism, but a rapidly moving and immensely traumatic period under the external pressures exerted on a small and isolated social organism by the world economy of the late twentieth century.

When Everton made his first photographs of it, the Maya way of life seemed to possess the stability and permanence of a culture which has been there since time immemorial and will continue to be there beyond forseeable horizons of time. But more recently the Maya's seemingly unlimited life expectancy has dramatically shrunk. Everton has this to say about his growing awareness that he was documenting a *changing* culture.

> As I researched and photographed I noticed that something important was happening. The government was bringing roads and electricity to rural areas. Work patterns shifted, native industries disappeared, and the tourist trade became big business as Cancun was developed. My thinking changed accordingly. At first, it had been natural for me to see and record Maya life as the continuation of a culture that was thousands of years old. But then I became aware of the rapid changes in the lives of many of my Maya friends and it was no longer possible for me to resist documenting the signs of Western culture which appeared everywhere.
>
> More than anything it was a rain ceremony in Chichimila that led me to modify my approach. Instead of being held in the jungle, the ceremony was conducted in a farmer's backyard on the outskirts of town. Instead of a jungle altar a small hut with a clothes line attached to it was used. The older farmers were dressed in cotton shirts and trousers, but some of the younger men had clothes made from synthetics, and wore new watches. I tried numerous approaches to keep these offending items out of the photographs until I realized that these were the very elements that I needed to show. I was documenting a culture in transition.[12]

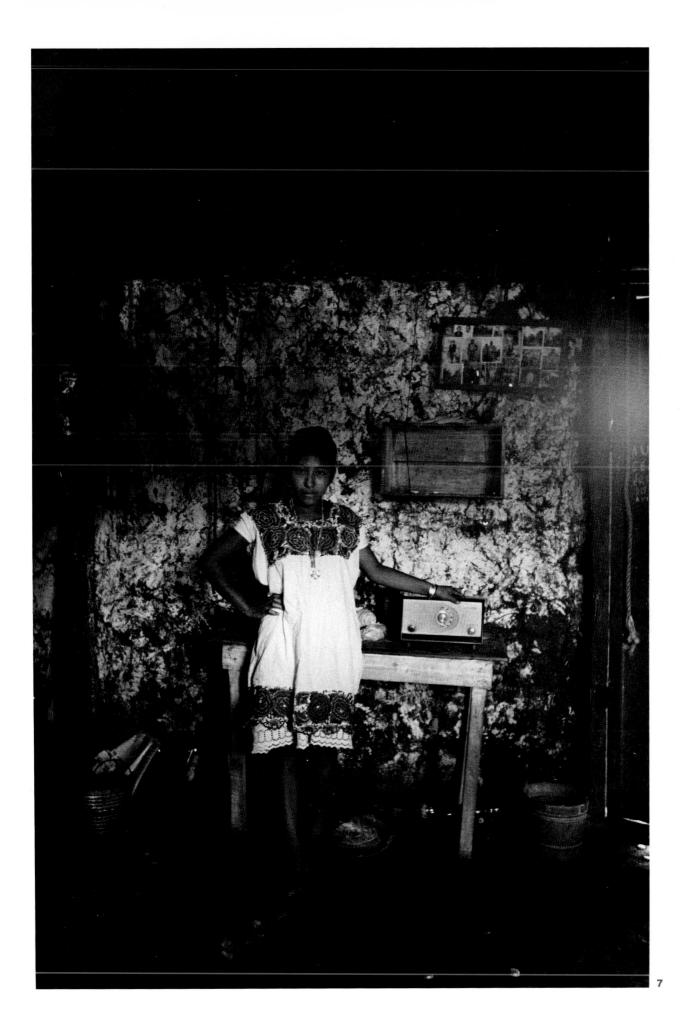

7

What cultural change means in a Maya village in Yucatán can perhaps best be summed up in a pair of photographs (Figs. 9, 8). In 1976 Doña Veva had her hammock strung out in a hut with a thatched roof and a dirt floor; the walls were made of loosely planted bamboo poles, and light and air passed through the intervals. Ten years later Doña Veva's hammock had migrated to a room with concrete walls; with her back turned toward the window she is shown watching a television movie—that is to say, we see her looking into our world, beginning to participate in it, becoming like us. Doña Veva has at last caught up with the twentieth century.

Is this bad? Most likely, life is more comfortable for her now; after all, the passage from jungle to town usually brings a reduction of physical exertion, together with an increase in social security. As far as her own interests are concerned, therefore, we probably have little reason to regret the marked change in her life.

Generally speaking it is a rather dubious habit to describe in totally negative terms the processes of adaptation to which the ancient non-European cultures have been subjected in our century. True, cultural change is a cruel business, especially when imposed from the outside under colonial to imperialistic auspices, and the dry academic concepts used by anthropologists to classify kinds of Third World change (syncretism, deculturation, rejection, etc., above all: modernization) tend to refer to often bloody historical processes. True, too, that Doña Veva, in watching "Dallas" on television, has embarked on her own quiet Cargo Cult.

Still, it is a fact of considerable relevance that the strongly knit social textures of Third World nations are not only and not always eroded under Western influence. They also seem to have a remarkable integrative power which may permit constructive fusions of traditional and modern ways of life. As Manning Nash has demonstrated in his notable sociological study *Machine Age Maya*, for example, a factory in a small Maya community will turn out to be a more communally structured and thus a very different institution from what we know it to be in Columbus, Ohio, or Manchester, England.[13]

To come back to the concrete case at hand: certainly great changes have recently occurred in Doña Veva's life, but even though she has become much more like us she will be all right, it stands to reason, and we even can assume that to a much larger degree than seems superficially evident to American viewers she and her children will preserve significant elements of their Maya identity.

But, of course, we do regret the changes; we would prefer to keep looking into her world as it used to be, to preserve the hope and possibility of a way of life essentially different from anything known to us. From our own vantage point, Doña Veva's passage from first to second nature involves a great loss. To be sure, this loss primarily belongs in a nostalgic category and is registered almost exclusively by the peculiar sensitivity of intellectuals in advanced industrial societies. Yet an argument could be made that something much more serious is at stake when bamboo huts are irrevocably replaced by concrete houses.

Few people will deny that we are witnessing the beginning of an industrial world culture which increasingly obliterates the differences

between the nations and regions of this globe. As people think and act more and more alike, a very real danger emerges. Scientific research in several disciplines leaves no doubt that the survival of a given population, human or otherwise, depends on its adaptability in the face of change and crisis; again, the ability to adapt depends on the diversity of both the genetic endowment and the cultural skills represented in the population.

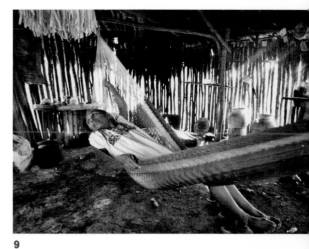

9

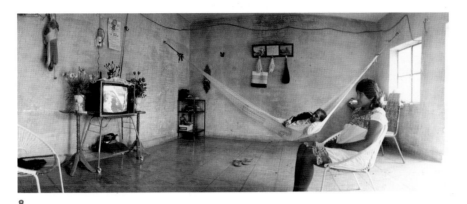

8

8 *Veva and her daughter Alicia watching television in Alicia's new house. Chichimilá, 1986.* 9 *Veva in her house. Chichimilá, 1976.*

To use a hypothetical example cited in an anthropological textbook:

> Suppose that the earth's supply of fossil fuels were to be totally exhausted by the start of the twenty-first century. What would happen to the people in northern climates if they could no longer heat their homes artificially or buy gasoline for their piston-engine vehicles? If such a calamity were to occur today, while true cultural diversity still exists, it is highly probable that Eskimos, Lapps, Siberians and other peoples accustomed to a frigid, harsh environment would survive; these marginal cultures have the social organization and technology necessary to live, perhaps even to thrive, in this kind of ecosystem.
>
> [However,] if the Eskimos had been assimilated into the single culture, they would all have traded in their dog sleds for snowmobiles, and their kayaks and umiaks for stainless steel boats powered by outboard motors. Thus their traditional techniques for survival would be lost and forgotten; the Eskimos would perish with everyone else.[14]

Mutatis mutandis, the same applies, of course, to the first inhabitants of Yucatán. The Maya possess one of the world's oldest cultural traditions. It is a culture fundamentally "other" than ours and in its otherness a paradigm of human existence which must never be lost. If it were an entirely past and ancient culture, nostalgic intellectual retrospection might be the only proper way to relate to it. But because of the unique thoughts, values, and skills encoded in it, Maya culture is of crucial future importance as well. Ultimately, being aware of Maya culture (among others) and trying to preserve it in some form, is a matter of survival, not just for the Maya but for ourselves, too.

10

10 *This man is waiting for the music. He wanted a portrait of himself dancing at a baptismal party. He is trying to be very serious. Meanwhile, more than thirty people behind me are laughing and commenting on his abilities as we wait for a piece to begin on a portable record player. Chichimilá, 1976.*

Notes

1. J. L. Stephens, *Incidents of Travel in Yucatan* (New York: Dover, 1963), vol. 1, p. 120 (originally published 1843).

2. F. Cancian, *Another Place: Photographs of a Maya Community* (San Francisco: Scrimshaw, 1974), unpaginated preface.

3. Stephens, p. 57.

4. K. F. Davis, *Désiré Charnay: Expeditionary Photographer* (Albuquerque: University of New Mexico Press, 1981), pp. 101 ff., 155 ff.

5. *Notes and Queries on Anthropology,* edited for the British Association of the Advancement of Science . . . (London: The Royal Anthropological Institute, 1929, 5th ed.), p. 376 ff.

6. G. Bateson and M. Mead, *Balinese Character: A Photographic Analysis* (New York: N.Y. Academy of Sciences, 1942).

7. *Gertrude Blom: Bearing Witness,* edited by A. Harris and M. Sartor (Chapel Hill: University of North Carolina Press, 1984).

8. G. E. and G. S. Stuart, *The Mysterious Maya* (Washington, D.C.: National Geographic Society, 1977), p. 180.

9. This quote and the following, as well as the biographical data, are taken from the author's interviews with the photographer.

10. For the history, problematic and literature of the "photo essay," see *The Highway as Habitat: A Roy Stryker Documentation, 1943–1955,* edited and with an introductory text by Ulrich Keller (University of California, Santa Barbara, 1986), pp. 31 ff.

11. M. Mead, *Blackberry Winter: My Earlier Years* (New York: Simon & Schuster, 1972), p. 155.

12. Quoted from a recent grant application by Macduff Everton.

13. M. Nash, *Machine Age Maya. The Industrialization of a Guatemala Community,* published as vol. 60, no. 2 in the series *The American Anthropologist* (American Anthropological Association, 1958).

14. W. A. Haviland, *Cultural Anthropology* (New York: Holt, Rinehart & Winston, 1975), p. 390.

I wish to thank the Interdisciplinary Humanities Center at the University of California/Santa Barbara for a summer stipend which facilitated the preparation of this essay. I am also indebted to my colleagues Thomas Harding and Juan Vicente Palerm for liberally shared anthropological advice.

Suggested Reading

Banta, M., and C. M. Hinsley. *From Site to Sight: Anthropology, Photography and the Power of Imagery.* Exhibition catalogue, Peabody Museum of Archaeology and Ethnology, Department of Anthropology, Harvard University, Cambridge, Mass.: Peabody Museum Press, 1986.

Theye, Th., ed. *Der geraubte Schatten. Eine Weltreise im Spiegel der ethnographischen Photographie.* Exhibition catalogue, Münchner Stadtmuseum. Munich and Lucerne: Bucher, 1989.

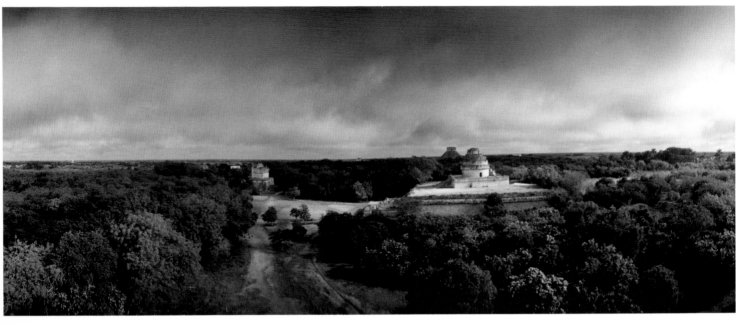

11

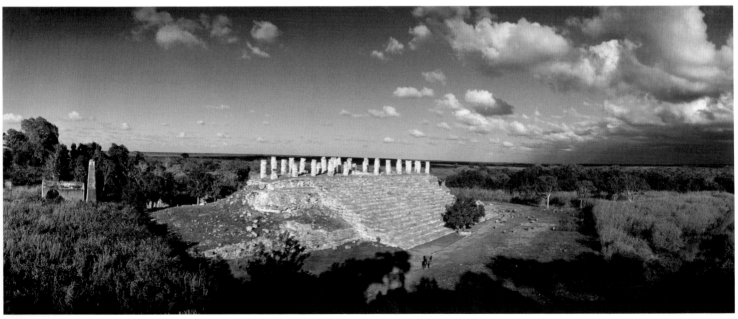

12

Maya Civilization Prior to European Contact

𝄢𝄢𝄢𝄢𝄢𝄢𝄢𝄢𝄢𝄢

DORIE REENTS-BUDET

The Maya of today are the descendants of one of the world's great civilizations. Their accomplishments during the first millennium A.D. include sophisticated architecture, some of which was surpassed in size only in the twentieth century, sophisticated calendric calculations based on long-term observational astronomy whose tabulations were as accurate as those of sixteenth-century Europe, and a true writing system. The pre-Columbian Maya are characterized by deep-seated religious beliefs and institutions with a strong philosophical base and accompanying literary tradition, long-distance economic relations among the many peoples of Middle and Central America, highly productive, intensive agricultural systems that are being revived today to meet the needs of a hungry twentieth-century population and administrative institutions of a complexity that mirrors that of Maya culture as a whole. While Europe fell into the depths of the Dark Ages, the Maya were revelling in their Classic period (A.D. 200–900).

These Classic cultural developments were the result of thousands of years of human development, culminating in a thriving village life as early as 2000 B.C. The basis of stationary village life in Middle America was the agricultural triad of corn, beans, and squash, three crops which when grown together replenish soil nutrients, and when consumed together provide sufficient protein and other dietary needs for human sustenance. As among all human groups, from this humble base the

11 *Looking towards the observatory and El Castillo pyramid at Chichén Itzá, 1986.*
12 *The main remaining structure at Ruinas de Aké, 1986.*

23

Maya created a vital, complex, and unique culture which survives today in the face of unbelievable social and economic odds.

Because corn has always been the basis of life among the Maya, we find present-day ceremonial activity surrounding the cycle of corn and the milpa, from the *hanli col* planting rite to harvest rituals. Over and above its place as the basis of existence, corn is considered sacred such that tortillas made from corn and honey are the host during Catholic Masses in the more remote villages. This reverence for corn and the milpa is preserved in the art and architecture from the Classic period. In the earliest elite art in Middle America, corn functioned as a symbol of power and royalty. For example, an ear of corn is found in the headdresses that identify the rulers of the Olmec civilization, the "mother culture" of Middle America (1200–400 B.C.), that predates the Classic Maya by one thousand years.

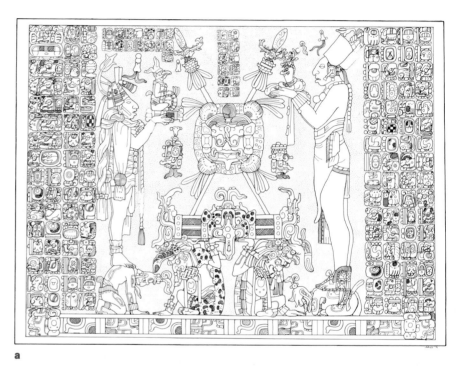

a

During Classic Maya times, the rulers included the corn plant as an integral part of their royal costumes and decorated their most sacred buildings with corn imagery. For example, corn growing from the sacred mountain adorns the borders of the two outside carved panels from the Temple of the Sun at Palenque. Here corn imagery surrounds the ruler Chan Bahlum, who is depicted on these two panels dressed in the royal costume of accession to the throne (Figure a). Corn is personified as the Young Corn God, patron of the number eight, and this deity's image is worn as part of the royal regalia of Maya rulers. Chan Bahlum sports the sprouting head of the Young Corn God on the back of his royal belt on the flanking panels of the Tablet of the Foliated Cross (Figure b).

At death, the Maya believed the human soul sojourned through the Underworld. After defeating the lords of the Underworld, the resurrected soul dances out of the realm of death, resurrected in the persona of the Young Corn God, just as the corn plant is reborn each year in the milpa. This image of the resurrected Young Corn God is painted on many of the beautiful pottery vases and is sculpted on some of the finest stone

wall panels for which the Classic Maya artists are famous, including the Dumbarton Oaks Tablet (Figure c). On this tablet, the Palenque ruler Kan Xul dances from the Underworld, his hairdo adorned with a corn leaf signaling his resurrection as the Young Corn God.

The ancient Maya also believed that an enormous ceiba tree bridged the realms of humans and those of the supernaturals who resided both above and below the earth in the heavens and in the Underworld. It is along the trunk of this tree, envisioned in the shape of a cross, that humans transcended these levels. This axis mundi is found throughout Classic Maya art, adorning such major pieces of artistic expressions as Lord Pacal's sarcophagus lid at Palenque (Figure d). Delicately carved on this two-ton slab of limestone is the portrait of Pacal, one of Palenque's greatest rulers (and the father of both Chan Bahlum and Kan Xul mentioned above). Pacal here is dressed as the Young Corn God as he

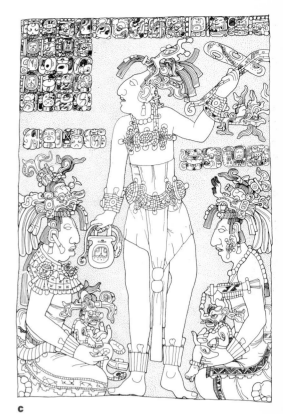

c

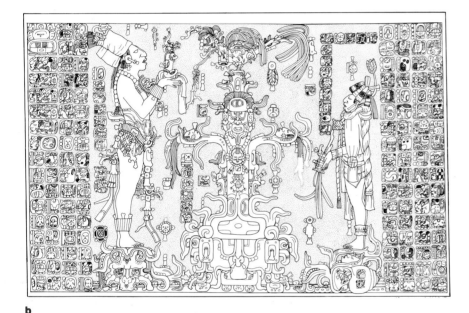

b

descends into the Underworld along the axis mundi of the world tree. That he is depicted in this guise as he descends into the Underworld speaks to us across of the ages of his assured resurrection from death.

In other instances, the corn plant is combined with the symbol of the world tree which conceptually bridges the three levels of the Maya cosmos. Along this axis mundi, the Maya move from the heavens to the earth to the Underworld and contact their gods and deified ancestors through prayer and other rituals. This axis mundi/corn plant is depicted in the center of the Tablet of the Foliated Cross from Palenque (Figure b). On this tablet, the axis mundi/divine corn plant visually and conceptually separates the deceased Pacal (on the right) and his living son Chan Bahlum (on the left). Pacal stands on a corn plant rooted in the Underworld. The corn plant includes the portrait of the Young Corn God, signaling Pascal's resurrection and divine status. The tablet celebrates Chan Bahlum's heir designation. On the left flanking panel, Chan Bahlum wears the Young Corn God at the back of his royal belt, thus connecting him with his deified father and substantiating his legitimate claim to the throne.

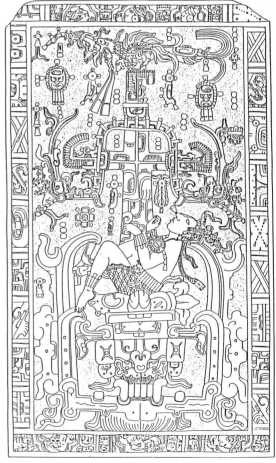

d

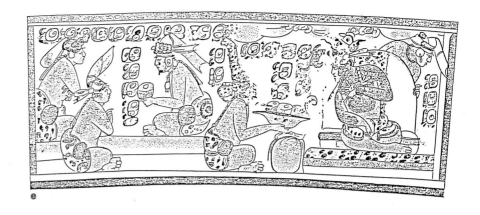

A Late Classic Maya painted vase. Corn offerings in the form of wah *(tamales) are being presented while various lords are seated within a palace or temple. From Michael Coe,* The Maya Scribe and His World *(New York: Grolier Club, 1973).* **f** *A Late Classic painted vase whose inscription states that the vase was used to hold a ritual cacao beverage. The vase is from the collection of the Duke University Museum of Art.*

Intimately tied to the persuasiveness of corn as the primary support of life is rain. The Maya were and are keenly aware that without this life-giving element corn and thus all life cannot exist. Extensive remains of ritual activity associated with rain are found in the archeological record from the Classic period, much of this evidence from caves in Yucatán, Belize, and Guatemala. For the Classic Maya caves were not only the entrance to the Underworld where dwell many supernatural beings, but also the source of clouds, and of course clouds are the origin of rain. This phenomenon can be witnessed every morning at the mouth of many of the hundreds of caves in the Maya lowlands; a cloud of mist, seemingly originating in the dark depths of the cavern, develops at the cave entrance and rises into the sky as the day becomes warmer. Based on observation of the world, which is the foundation of all science, the Maya deduced that clouds, and thus rain, must originate in caves. Thus, caves for the Maya were and are the abode of the Rain God Chac.

In Yucatán today, caves are still used for religious ritual. In many, there are extensive remains of pre-Columbian ritual activities associated with water and rain such as the collection of *zuhuy ha'* or "virgin water" required for all ceremonies dedicated to Chac. In the late 1950s while excavating at Chichén Itzá, archeologists discovered the nearby Cave of Balancanche, which was filled with pre-Columbian pottery modeled and painted with images of Chac and other artifacts arranged in intricate patterns. Prior to any archeological investigations in the Cave of Balancanche, the local Maya insisted upon completing an extensive two-day ritual in order to appease the Underworld deities, including Chac, to ensure that the archeologists did not upset the balance between the deities and humankind and in the process

Dorie Reents-Budet

jeopardize the cycle of rain/life. Although various Christian saints were invoked in the offered prayers, many indigenous and probably ancient Maya deities were also called forth. Further, the structure of the prayers is Maya and no doubt reflects ancient religious litanies.

Observations of these present-day rituals and beliefs provide a rich source of information for understanding the archeological remains of the past. In Yucatán, the intricately carved exteriors of the temples found atop pyramids, such as the Temple of the Magician at Uxmal, represent the open mouth of a "monster" identified as the *cauac*, or earth, monster. The doorways into these temples, then, are symbolic entrances into the earth, while the temples themselves are man-made caves and the abode of the supernaturals. In essence, the Classic Maya of Yucatán replicated sacred caves atop their pyramids, both of which were the locations of religious ritual.

Today's ceremonies associated with the milpa and the coming of the rains, which take place in the fields, in caves, and at other sacred natural locations, include the preparation of ritual offerings such as special drinks and tamales, or *wah* in Yucatec Maya. We find these same items painted on the Classic Maya pictorial pottery. Plates piled high with tamales are set next to the rulers depicted participating in rituals. On the vase in Figure e, the tamales are even marked with the hieroglyph for corn. Many of the glyphic texts painted around the rims of cylinder vases state that the vases were created to contain a ritual drink made from cacao, or chocolate, and ground corn (Figure f). Such drinks are an integral part of modern rituals as well. The twelve hundred years that separate today's rituals from the Classic period painted pottery attest to the survival and longevity of Maya culture.

Human culture is conservative and the Maya are no different. Many of the basic patterns of life that we identify from the Classic period are present today in Yucatán and highland Guatemala, the two major bastions of modern indigenous life. In particular, we find a strong continuity from pre-Columbian times to the present in the sphere of religion. For example, we find today that the New Fire ceremony, which bridged the transition from the old year into the new year and whose themes included rebirth and renewal, has been grafted onto the Christian celebration of Easter whose theme is also one of rebirth and renewal through resurrection. The early acceptance of the symbol of the Christian cross no doubt also is related to the central place of the cross in pre-Columbian religion, where it was the symbol of the tree (axis mundi) that bridged the world of the humans with that of the deities.

Additional evidence for the conservatism of culture and of the Maya people is the continuity of sacred places. Many places that today are centers of Christian ritual were considered sacred in pre-Columbian times. In fact, the presence of a sixteenth-century church or monastery usually identifies a pre-Columbian sacred place because at the Conquest the Spaniards purposely erected their Christian structures atop Maya sacred mounds in order to demonstrate the supremacy of Christianity over the "pagan" native religion.

As with most great religions, the concept of pilgrimage to sacred places has been an integral part of Maya sacred ritual for thousands of years. In Yucatán, many such places existed in pre-Columbian times.

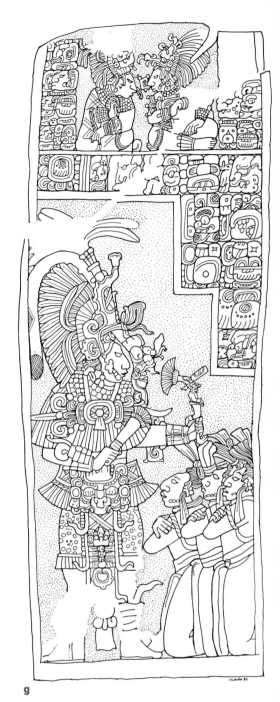

g

g *Yaxchilan Stela 11. Bird Jaguar receives war captives while dressed in the guise of one of the supernatural Hero Twins (GI, Hun Ahpu). Drawing by Linda Schele.*

The well-known island of Cozumel, a modern-day tourist resort, was dedicated to the Moon Goddess Ix Chel, and archeological remains on the island suggest that it had been a point of religious pilgrimage for many hundreds of years during the pre-Columbian era. Loltun Cave, located in central Yucatán, also has been a point of pilgrimage from Preclassic times (as early as 100 B.C.) into the Christian era.

The sacredness of the archeological sites thmselves is not lost, even though a new foreign culture and religion have come to the Maya. At many sites, such as Cobá in Quintana Roo, the present-day Maya burn candles and leave other evidence of devotion in front of the stone monuments whose carved images are those of the ancient kings. The modern Maya say that the *abuelos* (or "ancient ones") are still lively and powerful, that the power of these ancient sites and their rulers is still present; thus it is important to pay due homage to their presence.

We find this same kind of devotion to the ancestors during the Classic period when they were considered divine, having been transformed at death into deities. On both the Tablets of the Sun and the Foliated Cross from Palenque (Figures a and b) the dead Pacal, father of the ruler Chan Bahlum, is depicted participating in the accession rituals of his son. Only a supernatural being would have the power to return to earth to take part in these earthly events.

Of particular note as a place of pilgrimage is Izamal, a large town in north-central Yucatán and the site of the first bishopric of Yucatán. Izamal was a long-standing sacred place for hundreds of years prior to the coming of the Spaniards. The name *Izamal* means "Place of Itzamna," Itzamna being one of the principle deities of the Postclassic Maya. Itzamna seemingly came to prominence during the influx of the powerful Itza Maya who were one of the later transformers of the site of Chichen Itza after the collapse of the Classic Maya centers. The Itza Maya were one of the few invaders of Yucatán who were strong enough to leave their cultural imprint upon the region, coming from Tabasco in the tenth century A.D.

After the Itza fell from power, Yucatec Maya life and religion continued as it does today with pilgrimages to Izamal on three important days in the Christian calendar (February 2, August 15, and December 8). The religious importance of Izamal has been so great through the centuries that the Virgin of Izamal was made the Patroness of Yucatán by papal decree in 1970. In short, typified by their adaptability, the Mayas' modern religious beliefs and practices include elements that have survived from pre-Columbian times. These ancient religious patterns were grafted onto Christianity during early Colonial times and are alive and well today, helping to maintain a healthy Yucatecan Maya culture in the face of many odds.

The continuity of socioreligious belief and practices despite all types of cultural onslaughts typifies the Maya. Yucatán has survived three major sociopolitical invasions in the past one thousand years, each of which could easily have destroyed a less strong culture group. The first, mentioned above, was the Itzá Maya invasion in the tenth century A.D. The second was the so-called Toltec invasion in the late tenth or early eleventh century A.D. which, according to legend, coincides with the expulsion of a great ruler and warrior (the now-mythical Quetzalcoatl

or Kukulcan in Yucatec Maya) from Tula in highland Mexico. The third invasion was that of the Spanish in the sixteenth century. Yet throughout these invasions, each of which left its mark both on the landscapes of Yucatán and on Yucatec society, the Maya have prevailed and their culture has survived. This outstanding ability to survive comes from the Mayas' adaptability and resiliency. That is, rather than fight the new influences, each time they incorporated social and cultural elements of the newcomers into their indigenous patterns. In this way, the Maya were able to maintain a healthy balance and ensure continuity in the face of severe threats to their indigenous culture.

This resiliency and ability to re-create traditional patterns was demonstrated all too well during archeological excavations at the site of Cerros, located in northern Belize, in the late 1970s. The crew of gringos from Texas (the majority from Southern Methodist University and myself from the University of Texas at Austin) were assisted during the excavations by a group of Yucatec Maya from the nearby village of Chunox. These young men are the third-generation descendants of refugees from the Caste Wars in Yucatán during the nineteenth century. Today the people of Chunox are Belizean citizens who are schooled not only in Maya and Spanish but also in the King's English.

During the first week of the Cerros project, the men working with me excavating the temple on top of the largest pyramidal mound began called me "Na-chem" and "Cayuco," and then would commence giggling. I knew something was going on, yet it took me a while to comprehend their cleverness. Having remembered that punning is an integral part of Maya culture, I realized that they had transformed my name "Dorie" into "dory," the English word for "little boat." From here, they crossed language boundaries to "cayuco," which is Spanish for "little boat," and then moved to Yucatec with "Na-chem" or lady canoe"! With the Maya of Chunox, then, we see a refugee population that has adapted itself well through time and across both the Spanish and English cultures, incorporating elements from all three (in this instance linguistic elements) in their renowned punning and good humor.

The pre-Columbian Maya modeled the universe around the concept of cyclicity. All events both human and divine were locked into their own cycles, which in turn were tied to one of the Mayas' many calendric and astronomical periods. Thus the Maya concept of time, and of the interlinkage of human and divine events, was one of annular history. Significant intellectual efforts were dedicated to charting these cycles of time and existence, based on observations of the heavens, including solar, planetary, and astral cycles.

These intellectual achievements are preserved in the four Maya books that survived early church zealousness to stamp out all remains of the "pagan" religion. For example, the Dresden and Madrid codices (named for the codices' current locations) include many pages dedicated to the accurate recording of the cycles of Venus. Round buildings, such as the Caracol at Chichén Itzá, were constructed with numerous isochronal windows whose views isolated the horizon points of the risings and settings of the various astral bodies. These buildings thus functioned as observatories where the Maya intelligentsia would gather the data

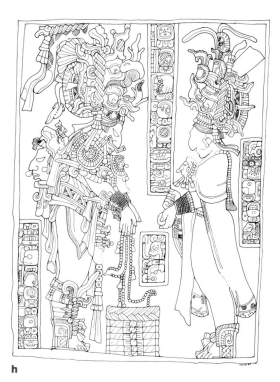

h *La Pasadita Lintel 2. Bird Jaguar of Yaxchilan and his* cahal *from La Pasadita participate in a ceremony at the latter site.* Drawing by Linda Schele.

recorded in the astronomical tables in the pre-Columbian books and where the calendar priests would carefully chart the progression of the cycles in order to keep the Maya on track with the cosmic continuum.

Much has been written in the last decade about the Maya having independently invented the concept of zero, which is understood in the Western world as the point of nothing. In fact, the Maya concept and its accompanying hieroglyph is not one of "nothing" but rather of "completion," of the simultaneous ending and beginning of a cycle. When we transcribe the calendric portions of the pre-Columbian hieroglyphic texts, we use the term *seating* for this "zero" point, as the old cycle lays down its burden and the new cycle is set in place. Western culture can only call this "zero" because we do not share the Maya cosmic model of cyclicity. *Zero* is the only term we have for this ending point that is also the point of a new beginning. For the Maya, nothingness does not exist; it is instead the "seating" point of rebirth from death just as the fallow milpa gives lifes once more to another cycle of corn.

These cycles were intimately tied to the religious beliefs because of the recurrent interdigitation of time, of the supernaturals, and of human existence. Thus the calendric cycles and the individual days within these cycles took on divine status, and religious rituals were created which marked the important stations within the many cycles. It is these many cycles that are recorded in the extensive calendric information carved on the standing stone monuments (stelae) found at all major Classic period sites. With the coming of Christianity, the Yucatec Maya easily adapted to the foreign religious cycles because of the marked similarity between the two systems. That is, the Maya simply attached to their deep understanding of religious cyclicity the new church calendar, overlaying the pre-Columbian deities with the new saints of Roman Catholicism. Once again, herein lies the strength and continuity of modern Maya culture; in the face of a new religion that threatened the very foundations of their culture, Maya adaptability through syncretism preserved their culture.

A related social survival pre-Columbian times is the syncretism of political and religious offices. Today many positions in the Yucatecan church carry titles such as "comandante," whose Spanish origins were solely in the realm of political office. Yet in pre-Columbian times there was no division between church and state. The rulers were not only the political figureheads but also primary religious figures. During the Classic period the ruler was considered endowed with supernatural power because he was believed to be in touch with and substitutable for the divine ancestors and even the gods themselves.

This belief in the divine basis of kingship is recorded on the stelae where the rulers take on the personae of the gods, such as Bird Jaguar of Yaxchilan who dresses as one of the Hero Twins on Stela 11 from that site (Figure g). Yet the image on the stela depicts Bird Jaguar receiving captives taken in battle, clearly recording an earthly political event. Divine kingship is also preserved in the myriad royal names and titles in the hieroglyphic inscriptions; here the rulers share nominals with the gods and are noted as holding symbolic parenthood of and responsibility for the care and sustenance of the divinities. One of the

most straight-forward examples is the name of the famous ruler of Uxmal who was responsible for the construction of the site's more spectacular buildings such as the Palace of the Governor. This ruler's name found in Uxmal's hieroglyphic inscriptions, is "Lord Chac," or "Lord Rain God."

A very common title found in the pre-Conquest inscriptions and surviving through the nineteenth century is "bacab," which is translated as "agent." The bacabs also were the supernatural beings who lived at the four corners of the universe and held the sky from the earth and the earth from the Underworld. These supernatural beings can be seen carved on the pillars of the temple atop the Castillo at Chichén Itzá, upholding the sky and thus helping to support the cosmological order.

Thus, to be a political figurehead in Classic times meant being responsible for maintenance of the world through correct observance of the religious rituals. The "politician," then, was also the embodiment of the religious beliefs and the possessor of divine nature. Continuing strongly through the nineteenth century, the sociopolitical structure among the Cruzob Maya combined both political and religious duties in each office, from the lowest positions to the highest office of *Nohoch Tata*, the leader of the Cruzob, whose legitimacy and power was believed to come from God. Again, we see the survival of the pre-Columbian social system that was based on divine sanction and the merging of spiritual and political offices. Although personal deification today is considered heretical in the Christian church, the survival of the many Spanish political titles in the modern Yucatecan church provides additional evidence of the strength of pre-Columbian sociopolitical patterns.

After the Conquest, the Spaniards imposed the European concept of the populous town, which was the residence of all the political and religious figures, and the depopulated countryside. Yet the pattern did not hold. In the later years of the Colonial period the Maya returned to the pre-Columbian pattern of the holy and economical town with its subsidiary satellite villages. The combined populations of these satellite villages significantly outnumbered that of the central town, and each village had its own council of leaders who answered to their superiors in the leading town. We find the same pattern today throughout Yucatán and exemplified by such centers as Izamal and Peto; the main town includes the church, and the most prominent sacerdotal and political figures reside here, although each of the villages retains its own leaders who are under the direction of the officials of the major town. During religious festivals, the citizens of the satellite communities travel to the center to participate in the events, and if political issues cannot be resolved within the village, they are adjudicated by the officials of the town.

This same structure characterized the Classic period Maya. From transcriptions of the hieroglyphic texts carved on stone monuments found at the major sites, we learn that many sites included smaller subservient towns and villages within their jurisdiction. For example, we know that Yaxchilan had under its sway other local towns including the site we call La Pasadita. On a carved wall panel from the site (Figure h), we read that Bird Jaguar traveled from Yaxchilan to La Pasadita in

order to assist his *cahal* (or "secondary lord") in an important ceremony. On the panel, Bird Jaguar is depicted on the left as the primary actor, while he is assisted by his *cahal* from the subsidiary La Pasadita. The hieroglyphs record Bird Jaguar as the main participant yet note that the *cahal* also took part in the event. This sociopolitical structure matches that which we find today in Yucatán.

Comparing the Yucatec Maya with their counterparts in highland Mexico, the Yucatecos stand out as having weathered much better the coming of European civilization. Seemingly the Yucatec Maya were more impervious to the various Spanish institutions. The reasons for this indigenous continuity are found in the historical and environmental conditions of Yucatán. First, the Yucatec Maya may be more accustomed to foreign contact because of the various invasions during the past one thousand years that left indelible marks on Yucatán. The Yucatec Maya seem to have developed a certain capacity to absorb foreign influences without surrendering their own lifeways.

Second, the Spanish conquistadores' influences upon Maya culture were not as great because of the lesser economic opportunities and high temperatures in Yucatán. Unlike highland Mexico, the Yucatecan climate was not hospitable to the invaders. Furthermore, the Spaniards' more temperate crops did not grow well in the heat and thin soils of the region. As a result, until the ascendancy of sisal in the nineteenth century, there was no exploitable crop that would provide a solid economic base for the Spaniards. Thus the first Spaniards were not able to develop large haciendas that kept the Mayas in indentured servitude. Even though the Spaniards attempted to enslave the Maya during the early Colonial period, many Maya simply disappeared into "uncharted" territory away from the Spanish settlements, existing as they had for thousands of years, growing their corn and other crops and refusing to be enslaved by these upstart newcomers. Further, the lack of exploitable resources such as precious metals contributed to the commercial isolation and relative poverty of the first Spaniards of Yucatán. Thus, fewer numbers of Spaniards settled in Yucatán, and fewer numbers with little economic superiority meant less control.

Unlike the populations of central Mexico, the Maya did not merge genetically and culturally with the Spaniards into a new mestizo society. Instead, with their numerical superiority, the Maya prevailed during the Colonial era as the few Spaniards were absorbed into the new emerging Yucatecan culture. Because of this numerical preponderance, the Maya language held its own in the face of Spanish. Today Maya and Spanish are taught in the schools and are spoken by nearly everyone on the peninsula, regardless of whether they are city or country dwellers. And if you ask someone on the streets of Mérida or anywhere on the peninsula who he is, he will answer "Soy Yucateco" (I am Yucatecan), not "Soy Mexicano" (I am Mexican).

The Maya of Yucatán are the descendants of one of the world's great civilizations. The pre-Columbian social, intellectual, and artistic achievements rival those of any of the world's better-known preeminent cultures. This pre-Columbian greatness is preserved by the present-day Maya, who maintain strong attachments to home, family, land, and religion, the latter of which includes their understanding of the cyclicity

of human existence. The Mayas' sacred teachings speak of the rise, fall, and inevitable return to greatness of all human groups, including themselves. The continuity of Maya culture throughout pre-Columbian times and during the five hundred years since the coming of the Spaniards to Yucatán provides hope for the future survival of these great people.

Suggested Reading

Fariss, Nancy. "Indians in Colonial Northern Yucatan." In *Handbook of Middle American Indians* Supplement #4: Ethnohistory, edited by Ronald Spores. Austin: University of Texas Press, 1986.

———. *Maya Society Under Colonial Rule*. Princeton: Princeton University Press, 1984.

Freidel, David, and Linda Schele. "Kingship in the Late Preclassic Maya Lowlands: The Instruments and Places of Ritual Power." In *American Anthropologist* 90, no. 3 (September 1988): 547–67.

Morley, Sylvanus. *The Ancient Maya*. Stanford: Stanford University Press, 1946 [Revised fourth edition by Morley, Brainerd, and Sharer, 1983.]

Perry, Richard, and Rosalind Perry. *Maya Missions: Exploring the Spanish Colonial Churches of Yucatan*. Santa Barbara: Espadana Press, 1988.

Schele, Linda, and Mary Miller. *The Blood of Kings*. Fort Worth: Kimbell Art Museum, 1986.

Tedlock, Dennis. *Popol Vuh: The Sacred Book of the Quiche Maya*. New York: Simon and Schuster, 1986.

Thompson, J. Eric S. *The Rise and Fall of Maya Civilization*. Norman: University of Oklahoma Press, 1970.

Tozzer, Alfred M. *Landa's Relación de las Cosas de Yucatán*. New York: Kraus Reprint Corporation, 1966. Originally published as Papers of the Peabody Museum of American Archaeology and Ethnology 18, Harvard University.

The Modern Maya

A Culture in
TRANSITION
Macduff Everton

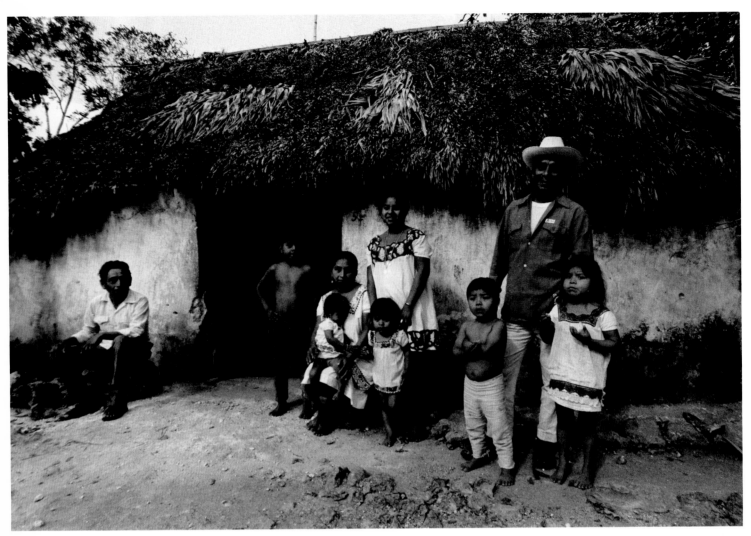

13

13 *Dario and Herculena with six of their ten children. From left to right, Don Ermilio (Herculena's father), Jose, Herculena and Maria Concepción, Gonzala, Ursina, Benancio, Dario and Hermelinda. (Victoria was at the corn mill.) Chichimilá, 1976.*

1

Milperos and Maize

▨▨▨▨▨▨▨▨▨▨▨

The Foundation of a Culture

Dario Tus Caamal was the first person I met when I visited Chichimilá in 1969. He was one of the happiest people I ever knew. He claims he is still happy, but I feel I've witnessed his loss of innocence.

Dario was married to Herculena and they had seven children, six of whom were living. I accompanied Dario to his milpa (cornfield) and relaxed in his home. I remember most the sense that there was always time to enjoy ourselves. We could work in his field and still have time to go swimming in a *cenote* before returning home. (*Cenotes* are underground pools of water, often exposed to the light when the surface rock collapses. The most famous is the Great Cenote of Chichén Itzá, sometimes luridly referred to as the Sacrificial Well). While other villagers were embarrassed and shy when I brought out my cameras, Dario and his family weren't. He'd even pick up something like an empty can and put it to his eye and make sounds as if he were taking pictures of me. His children adored him, and his playfulness was like that of a happy child. He had the type of laugh that caused other people to laugh just hearing it.

One afternoon we made bundles of firewood to carry back from his milpa. Dario, Hilario, and I walked bent over, carrying our loads using a tumpline. My neck muscles tingled from the weight. It was a strain to look up to see where I was going, so instead I watched my footing along the rocky trail. The sun was so intense it gilded the edges of the clouds.

"If one looks closely he will find that everything [these Indians] did and talked about had to do with maize; in truth, they fell little short of making a god of it. And so much is the delight and gratification they got and still get out of their corn fields, that because of them they forget wife and children and every other pleasure, as if their corn fields were their final goal and ultimate happiness."
—CHRONICA DE LA SANTA PROVINICIA DEL SANTISSIMO NOMBRE DE JESUS DE GUATTEMALA, CAP. VII (SIXTEENTH-CENTURY MANUSCRIPT)

14

When we reached Dario's house, we dropped our loads outside the front door and wiped away the sweat from around our eyes. We sat down in the road to rest, leaning against our bundles. Dario laughed with pleasure when his children ran out to greet us—he didn't hesitate to show affection to his children. He pulled Jose and Vicha into his arms. Ursina, his eldest daughter, came over and rested her hand on my shoulder.

"You're tired?" Dario asked me.

"Yes," I said, wiping the sweat away again.

Hilario leaned back and closed his eyes. "Sometimes I wonder why we carry these loads," he said. "It seems that our whole life is full of these hard, time-consuming jobs."

"It's God's wish," Dario said. "In life, it's very difficult to help your fellow man, but each of us feels a need to do this. In order not to feel insufficient or helpless, God has given us these loads to carry to occupy our time."

I laughed because it was just the sort of answer I had grown to expect from Dario. He was the son of a famous *(ah) men* (holy man or shaman), Don Juan de la Cruz Tus, and his neighbors often came to him for counsel. He frequently offered them a new perspective by telling parables and allegorical stories. By rarely answering a question directly or telling them what to do, he let them solve their own problems.

It was late afternoon and, while we put away the firewood, the children took their baths. Herculena offered me a bath as well. The evening bath is a strong tradition among the Maya. Everyone bathes except those who are sick. Herculena had learned the water temperature desired by her husband and prepared it that way every night. I found it interesting that there were many hotels in cities such as Mérida that didn't offer hot water, while in the villages, considered more primitive and backward, no one would think of taking a cold shower or bath.

Herculena heated my bucket of water over her kitchen fire. I carried it into the house and went behind a curtain of blankets which offered everyone privacy while bathing—even though ten other people might be in the room. The bath area consisted of a little stool sitting on a small slab of cement that had a drain leading out through the wall. I put the bucket next to the stool and poured water all over myself with a *jicara* cup—half a gourd scraped clean on the inside and hard and polished from use on the outside. Once wet, I soaped myself, then rinsed off using the *jicara*. This was the time I liked the best. I still had more than half a bucket left, and I poured it over myself all at once.

Herculena insisted I stay for dinner so I joined her in her kitchen. While Dario could make you laugh, Herculena made you smile. She always made me feel welcome in her home, no matter what time of day or night. Dario often helped her with the chores so they could be together around the house. They took turns giving each other a massage after a hard day of work.

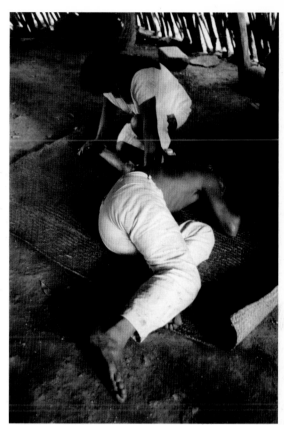

16

14 *Dario waters herbs and seedlings on the* canche, *a raised platform in his yard, away from pets, scavenging chickens, turkeys, and other livestock. Herculena's wash area on the left is thatched with palm leaves. Chichimilá, 1976.* 15 & 16 *Herculena and Dario exchange massages after a day of hard work. Dario sometimes works on neighbors as well— relaxing tense muscles, curing intestinal disorders, and setting broken bones. Chichimilá, 1976.*

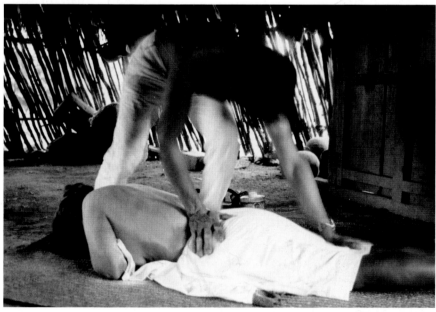

15

The kitchen was typical. The predominant color was brown. The table, stools, chairs, utensils, drinking cups—even the walls and the roof—were made from trees or vines. Almost everything Dario and Herculena used in their daily life had been grown around them, and its life had been taken by their hand and cut into a useful item. They had transformed something living into a functional object in their home, and you could see how its livingness could not be separated from the object. The food they ate was also a product of their work and collaboration with nature and the Maya gods of the forest.

Dario, his eldest son Jose, and I sat on stools around a low table. We were served black beans and, on a separate plate, a garnish of lime and chile, along with chopped onion, radish, and coriander leaf. Lying near the center of the table were slices of *chili habanero*, the most flavorful chile I've ever eaten, and also the hottest. It has so much oil that you only need to tap your tortilla against a slice and the entire portion is hot. I discovered when I began to enjoy spicy food that I didn't lose my taste buds when I ate more chile—something I never would have believed when I got burned the first time.

Herculena, Ursina, and Victoria, who had already eaten, made tortillas for us as we dined. Ursina flipped tortillas on the griddle, while Herculena and Victoria placed balls of masa on a piece of plastic (a banana leaf before plastic was available) and flattened them with one hand, rotating and forming the edges with the other. This kept the tortilla round and of even thickness. *Pak'ach* is the Maya verb for making tortillas, and *pak'ach, pak'ach, pak'ach* was the sound they made in the process. The sound changed as they used their fingertips for making it round and used the palm of their hands for flattening it out.

Ursina heated each tortilla on the griddle, then placed it on the coals of the fire until it puffed up with air. She'd quickly remove it and slap it against the table to knock the air out. It was *kuhoko-u-siyuwah*—a tortilla that puffs and is therefore well made.

After eating dinner, we all moved into the house. Dario brought in a basket of corn to shuck and spread out a mat which all his children gathered around. Using a knife, he took out one row of kernels on each ear. The children then rubbed these ears together and the kernels fell off onto the mat. While they worked, the children told their father what they'd done while he was at his cornfield.

Herculena scooped up five or six kilos of corn and put them in a bucket of water to boil for the next day's meals. She stirred the corn, skimming off everything that floated to the surface. She then added a heaping handful of powdered lime, mixed it into the water, and put the bucket over the kitchen fire. When it came to a boil, she stirred the kernels again, letting them boil until the outer hulls were somewhat soft and flexible. She'd occasionally take a tooth of corn and bite it to see if it was done. When she was satisfied, she put the bucket off to the side to cool and soak overnight.

The next morning she repeatedly washed the corn with clean water, rubbing the kernels vigorously together until the rinse water wasn't yellowish or contained any hulls. At this stage the corn was called *k'u'um or nixtamal*, and was ready to be ground for *sakan,* or masa, on a stone metate, in a hand mill, or in the center of the village at the mill. Going to the village mill was the most fun for her and her daughters. They'd wash and put on clean dresses, comb their hair, pat on talcum powder, even add rouge, then carry the corn to the mill where they'd meet other village women and girls doing the same thing. Waiting in line, they could talk and find out the latest news from each barrio. It was a welcome break from the other daily chores.

The masa was used for the day's meals and also for feeding the dogs, parrots, cats, baby chickens, turkeys, and ducks. The Maya feed corn to larger animals like pigs and horses, but not in balls of masa.

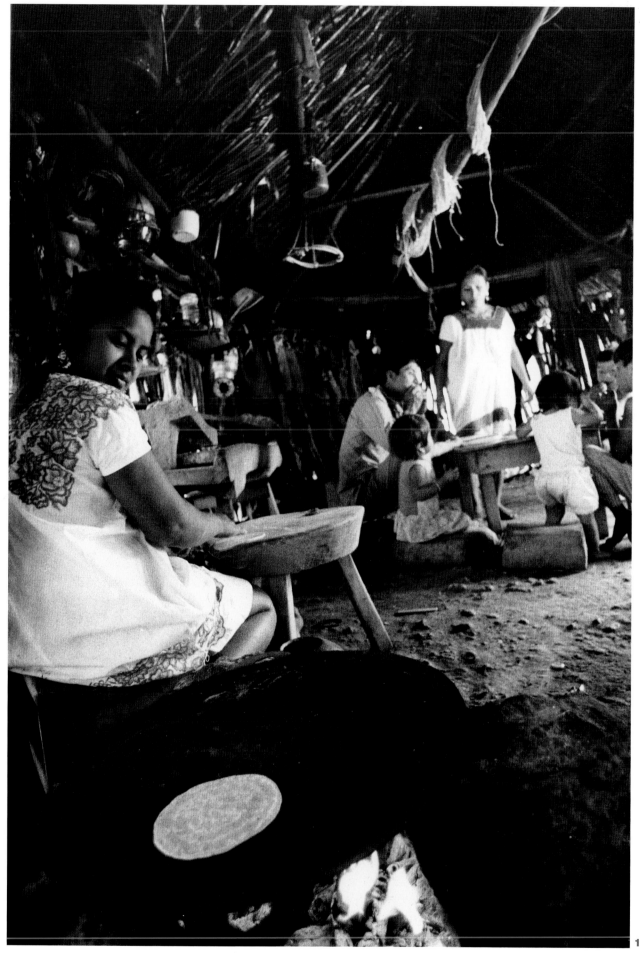

18 *The hot tortillas are kept warm wrapped in a towel in the center of the table. Portions of tortillas are used as spoons for scooping the black bean soup. Chichimilá, 1976.*

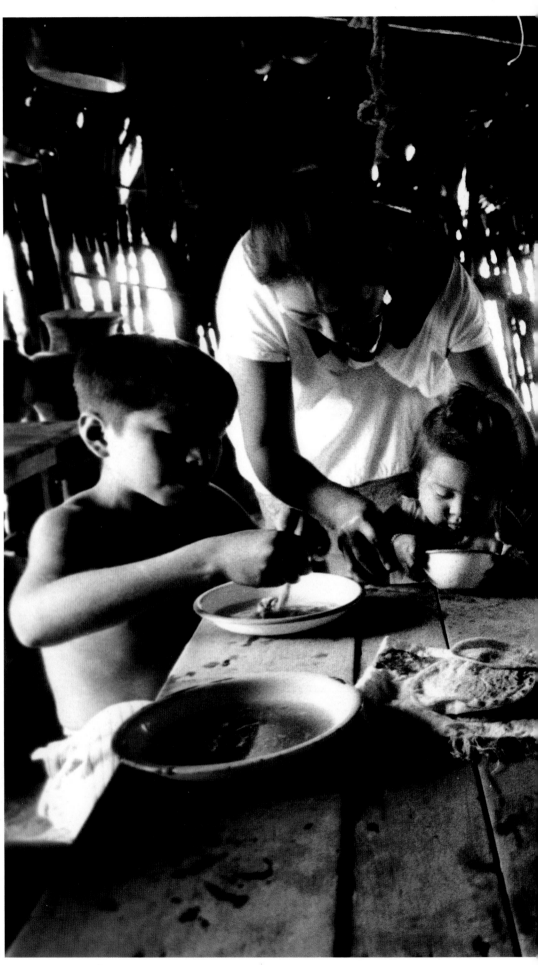

18

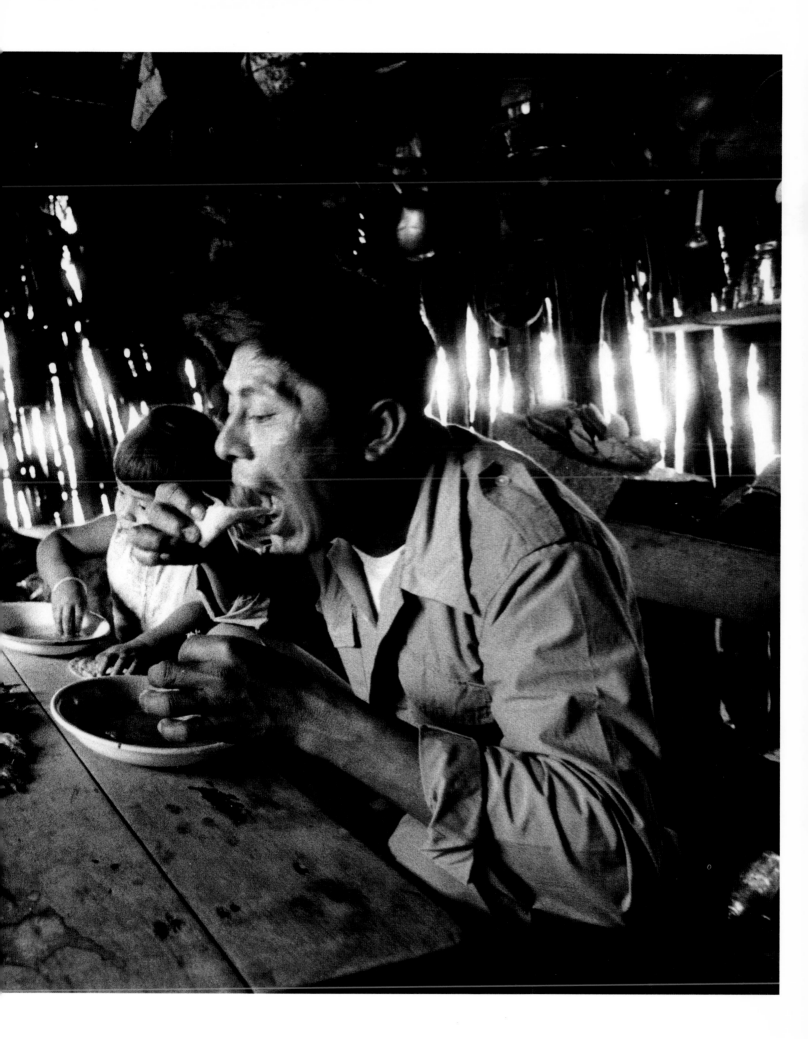

• • •

Yucatán is the only major peninsula in the world (outside of Antarctica) which juts up rather than down. If Italy is shaped like a boot, then Yucatán resembles a thumb sticking into and separating the Gulf of Mexico and the Caribbean Sea. It is a monotonously flat limestone plateau, although a small ridge tries to cross it diagonally but soon runs out of height. The land is rocky, offers very little soil to grow crops, and has few lakes, streams, or rivers. A thorny scrub forest covers the land, gradually becoming a jungle to the southeast.

I first arrived in Yucatán in 1967 to photograph Maya ruins for an educational film company. Even though I was just learning Spanish I enjoyed working there. Yucatán can be uncomfortably hot during the dry season, then uncomfortably humid in the rainy season. Insects, such as mosquitoes, biting flies, and scorpions, are prolific. But I couldn't resist experiences such as watching an early morning fog burn off at the ruins of Uxmal where the long white limestone House of the Governor seemed to appear out of the mist as mysteriously as it emerges from history, or arriving for the first time in Mérida and taking a horse-drawn carriage taxi down cobblestone streets from the station to my hotel in the early evening, passing between colonial buildings centuries old. Or coming out of the jungle at Chemax and taking a bus over to Puerto Morelos where the Caribbean was so many different hues of blue, I needed to redefine the color.

It was all strange, romantic, and exciting, but I quickly became disenchanted with photographing only ruins. The Maya have continuously occupied these lowlands for at least 4,000 years and created arguably the most advanced culture the Americas have ever known. The archeological sites were intriguing, but Yucatán's real beauty was in its people. They were friendly and warm. From the very beginning I was invited into their homes and made to feel welcome.

I was supposed to be on my way to South America, but I got as far as Guatemala before I turned around. I had been thinking of putting together a book that would show people as more than two-dimensional artistic conveniences and had planned to return to Ceylon, or Burma or Nepal in Asia. While Yucatán wasn't nearly as pretty, it was closer—and there weren't any photography books on the contemporary Maya. Everything focused on the ancient Maya and their ruins and art.

In 1969 I returned to Yucatán. I started photographing at random, collecting stories and living in different parts of the peninsula. I eventually met two other Americans. The three of us became fast friends, and we have continued working together now for two decades. It was interesting that none of us had planned on coming to Yucatán— we were all headed somewhere else but decided to stay.

I first met Hilario Hiler at the ruins of Palenque. I had two cameras hanging around my neck, plus other assorted camera equipment and supplies. A tall, skinny American who walked with splayed feet came up and asked me if I was a photographer.

"I wanted to speak English," Hilario apologized, "and I couldn't think of anything else to say." He told me he was living in the village of Chichimilá, in Yucatán, learning Maya and doing research. Like

Columbus, Hilario had actually been on his way to India (he was a student of South Indian music at Wesleyan University) when he discovered Yucatán and decided to stay. He invited me to visit him, which I eventually did in the spring of 1971.

Hilario and I got along well, and I began using his home as my base. Soon afterwards, we met Carl Demangate, a young anthropology student from the University of California at Santa Cruz, who was headed for South America but ended up traveling from village to village with a Yucatecan regional family circus, El Circo Magico Modelo. Don Luis Ramirez was the patriarch of the circus family, and he told Carl he already had three Carlos's working for him so he would have to become Charles (pronounced t'char-lace). Don Luis and Charles made Hilario and me feel the circus was our home. It soon provided me with another base from which to work. In Charles I found warmth and intelligence, as well as a free spirit and curiosity that made him a ready partner in many of my excursions.

Chichimilá is five kilometers south of Valladolid, the largest town in central Yucatán. It is an old village that predates the Spanish with a small ruin hidden among the village yards. Chichimilá is famous for its cooking, hammock makers, and for its (ah) men.

Hilario had immersed himself in village life. He'd purchased land where he built a pole and thatch house, dug a well, and planted fruit trees. He courted, then married the girl next door, adopting her young son, the first of eight Maya children he adopted or helped conceive.

The longer I stayed in Chichimilá, the more the villagers became used to me and my cameras. Gradually I could go almost anywhere and photograph. Both Charles and Hilario were excited about my book and we spent many evenings developing ideas. What grew out of these discussions was the realization we were observing a culture in transition.

Our first response was romantic—we wanted it to remain as we had found it. But cultures have been emerging and dying for thousands of years. On one level the cultural change offered a priceless challenge to the Maya who could pick it up. To utterly resist technology would be suicide for them just as it would be to totally abandon their cultural heritage. It has become one of the globally important issues of today— the choice of an ancient, non-European culture to persevere and face possible annihilation, or to change and survive under the conditions of twentieth-century industrial civilization.

I decided not to try to conceal a new shiny watch on the wrist of a villager, or to avoid photographing the person wearing polyester clothes next to another dressed traditionally or new electrical lines coming to a village. It was hard. It went against my artistic sensibilities, but I had to remember the Maya had as much right to the joys of progress as my parents and grandparents had when electricity came to their homes in Oregon.

How could we illustrate this change? We argued about this. Should we use a collection of photos that showed the new meter maids in Mérida or a Maya teenager riding a motorcycle next to an old man carrying a load of firewood on his back? These ideas seemed too much like other work I found dissatisfying. We wanted the Maya to become real for the reader rather than merely interesting images. I suggested a

series of stories on individuals engaged in different types of work, such as what I had already started with Dario. I felt we should also include a village woman, a henequen (sisal) worker, a cowboy, and a jungle worker who collected the chicle base for chewing gum. Hilario and Charles agreed and then suggested it was important to include a coverage of the Cruzob, the rebel Maya that had fought to live apart in as pure a form of Maya culture as possible, where the impact of change might be the most severe. I figured our project would take a year at the most to complete. However, the more we investigated, the more interesting the project became, and one year led to the next.

Yucatán had long been separate, both culturally and geographically, from the rest of Mexico.[1] It wasn't until 1950 that Yucatán was connected by rail with the Mexican mainland, and a paved highway was only completed in 1961. In 1970 there were only 1,551 kilometers of passable (paved and unpaved) road in the state of Yucatán. By 1975 that number had increased to 4,266 kilometers. Remote areas suddenly had roads and bus service, and electricity and potable water soon followed. It was part of a government plan to bring rural areas into the mainstream economy, especially groups that were self-sufficient and relied on barter.

The Maya could be placed in three main groups—those who had long been acculturated to Spanish and Western influences, those recently acculturated, and those who were just starting to experience acculturation. Generally speaking, the first category included the Maya around the capital of Mérida and a few of the larger towns, the second category included people that had roads reaching their villages, and the last group lived in areas where new roads were just beginning to arrive, specifically the Cruzob zone. Besides the Maya, two other groups completed the population. They were the *mestizos,* mixed bloods that were Mexican in outlook, and the upper class who called themselves the *gente decente* (the decent people).[2]

Something of the ancient Maya culture has survived in the contemporary Maya. It is evident in the patterns of domestic life, in rites, beliefs, and customs, and in the Maya language spoken by over two million people. The Maya persevere with physical and spiritual features still very much like their ancestors, and their common pre-Columbian background is what unifies them.

Why is any of this important? What ultimately happens to the Maya, and to other non-European cultures, may affect us all. We are seeing the growth of an industrialized and computerized world culture that increasingly erases the differences among cultures. In 1990 the Super Bowl football game was seen live by over 200 million people in fifty countries. In 1990, 25 billion viewers watched the World Cup games, with an estimated one-half of everyone on earth watching the final game. In our age of satellite television broadcasts and rapid transport the global village is becoming a reality. However, biologists know that if a species gets too specialized it risks extinction when outside factors change—an idea that is not too far-fetched when we consider environmental factors such as the greenhouse effect. Botanists are now pointing out that not only is it important to save tropical rain forests for their biological diversity, it is also important to include the local cultures

for their knowledge of the forests. In order to understand the human role in conservation of the tropical world, we need to learn more about the local culture's successes and failures today and in the past. Cultures other than our own need to be considered not merely as curiosities and anachronisms, but for the unwritten knowledge they have to offer.

For instance, scientists have discovered evidence of the management techniques used by the ancient Maya to conserve successfully the biological diversity, knowledge that is useful today. Unfortunately, many of today's ecological problems exist because of the modern world's neglect for the experience and knowledge found in past and present traditional cultures.

Different cultures continue our social diversity and allow us to look at things from different perspectives. As indigenous cultures are absorbed into the world culture, we are losing our cultural as well as environmental resources and decreasing the choices available to us. We can't afford to see them disappear. The cost of conservation needs to be borne by all of us rather than just those living in tropical zones. We all benefit. This diversity may save the human race.

The dilemma of conservation versus development is one of the most important questions of today, and too often native people using shifting cultivation are perceived as the main problem. Arturo Gómez-Pompa, professor of Botany at the University of California, Riverside (and the founder and former director of the Instituto Nacional de Investigaciones sobre Recursos Bioticos de México and a recent MacArthur grant recipient), believes that the recent history of the deforestation of Mexico follows a regular pattern. Lumber companies, with government help, build roads into remote regions and extract valuable woods. Landless farmers follow, usually motivated by government incentives, and use the land for agricultural purposes. These colonists rarely have adequate knowledge of the area and resources to practice anything but slash-and-burn techniques. Once the land is cleared, it is more valuable for cattle production, and it is acquired, legally and illegally, by wealthy ranchers. The *colonos* move to new areas, the process begins again, and the landless farmer is blamed for the deforestation.

It is also important to recognize who perceives deforestation as a problem. Certainly not the government that is making a quick profit on the sale of the lumber and is providing temporary jobs and land to landless peasants. Deforestation is also not a problem for the private sector who see high returns on low investments over a very short period of time. These short-term economic effects have contributed to the belief that tropical forests are useless and not a renewable resource.

Deforestation in the tropics has only been identified as a problem by scientists and concerned citizens who recognize the environmental problems. Primarily this problem is the loss of a very important reservoir of species and genes that forms a most important biological bank. About half a million species are known to exist in the tropics, and it is calculated another 2.5 million remain to be discovered. With current deforestation going on, thousands of species are disappearing without modern science ever getting a chance to describe them or study their potential for helping humankind.

Mexico recently created the 1.8-million-acre Calakmul Biosphere

Reserve, adjoining the Guatemalan border in southern Campeche, and the 1.3-million-acre Sian Ka'an Biosphere Reserve south of Tulum in Quintana Roo. Joann Andrews, the head of Yucatán's chapter of Pronatura, a national citizens group, applauds the courage of the government in protecting these areas, and she stresses the fundamental need for good urban planning and finding new jobs to relieve the pressure on the environment.

Instead of trying to prevent human disturbance to the environment, it is important to provide ways of transforming detrimental processes into beneficial ones. One common misconception is that overpopulation leads inevitably to deforestation. First of all, some of the highest rates of deforestation today occur in countries with very few people, such as Australia. Secondly, many of the tropical areas of the Americas had more inhabitants in pre-Hispanic times than they do today. H. O. Wagner estimates 8 million Maya in Yucatán and nearly 7 million for greater Amazonia. It is important to know that what we consider virgin forest today is not—the forests reflect the effect of past civilizations on the environment.

The ancient Maya may have had a very complex system of natural resource management in which conservation of biological diversity was a common denominator. These complex systems supported rural areas with population densities of as many as 400–500 people per square kilometer as opposed to 5 people per square kilometer today. In spite of this high density, there is no evidence of mass extinctions of species, nor any evidence that species diversity or richness were diminished by the actions of the ancient Maya. Only recently have the variety of subsistence systems practiced by the present-day and ancient Maya been recognized, and they include a great diversity of agricultural systems and silvicultural techniques. This challenges the theory that the collapse of the Maya culture was triggered by an ecological catastrophe brought about by poor management of the environment.

Arturo Gómez-Pompa has found that one approach to tropical silviculture is to follow the example of the ancient Maya who seem to have practiced a mixed tropical agrosilviculture. He's found evidence that the Maya may have preserved and protected seed banks in artificial rain forests ("*pet kot*") that were previously considered part of the mature forest.

In a chapter of *Alternatives to Deforestation Steps Towards Sustainable Use of the Amazon Rainforest* (1989), Gómez-Pompa and Andrea Kaus raise several questions. What were the biological and ecological conditions that permitted the conservation of the rich biota in these regions, and what types of resource management practiced by the ancient civilizations could explain the present diversity? And then they ask why we don't already know the answers. They feel that our ignorance and neglect of the knowledge and experience in resource management of the past and present local cultures is the most important underlying factor for today's tropical deforestation. They are proposing that traditional knowledge be recognized as generations of "scientific" fieldwork and that, from now on, indigenous techniques of the past and present are taken into account in all future management policies. Our

generation is failing to maintain the tropical biological diversity left to us by former generations.

Gómez-Pompa has been active in studying wet-field agriculture, which was extensively used in pre-Columbian Mesoamerica and is practiced today in the Valley of Mexico. In the last twenty years experimental *chinampas* in the Valley of Mexico have been started in the states of Tabasco and Veracruz. Crop yields from *chinampas* have been higher than many of the modern agricultural systems practiced in Mexico. Gómez-Pompa claims that if we consider the production of nondomesticated species along with crop yield, it might be the most productive agroecosystem ever known.

The problem in Mexico, and in many underdeveloped countries, Gómez-Pompa points out, is not the ability to produce abundant food. The problems are marketing, the distribution of the products, and the redistribution of wealth so that the population can afford to buy the food, compounded by poor management practices, incorrect technology, and lack of broad ecological consideration in land-use planning.

Gómez-Pompa writes, "The present-day activities of doubtful agricultural projects, extensive grazing, and timber harvesting on the same sites where the old Maya had temples, towns, intensive hydraulic agriculture, permanent agriculture, and artificial and 'natural' forests, should cause us to doubt our wisdom and the congruency of our actions."

19

19 *"Corn, a source of energy, is comparable to our discovery of the energy within the atom, which enabled primitive man to carve his empires in the jungle. It is the core of American Civilization, the most efficient device for trapping the energy of the sun and turning it to our uses. Corn is indeed the grain that built a hemisphere." Dr. Richard MacNeish and Alan Linn,* Smithsonian.

I had read anthropological studies estimating that 85 percent of the contemporary Maya diet consists of corn, but I found it hard to believe they could actually eat that much corn. They would have to eat it for breakfast, lunch, and dinner, and anyway how many ears of corn-on-the-cob can a person eat? Right off, I found the Maya rarely eat corn on its cob, but they have many other ways to consume it, including drinks and breads. If you consult the anthropological accounts, however, you find the descriptions of the foods contradictory, often written by men who asked informants rather than preparing the food themselves.

Hilario decided to try to clear up some of this. His Maya wife's and in-laws' kitchens became his research laboratory. One of the remarkable things about Hilario was the expertise he brought to his investigations. He was born in California, but his father, a painter and color theorist, had raised his family all over the globe. Hilario had graduated from the Cordon Bleu cooking school in Paris, then worked as a chef on two continents. Now instead of in a gleaming tile and stainless steel kitchen, he worked in a village hut with a bucket and gourds. But he didn't treat the food any less seriously. Since this was a very old form of cooking, changing from area to area and with time, Hilario didn't claim his versions were infallible either, but at least they were correct within his home and the kitchens of his extensive immediate family of in-laws, and Chichimilá is famous in Yucatán for its cooks.

Hilario found variations just within the drinks made from water and corn; there were seven main ones, with many nuances.[3] The same was true for the breads, including the common tortilla.[4] He found it was true

20

20 *Hilario Hiler, Chichimilá, 1971.*

that almost everything the Maya drink has corn in it, and everything they eat is accompanied by corn. Breakfast and lunch usually consist of a corn drink with roasted tortillas. Black beans, the basic *plat de résistance,* is eaten with hot tortillas used as spoons to scoop up the meal. Each bite requires a new corn spoon. Fresh, hot tortillas made from freshly ground corn were infinitely better than any tortillas I'd eaten in California. Hilario and I once counted how many we ate at one meal of black beans—his wife and sister-in-law made forty-three tortillas for each of us.[5]

Hilario was pleasantly surprised to find the Maya had some very refined and highly developed sauces that he put in the category of *haute cuisine,* equal to the fine French sauces he knew. I wasn't surprised when he told me they used cornmeal to thicken them.

Cornmeal thickens the plot in the *Popol Vuh,* the sacred book of the ancient Quiché Maya. The text relates how the gods were unhappy. They wanted a living thing that would worship their maker. The birds and animals that lived on earth could only hiss and scream, but they couldn't say words of praise, nor say their maker's name. So the gods decided to make humans.

They made the first ones from clay, but these humans were too soft and had no minds. They couldn't stand upright and dissolved in water.

Then the gods fashioned humans from wood, but these were hard-hearted and wouldn't worship their creator. The gods destroyed them with a flood.

Finally, the gods made humans from maize. They were intelligent, far-sighted, and could contemplate all heaven and earth. The humans gave thanks to their creators. However, the gods feared their powers and decided to limit them. Huracan, the god who was the Heart of Heaven, blew mist into their eyes and clouded their sight. So it is still today— humans have an intelligence unpossessed by animals, but often their vision is unclear.

Maize is the Maya's flesh and blood—the staple of their diet, the basis for many of their religious practices—and almost everything they do is related to corn and its production, even today in many of the villages of Yucatán.[6]

The Maya generally have a slow heart rate and low blood pressure, which may be attributable to their diet, and they also have a high metabolism. The Maya's love for wordplay and puns is also attributable to their corny diet.

At Dario's doorway a man appeared. He squinted at us, his eyes adjusting from the bright sunlight outside, and asked for water. Dario told him to wait and walked back to the kitchen hut behind the house. I recognized the man as Antonio, one of the retarded people who lived in Chichimilá . Because he wasn't harmful to himself or anyone else, he was left to wander freely. Some of the pre-Hispanic Mesoamerican cultures treated their insane and retarded members as special individuals. Today in Mexico, however, people might close their doors on them and mothers encourage their children to flee.

Dario came back into the house carrying a gourd bowl of *choko'*

sakan, a refreshing hot corn drink, and offered it to Antonio. He quickly slurped it down and handed the *jicara* back to Dario, who asked him if he'd also like a bath.

Antonio nodded and sat down. Jose, Dario's eldest son, came over and offered to let him play with his yo-yo while Dario returned to the kitchen. He half-filled a bucket with water from one of the clay pots that lined a wall, then add hot water from a bucket heating on the fire. He came back carrying the bath water and curtained off a portion of the room.

When Antonio came out from behind the curtain, slicking his wet hair back with his hands, he looked very happy, showing his teeth as he smiled.

"You have refreshed my soul and cleansed my body," he said as he left.

The dry heat of February and March had been replaced by a sweaty humid heat. Even early in the morning the air was so heavy with humidity it pressed against me when I walked. By the end of May, the villagers knew it was time to talk to the rain gods. Dario had cleared and burned his *milpa,* and he waited for the rains to plant his crop.

Different neighborhoods in Chichimilá were planning their own *Ch'a Chaak,* a ceremony to petition the rain god Chaak. From all the reading I'd done, I expected the *Ch'a Chaak* to take place hidden in the jungle, with days of elaborate preparations preceding the event. I expected to find a large altar with young boys tied to each corner croaking like frogs to remind Chaak to send rain. Instead, the ceremony was held at one of the cardinal points of the village, in the back yard of Don Adub, one of Hilario's neighbors, at the eastern entrance.

The morning of the ceremony was particularly hot, and there wasn't a cloud in the sky to offer rain or shade. Don Adub's land bordered the forest on the outskirts of Chichimilá. His large yard was cleared around his thatched-roof huts and had a fence of drystone rock walls. Hilario and I walked up to the men who had already gathered, waiting in the shade of several fruit trees. Besides Dario, I didn't yet know many of the other men. They were dressed almost alike in work pants and shirts, sandals and hats.

I brought my cameras, but I didn't know if I'd be allowed to take pictures because I'd only been in Chichimilá a short time. I sometimes found it difficult to photograph in Yucatán. The Maya had no cultural background of photography outside of studio portraits taken for baptisms and weddings or the *recuerdos* (remembrances) for pilgrims taken by ambulatory photographers at yearly fiestas. The Maya's sense of a portrait was standing at attention, staring straight into the camera without a smile. My photographs were a contradiction of everything they knew about photography. I treated every day as a special event, including their work, play, and rest, and photographed them laughing and smiling as well as looking serious. And of course they were often embarrassed they weren't wearing their best clothes. They were not unwilling to let me photograph them—only they would try to accommodate me within the boundaries of their conception of photography.[7]

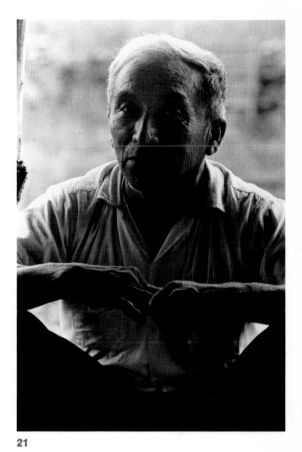

21

21 *Don Anastasio Chi,* (ah) men. *Chichimilá, 1971.*

After being introduced to everyone, I asked permission of Don Anastasio Chi, the *(ah) men* who was officiating and was well respected for his ability to speak the prayers in both Maya and Spanish. He was a slight man with refined features and white hair. He asked me why I wanted to photograph, and I told him—Hilario translating for me into Maya—that I wanted to make a record of the ceremony because I understood that things were changing—that today's ceremony was going to be different from when he was a child and that for his children's children things will have changed even more. The idea of documentary photography was new to him, but he readily agreed that customs were changing and gave me permission if I would give him copies of the photos.

Don Anastasio finished his cigarette and walked over to the altar—a wooden table set in an open-sided thatch-roofed hut. The table had an arch of branches above it and was aligned so that he would face east. He placed thirteen gourds of the sacred corn drink on the altar, then arranged an incense burner and a cross at the center. The Maya and Roman Catholic deities are now so interwoven that Don Tasio not only prayed to Chaak, but also to Jesus Christ, God, Saint Michael, and a plethora of other saints.

This combination came about when the Indians were forced to become Roman Catholics by their sixteenth-century Spanish conquerors.

22 *Don Tasio and his assistant (kneeling) orchestrate the ceremony. Chichimilá, 1971.*

22

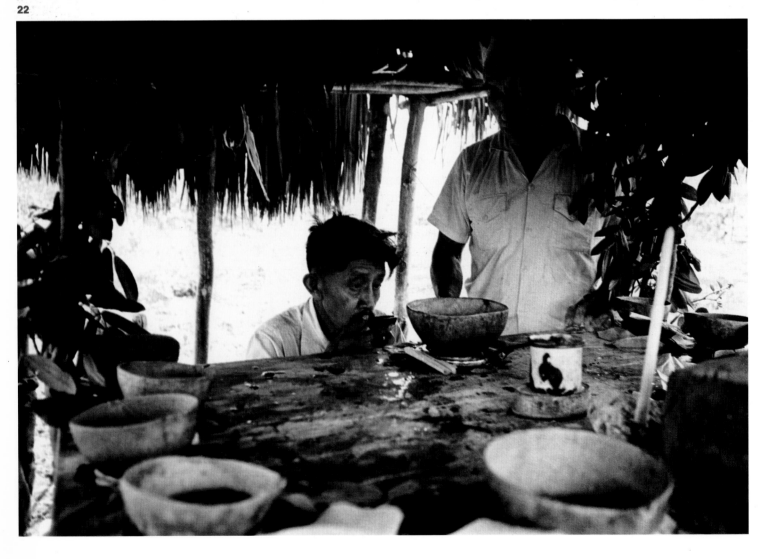

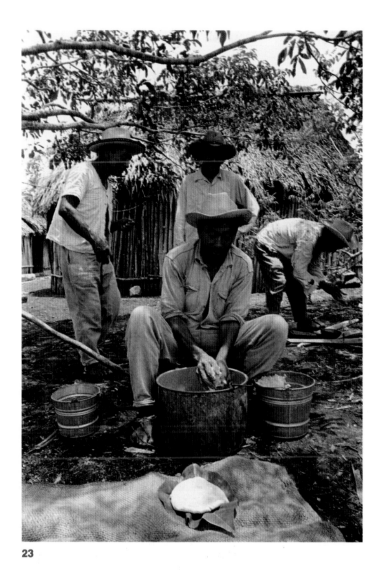

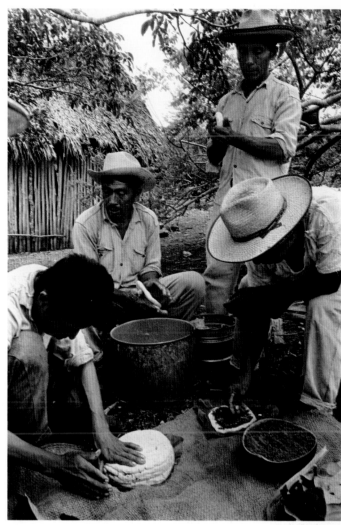

23 **24**

The Indian gods were often Catholicized by the early Spanish priests—Chaak became San Miguel the Archangel. The Spanish built their churches on top of Maya temple platforms where the Maya were accustomed to worship. Even rituals were co-opted and Roman Catholicized. For example, one of Yucatán's largest celebrations is the annual fiesta in Tizimin for the Three Wise Men. In pre-Columbian times, it is believed that the Maya made pilgrimages to worship three powerful gods—Yum Chaak (God of Rain), Yum Kaax (God of the Field), and Yum Ik (God of the Air)—at a temple which was situated exactly where the present church of Tizimin is placed. The Spanish substituted carved wooden images of the Three Wise Men for the clay Maya gods. The Maya continue their pilgrimages to Tizimin to this day, but the religion, names, and skin color of the idols have changed.

Don Tasio adjusted the cross again until he was satisfied with its placement. He began praying in a soft voice, almost a murmur. The men retreated to the shade of a tropical plum tree to begin their own preparations. As they washed their hands, they laughed and talked about how hot the weather was.

All the men had contributed freshly ground corn and *sikil* powder made from roasted and ground squash seeds. Dario brought over several pails of ground corn. A couple of the men started patting out large, fat

23 *Village farmers work together to petition the raingod at Ch'a Chaak ceremony. The men prepare large torillas to offer to the gods. Chichimilá, 1971.* **24** *The men layer large breads of corn tortillas and pepita powder. Chichimilá, 1971.*

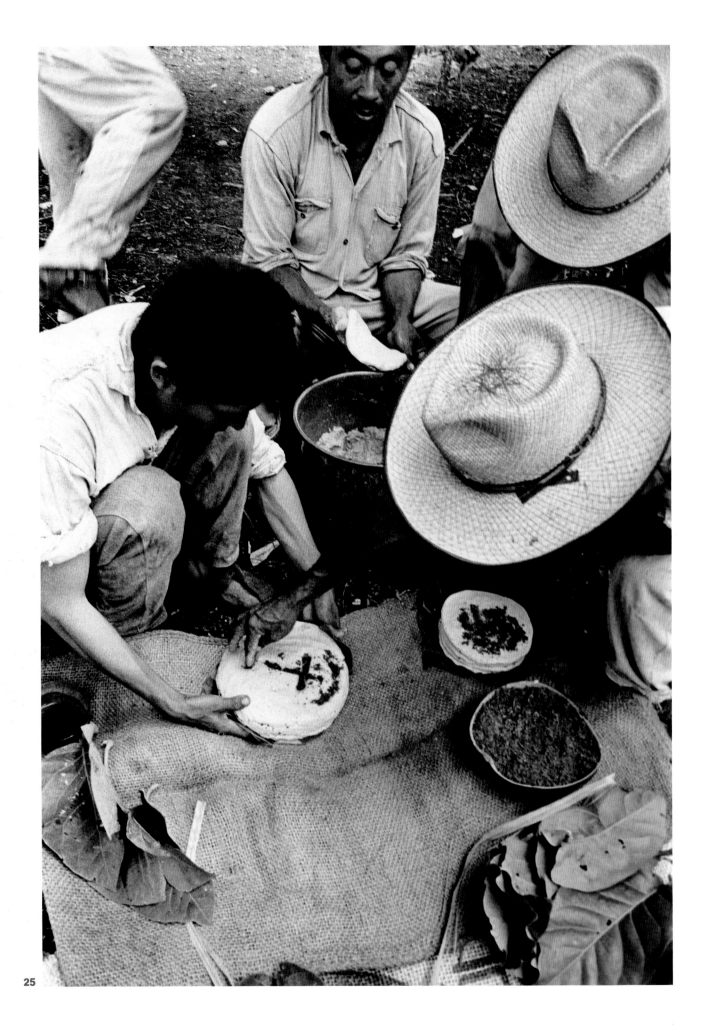

25

tortillas in their hands. As they finished, others took the tortillas to make the ceremonial breads.

They began by laying a tortilla on a palm leaf. The top was sprinkled with *sikil* powder, and then another tortilla was placed on top. The bread was built up this way until, on top of the seventh layer, Dario pressed a sign of the cross. He filled the indentations with *sikil* and poured a small amount of *balche* (ceremonial wine) on top. The bread loaf was then wrapped in palm leaves and tied with sisal and strips of bark of the *hol* tree.

Off to the side, in a open area of the yard, a few of the men filled with wood a narrow, shallow pit dug that day. On top of this they stacked rocks before setting the wood on fire. The flames were almost invisible in the white heat of the day.

The men made three more layered cakes with the imprinted cross, then made cakes which had four holes pressed on the top layer, representing the four corners of the farmer's *milpa*. Then they prepared and wrapped two large cakes thirteen layers thick.

One man passed out gourds of the sacred *sakah*, a simple drink of boiled and ground corn. It was thick and we had to chew it as we drank, swirling our gourds to keep the larger pieces of corn from sinking to the bottom. Since the corn had not been boiled with lime, the hulls weren't separated, and they stuck in our teeth.

The wood in the pit had burnt to charcoal when the men finished making bread. They prepared the *pibil* (earth oven) by pulling out some of the rocks which they would add later, and removing any pieces of

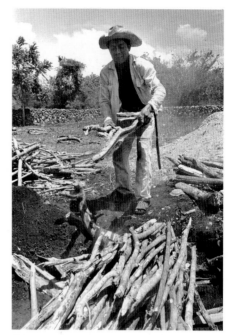

27

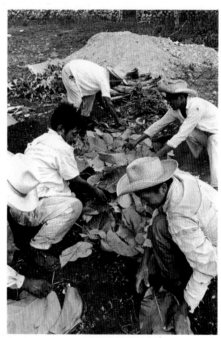

28

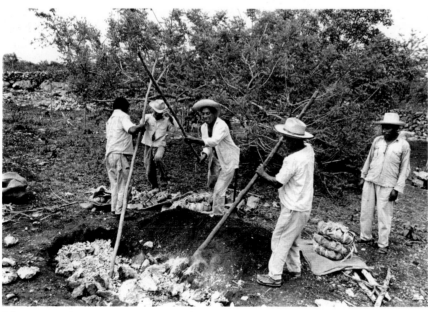

26

wood that hadn't been reduced to charcoal. Then they used poles to break up the stones left in the pit to form a bed of hot rocks and coals. The heat was intense so that the men were sweating profusely. As they worked, sweat rolled off their faces, sizzling and steaming in the pit below.

They arranged a layer of palm leaves in the oven, added the wrapped breads, then replaced the hot rocks they'd removed and covered everything with more palm leaves and branches. On top of this Don

25 *The large tortillas are made in layers and sprinkled with* sikil *(roasted and ground squash seeds). The tops are adorned with sacred symbols and blessed with* balche *(ceremonial wine).* **26** *The men use poles to break up the heated stones. Some will be removed and added on top of the wrapped breads once they are placed in the oven. Chichimilá, 1971.* **27** *Dario piles wood into the earth oven. The wood will burn down to coals, heating stones which will provide heat for the cooking. Chichimilá, 1971.* **28** *Layers of aromatic leaves are placed on top of the breads before the oven is closed. Chichimilá, 1971.*

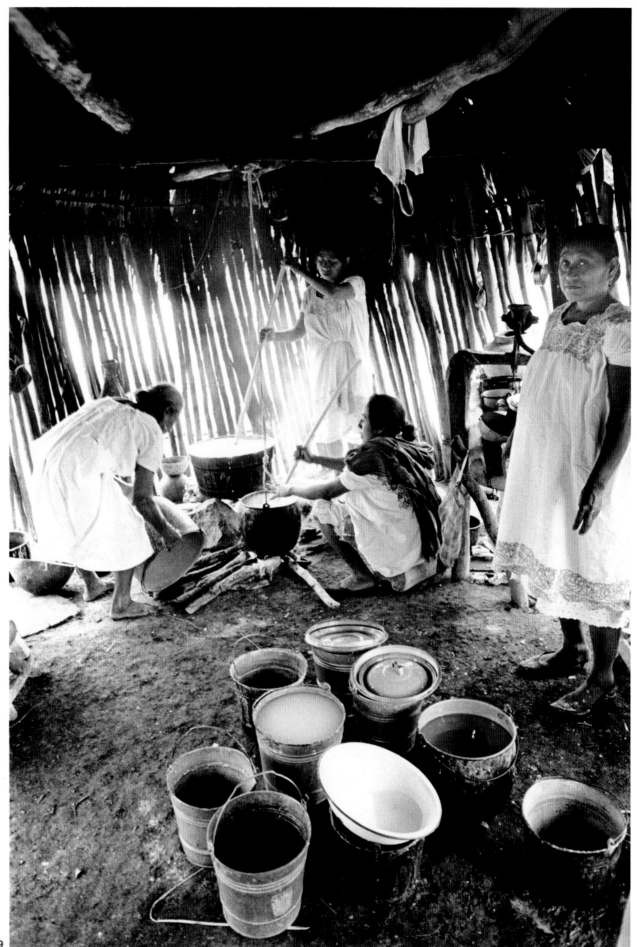

29

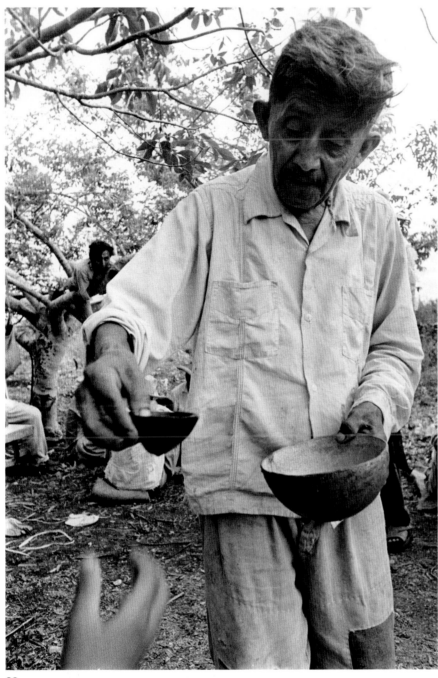

30

Adub dragged over and placed a sheet of corrugated tin, and then the men covered everything with a layer of dirt.

No women helped with this part of the ceremony—custom and tradition dictate that they can't. But we heard them busy in Don Adub's kitchen, preparing the meat that had been slaughtered for Chaak's feast. Deer, wild turkey, and wild boar were traditionally hunted right before the ceremony because these wild animals were under the care of supernatural guardians and thus their meat was more pure than that of animals under the care of man. But now wild game was hard to find, so domestic turkeys, chickens, and pigs were used after being blessed and purified by the (ah) men.

The wives and mothers of the farmers were cooking the meat and a broth, adding freshly ground corn, annatto, pepper, cloves, oregano, garlic, and salt. They had several pots cooking, stirring them with long

29 *The wives and mothers of the farmers stay separate from the men but are busily involved nonetheless in the kitchen preparing the meat and broth for the offerings. Chichimilá, 1971.* **30** Balche *is passed out in small cups, made from coconut shells. Chichimilá, 1971.*

31

31 *The farmers open the* pib, *removing the top layer of earth and a sheet of corrugated metal, exposing the protective covering of yax nik leaves. Chichimilá, 1971.* **32** *As the earth oven is uncovered, the rising steam is rich with flavors. Chichimilá, 1971.*

poles. Excluded from taking part in the men's ceremonies, the women had their own party. We could hear them talk and laugh, and occasionally some of them would come outside. It was obvious that the women accepted their traditional role, but I wondered how long this would last as the villages had more contact with outside influences.

The men moved back into the shade of the plum tree. Some talked. Others played cards. Don Tasio continued praying as he offered the sacred *sak-ha'* to all the gods and saints, pagan and Christian. His assistant handed out drinks from a small coconut shell cup. Every man and boy drank the sacred wine made from water, honey, and the bark of *balche,* which ferments quickly into an intoxicating drink that is both emetic and purgative. Ceremonies often involve ritual drinking, sometimes nonstop; it seemed that among the Maya the drunker you were, the closer to God you became and every man wanted to be in the company of the archangels. But the *balche* didn't affect any of us this day because they hadn't fermented it.

Hilario, Dario, and I joined Don Tasio, who was smoking a cigarette and resting in the shade of the tree. We were all sober. I asked Hilario if he would ask Don Tasio how he had become a *(ah) men.* Had his father, like Dario's father, been a famous *(ah) men?* Tasio took several puffs on his cigarette, watching the smoke before he replied.

"When I was seventeen," he said, "I was walking through the woods, carrying a load of corn from my father's *milpa.* A *cutz* [wild turkey] was scavenging at the side of the trail as I passed. I did not have my rifle so I could not shoot it, and it flew into a nearby tree. But when I looked at the ground where it had been feeding, I discovered a *sastun* [a crystal]. When I picked it up the turkey began to speak. It told me that his was the word of God and that I should carry the *sastun* home with me and dedicate my life to divining and healing, in service to the spirits and to the common people of my village."[8]

Tasio excused himself and returned to the altar. I asked Dario if he also planned on becoming a *(ah) men.* He said his time had not yet come—he hadn't been called.

The heat remained oppressive, but someone noticed clouds on the horizon, and soon they provided shade. The men knew when the bread was ready. They gathered around the *pib,* shoveling away the earth and removed the tin sheet and leaves. Don Tasio's assistant made three offerings of consecrated *sak-ha'* over the open oven in the four directions—the shape of a cross. Then the men pulled out the breads. As they worked, it started sprinkling. Big fat soft raindrops splattered on the hot rocks, sending clouds of steam into the air. The men laughed and turned their faces up to the sky. I think I was the only one surprised that it was raining.

The men unwrapped the leaves from the cakes and carried the loaves to the altar, and brought gourds of the meat and sauce from the kitchen. Don Tasio began dedicating the offerings to the gods as his assistant lit candles.

Underneath the plum tree, a little out of the sprinkle, the men made *sopa,* breaking up the two large loaves and adding the pieces to a large pot of meat sauce. They filled several gourds with the *sopa* and stuck in a few chicken legs before hanging the gourds above the altar.

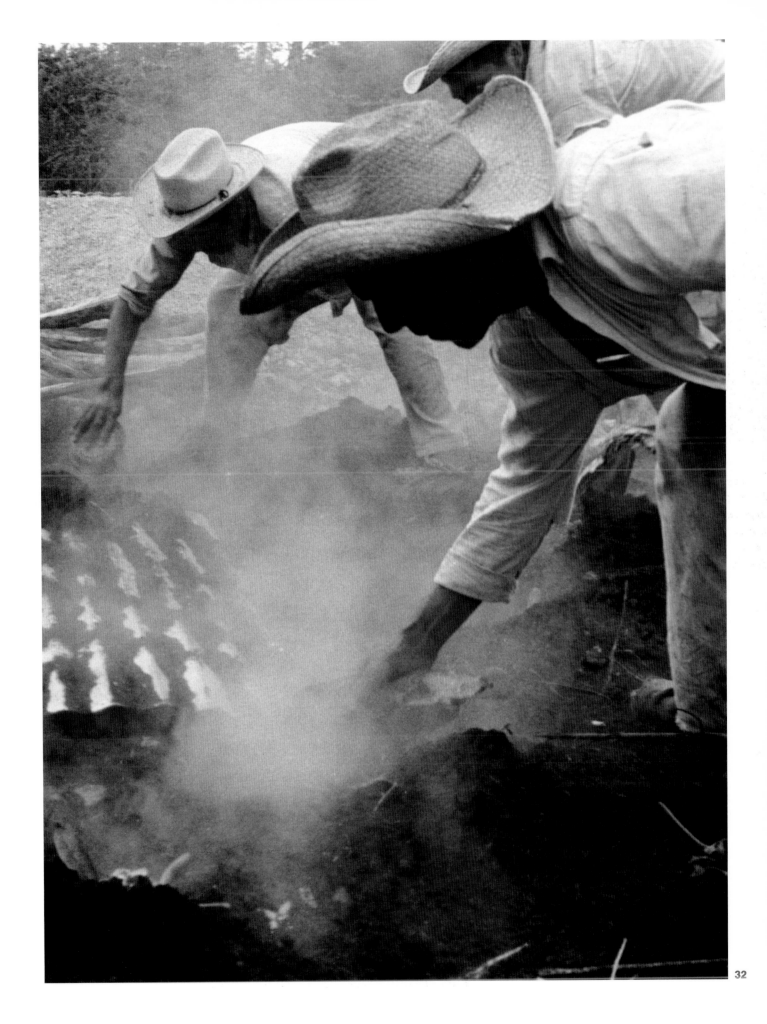

32

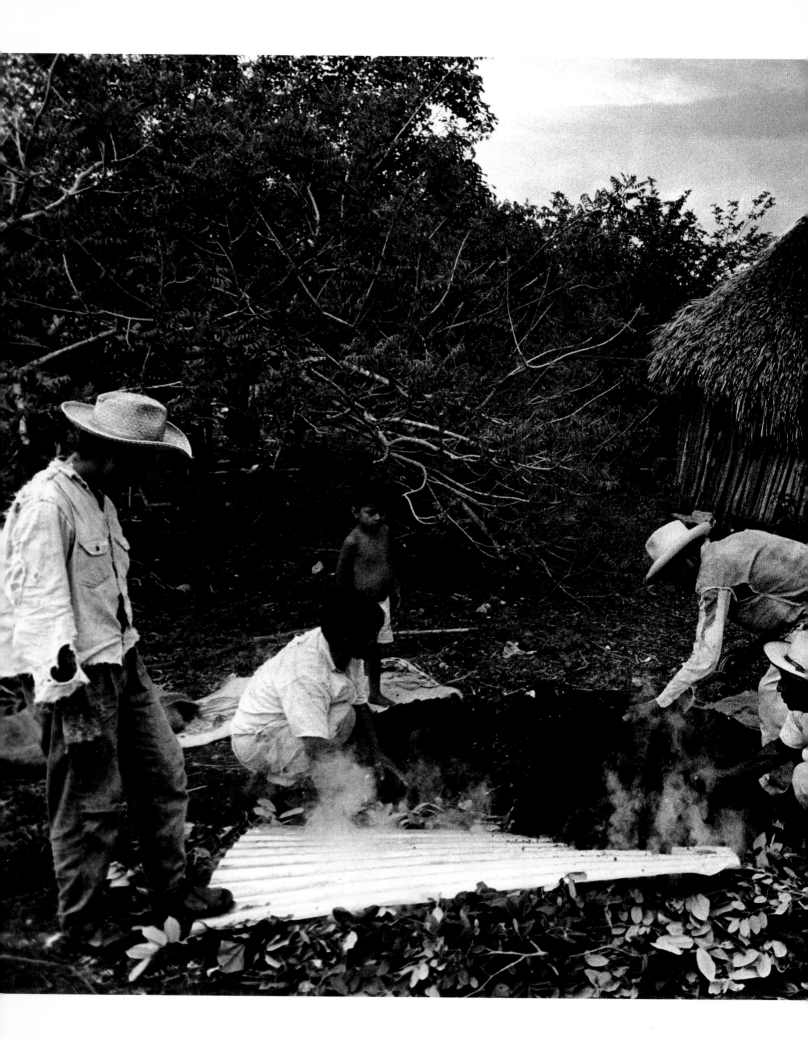

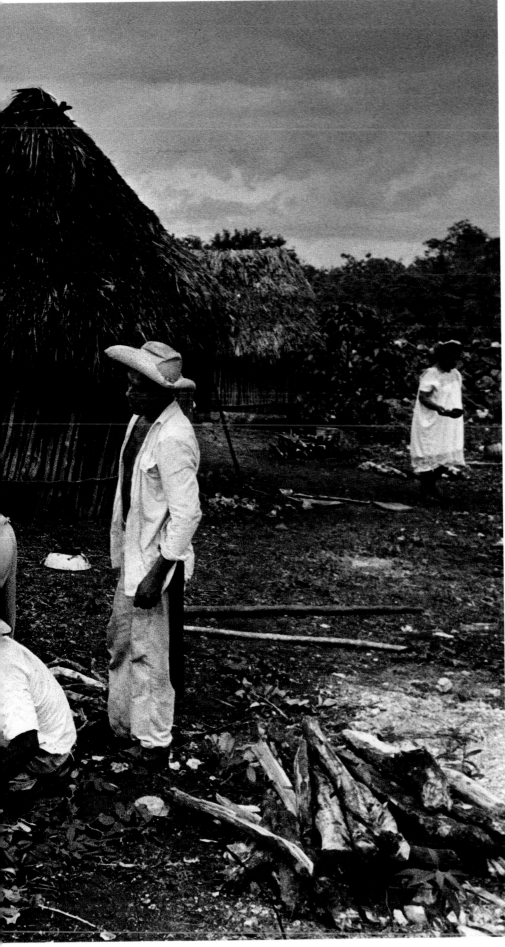

33 *The men pull the ceremonial breads out of the earth oven. Chichimilá, 1971.*

(following pages)
34 *A farmer proudly carries two of the baked ceremonial breads. Chichimilá, 1971.*
35 *Don Tasio prepares the altar. Chichimilá, 1971.* **36** *The ceremonial breads and gourds of meat are placed on the altar and offered to the gods so they can spiritually partake of the feast. Chichimilá, 1971.*

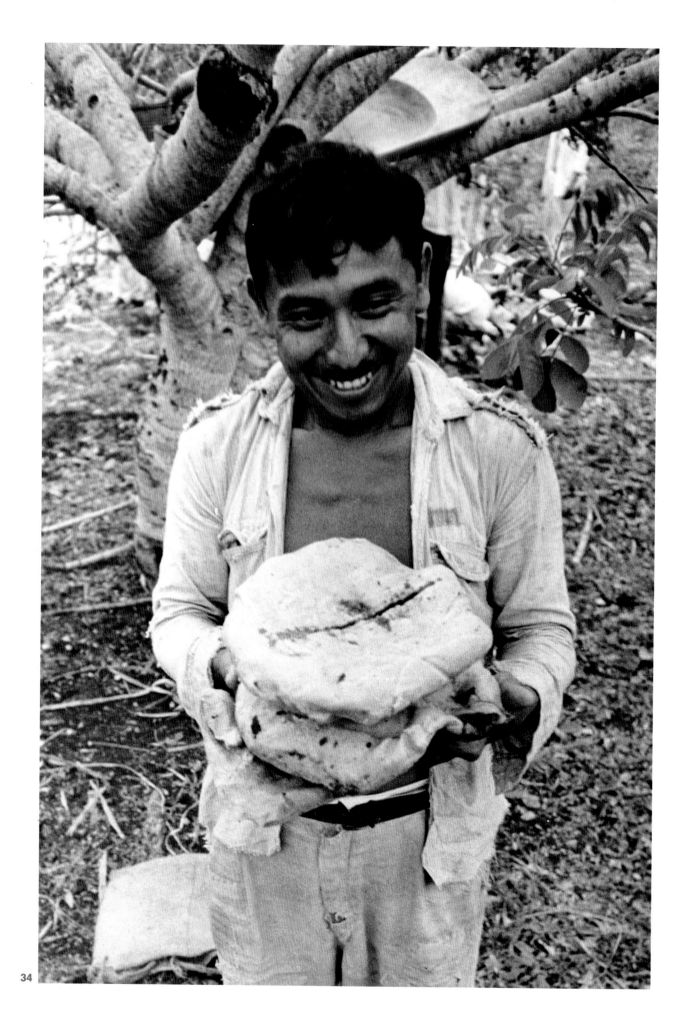

34

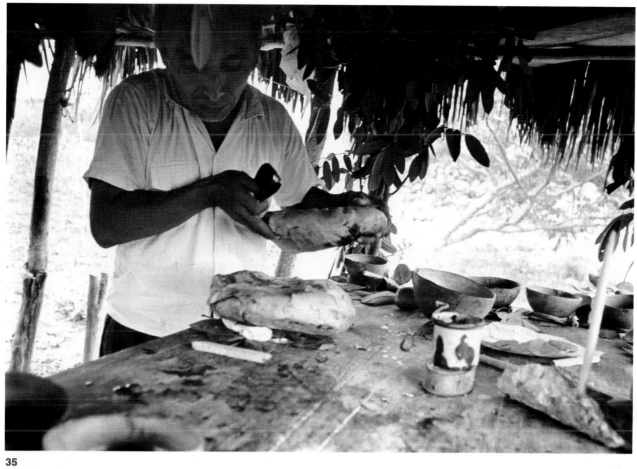

35

36

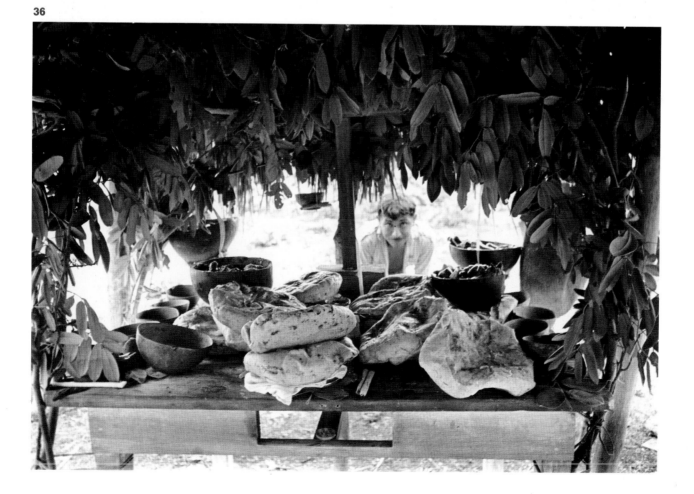

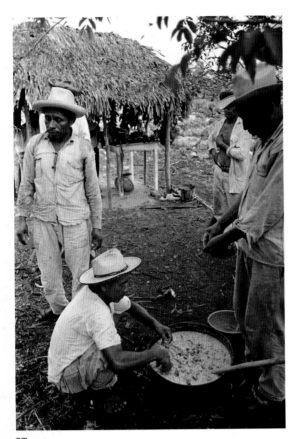

37

37 *After Chaak has partaken of the feast, the breads, broth, and meat are broken up and mixed together in a sopa. Chichimilá, 1971.* **38** *A gourd of turkey, chicken, and pork meat hangs above the altar. Chichimilá, 1971.* **39** *After making these offerings the villagers feast themselves. Chichimilá, 1971.*

38

After allowing time for the gods and saints to partake spiritually of the feast, most of the offerings were removed. Don Tasio prayed, calling out each man's name and asking that his harvest be bountiful as they slowly and reverently filed past, kneeling in front of the altar. Each man kissed Don Tasio's hand as he left.

Then everyone began to eat. They passed out gourds of *sopa*, then separate bowls of sauce and meat, along with slices of the consecrated loaves of corn bread. The men talked as they ate, some joking and laughing, happy with the change of weather. It continued to sprinkle and a wind came up, making the day even chilly. Pretty soon the men began leaving separately, each taking some of the remaining food and fat cigarettes of native tobacco rolled in corn husks (the cigarette of Chaak). It rained throughout the night.

The next morning Dario and Hilario were planting their fields. Each

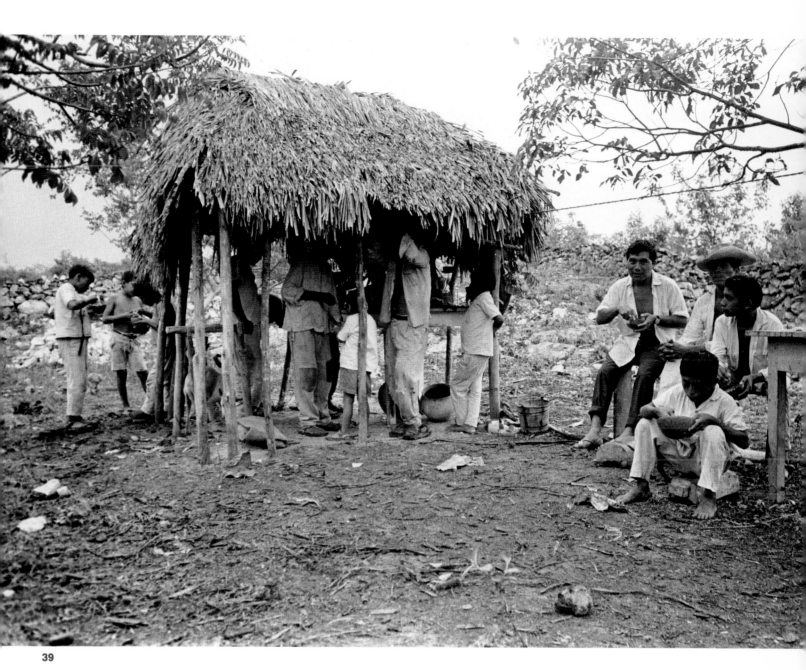

39

had a gourd hanging from his waist filled with corn and squash seeds and a metal-tipped planting stick. They moved like dancers, leaning forward to make a hole with their sticks, then tossing the seeds into the holes using their fingers as a funnel. They would take a sliding step forward, covering the seeds with earth. They didn't plant uniform rows in the fire-stained reddish earth because blackened stumps and limestone outcroppings pockmarked their fields and made it impossible. Later Dario explained the steps involved in the yearly corn farming cycle, starting from when a *milpero* first chose a new *milpa* site.[9] There are six steps that have to be followed: measure the field, cut the jungle, burn the brush, plant, weed, and harvest. Besides the physical labors, there are spiritual obligations and tasks the Maya farmer needs to perform. He informs the gods of the jungle that he is a friend and is going to be making a *milpa*, and that he wants their help in working the bush.

Other obligations require the aid of the *(ah) men*. When the corn matures on the stalk a thanksgiving ceremony is performed in the

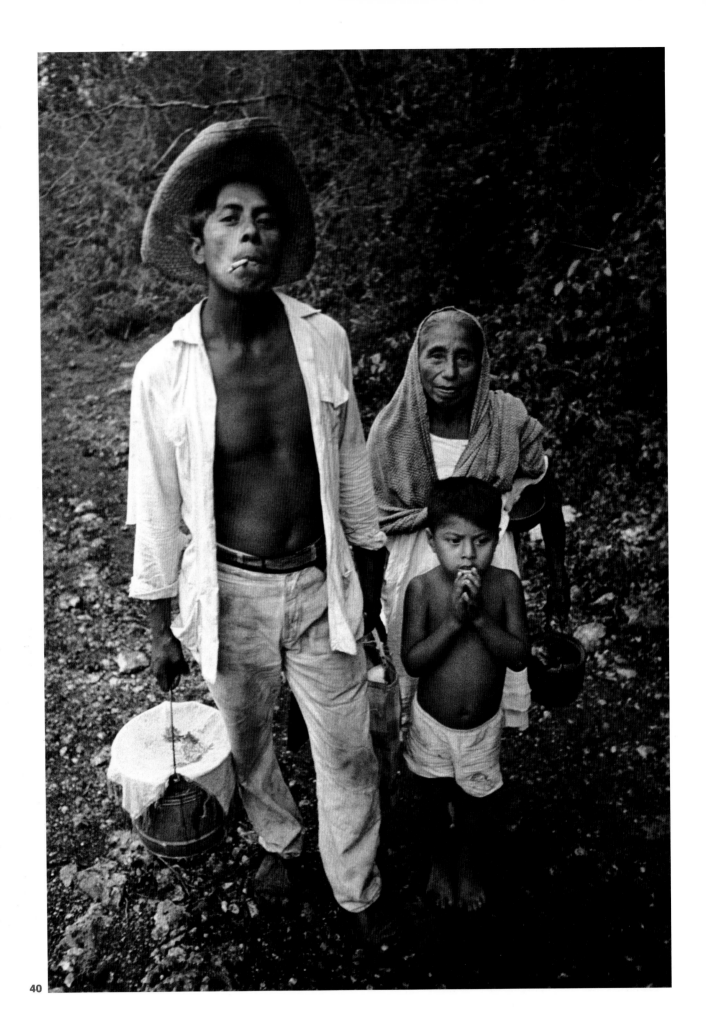

40

cornfield. Hundreds of choice tender ears are harvested and placed in a large earth oven covered with aromatic leaves; then the oven is sealed overnight with earth. The next day the corn and leaves' aroma rises with the steam toward heaven when the farmer opens the oven. The *(ah) men* sprinkles the steam with the sacred corn drink and gives thanks for the harvest to the four directions and to the earth and sky.

The farmer gives two or three ears of this freshly baked corn to everyone he meets coming home from his field. Then he holds a religious feast, inviting his neighbors to eat the baked corn along with new corn *atole*. Each farmer holds his own Thanksgiving ceremonies in his home—not all on the same day, but drawn out over weeks. It is a wonderful time of the year in the village.

Dario felt working in his cornfield was special; it gave him peace of mind and made him feel a free spirit. He alone decided when he worked, or when he devoted himself to his children, or when he attended to chores around their house. A good corn crop gave him enough food for the year, and the surplus could be traded for what he couldn't grow. I think Dario also liked his cornfield because he realized any other work that he could get would leave him very poor in an evolving technological society. As long as there wasn't a drought he would only be poor when he thought he needed more material things. Even in 1971 he could hear the advertisements on transistor radios telling him what he should own and buy, and he'd see new items in shop windows when he went into Valladolid. When he wasn't working in his field, he dug wells to earn money. Around Chichimilá wells were sixty feet deep before they reached water. It was exhausting work, using

40 *On their way home after the* Ch'a Chaak *ceremony, in a cool, light drizzle of rain, Dario smokes a ceremonial hand-rolled cigarette (chamal yum chaak), made from native tobacco, and carries a pail of ceremonial food, accompanied by his mother and his son Jose. Chichimilá, 1971.*
41 *Nado (Fernando Puc Che) asks Don Hilario Tunc, a village* (ah) men, *to solicit help from the gods for the coming corn season. Chichimilá, May 3, 1971.*

41

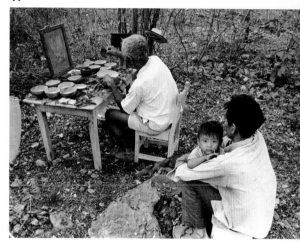

42

43

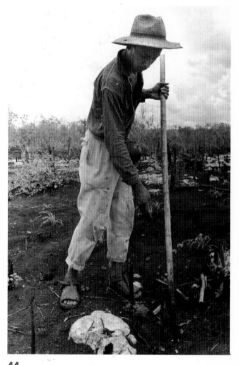

44

42, 43, 44 *A planting stick in one hand, corn seed in a gourd at his waist, Nado probes for soil pockets amid the rocky terrain. He plants not in rows, but randomly about the cleared land. Chichimilá, 1971.*

dynamite and digging by hand with a bar, pick, and shovel through the limestone rock.

Several months after living in Chichimilá, I developed a roll of film in Mérida and showed the results to Dario and his family. While his children talked excitedly about their photos, Dario pulled me aside. He asked if I could do him a favor by driving him to a doctor in Valladolid. His youngest daughter was ill. He'd called an *(ah) men,* who had killed

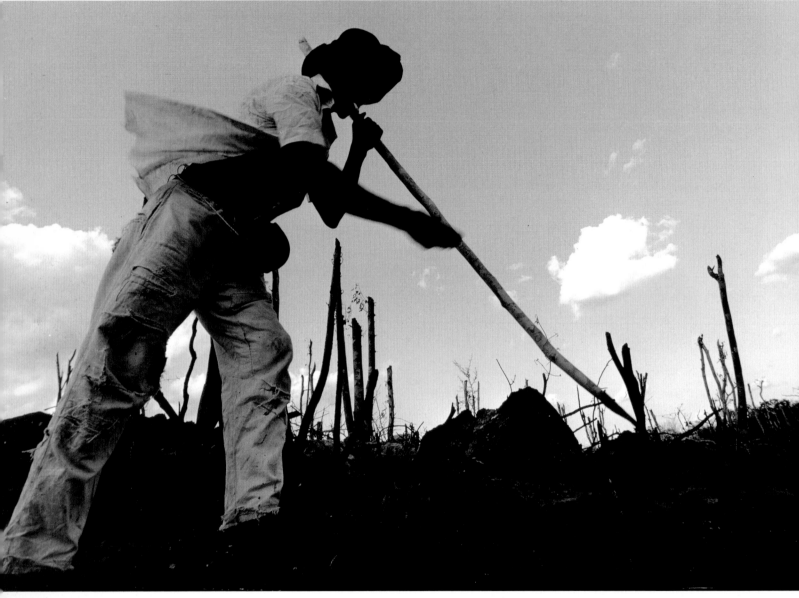

45

45 *Dario planting corn. Chichimilá, 1974.*

a chicken and sprinkled its blood around the entrances to the house and the yard to keep away evil winds (the Maya believed in airborne diseases long before they'd been identified by Western medicine), but his daughter was getting worse.

When we got back a couple of hours later, Herculena invited me to stay for dinner. The medicine the doctor had given their daughter seemed to be working. She was soon asleep, and as we ate we forgot her illness and were able to laugh and joke. But after we went to bed in swinging hammocks in the small hut, her coughing awoke me. It was a

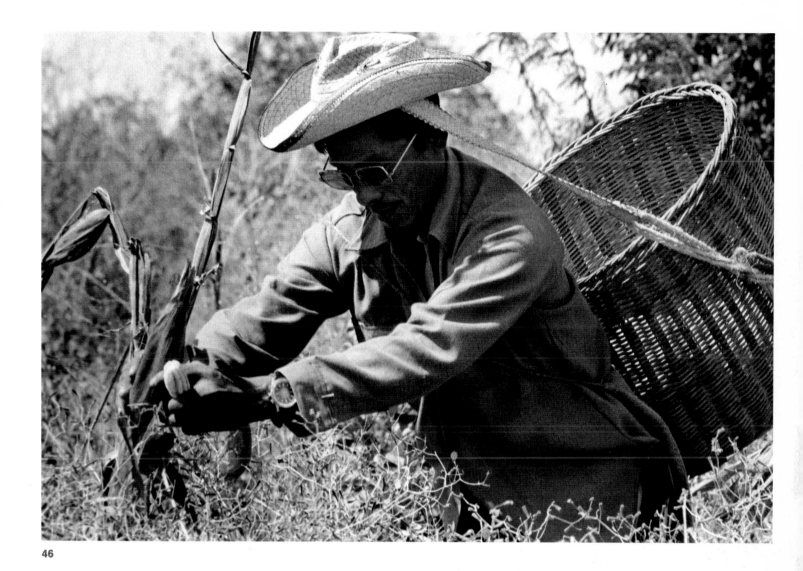

46

wracking cough that seemed to be shaking her body apart, and then she would spit, and cry, and cough again. Dario and Herculena tried to console her, but she coughed all night long. I was sure it was tuberculosis, and I was worried for all the others within the cramped confines of the closed hut. It felt as if death had come into the room.

The next morning I offered to take them again to see the doctor in Valladolid, but Dario said they weren't supposed to return for at least a week. She died soon afterwards.

It is not uncommon when asking parents how many children they have, to be told how many have been born and how many are living. Two out of every ten children die at an early age. Living conditions in village homes can be unhealthy, especially for children, and often parents won't vaccinate their children, even when the health care is provided free. Sometimes parents take their children to doctors, get prescriptions, and then fail to give the medicine because of the cursory way the doctors treated them. Distrust, rascism, and ignorance complicate the health care system.

The Fiesta de Candelaria held every year in Valladolid attracts people from all the surrounding villages. People wear their best clothes; women choose their finest huipiles (white dresses embroidered around the yoke

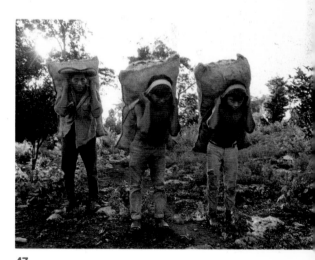

47

46 *Dario harvests corn in his corn field. Chichimilá, 1976.* 47 *Dario (on left) and two boys carrying sacks of corn in from the milpa. Dario was helping his cousin harvest his field. Monte Cristo, 1971.*

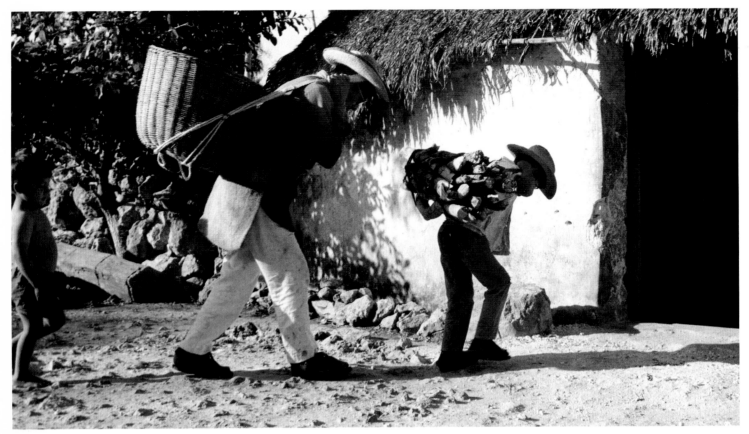

48

49

48 *In addition to corn, Dario will return from his milpa with melons, tomatoes, beans, and squash. His son Jose carries a load of firewood, Chichimilá, 1976.* **49** *Dario, Herculena, and their family. Valentina, the small girl standing in the foreground, died shortly afterwards. Chichimilá, 1971.*

and hem), while the men try to be equally colorful by wearing, for example, a pair of turquoise pants, a shiny green satin shirt, a yellow hat, and a pair of raised-heel dancing blue sandals. Loudspeakers on every block blare announcements and music. Streets booths are set up for gambling, eating, and selling merchandise. All day long truckloads of alcohol are brought in to replenish what is being drunk. In the afternoon there are bullfights, and in the evening there are dances.

I invited Dario and Herculena to go with me one year to the Vaqueria. It is the most exciting dance to attend, held on opening night of the fiesta. The dance was held outside in a large walled-in yard. Strands of lights stretched between palm trees, and we could see the stars overhead. The tropical air was sweet smelling from a thousand freshly washed and scented bodies. There were hundreds of pretty women wearing their most elaborate huipiles, traces of talcum powder on their faces and necks, their cheeks apple-red rouged, their mouths brightly lipsticked, gold sparkled from earrings and necklaces, and adding to the effect, many of them had bright red, green, blue, or yellow ribbons in their jet black hair. Some sparkled, some shone, some had sequins. It was exciting because it was the one night that both villagers and townspeople dressed as Maya.

Dario and I were dressed conservatively in white pants, white *guayaberas* (pleated shirts), white hats, and white sandals, but we had colorful bandanas tied around our necks. Herculena was beautiful in her huipil and underskirts worn so they showed. Victor Soberani y su Orchestra, featuring a saxophone, clarinets, trumpet, drums, and an electric bass guitar, were set up in a corrugated metal band shell. When they began playing *Chinito Koy-Koy*, a heavy beat *jarana*, the dance

area was jammed. The *jarana* is danced something like shifting gears in a truck while double clutching thirty times within a second, with a little tricky footwork thrown in. There was a wooden platform set up for dancers where the stomping was tremendous, but when I felt the cement dance floor where I was standing shake as well, I was impressed. Enough people were dancing to give me the courage to ask someone, too. As we started she asked me if I knew how to dance "le bump."

A number of the Valladolid upper class invited me to join them at their tables. Then they found out Dario and Herculena were with me. They were drunk and began yelling things at Dario.

"Hey, corn farmer, shouldn't you be out in your field planting?" they began. When they continued baiting and teasing Dario, I became very angry, but Dario restrained me. He told me it was not unusual. It was something that he and most Indians in Mexico live with. Racism will be one of Mexico's great problems as long as Mexicans profess to be proud of their country's Indian heritage but embarrassed by contemporary Indians.[10]

Antonio "Negro" Aguilar was a Valladolid businessman who didn't belittle my friendships with the Maya. Negro, who got his nickname because he was dark-skinned, ran a grocery and sporting goods store, and supplied most of the baseball equipment used in the area. He was chief of police in Valladolid in 1971 when I met him. The first thing I noticed was that none of his policemen wore guns, which was unusual. I asked him why.

"It didn't take me long to figure out that most of the problems were domestic situations where you need to be more a psychiatrist than a policeman," he explained, "and psychiatrists don't need guns."

Negro had been the first Yucatecan to play baseball in the States, scouted by Joe Cambria of the Washington Senators, who was responsible for discovering many of the early Latin American baseball players. Negro was known all over Yucatán as a star and a local hero, but when he was seventeen and sent to Morristown, Tennessee, with the Mountain State League, he was shy, unknown, and spoke no English. He ordered ham-n-eggs for every meal until he learned to say

50

50 *Antonio "Negro" Aguilar and two of his sons in the doorway of his store. Negro sells dry goods and sporting equipment, especially baseball gear. Valladolid, 1976.*

"hamburger." It took a while before he ate well. He never forgot the loneliness of being a stranger in a foreign country and how kind some people were to him. Whenever a holiday came up, Negro always came around inviting me to celebrate.

"I remember," he would say in his baseball English, "I be many miles away from my family on big holidays. Everywhere fiesta, and I think of home. I know, I know, I remember. It not be that way this year for you. You have home here in Valladolid, Yucatán, with Negro. You not strike out!" he'd exclaim, gesturing like an umpire, "You safe! You safe at home!"

In 1976 the United States Drug Enforcement Agency provided helicopters and drug enforcement agents to Yucatán. One of these helicopters, flying low over Chichimilá, spotted several marijuana plants growing in the back of Dario's yard. Dario was arrested and taken first to Valladolid, then to Mérida.

Dario was neither a drug dealer nor a smuggler. He had been brought up like many Maya believing that God had provided marijuana to make life bearable for a hard-working man. Hilario immediately arranged for a local lawyer for Dario, and I worked from the United States contacting the governor of Yucatán. Unfortunately for Dario, the governor's reply indicated a tremendous pressure from U.S. agencies for his going to jail so as to support their statistical war on drugs.

The judge handling Dario's case suggested to Dario that he might have a better sentence if Ursina, Dario's eldest daughter, would come and live with the judge's family as a maid. But he never made clear the extent of the duties he expected from her, so Dario never agreed. The judge gave Dario a stiff sentence and sent him to prison in Mérida. Dario always made hammocks and continued to do so in prison. This provided a little money, but not enough to support his family.

Charles had quit the circus and was working in Alaska when he heard the news of Dario's arrest.

"I remember Dario as a hard worker who had very little money," Charles told me later. "I knew his family would suffer as much as he would. Since I was doing well, I thought the least I could do was help them out. I wired money to Herculena, but I found out in a letter from Hilario that she had trouble cashing it at the post office. It seems the postmaster couldn't fathom an Indian woman receiving funds from abroad. So I continued to support them for the next five years by sending money to Ursina, who was schooled in Spanish and better prepared to deal with bankers and the postmaster in Valladolid.

"I made several trips to Yucatán and always made a point to drive Herculena to Mérida so she could see Dario. She usually brought Pedro, their youngest child who had never seen his father anywhere except in jail. One time we were delayed by a flat tire. Even though we'd arrived only a few minutes late for visiting hours, the jailers refused to let Herculena in. She cried.

"Flustered and saddened by the whole thing, I took her to a hotel for the night. I ushered her into a room hoping a warm bath would make her feel better after our disastrous day. When I knocked on her door a

half-hour later to take her out for dinner, she still hadn't bathed. This woman who had pulled countless buckets of water out of a well and heated it for her nightly bath did not know how to draw a bath from hot and cold water faucets into a tiled tub. It was at that point I realized how little she understood about the outside world and the whole system that had taken her man away."

In 1980 I visited Dario's wife and children and was pleased to see his mother too—looking much older but very alive. They pulled a hammock down for me to sit while Herculena filled me in on the latest chances for Dario to be released. He had endured his fourth year in prison, and she spoke with no immediate hope.

It was a cold, quiet morning with a chance of rain. I watched Ursina working at a foot-pedal sewing machine. She smiled at me whenever we caught each other's eye, but neither of us knew what more to say as we thought about Dario. Herculena joined a neighbor who was sitting in a hammock. They sat back to back, as in a love seat, and she went back to work using thread and needle to make lace for the fancy underskirt worn beneath the huipil. She would sell it to help support her family.

Behind them through the doorway, chickens and a few dogs walked around searching for food. One of the dogs edged up near the entrance to the kitchen and watched the youngest daughter at a small, low table eating beans and tortillas. The dog inched closer, stole a tortilla, and ran off.

A whirlwind of dry leaves came down the street and darted into the house, dying with a rustle inside the open doorway, leaving goose bumps. Pedro Pablo, Dario's youngest son who'd been born after Dario's arrest, noticed photographs in my bag, so I brought them out and passed them around. Everyone in the room laughed happily with the pictures of themselves, until they came to those of Dario before he went to prison.

"He's not as thin anymore . . ." his mother began telling me; then she started weeping. A rooster crowed and some pigs squealed as they were chased down the street.

Dario was released later in the year.

Prison life was very hard for Dario. He was used to having his family around him and a *milpa* to work each year. However, he strived to do well in prison. He became one of the head prisoners and reported daily to the warden. He listened when the warden lectured him about his backsliding ways. When Dario was released, he even suggested to his wife that they should move to Mérida and he could sell fruit drinks and bottled soft drinks from a cart. Herculena refused, and Dario returned to his *milpa*. But he kept thinking about how the warden had admonished him to improve his life.

Dario's eldest children had come of age and moved to Cancún while he was in jail. Dario followed them and found work at the Camino Royale Hotel in the tourist zone along the beach. He was put on the night shift and then transferred to the day shift. He cleaned, he swept, he did anything he was asked so they would see that he was a good

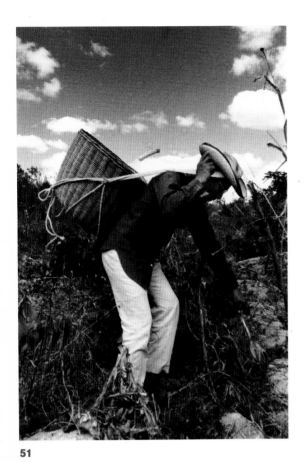

51

51 *Dario at work, harvesting his corn. Chichimilá, 1976.* **52** *Dario at work, washing his boss's truck. Cancún, 1988.*

52

worker. Dario quickly learned that he wanted a job where he could be tipped. The hotel put him to work washing their executives' cars each day, and sometimes he received a tip.

Herculena hated Cancún. She claimed she would rather visit the United Stated before she visited Cancún, and she didn't like to travel. When Dario brought her to Cancún, trying to get her to live there with him so their family could be together, Herculena stayed inside the cinderblock house. She stubbornly refused to adapt to the city. She didn't like it.

In Chichimilá , whenever Cancún was mentioned in her presence, she'd mutter "*Hach k'aas*"—"how ugly" or "how bad." She didn't like having her husband returning only on weekends for thirty-six hours or less, but she refused to go to Cancún with her family because she thought the town was too corrupt.

She didn't come right out and say it, but everyone in the house knew she thought Victoria and Jose were two examples too many of what Cancún would do to her younger children. Victoria, her next-to-eldest daughter, had two kids without a father, and Jose, her eldest son, was often drunk. It wouldn't have been as easy for this to have happened in Chichimilá, but in Cancún, Herculena implied, nobody cared.

She had even allowed the Evangelistas, a proselytizing Protestant sect, to teach dressmaking to her teenage daughters Concepcion, Emerita, and Gonzala. Herculena hoped they would learn a trade they could practice in Chichimilá or Valladolid so that they would not have to go to Cancún to make a decent wage.

I remember Hilario asking Dario in 1974 why he hadn't "taken the *lek*," or gourd, a Maya euphemism meaning "to become a *(ah) men*." Dario told me he hadn't done this because there was an active shaman on his street, and until he was needed to do the work, he wouldn't take the *lek*. He said he already functioned in many respects as a shaman, except for performing the Maya religious ceremonies.

Fourteen years later when we asked him if he thought he had forsaken helping his neighbors in his village by working in Cancún, Dario answered that he could be a wise man anywhere.

On one of his weekend visits in July 1988 I saw Dario in Chichimilá and made arrangements to meet him later the following week in Cancún. The easiest way to find his house, he said, would be for me to pick him up after work at the hotel. As he left to go back to work Herculena gave him a large stack of fresh, bright yellow hand-made tortillas wrapped in cloth.

When I arrived, all the day shifts at other hotels and businesses were also getting off so Paseo Kukulcan was lined with thousands of workers trying to flag taxis and buses already so full that people were hanging out the doorways.

Dario talked and gave me directions in a mixture of Spanish and Maya, waving to friends passing in other cars and trucks. I couldn't get over meeting him in this setting of sleek hotels, wide palm-tree-lined avenues, and people running along the sidewalk in color coordinated jogging suits—it was more like Las Vegas-by-the-sea than Yucatán. It seemed so foreign I immediately asked him if he missed his *milpa*.

"The hotel work is not hard," he said. "My body doesn't ache and my back doesn't hurt after a long day like it used to. The hotel has classes if we want to learn a foreign language. We have health care. A person can improve himself if he has the desire."

Dario's Cancún home was a flat-roofed cement block house in the center of town just off where two of the major streets intersected. Roque, Dario's son-in-law, had originally rented the place from the El Camino Hotel, which subsidized its workers' rent. Living in the house were Roque, his wife Ursina, along with their four children, her father Dario, her eight-month-pregnant sister Victoria with her two young children, and also her brothers Jose and Venacio.

The house had two small bedrooms, a bathroom, and a narrow living room/kitchen that was dominated by a color television and a Sony Betamax along one wall, with a row of chairs and couches facing it.

53 *The family kitchen, I. Chichimilá, 1976.*
54 *The family kitchen, II. Cancún, 1988.*

54

There was a sound system that included a record and cassette player beneath the television. When we came in, all the children were watching Japanese cartoons in Spanish.

Ursina and Victoria were in the kitchen. Victoria's hand was swathed in bandages.

"What happened?" I asked.

"Some grease spilled on me at work."

"Ow! It sounds terrible. Where do you work?"

"At MakBurger," she laughed.

"Did you see a doctor?"

"Right away," she said. "They paid for it. I haven't been to work for four days, and the doctor says I have to stay home another four so my skin can heal."

"You even get paid for not going to work if the doctor tells you not to," Dario added.

55

Dario's daughters were making a dinner of ham and cheese sandwiches, toasting the white "Pan Bimbo" bread over the gas rings. Their cement block kitchen was so different from what they'd been brought up in. I wondered what effect it had on them.

A flash of lightning lit up the room and the thunder followed only a second later, drowning out all our voices. As rain began falling the room grew very dark and the walls took on the reflected hues of the cartoon show on the television.

"Guess what happened to me today," I said, over the noise of the storm. "I was diving at a *cenote* near Tulum when it started raining like this. I climbed out—I had to scale a twenty-foot cliff, but I decided it might be safer in a little cave below. There were already two inches of water on the ground when a bolt of lightning hit. I had my hand on a tree and was climbing back down the cliff, and I remember this bright light traveled up my hand. I got shocked. I feel lucky to be here at all."

"There was a man killed in Chichimilá by lightning," Dario said.

"Wow," Roque interrupted. "In my village a storm came like this . . . lightning and thunder all around. We had a wire coming into our hut and the electrical socket was fastened on a post. The little boy from next door was sitting on a stool leaning against this post, and the lighting hit the electrical lines. A big ball of flame came into the hut following the

wire right to the socket. It went right down the post and knocked the boy off his stool. He was dead. We were sitting right next to each other but no one else was hurt."

"You never know when your time might come," Dario said.

"Yes, but you can take some steps to prevent it." Roque got up and turned off the television. "Let's keep it off for a while," he said.

As soon as he went in to take a shower, the children turned the television back on and started eating.

Later Dario and Roque had dinner at the table. Afterwards a couple of hammocks were strung up to add more room, so the adults could join the kids in front of the television. They watched a variety show.

"How did you decide to come here in the first place?" I asked Dario.

He leaned towards me so I could hear him. "When I got out of jail, I thought I might stay in Mérida" he said. "There was a chance for work and things are inexpensive there. Houses, food, everything you need are very cheap. But my wife didn't want to move because her parents are living in Chichimilá. 'OK, I told her.' And then friends wanted me to come to Cancún. No, I'd tell them. I'm a *campesino*. I can do my *milpa*, I can dig wells. But my kids came to Cancún and I came here also. I remember what the warden told me when I was in jail. 'There are other ways to make a living,' he'd tell me.

"I met a fellow in Mérida who told me he had worked in the United States. He made money and sent it home. He even bought plans for a house and built it in Mérida. It was really beautiful. I realized I had gotten used to working hard and I didn't think of doing anything else. But now people in my village are becoming teachers and secretaries and building nice houses and becoming modern."

"What do you think about all these changes?" I asked.

"I think it is good. Before, you had to go to Mérida to know lights and streets, houses and hotels and things like this, but now the government has brought them to us."

"It seems like just a few years ago we were going out to your cornfield together and you were teaching your sons to become *milperos*, and now your children are in Cancún working at hotels and MakBurger."

"I still have a *milpa*," Dario said, "although I pay my neighbor to work it. What I make here goes back into my village."

"What about Jose?"

"He doesn't attach much importance to farming. He doesn't help me, even to go out to the *milpa*. He just knows that I have it. Same with my son Venancio. He still lives in Chichimilá, but his passions are here in Cancún right now."

"What do you think will happen when the children don't plant their *milpas*—what about the next generation? Will a *Ch'a Chaak* still be performed?"

"Of course," Dario immediately said. "The village won't forget. They'll always do it."

"But who'll do it if the children aren't *milperos*?"

"No, there will always be *milperos*, and they won't abandon their way. Like me, even though I'm living away from my village, the day I'm needed in Chichimilá for a community function, I return. And there are

a lot of villagers who say we don't need roads and these new things the government is bringing us."

"What about your grandchildren who are raised here in Cancún?"

"Well, maybe they won't know the village ways, but they won't forget their race. My grandchildren are speaking Maya—it's not the true Maya, but mixed with Spanish. Maybe it's like when the Spaniards came. Customs changed, but the Maya didn't forget we were Maya."

"Do you feel that after living and working here for a while, Yucatecans are appreciating their culture more, or are they forgetting it as they adapt to the modern ways?"

"Well, those who find a good job and home can live here contentedly, but those who don't will probably return to their villages."

The news came on the television, and two of the children tried climbing up in Dario's lap. He laughed. Picking up his grandchildren, he looked over at me. "These are the reasons I'm in Cancún," he said.

Notes

1. The first Spanish arrived in Yucatán in 1511, a small group of shipwrecked sailors. According to one of the two survivors, the Maya who found them promptly sacrificed and ate five of their companions. Gonzalo Guerrero and Gerónimo de Aguilar escaped to a friendlier, less hungry group where they were taken as slaves instead of sacrificed. The two survivors couldn't have taken two more divergent paths.

Guerrero adapted to the Maya way of life and was accepted by them. He rose from slavery to become a war leader. He tattooed his body, walked around naked, let his hair grow, and had his ears, nose, and lips pierced. He married a Maya woman of royalty and their offspring were the first Mexican mestizos, the mixture of European and Indian blood.

Aguilar kept his Roman Catholic faith and tried to keep his clothes. In 1519 Hernando Cortez stopped at Cozumel, an island off the east coast of Yucatán, where he was told by the friendly local Maya that two of his countrymen were being held captive on the mainland. Cortez sent envoys with beads for their ransom. Aguilar wept with joy when he was reunited with fellow Christians, and soon provided invaluable service as Cortez's interpreter during his discovery and conquest of Mexico.

Cortez was unhappy that Guerrero did not show up and was thinking of going after him until Aguilar informed him there was little gold at his village. Cortez instead continued his expedition, as he said, to acquire land and riches for God, for his king, for himself, and for his friends. Two years later, on August 13, 1521, Mexico fell to the Spanish.

Guerrero gave to his three sons the ransom beads sent by Cortez. He not only preferred to stay with the Maya, but also chose to defend them from his own people. Guerrero was elected by the different chiefs to lead the defense of Yucatán. He trained and prepared them for warfare against the Spanish and was almost successful. Whereas a small group of Spanish had conquered the entire military empire of the Aztecs in only two years, they were unsuccessful in Yucatán for more than twenty years. It wasn't until after Guerrero was killed on August 13, 1536, while fighting the Spanish in Honduras, that the Maya began losing ground. Francisco de Montejo the Younger established Mérida in 1542, and by 1546 the political conquest of Yucatán had been completed, although culturally the Maya conceded little to the Spanish.

Much of what we know about the Maya was provided in *Relación de las cosas de Yucatán,* a book written by Friar Diego de Landa as a defense against charges of

overzealous and despotic behavior. He had done all he could to wipe out Maya culture and civilization and was responsible, in 1562 for the auto de fé of Maní where he destroyed 5,000 idols and burned twenty-seven hieroglyphic rolls.

"We found a large number of books" he wrote, "in these characters [Maya writing] and as they contained nothing in which there were not to be seen superstition and lies of the devil, we burned them all, which they regretted to an amazing degree, and which caused them much affliction." The gathered Maya watched two thousand years of their collected culture being burned. Landa, who later became bishop of Yucatán, claimed that Spain brought to the Maya "justice and Christianity, and the peace in which they live."

However, the Spanish brought diseases which the American Indians had no resistance to; the first epidemics killed from one-third to one-half of the Indians in Mesoamerica. They died from cholera, malaria, measles, plague, smallpox, tuberculosis, typhoid, and typhus. They also died from zealous religious persecution and overwork as slaves. By the end of the first one hundred years of Spanish rule in Mexico, the Indian population had been reduced by as much as 90 percent.

Not until the 1840s did the outside world become interested in the Maya when John L. Stephens and Frederick Catherwood published four volumes detailing their two journeys in Mesoamerica. Catherwood's illustrations evocatively captured romantic visions of the Maya ruins, while Stephens's account provided solid information on the Maya Indians and their culture. The books intrigued generations with the art of the mysterious Maya and their indecipherable hieroglyphics. It was easy to fall under the spell of the Maya. Charles Lindbergh, who flew over the Yucatecan peninsula while charting new airmail routes for Pan American Airways in the late 1920s, became excited when he spotted mounds rising from the jungle. This led to his conducting the first major, exclusively archeological undertaking performed from the air in the Western Hemisphere. Recently, archeologists have been using satellite photos to discover ruins and confirm theories about, for example, intensive farming techniques by the ancient Maya.

There have been tremendous breakthroughs in the understanding of the Maya within the last twenty years, including deciphering the hieroglyphic writing. Linda Schele, author of *The Blood of Kings*, recently mentioned that today is the most thrilling time for a Maya archeologist, even more exciting than last century when many of the great ruins were discovered, because there are so many breakthroughs occurring in our understanding of the ancient Maya.

2. In Yucatán, the Spanish words *mestizo* and *mestiza* (which translate to half-breed or mixed-bloods) are synonomous with *indios*—men and women dressing and living as rural Maya.

3. *P'u'ukbil sacan,* the simplest of the corn drinks, is grainy, requires no heating, and is the quickest to prepare, but it's not the favorite because it's not cooked. It is simply masa (cornmeal) dissolved in water, salted or sweetened. It's used as a quick snack, or made by hungry youngsters.

Chokó sakan, or hot masa, is made with masa dissolved in water and then heated until creamy. It's lightly salted, and often the Maya start off their day drinking this with toasted tortillas.

Sakah is the sacred drink of the Maya prepared by *(ah) men* for their ceremonies. It's made by adding clean corn to a bucket of water without adding lime and boiling until it pops open. The corn is washed, ground in a hand mill, and mixed with water, rarely salted or sweetened, and drunk as a sacrament. The ancient Maya had a *sakah* made from cacao (chocolate) and corn, but no one knows what the proportions were.

K'eyem, or pozole, is ground hominy. The Maya take *nixtamal* (corn boiled with lime and then rinsed clean), return it to the fire, and boil it until the kernels swell and pop open. The drained corn is ground and then mixed with water; salt or sugar is added, or even grated coconut and honey.

K'ah or *x-ta'an,* or pinole, has an elusive flavor that conjures up roasted peanuts, coffee, or chocolate, but it's made with toasted corn, allspice, star anise, and cinnamon. The Maya roast clean, dry corn kernels on a griddle and lightly toast the spices, grind up this mixture—the powder keeps well—and add it to water, cooking

thoroughly until creamy and the tiny ground pieces of corn are tender. There is a saying that after bubbling up three times, pinole is done.

Atole, or *sa',* is the national corn drink of Mexico with many variations. Typically, corn is boiled, ground, passed through a fine sieve, and then boiled again, after which it is salted or sweetened to taste. Some of the Maya variations include: *sikil sa',* where pepita powder is added; *tumben sa'* or *sa' is ul* (atole made from new corn); *chiliatole*—atole with chile added; *ts'ambil sa'*—atole left to ferment overnight for a stronger flavor; *tan'chukwa*—atole made with ground chocolate, anise and allspice; and *ch'uhuk sa'*—a sweet atole.

Che'che' ixi'm, or *soki kuk* is made from raw kernels run directly through a hand mill, added to a pot of water, and stirred, with everything floating to the top removed with a strainer. Then it is brought to a rapid boil three times. It's the only food given to mothers for the first few days after giving birth, because the Maya think it encourages the flow of the mother's milk. The hand mill leaves little chunks of corn that give the drink a nutty texture.

4. Called *wah,* which means bread, a tortilla is made from corn masa which contains no sugar, salt, or yeast. Tortilla making can be an art. When men cook for themselves, they usually make fat tortillas because they're quicker and easier. Machine-made tortillas don't taste as good as hand-made tortillas. There is a tremendous difference in taste and texture, but machine-made tortillas are replacing the handmade ones all over Yucatán. Here are nine main traditional types of corn tortillas found in Chichimilá—*u wah ixi'm.*

1. *Wah:* The common tortilla provided with a meal. *Wah hay pak'ach* means thin tortilla.

2. *Pim:* Fat tortillas. Also known as *pen cuch, pem chuk,* or *piston.*

3. *Op:* Toasted tortillas done over the coals or on the *comal.*

4. *Sak pet:* A tortilla that is cooked on one side only until well done. It preserves well and is taken when travelling. Also called *op'o suk pet.*

5. *Ch'ooch' wah:* Tortillas made with salt added to the masa.

6. *Xix wah:* The residue left in the sieve (from making various corn preparations) is used to form this tortilla on the *comal* itself. The tortilla is large, grainy, and toasted.

7. *Is wah:* New corn tortillas prepared at harvest time. Also called *Tumben wah* and *chepets'.*

8. *Sikil wah:* Pepita powder and salt added to the masa.

9. *Bu'ulil wah:* Cooked and strained black beans can be added to the masa. Also called *muxub.* Sesame seeds added to masa is called *sikil pus wah.* Pepita seeds (whole) can also be added to the masa and is also called *sikil wah.* While tortilla is toasting, the seeds are roasting.

On many of these, especially the fat ones, a little manteca is added to enhance the flavor. You have to be careful turning the tortilla over on the *comal* because the manteca can burn your fingers. Another variation is called *churepa* and is made with sugar and manteca.

Nohwah (big bread), or *kanlahun tas wah* (fourteen-layered bread), or *yahaw wah* and *oxlahun wah* (thirteen layers) is a large layered cornbread with pepita powder sprinkled between layers. Sometimes ground frijol is alternated with the *sikil.* These are then covered in *bob* leaves and cooked in a very hot, large earth oven, or *pib.* It's prepared for the *Ch'a-Chaak* (rain god ceremony).

Tamales are corn breads, wrapped in leaves, that are either steamed or baked in a *pib.* Tamales certainly go back thousands of years, and there are many varieties in Mesoamerica. In all of Bishop de Landa's writings about the recently conquered Maya, he never mentioned tortillas, although he described many other methods of corn preparation.

"On inspecting the town and entering the houses our men (Cortez) found in all and each one of them a great quantity of turkeys all prepared and dressed for eating by those Indians. Besides these things they also found much corn-bread and other supplies such as drinks, and a dish made of meat mixed with corn-bread called by those Indians tamales."

To'obil wah, tamales, *vaporcitos* and *Pibil wah* are corn breads wrapped in leaves.

They are found in the markets and street stands as well as in the Maya home.

Pibil wah are baked in a *pib*.

Xmak'ulan has an *ib* (Yucatecan lima bean), chili, and *sikil* filling. It's wrapped with an edible *xmak'ulan* leaf which imparts a licorice flavor. It is flat and rectangular.

Tuti wah has a bean, chili, and sikil filling. It is sausage-shaped.

Ch'a-Chaak wah is stuffed with pork or chicken and eaten with a sweet atole.

Some corn breads are cooked in the earth ovens, others are steamed. In the Maya home, steamed tamales are elaborate dishes, and often several people help make them. There are several types, and, within a village, homes become famous for their particular style of steamed tamales. They are a corn mush pie that may include egg, turkey, chicken, pork, deer, or other meats and are then wrapped in banana leaves and tied closed with *hool*. Steamed tamales are made for special occasions, such as Christmas, and are served with hot and frothy cocoa.

In Chichimilá there are two distinct types—*tamali* and *sa'kay tamali*. The *tamali* has a smoother consistency because the masa is put through a sieve, whereas the *sa'kay tamili* is coarser and has a stronger flavor. Both of these are made the following way: You make a thick corn atole with manteca. Then spice and thicken with masa the broth in which the meat has been boiled, adding annota which turns it orange. This mixture is called *col*. Debone and shred the meat(s). On prepared banana leaves place a layer of corn mush which is creamy in color. In the middle, spread a portion of *col*. Lay on this bed a slice of tomato, a couple of leaves of epazote, and the filling of meat or egg. Wrap it in the banana leaf, tie it securely and then steam for at least a couple of hours. Or it can be steamed all night.

Brazas de reina or *braza de chaya* is made with *sikil,* eggs, and beans and wrapped with chaya leaves.

Expelóni wah uses the *expelón* bean as a filling.

Dzoto bi chay uses pepita powder and egg mixed with the masa and is wrapped in a chaya leaf.

Tamales de Chaya has chaya mixed with the masa and a filling of pepita powder and egg.

Tamales available commercially are smaller than the special home-made variety and have less of the filling.

Vaporcitos are small, firm tamales which often have a bean filling and are served with a tomato sauce. *Vaporcitos* are wrapped in a banana leaf or corn husk. A spicy tomato sauce accompanies them.

Antojitos (literally, little cravings) are not found as often in the Maya home but are readily available at markets, from street vendors, fondas (small restaurants), loncherias (snack bars), food bazaars, and restaurants. These include *salbutes, panuchos,* empanadas, tortas, tamales, *vaporcitos, papadzules,* and tacos. Quality varies considerably, and anything fried or cooked is best hot.

If you want good *salbutes, panuchos,* and empanadas, eat them fresh and hot. *Panuchos* are my favorite. It's a tortilla with black bean paste brushed inside and dropped in hot manteca. *Panucho sencillo* is served with red onion, vinegar, and chili garnish on top. *Panucho con carne* adds shredded meat. Vendors often sell old and cold ones around bus stations and movie theaters. I like my pig lard dripping hot. *Salbutes* are made with a tortilla that has ground meat added to the middle and then fried. Empanadas are also good.

Papadzules are rolled tortillas fried and served with a *pepita gruesa* sauce.

5. I know this sounds like a lot of tortillas, and a sum that would be impossible for me to duplicate if eating store-brought corn tortillas available here in California, but hot, hand-made fresh tortillas in Yucatán are delectable. They are smaller, lighter, and much more flavorful than any I have ever eaten in the United States.

6. Corn was first used as a food when nomadic groups in the Valley of Tehuacán, located in the Highlands of Mexico, began domesticating plants 7,000 years ago, successfully farming squash, water-bottle gourds, beans, peppers, amaranth, and maize. Corn originally was a short, spindly wild grass with tiny cobs and two husks that easily parted. But when humans started planting the seeds, the two became interdependent. Corn cobs developed from less than an inch long into large cobs

that stored the sun's energy in kernels that would keep all year long; but no longer was the plant able to seed itself—it needed humans. No longer did the nomads need to wander to find sustenance. These early plant gatherers made the most important discovery of any of the American Indians. They developed the grain that would build a hemisphere, and corn would become the most productive food plant in the world.

As the nomads began depending on agriculture, their ability to forecast rainfall and weather became increasingly important. Vessels to prepare and cook their food came into use. These various needs were the foundations for the beginning of a civilization, and several thousand years later, thanks to corn, the Maya became the greatest civilization in the Americas.

7. I remember being shocked the first time a Maya refused to recognize himself because he was smiling. I had brought back a delightful portrait of a villager whose whole face seemed to glow as the light hit two rows of gold teeth. To me it was a good photo. For him it was unreadable. However there were unexpected rewards. In 1980, according to local custom, we dug up the bones of Hilario's mother-in-law who had died in 1976, freeing the plot in the cemetery for another burial—a not uncommon practice in areas of very rocky soil. That evening there was a *resa*, a service and celebration in her remembrance accompanied by ritual drinking. About 3:00 A.M. I was finishing off a bottle of rum with one of her sons, who years before had been reluctant to let me photograph him. Finally he had tolerated me and my camera just as he might humor a village idiot. But as we sat together in the darkness outside of the hut, he told me, "Macduff, you are one sombitch. Today we dug up my mother, and my children don't even remember her. But because of you, because

56 *An early morning* resa *(prayer service) during All Saints observance (October/ November) for Dario and Herculena's recently departed daughter. The two women in front are leading the singing and chants. After sunrise, everyone attending ate breakfast together. Chichimilá, 1971.*

56

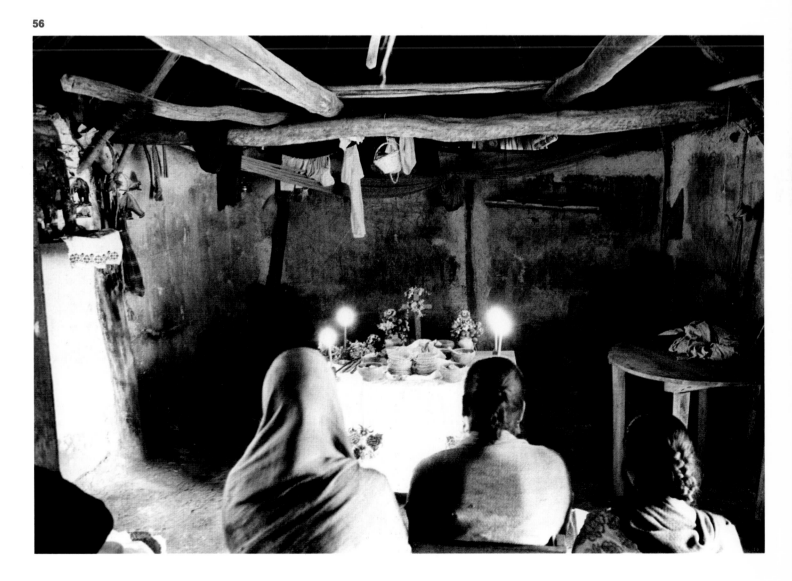

of the album of photographs you gave me, my children and their children and their children's children will know who I am and what my life was like. You've made me immortal."

8. "One of the things you have to remember," Charles told me, "is the cultural context for these stories. I once interviewed five *(ah) men* in Chichimilá for an Argentinian working with INAH (Mexico's National Institute of Anthropology and History).

"Each one of them told me that they had been inspired to become a shaman by an encounter they had had with an animal in the woods—it was usually a bird. Most Westerners would probably laugh at such a notion, but if we had been brought up in a culture which believes that animals can communicate with people, we might be prepared to experience such encounters ourselves, if and when they occur."

9. The *milpa* technique, under conditions of isolation and low population density, is an excellent agroforestry system and one of the best adapted to the ecological and economic conditions of the tropics. It frees more people than was originally assumed, while conserving a biological diversity. As Gómez-Pompa points out, it should be seen as a starting point for future permanent agriculture and silviculture and not only as a destructive technology.

The first stage of making a *milpa* involves measuring the jungle and becoming familiar with the land where the farmer will be working for the next three years— sometimes finding a *cenote*, or a ruin. The measuring requires two people using a line twenty meters long, or one *mecate* (a measure that can mean either twenty meters distance or twenty meters square). Fifty *mecates* would support a small family and contain 2,500 square meters. Most of the *milpas* around Chichimilá were from 50 to 300 *mecates*.

Next the farmer needs to fell the jungle. He begins by cutting down the smaller brush and trees with a machete and *koa* (a curved knife) to give himself room to work with an axe. He then fells the larger trees on top of the brush, trying for a uniform cover so the burning will be even and the ash will fertilize the soil equally.

The farmer pulls out long poles and short forked ones as he cuts to build a sturdy fence to keep animals out, including free-roaming cattle. At the same time, he saves choice pieces of wood useful for posts and beams in house building, using them himself or selling them. He also puts aside the best firewood, cutting and staking it away from where he'll burn. But not everything is cut down. Everyone leaves the guano palm that's used for thatching, and also the ramon, ceiba, and zapote trees, among others, are rarely cut.

This is also the time for making lime. The farmer prepares a round platform of logs and then piles limestone rocks on top. The logs can burn anywhere from twenty-four to forty-eight hours, and the farmer will be left a pile of white lime powder. He'll use it primarily for adding to the corn when it's boiled each night, but also for whitewashing, for making mortar and plaster, and for painting the trunks of fruit trees against the night cutting ants.

The work is done months before it is time to burn so the wood can dry out, but he must burn before the rains come, or it might be impossible to plant that year. The farmer might consult the *(ah) men* for the right time to burn, but he also observes conditions like the wind or the color of the fires in his home. When a cooking fire burns bright orange, it means the rains are coming and it is time to burn. Then he'll cut all the new growth in the field and clean the outer edges to contain the fire.

He'll often ask friends to help with the burning. It is hot, intense work. He wants a good wind to spread the fire across the field so it will burn evenly, but if the wind shifts, it can suddenly become dangerous. The fire should burn completely down, not leaving any large logs. The heat loosens the soil and kills the insect life in the ground. That's important because there isn't a cold or frost season in Yucatán, and there are many insects that aren't welcome when the corn begins to grow. If the field doesn't burn completely, the *milpero* will have to burn it again. Most of the *milperos* will burn at the same time, covering the whole peninsula in smoke. The sun turns red and light turns yellow.

After the first heavy rain, it's time to plant. The farmer will have set aside his

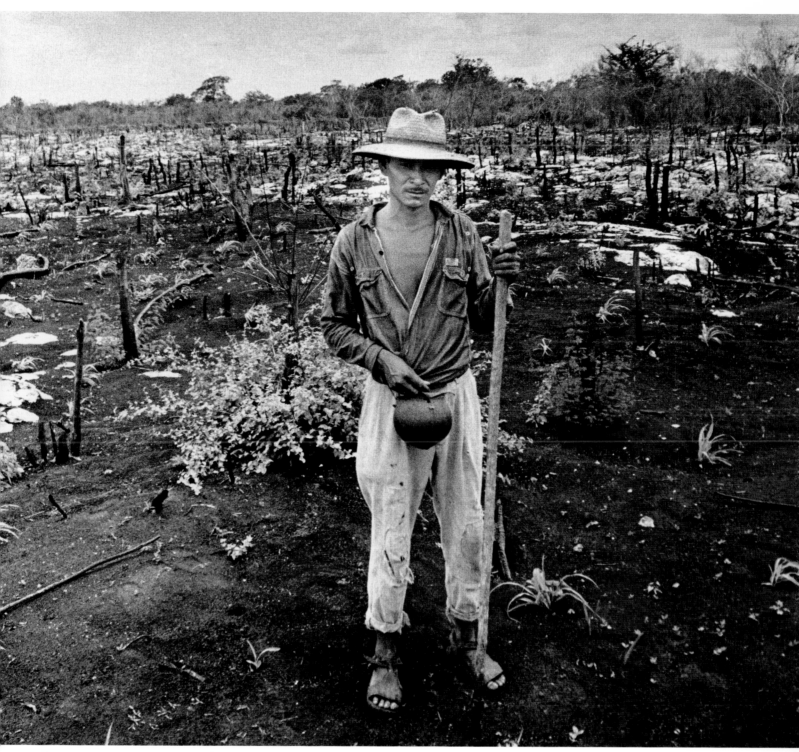

57

biggest and best ears from the previous harvest and use the kernels from the center rather than the smaller kernels from the ends. He can't be sloppy when he tosses in the seeds or he will spend too much time bending over picking them up, and his back might give out. A farmer really likes to get the seeds into the ground two or three days before the next heavy rains come. He can't put the seeds in the ground many days before that because animals such as raccoons, birds, and squirrels will dig them up and eat them.

The farmer usually uses seeds of two varieties of corn. One type takes only two and a half months to develop, while the other takes four months. The latter is larger and preferable, but in case the growing season is cut short by a hurricane or lack of rain, the other he can fall back on.

57 *Fernando Puc Che in his cornfield. Dario and "Nado," Hilario's brother-in-law, worked together to plant the milpa. Chichimilá, 1971.*

The corn is up within a week under favorable conditions. That is when the farmer sees where a second planting is necessary. The Maya have names and descriptions for corn from the time it just pops up until it's harvested. It's much like the Eskimos having so many descriptions for snow. A Maya farmer might say his corn is the size of a rabbit and his neighbors know exactly what he means. During the season, if you ask a farmer how he is, or how things are in his village, he'll start telling you about his cornfield. Corn isn't called corn by by the Maya while it is in the *milpa*, but the farmers refer to it as *gracia,* or *santa gracia* (thanks or holy thanks), denoting the spiritual essence of the offerings made to the gods.

Almost as soon as he's finished planting, the farmer needs to start weeding because the soil can often be thin and won't retain much moisture. This work is intense because, if neglected, the corn is overrun with weeds and won't develop. Dario could weed six or more mecates a day using a koa and machete. Now the Maya only plant a *milpa* three consecutive years in a spot—each year getting less return on their labor. In the 1930s the Carnegie Institute ran tests where the weeds were pulled out by their roots, and they were able to use the same plot for 10 years without a loss in crop yield, suggesting that it was competition with the weeds and not soil deterioration that led to diminishing returns. But no one weeds like this around Chichimilá. Archeologists have also recently discovered through aerial surveys and ground work that the Maya employed intensive agricultural plots with irrigation channels and raised beds, but this agricultural knowledge was probably lost because of the Spanish Conquest. (Raised beds were present in Quintana Roo in the sixteenth century.) The Mexican government is currently experimenting with reviving raised field agriculture in southern Quintana Roo to help feed a hungry nation.

The contemporary Maya practice a soil classification system developed by their pre-Hispanic ancestors that is better than any other known for the area, and they make planting decisions based on soil attributes. Their system for classifying vegetation is based on ecological data, including the age of the fallow, past management of vegetation, and past yields from specific areas and soil types.

Besides planting corn and squash, a *milpero* might plant beans, chiles, tomatoes, cherry tomatoes, watermelons, papaya, sesame, bananas, and pineapples. The farmer weeds and watches his crops grow. Each day when he returns to his house, he'll carry something from the *milpa,* such as lime or firewood.

When the plants turn brown, the *milpero* bends the stalks, which keeps the rain and birds from the drying ears of corn. Birds can be a problem, as well as other animals such as deer and raccoons. During this crucial period, the farmer might spend nights in his cornfield with a slingshot or a gun. It's a good time for hunting.

When he is ready to harvest, he'll carry a large woven basket on his back and toss the ears of corn into it. He'll look at each husk. If it's in good condition, he'll leave it on to protect the corn against mice, bugs, and moisture during storage. If the husk has been damaged, he removes it with a deerhorn husking tool. He'll use the husked ears first.

Inside the farmer's house a place is prepared, or a separate small house is tied up—which is the Maya saying for building, since tying with vines is what holds it together—and the corn is stored for the rest of the year. A few villagers still put a boa constrictor in with the ears of corn to keep mice and rats out.

10. This is just one of many examples that I was unfortunate to witness. For a casual visitor, it is easiest to see it in Cancún. You don't see Maya in any positions of authority; they are the hired help and treated by many Mexicans as second-class citizens. In 1988 when I was in Cancún setting up arrangements for a University of California, Santa Barbara, extension class I invited my goddaughter and her siblings to come swimming with me in the hotel pool where the students were going to stay. Very quickly staff personnel asked them to leave. When I protested that they were my guests, they still insisted my goddaughter would not be able to play in the pool. I went to see the manager. The only reason they were singled out, I said, was because of the color of their skin. The manager, a man from Mexico City, agreed. "We've never had a Maya stay here so of course we assumed she didn't belong," he told me. But he agreed that since she was my goddaughter, Cecilia could continue

playing. But when her older brother came to visit later, Felipe was stopped by security who wouldn't believe that he could have a friend staying in their hotel. It was deeply embarrassing for Felipe. Sometimes I forget that even though I can eventually show them that they can move more freely than they are used to, not everyone is ready to be subjected to the embarrassment and degradation that proving it entails.

It was hard rationally to understand the sometimes brutal attacks by supposedly educated people. An Argentinian friend once tried to explain to me the difference between North Americans and Latin Americans. He told me I came from a background that was founded on religious freedom and the work ethic. However, he was a descendant of Europeans that came to conquer. Regular work was beneath his class, and he was taught that living by his wits and stealing were more honorable than working with his hands. Other people were to be used, otherwise they might use you.

William Pfaff, a columnist for the *Los Angeles Times,* offers another explanation. "The Latin American intellectual and religious tradition is absolutist, intolerant, unpragmatic—a constant obstacle to compromise and political reforms. The imperialism that populated and culturally shaped Latin American society, destroying the Indian civilizations already there, was peculiarly uncompromising, motivated by the search for gold and a search for souls. Spain and Portugal, at the peak of their powers in the 16th Century, failed to make a creative adaption to the modern world that followed. Their American colonies could do no better. The Enlightenment and the social revolutions of the 19th Century passed them by. They walled themselves off from modernity, reemerging only in the 1960s and '70s."

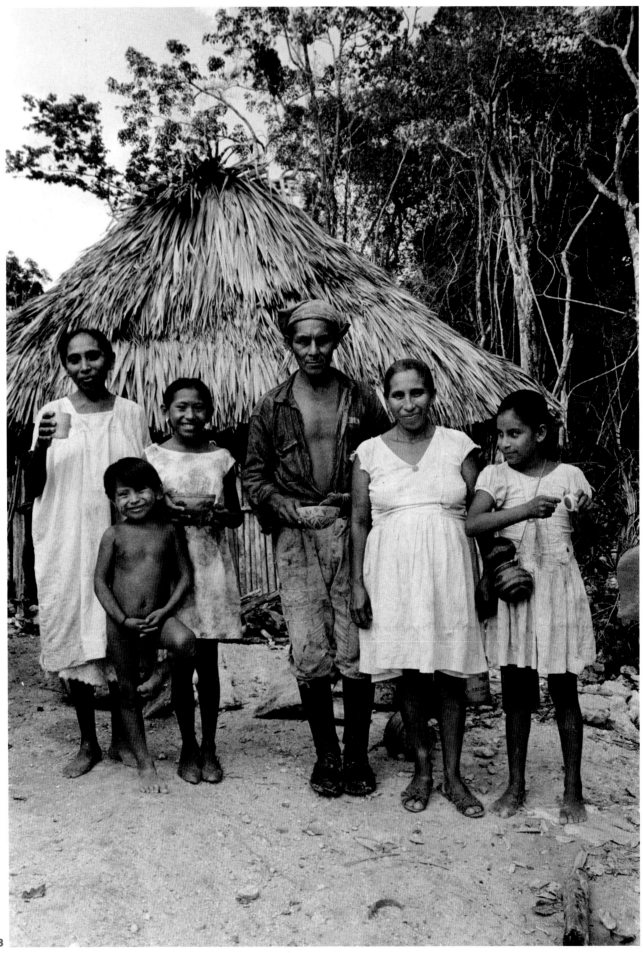

2

Chicleros

𐄁𐄁𐄁𐄁𐄁𐄁𐄁𐄁

A
Season
in the
Jungle

In 1967, in order to reach the archeological site of Cobá, I had to hire a guide and walk fourteen hours in the rain from the town of Chemax. Hurricane Beulah had just swept across Yucatán, knocking down trees, flooding low areas, and leaving the trail littered with branches and dead snakes.

On the return, my guide and I were on the trail long after nightfall without flashlights. The starlight filtered through the trees as we followed a vague outline of the limestone rocks that pocked the trail. We took turns leading. It was very quiet and seemed to take forever. I worried about snakes.

Suddenly we heard singing ahead of us. We came to a man, reeking of rum and straddling a mule laden with supplies, and I could hear the creaking and jingling of the packs on the mules behind him. The only light was the tip of his cigarette which lit up the scene each time he took a drag. He offered us a cigarette, then, pulling out a carton, handed me a pack. We smoked and talked for a couple of cigarettes' time.

Talk is a loose term. This was my first trip, so I knew very little Spanish or Maya. He said something—I'd recognize some words—then I'd try to say something. He'd laugh, hand me his bottle of rum, and signal for me to drink up. We'd say a little more, then have another drink, and a few more drags on our cigarettes. I understood that he was a *chiclero,* a man who collects chicle, the base for chewing gum. His

All kinds of riff-raff run together in a chicle camp, mostly men who are wanted somewhere by the law. Fights in the camp are frequent, drunkenness is usual, and stealing and smuggling are daily occurrences. From the collector's camp, blocks [of the dehydrated resin] are hauled out on mules, often requiring days and weeks over trails. . . . Sometimes enterprising bandits hold up teams of 20 or 30 mules and mules and gum disappear, leaving only a few dead chicleros as mute records of what has happened. Fantastic are the tales that can be heard in the evening around the chicleros' camp fire, and most of them are true.

—FRANS BLOM,
MAYA ARCHEOLOGIST, 1926

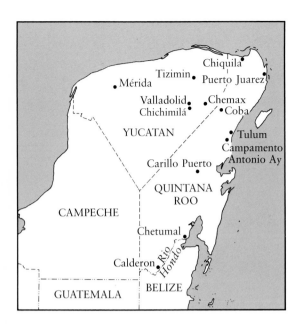

58 *(p. 88) Veva with her son Felipe and daughter Alicia (1). Diego, Margarita, and their daughter Maria. Campamento Antonio Ay, 1971.*

campamento was still fourteen hours away. I was impressed that he would take off alone in the middle of the night. I figured if anyone could teach me to enjoy the jungle, it might be a *chiclero*.

When I got back to Mérida, I talked with the American consul, who shared my interest in the Maya and Yucatán. This was before the threat of terrorism drastically changed the procedures at consulates and embassies. Then you could just go in and talk.

We wondered how long the chicleros would continue working on the peninsula. They collected the sap of the zapote tree, which along with sugar, corn syrup, softeners, and flavoring, made up the five main ingredients of commercial chewing gum. Many gum companies were beginning to use synthetic vinyl gum bases.

I told the consul I wanted to document their work before it disappeared. He was very interested but advised me to be careful; an American had recently been robbed and murdered in the area I'd been in, and a chiclero was suspected.

The chicleros were usually included in any discussion of the dangers of the jungle, along with poisonous snakes and plants, disease-carrying insects, jaguars, and packs of wild boar. They had a reputation of being bandits and murderers, beyond the reach of the law in their jungle camps. The chicleros had been convict laborers and renegade Cruzob Maya who killed intruders to their jungle outposts. However, the contemporary chicleros were reputed to be much less violent, and many came from Yucatecan villages.

It was four years before I spent a season with a chiclero. Getting to know one took time, but finally Pablo Canche Balam of Tulum said I could come with him. He planned to start collecting once the rains came and the sap of the zapote began to flow. When the rainy season was late in arriving, Pablo went off to his cornfield for several weeks. Soon afterwards I met Cornelio Castro Salazar and Pacio Diego Venerado Jimenez Chi, from the village of Chichimilá. They were in Tulum, also waiting for the rain. Unlike most chicleros, they had brought their wives and children with them.

I had a twelve-year-old boy with me, Andy Johnson, a neighbor from California. His parents thought half a year spent in Yucatán would be highly educational for their son. Margarita and Veva, Diego and Cornelio's wives, made sure that he didn't lack a mother's attention, and regularly invited us for meals. In turn, Andy and I, camping on the beach near the ruins of Tulum, shared the fish, conch, and lobster that we caught diving. With his bright blond hair and cheerful disposition, Andy captivated the chiclero families. It wasn't long before the women insisted we spend the season with them.

A hurricane passed in late August. The winds howled and the sea grew dark and stormy, but no rain came. Diego and Cornelio grew uneasy. They had been advanced an *enganche,* a sum against which they could buy supplies from their *patron* (boss) to outfit themselves, leave their village, and move into the jungle camps. Each day that it didn't rain they owed more money without being able to work to pay it off.

In 1971 Quintana Roo was still a territory and Cancún only an idea. A new road opening up the Caribbean coast was being built from

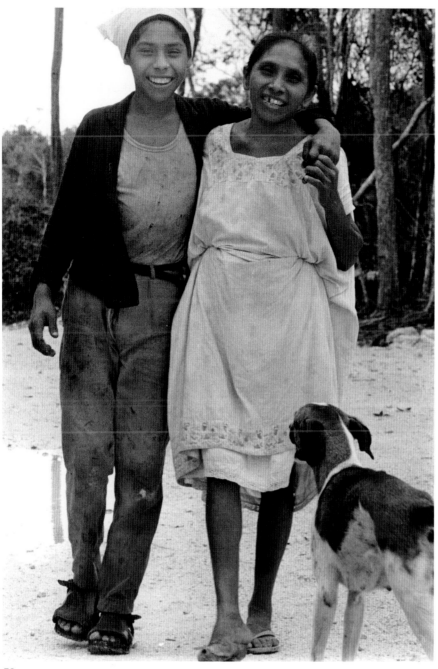

59

Puerto Juarez to Carrillo Puerto. Diego and Cornelio built their
campamento (camp) near the road twenty kilometers south of Tulum.
They set up camp in an abandoned quarry used in the road building—
one of the few open spaces in the jungle. Andy and I helped them get
the camp ready to bring their families out.

At night we ate beans and made our own tortillas. They were a
travesty of the perfectly round, thin tortillas we were used to. Cornelio
and Diego jokingly referred to them as "chiclero tortillas." Our
misshapen efforts caused Diego and Cornelio to talk about their wives.
They liked the idea that they would have someone to make regular
tortillas, do the cooking for them, and wash their clothes. But these
were things men say in front of other men. They were proud of their
wives for being strong enough to live in the primitive camp, and they
looked forward to coming back each day to a camp that was also home.

59 *Cornelio, Jr. (Nelo) and Veva. Campamento
Antonio Ay, 1971.*

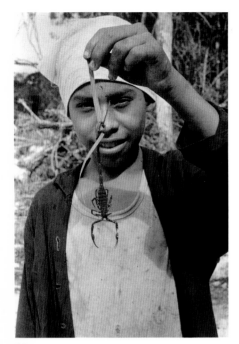

Cornelio and Diego built a main hut that was both kitchen and living quarters. Veva and Margarita started fixing it up as soon as they arrived. They resurfaced the exposed stone floor by hauling in buckets of *saskab* (crumbly limestone) and stamping on the sandy clay-like soil until it was hard and smooth. They told their husbands where to build shelves of poles lashed with jungle vines, and set up their corn grinder along a wall. Outside in the clearing, they built wash stands for laundry. The camp was temporary—it would be used for the season and then abandoned—but a lot of work went into making it comfortable.

The men prepared their equipment. They spent a day just sharpening their machetes, filing them sharp as razors. They put an edge from the tip to within six inches of the handle. This last six inches was left dull so they could grip the machete with both hands. They boiled their canvas chicle-collecting bags, removing the previous year's stickiness,

60

61

60 *Nelo holds a scorpion he caught. Campamento Antonio Ay, 1971.* **61** *Alicia. Campamento Antonio Ay, 1971.* **62** *Veva and Felipe. Campamento Antonio Ay, 1971.* **63** *Diego sharpens his machete razor-sharp while he waits for the rain and the season to begin. Campamento Antonio Ay, 1971.*

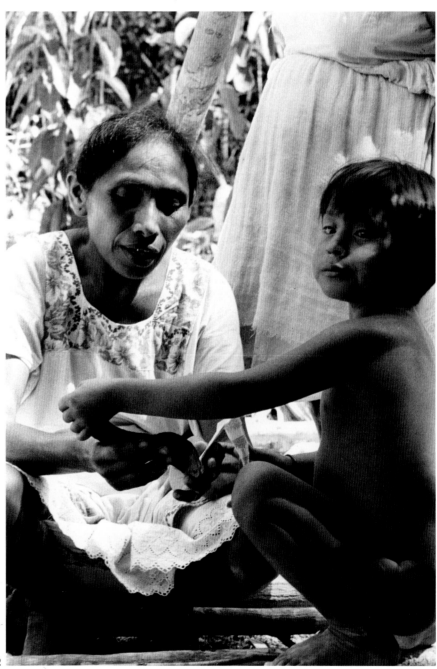

62

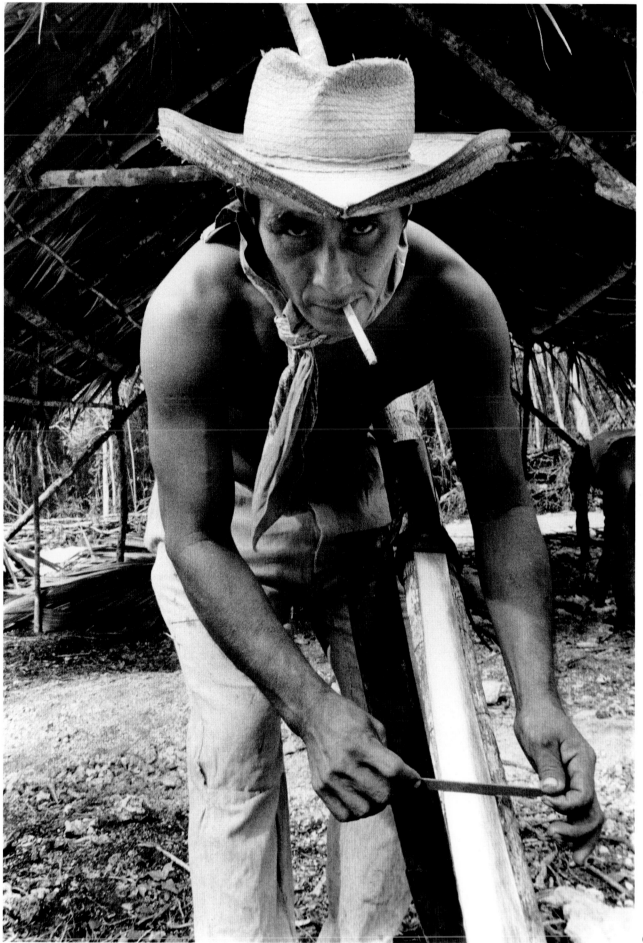

Chicleros 93

64

64 *Diego visits a nearby camp where the chicleros are putting the roof on their temporary hut. Near Campamento Antonio Ay, 1971.*

and checked their climbing ropes and spikes, looking for defects that could injure or kill them.

The children also had jobs. Nine-year-olds Maria and Alicia helped their mothers cook, collect firewood, and fetch water from the *cenote* three hundred feet away. Four-year-old Felipe was given small chores. Thirteen-year-old Nelo (Cornelio Jr.) was at the awkward age of not being an adult, but not quite a child any longer. He sometimes helped his sister Alicia but wanted to do a man's work. Elmer and Luis, the eldest sons and both in their early twenties, prepared their equipment. Elmer was in our camp nearly every day but was staying in Campamento Santa Cruz de Tulum, run by our friend Pablo Canche.

Almost every meal included black beans and tortillas. Two cooking fires were set up, one for making tortillas, which Veva and Margarita made until the men finished eating. The younger children ate separately near their mothers and the cooking fire. Veva and Margarita ate last. After washing the dishes, they would serve hot chocolate and coffee.

To add meat to this vegetarian fare, Elmer and Diego often carried guns when they went out. Elmer spent the most time hunting, even after a full day's work, and brought in wild pig and game birds which he shared with us. Diego's dog caught moles which Veva and Margarita took from him, and cooked. The moles were roasted over the fire

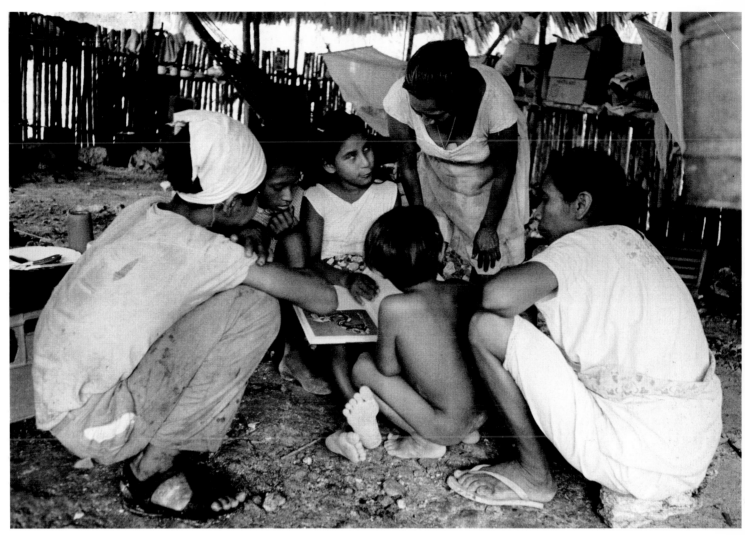

65

without being cleaned or gutted. Their singed little blackened naked
bodies would then be served for a meal. Because we were guests, these
treats would be served us first. I was very impressed that Andy, at an
age when most kids are finicky, would gamely eat a few bites with me,
and then insist that anything so wonderfully tasty had to be shared
among everyone.

The chicleros' generosity embarrassed me. I knew their supplies were
being charged against an account based on chicle which had yet to be
collected, but they insisted on feeding us. I knew of the Maya reputation
for generosity, including what Bishop de Landa had written four
hundred years earlier. "The Yucatecans are very generous, and
hospitable; since no one may enter their houses without being offered
food and drink of what they may have had during the day, or in the
evening. And if they have none, they seek it from a neighbor; and if they
come together on the roads, all join in sharing, even if little remains for
themselves."

I took the bus to Chetumal, the provincial capital of the territory of
Quintana Roo, to buy staples and fresh produce. I returned with 150
pounds of corn flour, black beans, oatmeal, sweetened condensed milk,
eggs, cocoa, coffee, and fresh fruits and vegetables. Andy and I presented
all the food to the camp. We felt the very amount of food made it

65 *Inside the main hut, grouped in the kitchen
area, Nelo, Alicia, Maria, Felipe, Margarita,
and Veva look at a book. Campamento
Antonio Ay, 1971.*

obvious it was for everyone, but every day we had to remind them.

Felipe might ask his mother if he could have scrambled eggs. Veva would tell him no, they didn't have any eggs, even though I'd just brought fifteen dozen. Andy or I would then ask if we could have scrambled eggs. When she said yes, if that was what we wanted, we'd ask her to make enough for everyone. Then we would have to pass out the fruit. We would offer everyone cocoa and coffee; but as soon as we'd start to make it, Margarita or Veva would take over. At our insistence, everyone would have some. Finally, I spoke with Diego.

"You told me that your house was my house. Do you mean it?"

"Of course," he answered.

"Well," I explained, "my food is your food. I mean it also."

Diego smiled and nodded. It had no effect at all.

We knew a storm was building when the blue sky disappeared overhead, turning gray, then black. The light dropped four f-stops in one minute. The raucous jungle noises ceased; an ominous quiet settled in its place. Cold gusts of wind started rustling leaves as the treetops shivered. A muffled noise became louder, sounding as if thousands of people were running in heavy boots. A few raindrops spattered around us, then it was a deluge. An inch of water quickly rose on the ground.

It rained day and night. It was a cold, chilling rain. Sheets of water ran off the low-slung thatched roof while strong gusts of wind blew them in through the open sides of the hut. Everyone was excited by the rain, however. It meant the sap would start running. Finally the men could start working just as soon as the rain stopped.

We made ways to enjoy being cooped up. At first we sat around the table, or in hammocks, telling stories. Then card playing became our obsession. We played all day long, and late into the night. With so little activity, it wasn't curious that Cornelio kept to his hammock. The evening of the third day of the rain, Elmer joined us for dinner and cards. A couple of candles provided light as we ate.

We were talking about food when Luis suddenly interrupted.

"Two years ago I went to Mérida," he said. "At night, in the plaza, I saw a man selling food from a cart. I was hungry, and it smelled good, so I asked him what he sold. 'Hot dogs!' he told me, and I couldn't believe it. Nobody eats dogs, I told him, but he said, yes, the Americans do."

"Did you try one? Elmer asked, interrupting his brother.

"No, of course not!" Luis said. "I told him he was crazy. But is it true?" he asked me.

"When you eat a burrito, do you think it is made from a burro? I said.

Luis laughed, but as everyone else joined in, he waved his hands, fighting off the laughter. "I didn't think they were really eating dogs," he protested. When he was sober, Luis was aware and sensitive to the fact that he was sometimes a buffoon when he drank.

Veva got up from the cooking fire and came over to the table with a stack of hot tortillas. She stopped to watch Elmer and Luis eat. When she didn't put the tortillas down, they looked up at her.

"Your father is ill," she said, motioning to Cornelio in his hammock.

"He'll get better, won't he?" asked Elmer.

"It's serious this time; he has to see a doctor."

The brothers continued eating. They kept their eyes lowered.

"He can't move his arm. He can't work. Your father will have to see a specialist in Mérida," she said louder, to get their attention.

"So why hasn't he already left?" Elmer asked. He tore a piece off his tortilla and used it to spoon up a mouthful of black beans. "If you are asking for money, why don't you say so?"

"We need your help," replied Veva. "Until he can start working again. We don't have any money."

"I can't help. It's his own fault!" Luis said, reaching for another tortilla.

Cornelio shifted in his hammock, but his sons ignored him.

"How many times have you heard me tell him, 'Stop working so hard, old man; you're not a kid anymore?'" Elmer asked. "I tell him, and tell him, and does he listen? No!"

"Elmer, he doesn't need your advice; he needs your help!"

"But I tried to help. You think I don't care? You think he'll listen to me now?"

"He needs to see the doctor. That's all he needs now!"

"How am I supposed to help?" Elmer yelled, throwing down his tortilla and standing up. He gestured wildly at his mother. "I haven't started work either, and already I've borrowed too much money. I can't just go and ask my patron for more and more."

"Yeah," Luis agreed. "You think I can go and say, 'Hey, Don Tomas, my old man is a fool, and he's gotten sick, so lend me another month's wages?' Hah!"

"But you'd do it for alcohol," protested Veva.

"Leave me alone; it's his own fault."

"Why isn't he borrowing the money?" Elmer asked.

"They say he is an old man. We need you to guarantee it." Her sons looked at her defiantly before starting to eat again. Veva started crying.

Her sons didn't say anything. The rain was thunderous in the awkward silence, and the wind tugged at the roof. Alicia and Felipe started crying, hugging each other tightly as they sat off to one side.

Veva reached for Nelo. "Is he going to be my only support?" she challenged her older sons. "A thirteen-year-old boy doing a man's job?"

Elmer and Luis tried to ignore her. "I didn't say I wouldn't help at all, but I can't right now," Elmer finally said.

Diego moved away from the table. He and Margarita got in their hammock. Andy and I went outside. Rainwater soaked the ground, filling the hollows, and rising to cover the floor of the hut we shared with Luis.

The next morning I offered Veva the money Cornelio needed, but she refused the offer. Later, however, she asked if I'd speak with Cornelio. Everyone else in the hut busied themselves when I walked up to his hammock. He smiled, and tried to rise, but fell back, groaning. He tried smiling again, then reached out his good hand and took mine.

"It is a sad day when a son, two sons! refuse to help their father," he said, "And yet you offer to help me."

"It"

"Don't," he said, squeezing my hand. He looked up at his wife, who

66

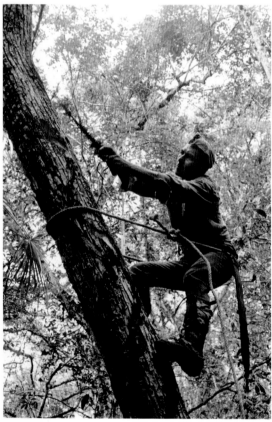

67

had joined us. "I will accept your offer only if you realize that this is to be a loan, and not a gift. And," he continued, "one other thing. My house in Chichimilá is always at your convenience. The key is yours. Please," he said, "never hesitate to stay there."

As we walked out to the road that afternoon to put Cornelio on the bus to Mérida, he and Veva were very formal, concealing with dignity their embarrassment of having to rely on a stranger instead of their own sons. They were sincerely grateful. From that day on, they referred to me as their compadre, and Veva introduced me as "the man who saved her husband's life."

It stopped raining after eight days.

The jungle in Quintana Roo is a tropical rain forest that contains mahogany, Spanish cedar, zapote, and other hardwoods. It smells of fecund growth and of rotting decay. Tree trunks and snaking vines make it hard to see more than twenty or thirty feet in any direction. The work the chicleros did was hard, time consuming, and repetitive. Each day I'd go out with Diego and Luis as they looked for zapotes to cut. Most of the trees bore old scars from previous seasons. Diego would typically begin by clearing away the vines and low saplings from around the base of a tree. Then, beginning at shoulder height, he'd work down, slashing V-shaped right angle gashes in the tree bark. Immediately the milky-white resin oozed thickly from between the bark and hardwood. At the base of the tree he'd hang his collecting bag by a peg, slipping the lip of the bag under a cut in the bark appropriately called a tongue.

Diego would strap his spikes over his shoes and wrap an end of rope around the tree. Tying himself inside the loop with a bowline, he'd begin climbing and cutting. He'd climb as high as he could go, telling me he felt a responsibility to realize the tree's full potential because it would be at least five years before it could be slashed again.

Diego tried to average eight trees a day, never knowing how much resin each might give. A thin one could yield a kilo, while a much larger zapote might give much less. He would collect his bags each afternoon, unless, when a tree was particularly good, he'd leave a bag all night.

Diego hoped for rain each night, with cool, cloudy days. A rainy day made it difficult to work, and washed away the chicle. Too much sun or wind, and the chicle dried on the tree.

Each day we went further from camp looking for new trees. The chicleros worked a new area each year as the trees needed at least five years between cutting. They also worked away from towns and villages where the slash and burn agricultural practices destroyed good stands of zapotes. Because of this, archeologists owe the discovery of many of the Maya ruins to chicleros, who found them while working deep in the jungle. The stands of zapotes growing at nearly all the ruin sites suggest that the ancient Maya planted the trees near their cities. They used zapote wood in their building construction, especially door lintels. The wood is so hard that many examples survive today.

When I first began to accompany Diego and Luis, I didn't know what I feared most—getting lost, or snakes. I had spent a lot of time living outdoors and had worked as a mule skinner and cowboy, but nothing prepared me for the jungle. I found it claustrophobic and hard to find my bearings. It took a long time to overcome this.

Snakes were something else. Diego's brother-in-law had spent six months confined to his hammock after being bitten by a fer-de-lance. He was alone and deep in the jungle, so he ate the root of the *viperor*, a low-growing vine all the jungle people know as a snakebite remedy. Its leaves are dark green with white lines on top and purple underneath. Chewing the root helped Victorio, possibly saving his life. The poison of most snake bites is injected into the flesh or muscle and is slowly absorbed into the bloodstream through the tissues. If the snake had injected directly into a large vein, Victorio wouldn't have gotten out of the jungle; he would have fallen down dead.

Victorio had a friend who was also bitten in the leg by a fer-de-lance. The friend pulled out his machete and hacked away the entire area of flesh—bite, meat, and calf—thus eliminating the poison in one quick stroke. His friend considered it as the only sure way of keeping himself from dying from the bite.

The only time I ran into a fer-de-lance, it was sluggish and lumpy in the middle, having just swallowed an animal. Besides snakes, the jungle was home for jaguar, ocelots, deer, peccary and wild boar, tapir, monkeys, armadillos, agoutis, wild turkeys, partridges, quail, curassows, doves, parrots, toucans, hawks, eagles, vultures, and many smaller animals. And most abundant of all was the insect life—mosquitoes, ants, termites, gnats, bloodsuckers, fleas, flies of different sizes and appetites, hornets, ticks, chiggers and other pests, butterflies, wasps and the Yucatecan stingless bee, and fireflies that twinkled at night.

Hilario had noticed the Maya, even the chicleros, were often ignorant about serpents.

"Being forest people," Hilario said, "the Maya are very sensitive to things in nature—what animals eat, where they sleep, when they breed, what their nests look like. But they have a problem with snakes. They're superstitious about them. They have no positive identification for snakes, unless you consider their saying that all snakes are poisonous is positive identification.

"Once I caught a boa constrictor, and they thought it was a snake that could sting you with its tail. They believe that snakes have retractable legs to chase you, or that snakes can chase you by grabbing their tails and rolling after you like hoops. Maybe the reason they have this trouble with snakes is that in the Bible they are portrayed as evil. However, the Maya used to venerate the snake. Just look at the ornamentation at the Nunnery at Uxmal.

"But, you know me." He laughed, glancing off into the jungle we were passing through. "I'm stimulated by snakes. If I see one, I like to catch it, or at least look at it. Just the other day I was on a trail and caught another boa. A *milpero* (corn farmer) came by and asked me why I didn't kill it. I told him, 'You know, boa constrictors are worth a lot more alive than dead. You can keep them where you store your corn and they will eat the rodents. The circuses will buy them, the tourist hotels will buy them, even tourists might buy them.' But I was talking to the wrong man. About three days before, he had been out measuring his *milpa* when his son was bitten by a fer-de-lance and died.

"So this fellow had no sympathy for my story," Hilario said. "He thought the only good snake was a dead snake, and you might say that that is a general Maya belief."

66 *Diego selects a zapote from the crowded jungle. Near Campamento Antonio Ay, 1971.*
67 *Diego works up a curving tree. Near Campamento Antonio Ay, 1971.*

(following pages)
68 *Diego cleans out a channel that he has slashed to allow the chicle to flow unimpeded into his collecting sack at the base of this zapote tree. Near Campamento Antonio Ay, 1971.* **69** *Diego rappels down a zapote tree he has worked all the way to the top. Near Campamento Antonio Ay, 1971.* **70** *Diego closes his eyes as he pulls his rope free after rappeling down. Near Campamento Antonio Ay, 1971.*

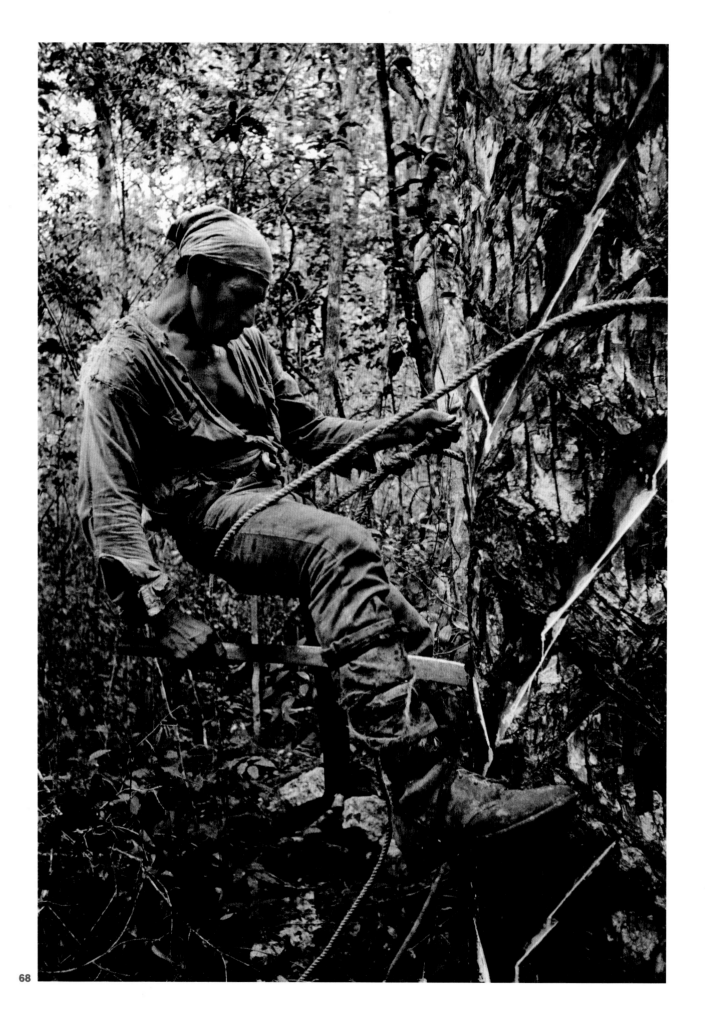

68

100 *Macduff Everton*

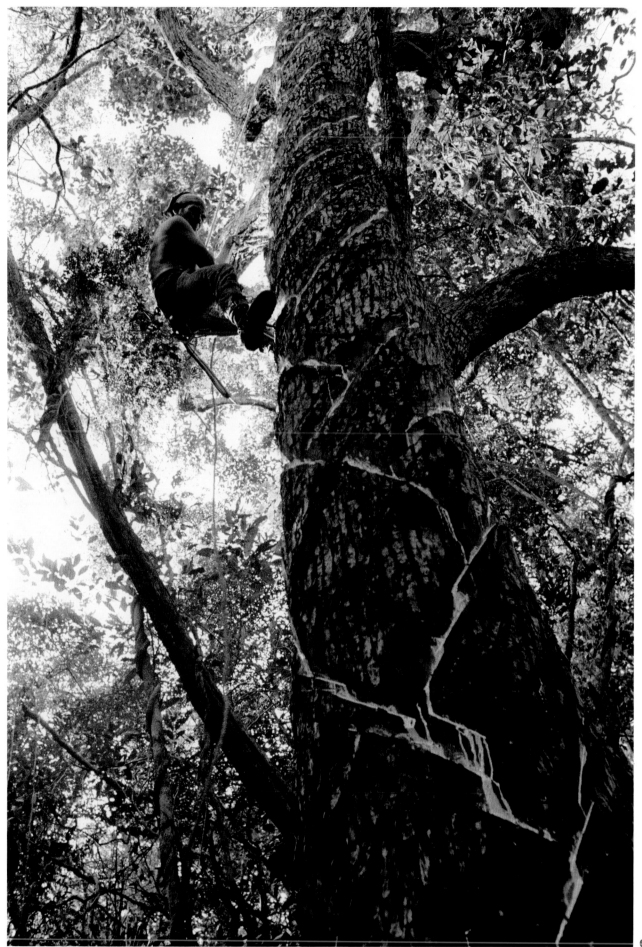

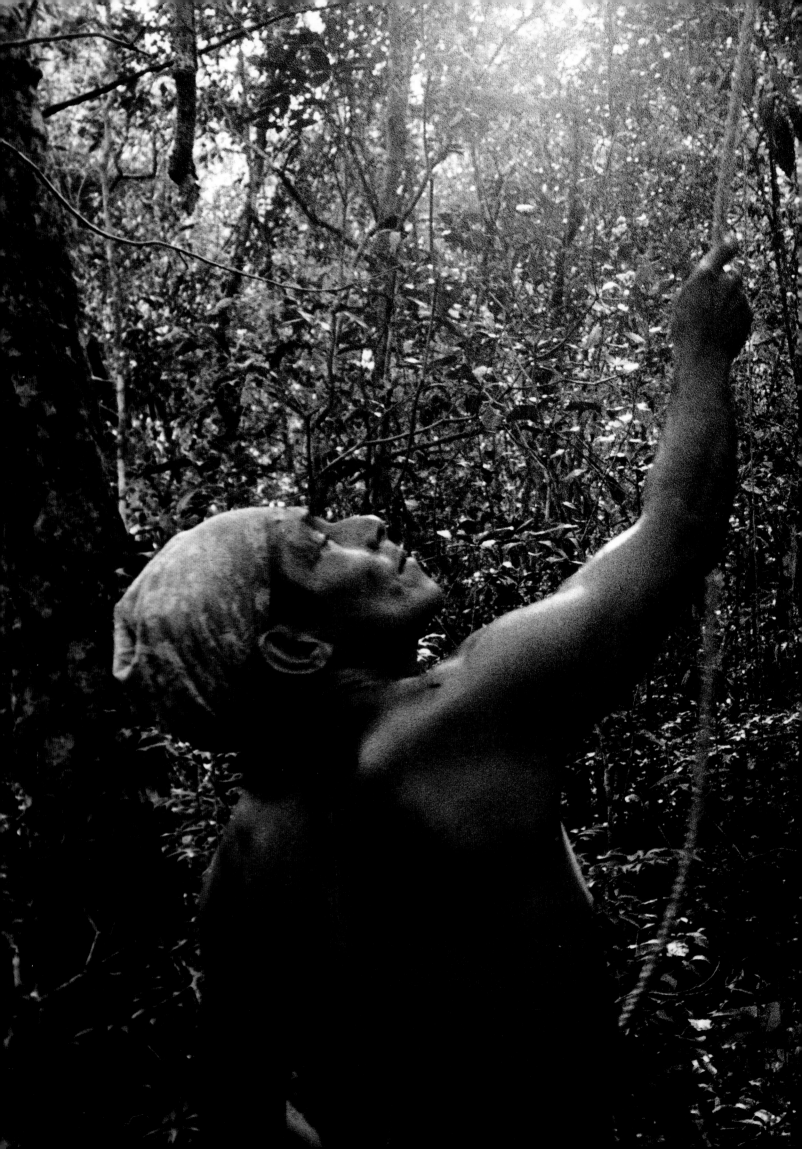

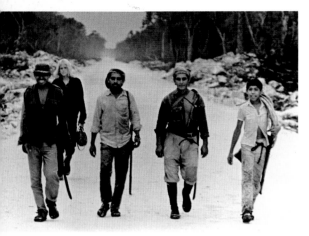

71

71 *Elmer, Andy, Luis, Diego, and Nelo come back from a day of work. Near Campamento Antonio Ay, 1971.*

When the rain caught us away from camp, we'd quickly cut guano palms and rig a temporary shelter just large enough to squeeze under. We'd crowd in—Diego, Luis, Nelo, Andy, and myself—taking pleasure that we shared this predicament together and we weren't alone. We would squat and smoke cigarettes. A humid chill settled under our skin until we felt as if we would never dry out.

One afternoon I asked Diego about the dangers involved in his work. He said he'd fallen twice—once when his machete glanced off the trunk and sliced through the rope holding him up. Another time the tree was wet and slippery and his rope slipped.

"Were you badly hurt?" I asked.

"I fell eight meters onto my back. Suddenly my feet were over my head and then I crashed down. Thank the Lord I didn't land on any rocks or stakes, but I hit very hard. My chest and ribs felt terrible and I thought I was going to vomit blood, but it was only water," he said. "If it had been blood—a person who vomits blood is going to die."

"Did you go to a doctor?"

"No," he answered incredulously, "I was too deep in the jungle. No, I'll tell you what I did," he said, starting to laugh. "I got up, and when I knew I wasn't going to die, I started looking for another zapote to climb. I found a good one about eighty meters from where I fell, and then, all of a sudden, I'm up in a tree and I realize, hey, wait a minute, I've just fallen from one." He laughed. "It was a good tree. It gave a lot of chicle."

"So you've never been seriously hurt?"

"No, never. God has looked after me."

"Did your father teach you?"

"My father was a *hierbatero* (herb doctor), but he died when I was nine. My mother needed money, so I started gathering chicle when I was twelve. There was a man from Chichimilá who was working in camp. When he was getting ready to sell his chicle to the *patron,* he told me to add mine to his, and he would pay me. I agreed because he was from my own village—he'd look after me. He told me at the end of the season he'd give me my money when we got back to our pueblo. When I went to his home, he said, 'Boy, I haven't been paid yet either. Come back tomorrow.'

"Each time I returned he told me he hadn't been paid yet. Finally, my mother didn't have any money for food. I told him I had to buy some corn. That's when he told me not to bother him anymore, he wasn't going to give me anything."

"'Lord help me,' I told him, 'when I'm grown and no longer a boy, I am going to return and pay you back for cheating me.'

"But when I grew up, my compassion also grew. I came back and this man seemed so old, I forgave him. I couldn't hit him. I didn't do anything." Diego looked hard for a moment, then laughed deep in his throat. "Those things happen."

• • •

"Bandits!" Veva and Margarita yelled as we came into camp for lunch. They came running out to meet us, followed by the children. "They waited until you left, and then came and stole the roof of the hut!" they said, pointing to the building Diego and Cornelio built for curing the resin. "The lazy cowards," Margarita added contemptuously, "stealing from women and children rather than going out and cutting them themselves."

"They've left?" Diego asked, looking around the clearing.

"Hours ago. They weren't going to wait for you!" Margarita said.

"They just took the leaves?" he asked tensely.

72

When Margarita answered yes, he seemed to relax, but I wanted to know what he was planning on doing. Diego had a reputation in Chichimilá as a dangerous man. Up till now, all the warnings I'd heard about chicleros had proved unnecessary, but now I was concerned for Andy's safety and mine. It turned out Diego was concerned for everyone's safety. While everyone else talked excitedly, he didn't speak except to ask when we were going to eat.

Diego told me, as we walked to the main hut, he didn't think the bandits would return. But we all kept our machetes nearby. After lunch, we went out to cut new guanos to rebuild what had been stolen. We returned to a spot in the jungle where Diego had found a grove of guano palms. The wide leaves, perfect for thatching roofs, grow on long, thin stems that branch from a narrow trunk. The guano palm is so important to the Maya that even when cutting it deep in the jungle, they always leave at least one or two leaves on each plant so it will keep growing.

73

When we had cut enough, we bundled them and used tumplines to carry the weight of the leaves with our foreheads. The leaves were surprisingly heavy and, spreading out wide behind us, cumbersome. Luis led the way back to camp. We didn't follow any trail, and with our heads bowed down, we tripped over vines and rocks. When our way was blocked by trees, we'd rush forward through gaps, hoping our momentum and weight would carry us through, but not so quickly that we'd fall on our faces. As we fell and tripped, we started laughing at each other, easing the tension of the afternoon. By the time we got near camp, we were in a good mood and making a lot of noise.

Veva came running out to meet us.

"Cornelio has returned!" she yelled happily, laughing and clapping her hands together.

We dropped our loads and ran into the hut. Cornelio lay in his hammock, raising his hand with a little twist of greeting.

We all talked at once, welcoming him back. He seemed to have aged twenty years, but we said that he looked a lot better. He laughed, calling us liars, then wanted to know how the chicle was running, how many kilos everyone had collected so far; he wanted to know everything about the season.

He was tired, but in good spirits. As he listened, he kept turning to watch Veva patting out tortillas for dinner. Whenever she looked up, they would smile at each other; then Cornelio would turn and smile at us.

"I'm a little tired right now," he said, "but I'll be up soon."

72 *Diego reroofs the hut after the bandits had stolen the roof. Campamento Antonio Ay, 1971.* 73 *Luis hands a guano palm up to Diego. Campamento Antonio Ay, 1971.*

74

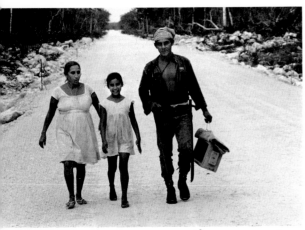

75

74 *Luis working a tree barefoot. Near Campamento Antonio Ay, 1971.*
75 *Margarita, Maria, and Diego returning from a nearby chicle camp where they borrowed the mold for making blocks of boiled chicle. Near Campamento Antonio Ay, 1971.* 76 *Diego stirring a cauldron of boiling chicle. Campamento Antonio Ay, 1971.*

A week later, Diego boiled his chicle. Elmer borrowed a *paila* (large kettle) from another camp that had been supplied many years before by a chewing gum manufacturer from the United States. Many chicleros' knowledge of English consisted of "Wrigleys" and "Chicago."

The morning was hot and bright, so nice that the men decided to work a half-day before cooking. Andy and I stayed in camp to cut and stack firewood. We were using an axe and machete on deadfall when Luis came back, his left hand dripping blood and wrapped in a bandana.

"What happened," I asked. "How badly are you hurt?"

"Not bad," Luis said, acting nonchalant, "but can you help me clean it up?"

"Of course, but what happened," we asked him.

"I was up in a tree," Luis explained, "clearing out a channel when I slipped and cut myself with my machete."

I looked. He had laid open his thumb down to the bone.

"You're going to need stitches," we told him.

"No," he objected. "Just clean it. I can't waste the time. I have too much work to do."

Veva was surprised to see Luis when we came into the hut and came running when she saw the blood. When she told him to see a doctor, he took his hand away from her and gave it to me.

"Wrap it up for me, please, Don Macduff."

"You need to see a doctor," Veva insisted.

"No," Luis laughed.

"You crazy fool!" Veva said. "Soon you'll be as sick as your father. The nerve of you to make fun of *his* stubbornness. What are all my men doing? You run around sick and injured until it's too late."

"OK," Luis said, "if it gets worse, I'll go see a doctor in Carrillo Puerto. I'll lose days of work and lots of money, but for you, Mama, I'll go see a doctor."

"Get out of here!" Veva demanded. "You're making fun of me, and you're nothing but a fool!" She whirled and went back to her cooking fire.

"Luis, it's going to be hard to stop this bleeding without stitches," I told him.

"It won't be a problem," he said. He told Andy to bring him some chicle and for me to crush a cigarette, then mix them together. We applied the mixture to the cut.

"This will work," he assured us.

Luis left the hut laughing when I finished wrapping his thumb. Veva got up from her fire to watch him walk across the clearing, the anger draining from her face. She started to laugh, then turned to me and reached up to put her arm on my shoulder.

"They may be fools," she said. "The good Lord knows that. But at least they are my strong fools."

When Diego and Nelo returned from the jungle, we had a fire going for them. We all helped put the heavy cauldron on it and scoured the inside with a small cooking of the chicle. We scrubbed the resin against the sides and around the bottom until Diego was satisfied that it was clean. He half-filled the *paila* with chicle and as it boiled down, added

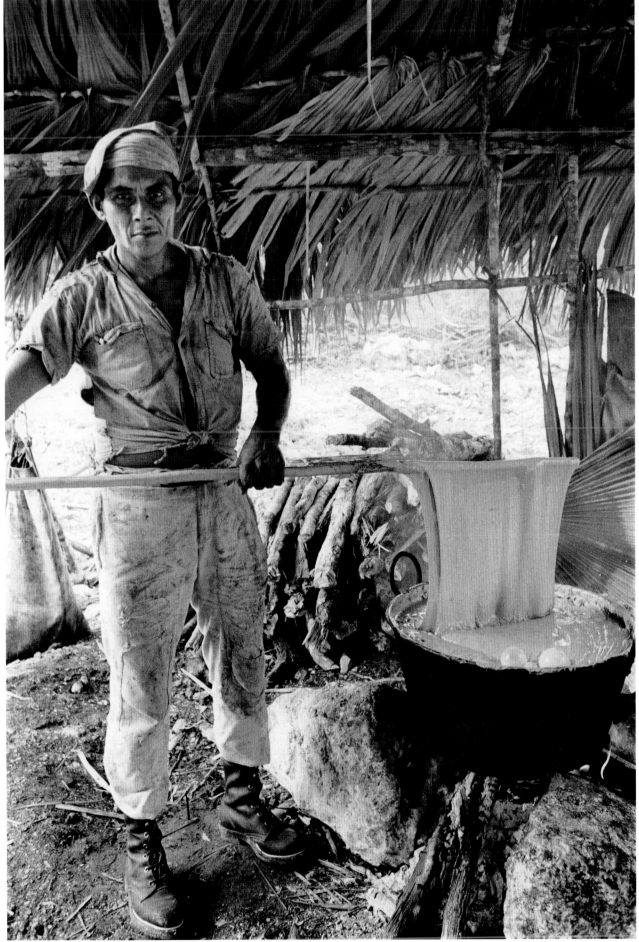

76

Chicleros 107

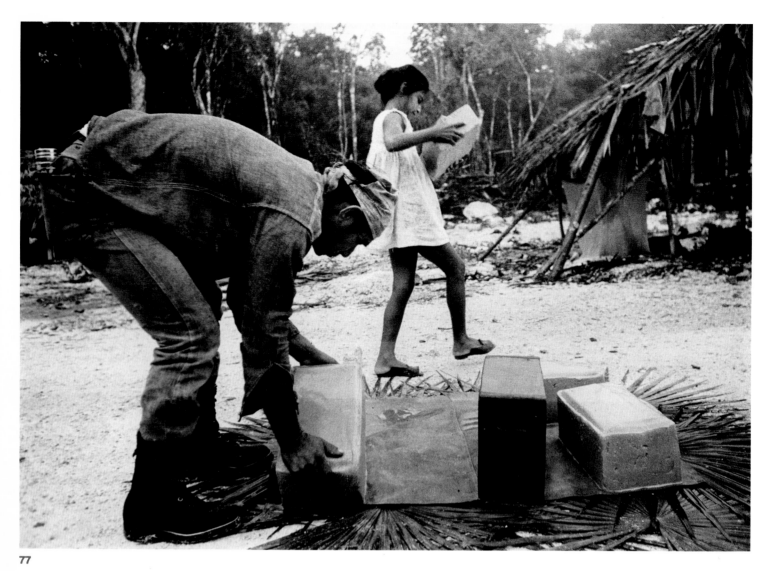

77

77 *Diego and Maria carry recently formed blocks of chicle. Campamento Antonio Ay, 1971.*

more. We hung hammocks in the cooking shack, and took turns stirring the pot and stoking the fire. Diego had spread word that he was cooking, so chicleros from other camps dropped by all afternoon to share in the stirring, turning it from work into a party and social get-together. The chicle had to be stirred continuously so it wouldn't stick. Veva and Margarita took their turns, and even Cornelio stirred—ignoring everyone's protests—to prove he was getting stronger. As we talked and laughed, hundreds of bright yellow butterflies circled around us, attracted by the sweet, yeasty aroma of the boiling chicle.

When no one mentioned the bandits, I figured Diego had dealt with this quietly. Instead, the chicleros talked about how difficult work was.

"Things are getting harder each year," Diego said. "We get paid the same, year after year, but what we buy costs more—our machetes, our food, our equipment."

"Huhhh," a number of chicleros said in agreement.

"Game is getting scarce," Elmer added, "and each year we have to go deeper into the jungle only to find someone has already worked the best trees."

Everyone again agreed. While one of the chicleros passed out cigarettes, Diego said, "I don't think I will *chiclear* much longer. It's hard to tell, but I'm thinking of becoming a *milpero*."

"In Chichimilá ?" I asked.

"No, I don't think so. The land there is so poor. Maybe up around the town of Tizimin. I've heard of friends who have moved there who had wonderful harvests."

Each chiclero added his opinion. Some thought they should join a chiclero cooperative to guarantee them better prices. Others agreed that going back to farming might be the best. We continued cooking for six hours, until the chicle didn't give off a trace of milky film when little bits were dropped into water. We carried the heavy cauldron off the fire and out of the hut. We continued stirring it so it would cool, lifting the chicle high into the air with the stirring stick. Gusts of wind caught the chicle and blew huge bubbles in it. They'd pop, exploding loudly, and splatter over the sides of the cauldron to the joy of both the children and adults gathered around.

Diego gave Andy and me each a piece of gum.

"This can last you a lifetime," he said. "It's pure and doesn't fall apart like the chiclets you buy. You can chew it, and give to your kids," he laughed, "or even your grandchildren!"

It took an hour to cool the chicle. We spread a large piece of canvas on the ground and soaped it until it was very wet and sudsy. On top of this the chicle was poured and worked into a wooden mold, forming 12 kilo blocks (*marquetas*) that were easily transported.

All the children tried to help—they were excitedly waiting to find the cans of sweetened condensed milk Diego had dropped into the cauldron. As soon as the blocks were formed and the area cleaned up, we opened the cans. The boiling had caramalized the milk into candy. We ate it, dipping in with our fingers. The butterflies still flew around us, their yellow wings turning to gold in the late afternoon sunlight.

Elmer invited me over to his camp the next night at 2:00 A.M. The trees were flowing so well he had decided to cook his chicle at night so he wouldn't miss any work during the day.

I didn't have a flashlight—my batteries were out. To find my way to Elmer's camp I used a Maya jungle trick of making a torch from a hardwood stick. With my machete I split one end of the stick in all directions, like the end of a match stick that someone has chewed. It burned quickly when I put it in the fire, and glowed as I walked. When I waved the stick back and forth, it would flame up and light the trail.

Elmer and I took turns stirring and keeping each other awake. While I was stirring, he added wood to the fire and began laughing. His laughter rose, then he cut it off with several sharp, piercing yells. He danced around in the firelight, grabbed his machete and started to cut up firewood.

"I feel great!" he shouted, throwing his head back. "You think this is hard work, climbing trees and collecting chicle? It is only play," he said grinning and waving his machete. "It's a game for me. I love being out here! Because here I am free. You know how important that is for me?"

He didn't wait for me to answer.

"Here there is no *patron* looking over my shoulder saying, 'Elmer, do this for me, Elmer, do that. Elmer, carry this! Here I'm only responsible to myself! But not in town! In town, if everything goes well, the *patron*

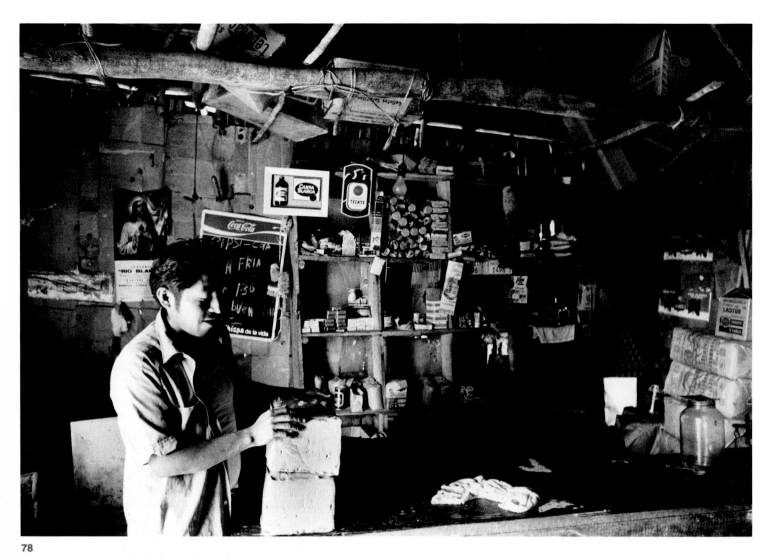

78

78 *Martin Canche checks the blocks of chicle from the first boiling. Tulum, 1971.*
79 *Maria, Alicia, and Margarita in Martin Canche's store. The sign above Alicia says "Don't be embarrassed to ask for credit even though there is no way I'm going to give it." Tulum, 1971.*

congratulates himself. If things go wrong, he blames you." Elmer snorted in derision. "That's why I like it here. I know the *patron* still screws me here, but I don't have to see and listen to him every day. He's not looking over my back. This job is more dangerous, but I feel free!" He laughed again, then slammed his machete down, cutting a piece of firewood with one stroke.

"It is hard to get a good job," he suddenly grumbled. "My father complains that I should have gone to school more. But, listen to me, Macduff. Since we were very small and first entered school, my father always pulled us out of school to accompany him to the chiclero camps each season."

"It's not the place of a son to talk back to his father, but how is it my fault I didn't go to school when it was my own father who prevented me? How is it my fault that I now return to the jungle to work? It is the only thing I was taught."

Elmer took a deep breath, then let out a low whistle. "Listen to me," he said softly. "I don't wish to speak against my father because I know he couldn't afford to support us unless we came with him, but I resent being told I am lazy, especially in front of company. Now he's going to try to provide an education for my sister Alicia because she's pretty smart. She'll get to venture into areas where I never had a chance to go." Elmer looked intently at me, then broke into a grin. "I start by

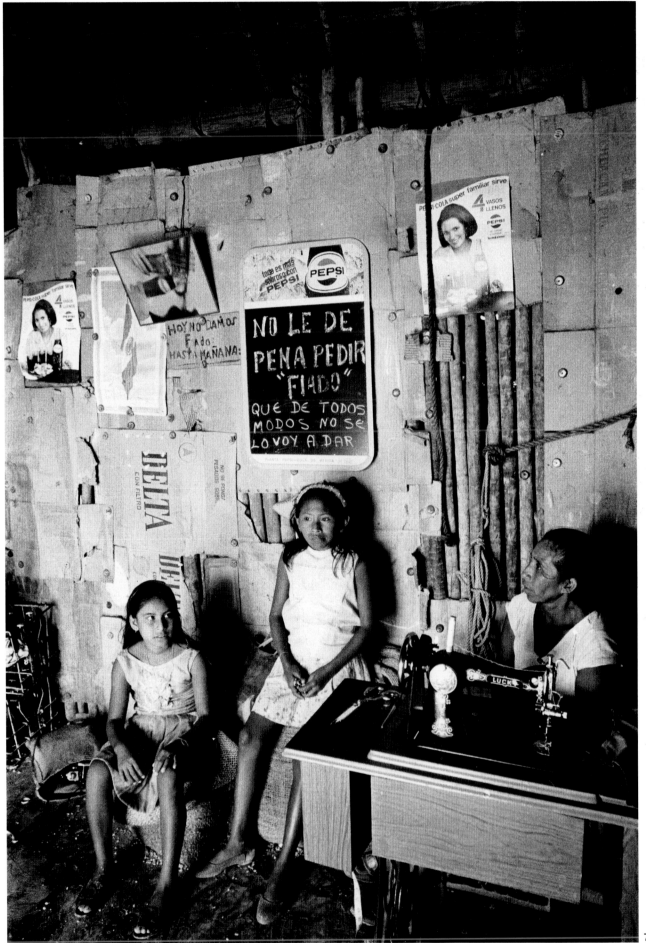

80

80 *Elmer gets help cleaning out the last of his cooked chicle after boiling during the night. Campamento Santa Cruz de Tulum, 1971.*
81 *Pablo takes cover under a sheet of plastic during a rainstorm as he boils his chicle. Campamento Santa Cruz de Tulum, 1971.*

telling you how happy I am here, but then I end up complaining." He laughed and shook his head, looking sheepish as he went back to chopping wood.

Elmer still felt embarrassed for not helping his father to medical care. Since that night, he'd been helpful and solicitous to his parents and his younger siblings. While his father was at the doctors', he'd made sure that there was food in camp, bringing in fresh meat regularly from his hunting.

We cooked the chicle until dawn. Pablo Canche began cooking his chicle as soon as Elmer emptied the *paila* to form his marquetas. It started raining as Elmer was getting ready to go out to work. Pablo wrapped a sheet of plastic over himself against the rain and continued stirring the cauldron. Elmer climbed into his hammock.

Diego's first cooking yielded forty-two kilos, worth $0.96 per kilo. Margarita delivered it by bus to the *patron*. Don Tomas Canche weighed it, then entered the sum against Diego's debt. He sold the chicle to a gum syndicate, which sold it to chewing gum manufacturers for approximately $5 a kilo.

Including the time Diego waited for the rain, he earned less than $41 for three months' work, which left him still in debt. However, the season improved, and by the end of it he sold over 500 kilos. Diego felt

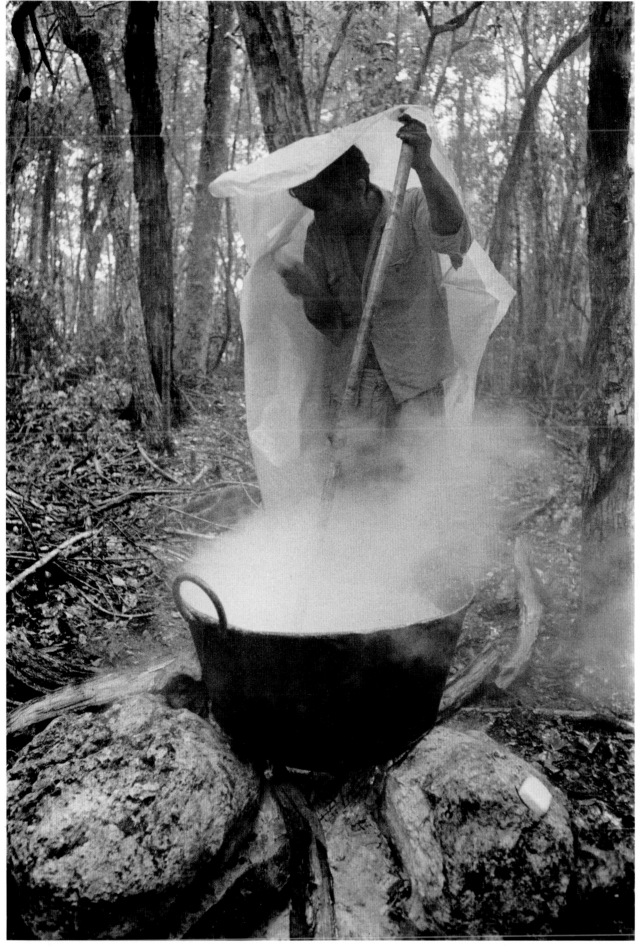

81

Chicleros 113

the season had been a success, but he wasn't sure how long he could keep working as a chiclero.

Cornelio regained his strength and worked as hard as everyone else. In December, Cornelio and Veva were very pleased to repay me the money they'd borrowed.

I continued seeing Veva and Cornelio after the chicle season ended, often staying at their house in Chichimilá. When I returned to Yucatán late in 1973, Cornelio and his sons left their jungle chiclero camp so we could celebrate Christmas together. They'd heard I'd brought down Andy Johnson and Bonnie Bishop, whom they had previously met in 1971. We agreed we should go somewhere special and selected to drive by our old *campamento* near Tulum on our way to the Caribbean.

Twelve of us piled into my pickup. We didn't pack much, but Cornelio had the foresight to bring along several liters of local rum. He and Veva rode up front with Bonnie and me. After passing Carrillo Puerto, Cornelio opened one of the bottles. We drank small toasts at first—to friendship and little remembrances. When Cornelio started toasting landmarks we remembered, and then the kilometer roadmarkers, he didn't need the pretext of a toast to drink seriously.

Traffic was light, and we made good time despite having to dodge the potholes and ruts in the dirt road. The day was warm and the jungle smelled strongly of rotting vegetation. We passed a tall dead tree where scores of buzzards perched like burnt leaves. Three of them had their wings fully extended and were turned toward the hot sun.

"Are they drying their wings?" I asked Cornelio. "Or are they trying to cool themselves?"

"Who knows, *compadre?* Let's drink to those who don't know!" he said happily.

"Old man! Stop speaking foolishly," Veva said sharply, then she laughed self-consciously. "He's getting crazy from the rum."

"Princess of my dreams . . . ," Cornelio sang, hugging his wife clumsily in the crowded cab.

"*Viejo,* what are you doing?" she said, pushing him away. "Don't be a fool and a drunk in front of our *compadres!*"

Cornelio laughed, and bobbed his head back and forth.

"Queen of my heart," he teased her. He tilted the bottle back and nearly finished the second liter of rum. He smacked his lips.

"My love," he said, "our *compadre* is our friend because he accepts the fool and drunk in me. He will let me sing and that, old woman, is what a friend is. We respect each other for what we are and what we might be, but we don't mistake the two!"

He kissed his wife on the cheek and passed her the bottle to finish before joyfully singing her a love song.

At Tulum we hung our hammocks among the coconut palms along the beach, the breeze keeping the mosquitoes away at night. During the day we fished, then each evening we roasted our catch over the fire as Veva supervised making tortillas.

We discovered a large sheltered cove so shallow we could walk out hundreds of feet and only be waist deep in the clear turquoise water. It was perfect for Alicia and Veva as they couldn't swim. They joined us to

splash and play, then they surprised me by lathering up with bars of soap over their *huipiles*. They sat waist deep in the water as if they were in a bathtub and washed underneath their dresses as soon as they were covered in suds. Their *huipiles* billowed out from their shiny brown bodies when they dunked themselves, and left a ring of soapsuds on the surface that the small waves slowly broke apart. They sat rubbing out all the soap in their dresses, dunked themselves one last time, then giggling, stood on the beach to dry off.

Veva welcomed me warmly when I arrived at their house after being away for several months. Inside the kitchen hut a bare light bulb hung from a line wrapped around a rafter.
"*Comadre,* you have electricity now!" I said.
"What?"
"You have electricity now!" I repeated, over the noise of a loud radio.
"Uh-hmm," she smiled, nodding her head.
"How was your trip?" she asked.
"What?" I said.
We talked on for fifteen minutes, yelling back and forth in the confines of the hut with the radio on full volume. Alicia and Felipe came in, but no one made an attempt to turn it down. I don't think it occurred to them. Electricity had come and it was great. It took months before the radios were turned down in the neighborhood.

When I arrived in Chichimilá by myself a few years later, I found their hut full of friends and relatives. Cornelio saw me first and held out a bottle to me.
"Bring a glass, Veva. We must drink a toast to our *compadre* who is honoring us with his return for our *Fiesta de Chichimilá!*" He smiled, waving the bottle, then took a sip.
"Old man, don't drink from the bottle!"
My mouth was as dry as your cooking fire," he said, dancing away from her, "But you are right, my beloved." He took the glass she offered him.
"*Compadre,*" Veva said as she came up to me, "make yourself comfortable. You are in your home and . . ."
"Pssst! *Compadre!*" Cornelio interrupted, waving a glass he'd filled for me.
"Please," continued Veva, "no matter how long you wish to stay . . ."
"My goodness, woman!" Cornelio laughed. "Can't you see our *compadre* is dying of thirst? Let us first welcome him with a drink, then we can welcome him with words."
"Drink up, *compadre,*" Cornelio said as he gave me a large portion of local cane alcohol. "Tonight we celebrate that the celebration begins tomorrow! The fiesta gives us a moment or two of diversion and to remind us that another year has passed. It is a time to renew our friendships!" he said, saluting everyone in the room.
That night twenty of us slept in the hut, with hammocks hung from every rafter and beam. The smaller children slept together, up to four in a hammock, while married couples slept in large matrimonial hammocks.

82

82 *Don Cornelio Castro Salazar in his youth.*

There was a chill to the February night air so I pulled my blanket tighter around me. I didn't expect any problem in sleeping after helping Cornelio finish several liters of *aguardiente,* not to mention the long bus ride.

I was no sooner asleep than I was awakened by someone switching on a transistor radio to a station that primarily had loud advertisements. I was surprised someone would do this with so many of us sharing the room. I heard a rustling noise and I hoped it meant someone would turn it off or at least change the station.

Someone did change the station, but not in a manner I would have considered. They turned on another radio. By this time I wasn't minding the second which was broadcast from Honduras and playing good *cumbia,* but I thought it would be nice to turn down the first radio. When a third radio was turned on, I started laughing. One radio advertised a movie coming to Valladolid, the second played a Colombian *cumbia* while the third featured Yolanda del Rio singing a very tearful *ranchera.* I wondered if people were so drunk they were oblivious to anyone else in the room—but how could they with all three radios blaring? I tried to look around but it was pitch black in the closed room. Then some one shook my hammock to get my attention.

"Yes," I said, not needing to whisper with all the noise. But no one answered. I leaned forward to feel along my hammock. No one was there but my hammock was still shaking. Then, despite the blaring radios, I realized no one was trying to attract my attention—just the opposite. Couples were making love and the radios were providing what little privacy was possible in such crowded conditions. Since all the hammock ropes were tied to the post and beams, the hut also danced to the accompaniment of the radios in the fiesta night.

In 1973 Diego became a colonist and farmer. The Mexican government was offering good land to settlers to open up the jungle along the Rio Hondo, the deep river forming the border between Belize and Mexico. When Hilario and I visited Diego in 1974, we took a Mexican naval boat up the river from Chetumal. Most of the settlements were so new they didn't have either potable water or medical facilities, and the navy tried providing both twice a week. At each stop the crewmen and colonists would shout greetings and talk as the sailors used fire hoses to fill the settlers' jugs, cans, bottles, boxes, and pails with fresh water pumped from the ship's storage tanks. During this commotion, the medical officer used a nearby house and received patients—a mother with a young child who had breathing problems, a case of mumps, a farmer with cracked ribs after being thrown by his horse, a pregnant girl in her eighth month. When a patient was too ill or injured for the dockside treatment, the navy would take him or her to the hospital in Chetumal.

Diego and Margarita seemed very happy in Calderon. They had a house near the river, and nearby were streams. Maria was excited because her father was teaching her how to swim. Diego immediately wanted to show us his cornfield and told us he'd had a good year. Most of their neighbors were from other parts of the republic and didn't know the way of the jungle. Some had even come from desert areas;

83

they were homesick and couldn't get used to the climate. They struggled, but, according to Diego, the land was so rich that if they could stick out a growing season, they usually wouldn't go home.

Andy Johnson and I visited Diego in August 1988. The new road to Calderon ran through sugar fields, then tropical jungle and small corn *milpas*. Calderon was a small clearing of houses around a large open grassy field. Everyone we asked knew where Diego lived. As we followed directions and drove down the final lane, we saw three homes.

"I hope it's not that one," I said to Andy, pointing to a cement block house that looked neglected. Just then Diego came out from behind it. He stopped when he saw us, then recognition flooded his face.

"I haven't been here for over a month!" he said excitedly. "How lucky you came now. I just returned last night." He stood back and looked at Andy. "You're not a child anymore. How many years has it been?"

A crowd of curious neighbors had gathered, coming out on hearing our car.

"What's going on, Diego?" one shouted.

"Nothing," Diego answered. "My brothers have arrived to visit me. We're going to eat lunch." He laughed and embraced us both again.

He led us to the open shed connected to the back of his house. Lying in a hammock was a disheveled man with a black eye who sat up.

83 *Maria and Margarita join other colonists getting buckets and containers of fresh water from a Mexican naval patrol boat on the Rio Hondo. Calderon, 1974.*

84

118 *Macduff Everton*

"Nicolas Cauich Hau," he said, introducing himself. He pushed back his matted, uncombed long hair and pointed to his eye. "It's an infection," he explained. "I don't know how I got it, but it started bothering me a couple of days ago."

"Don Nicolas was watching my animals when I was gone," Diego explained, making fat chiclero tortillas to eat with the black beans boiling on a small fire. He informed us that Margarita was visiting their daughter Maria, who was living on the northern Quintana Roo coast in Chiquila, where her husband was a fisherman. Diego had invested in a boat and motor with his son-in-law, but the fishing and weather had been poor, so he'd returned to check on his animals and his *milpa*.

"I didn't know you were a fisherman," I said.

"I wasn't, but I need to find a way to live," Diego said. "The *golpes de la vida* (the blows of life) have caught up with me. I'm going to be fifty-six this coming November first. I used to be very strong, but now I work a little and I get tired." He stopped making tortillas and stood in front of us, using his hands to punctuate what he said.

"When I was working as a chiclero, I fell from trees several times. Another time, here in Calderon, I was clearing my *milpa* and a tree fell on me. It knocked me down but luckily didn't crush me. Then I was in a bus accident which killed two people. I also got kicked by a cow. I flew twenty feet in the air," he said, jumping back as if kicked. "A horse kicked me too, right in the chest. It's amazing," he laughed, "that God has kept me alive, but now I am feeling all the effects."

Diego was laughing, but it was apparent that he was worried about his future. He only had an unfinished block house and a tired body to show for fifteen years of living in Calderon. He looked up when he heard a sound from inside the room.

"My grandson must be waking from his siesta," Diego said. "Let me go check." He stopped at the doorway. "You could take our photo," he added, his smile widening as the thought came to him. "I love him very much."

I took photos of Diego with his seven-year-old grandson in front of his large cassette player. The boy loved it and played tapes while we talked.

Our dinner plans never jelled after Andy brought out a liter of rum *anejo*. We ate sugar cookies and drank the rum. When we finished off the bottle, Nicolas went off and reappeared with a container of straight alcohol that was probably around 180 proof before he opened the cap. When we didn't join him in drinking it, he finished it himself and passed out in a hammock.

"I don't think his black eye is from an infection," Diego said. "He drinks too much. He probably fell down and doesn't remember it." He looked at his friend sprawled in his hammock. "He'd never purposely injure my animals, but I'm afraid he might pass out and forget to put the chickens in their coop at night, or forget to feed and water my horse. It worries me when I leave. He's not a bad man, but alcohol dominates him."

Around four in the morning, Nicolas woke up and stumbled around. He began muttering and grumbling. Finally he flung himself across the

85

84 *Diego holding his pet tigrillo. Calderon, 1974.* 85 *Diego, center, looks on as a buyer who has arrived on the naval patrol boat examines skins shot by one of his neighbors. Calderon, 1974.*

86 *Diego and his grandson ride out to the milpa. Calderon, 1988.*

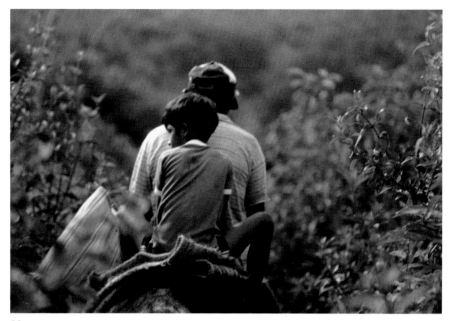

86

room, hitting my hammock and proclaiming he was going to kill Andy and me.

"*Nicolas, una cortesia, por favor,*" I interrupted him. "A courtesy, please."

"What is it?" he asked.

"Can you continue in the morning? I'm trying to sleep right now."

"Sure," he said, and went back to his hammock.

Diego laughed about it in the morning, but he said he worried about leaving his animals with Nicolas again. He wasn't sure what he'd do when he returned to go fishing.

Diego didn't want Andy and me to leave. He saddled his horse and wanted photographs of everyone riding it. He took us out to his small *milpa* and picked fresh corn, and when we returned, he ground the corn and made new corn tamales. As we ate them, a sudden, unexpectedly fierce tropical storm blew in. We went into his house and laid in our hammocks waiting for the rain to subside. As the room darkened, he brightened when he realized the storm might make the road impassable. A butterfly flew through the room.

"Was that a bird?" Diego asked.

We told him no.

"I just saw it out of the corner of my eye," Diego said." Sometimes a bird flies through a house, even wild doves. People say that they are the spirits of friends that have died."

"You're kidding?" I said. I remembered an evening in 1976 after recently returning from Yucatán. I was at my home in California, coming in from feeding my horses. A dove came gliding out of the twilight and landed near me, near my feet. I didn't move at first, thinking it must be hurt but probably frightened, so it surprised me when it walked toward me. I picked it up and carried it to the barn where I was living so I could look at it in the light. I couldn't see anything wrong with it. It's wings were fine, there weren't any cuts on its body, and its heartbeat wasn't too fast. It let me rub its head—

ruffling its neck feathers high like a parrot does. However, the next morning, the dove was dead.

Soon afterwards, I received a letter from Hilario.

"August 2, 1976. Very sad news. This morning at 6:30 in front of his house your *compadre* Don Cornelio Castro Salazar was hit by a *camion de cargo* truck and died a few hours later. His sons who are off working have been sent for. I have just returned from paying my respects—Oh! What sorrow. He's now gone as we know him—a great chiclero and man."

I keep thinking that if we are capable of a last gesture, my *compadre* would have done something like that. My only regret was putting out water for the dove. I should have found some rum.

87 *Diego inside his house. Calderon, 1988.*

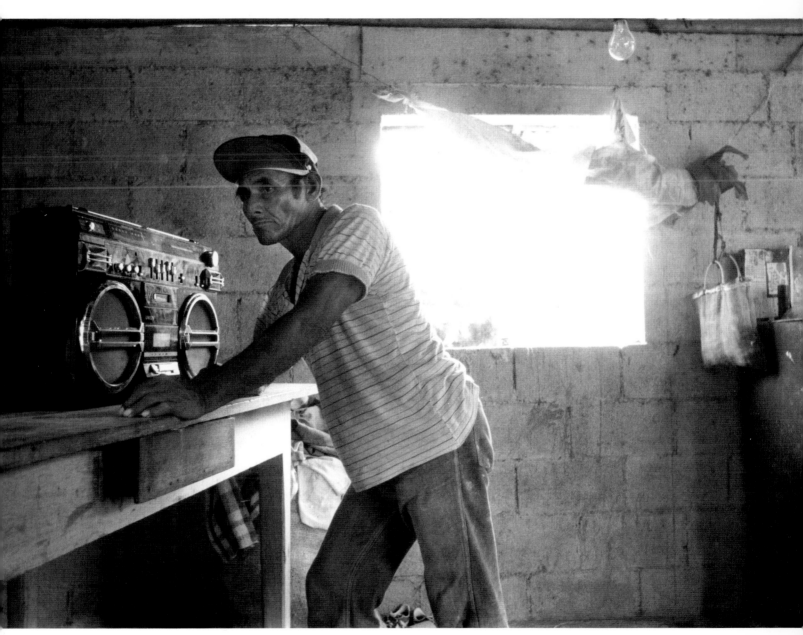

87

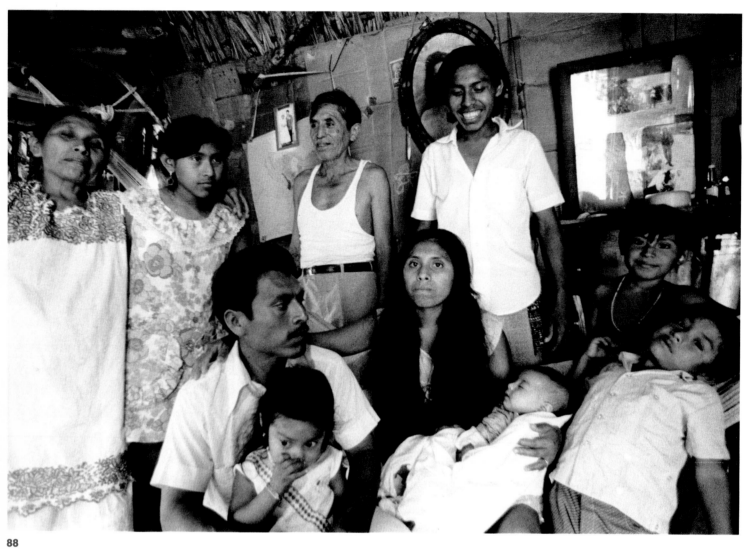

88

88 *The Castro family at home. From left to right: Veva, Alicia, Benito Uc holding Beatriz, Cornelio, Alba holding Cecilia, Cornelio, Jr., Felipe, and Willie (Benito and Alba's oldest son). Chichimilá, 1974.*

3

Doña Veva and Alicia

━━━━━━━━━━━━━━━━━━━━
🔲🔲🔲🔲🔲🔲🔲🔲🔲🔲🔲🔲🔲🔲🔲
━━━━━━━━━━━━━━━━━━━━

The Changing Role of a Maya Woman

I had been a *compadre* to Veva and Cornelio Castro since 1974 when I was the godfather at their granddaughter's baptism. Thereafter I was treated as an honored member of the family, which had its responsibilities. When their youngest daughter, Alicia, turned fifteen, I helped prepare the celebration which honored her coming of age.

Veva and I arrived in Valladolid before 7:00 A.M. on February 24, 1976, to shop. The six-block market area in the center of town was crowded with sellers from surrounding villages. They displayed their hammocks, fresh vegetables, fruit, spices, and herbs for cooking and healing on the high curb sidewalks. Shoppers jammed the streets while drivers in their cars, trucks, and buses tried pushing their way through the crowd by honking and shouting.

The main market was an old high-ceilinged building saturated with the odor of blood, meat, and produce. The butchers were in the center. Meat hung from hooks or was laid out on wide cement counters alongside swinging scales. Besides beef, pork, chicken, and turkey, smoked wild game was sometimes offered—deer, agouti, wild turkey, wild pig—the dark meat rich with the smell of the cooking fire. Around the meat counters were stalls selling fresh eggs, tomatoes, squash, habanero chiles, cilantro, chaya, chayote, jicama, onions, potatoes, beans, shucked corn, oranges, tangerines, pithayas, grapefruits, limes,

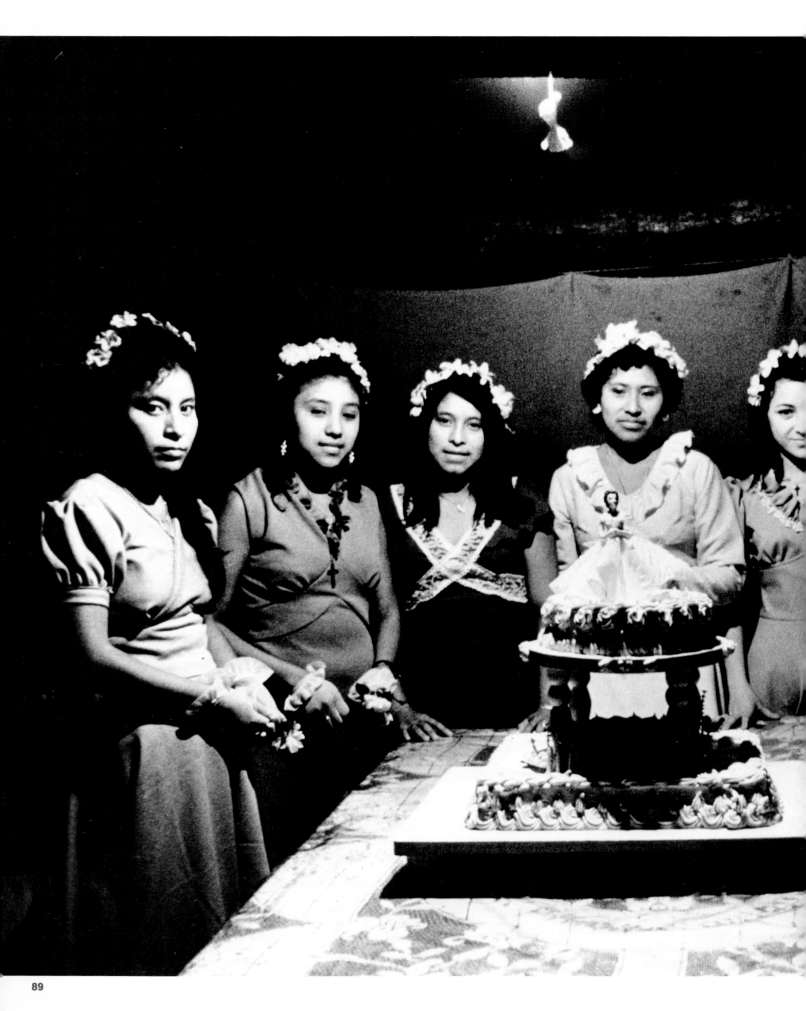

124 *Macduff Everton*

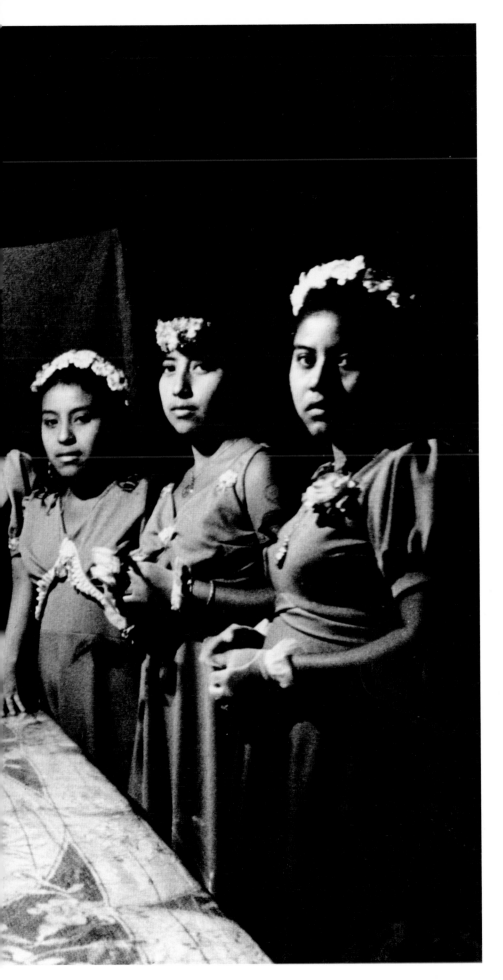

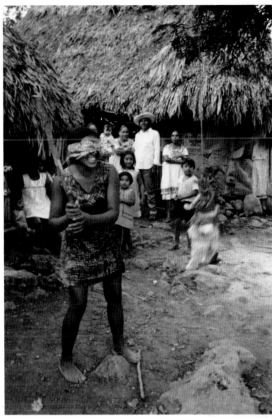

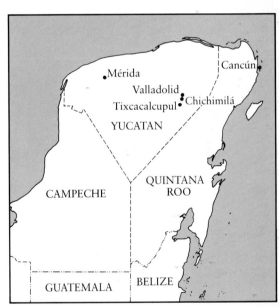

90

89 *Alicia flanked by her maids with her fifteenth birthday cake. Chichimilá, 1976.*
90 *Alicia, still with long hair but wearing a western dress, swings at a piñata during Christmas Day festivities. Chichimilá, 1975.*

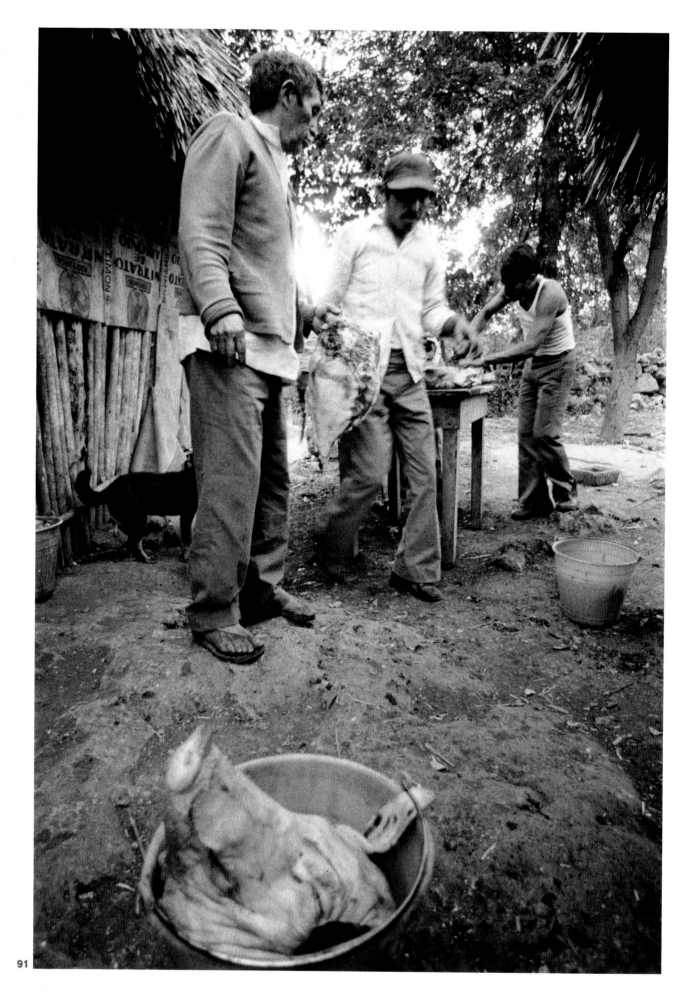

91

126 *Macduff Everton*

limas, pineapples, tamarinds, vanilla, allspice, zapotes, and coconuts.

Along one wall leather workers sold sandals, belts, machete scabbards, and other goods smelling of freshly tanned hides and oil. Along another side were booths selling ready-to-eat food—*panuchos*, *salbutes*, empanadas, *vaporcitos*, *tortas*, tamales, *cocteles*, tacos, fried eggs, black bean soup, sopa de lima, caldo de pollo, fried fish, meat, and chicken, and the daily specials. Other stands specialized in drinks, *licuados* made from fresh fruits with milk or water.

On the corner, with doors to the street, was the *tortillaria*. Hot tortillas came off a conveyor belt amidst the noise of the machinery and heat blasting from the oven. They weren't as good as fresh tortillas made over the fire in the village, but the townspeople bought them.

We walked along, making our purchases, filling bags with enough food to feed a party of forty or fifty guests. A fifteenth birthday is a big celebration in Yucatán and Mexico, the time when a girl is proclaimed a woman.

When we returned home, Alicia told her mother she was going into Valladolid to arrange having record requests played on the radio station and to pick up her gown. When I next saw her in front of the church in Chichimilá, preparing to celebrate the mass in her honor, I could hardly believe the transformation. A few hours earlier she'd been wearing her traditional embroidered huipile and her black hair was in a long braid. Now her hair was cut short and she had a permanent. She looked very stylish in her pink gown and matching gloves. She wore a white lace crown on her head and moved unsteadily on new high-heeled shoes.

From different directions her girlfriends arrived, all wearing full-length blue gowns which they'd made themselves. They stood around looking very serious and then someone would say something and they would break into giggling. There were seven maids all together and, like Alicia, they wore lace crowns and had on diaphanous white gloves. Seven boys showed up in dark pants and white shirts, her maids' escorts. Several had on large belt buckles patterned in fluorescent colors, the latest rage in village style. Veva wore her huipile with a shawl wrapped over her head and shoulders, and Cornelio was wearing a freshly pressed white *guayabera* shirt, with many pleats and pockets. Luis, Alicia's brother, came out to tell us it was time to start, so we entered the church.

Alicia had chosen her teacher to be her *padrino* for the church ceremony—you could have godparents for many occasions, including baptisms, birthdays, and pilgrimages. They stood together in front of the altar while the village Roman Catholic priest celebrated the service which dragged on too long. A lot of the boys and men went outside to have a smoke.

Afterwards, in the twilight, we walked down the street to the Castros', talking and laughing. Neighbors came out of their homes to greet Alicia and watch the procession. Inside the hut cases of soft drinks were stacked against the walls, and in the center was a table covered with a green floral print oilcloth bearing a large three-tiered cake crowned with a doll wearing a billowing white gown. The cake was deep in white and pink frosting—rich with swirls, scallops and curlicues—and fifteen birthday candles.

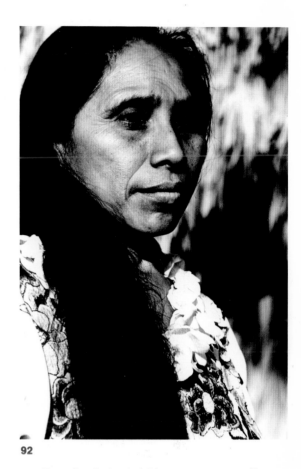

92

91 *Cornelio, Luis, and Elmer prepare to sell to their neighbors a pig that Veva raised. The money she earned was used for Alicia's fifteenth birthday party. Chichimilá, 1976.*
92 *Genoveva Castro. Chichimilá, 1976.*

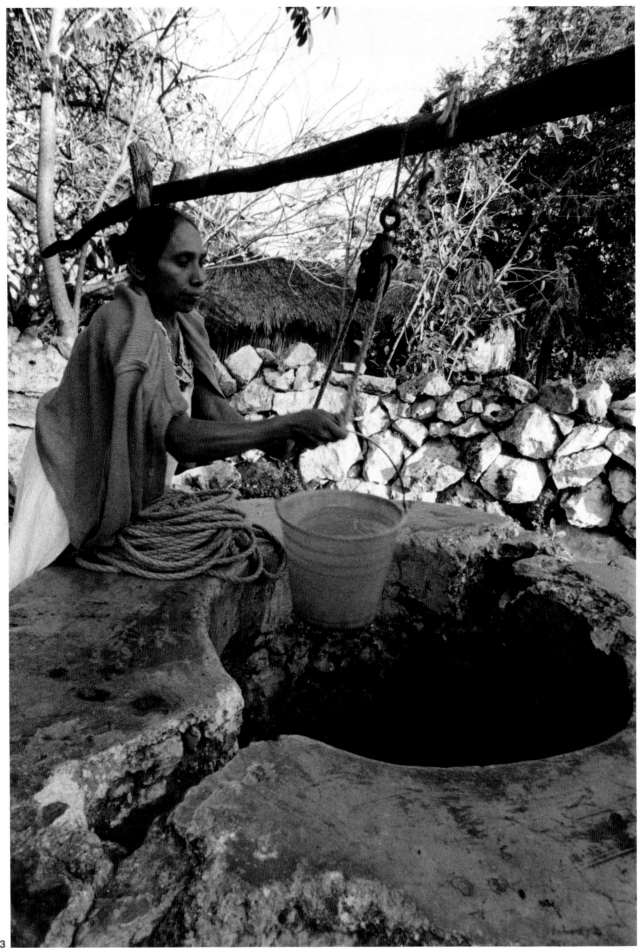

93

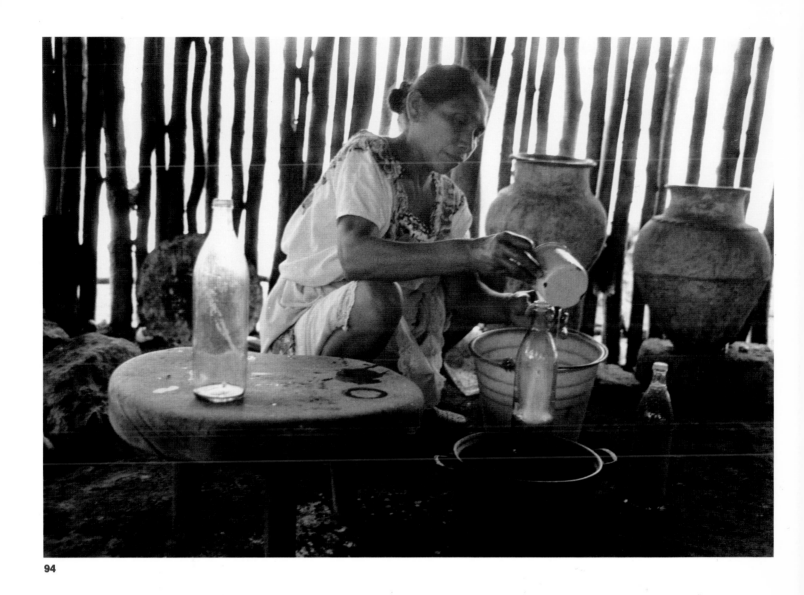

94

The party began. Everyone stood around the dirt-floored hut wearing their finest clothes, sipping soft drinks, and being very serious. Alicia asked me to take photographs and then she posed with her parents and her brother, with her *padrino* and his pregnant wife, with her maids, with their male escorts, with her friends and neighbors, and finally alone with just her cake.

Cornelio mixed rum drinks for the adults, Veva prepared food, and Luis hooked up a portable record player. People sat in borrowed chairs along the walls, and the birthday cake table was moved to the side to make more room for dancing. Some of the maids slipped out and changed into huipiles and shorter dresses when food was served and dancing began. Later, the light was turned off when the candles were lit on the birthday cake. Alicia blew them out with one breath.

The party continued on, with more eating, drinking, and dancing. I wasn't the last to go when I left at 4:00 A.M.

Genoveva Martin Kumul married Cornelio when she was nineteen. She spent much of her married life following Cornelio from one chicle camp to another every rainy season. Their sons became chicleros. Their eldest daughter, Alba, married a chiclero when she was only thirteen. But

93 *Veva draws water from a communal well in front of her house. Chichimilá, 1976.*
94 *Veva bottles a fruit syrup she's boiled for flavoring the snow cones she sells at her plaza stand. Chichimilá, 1976.*

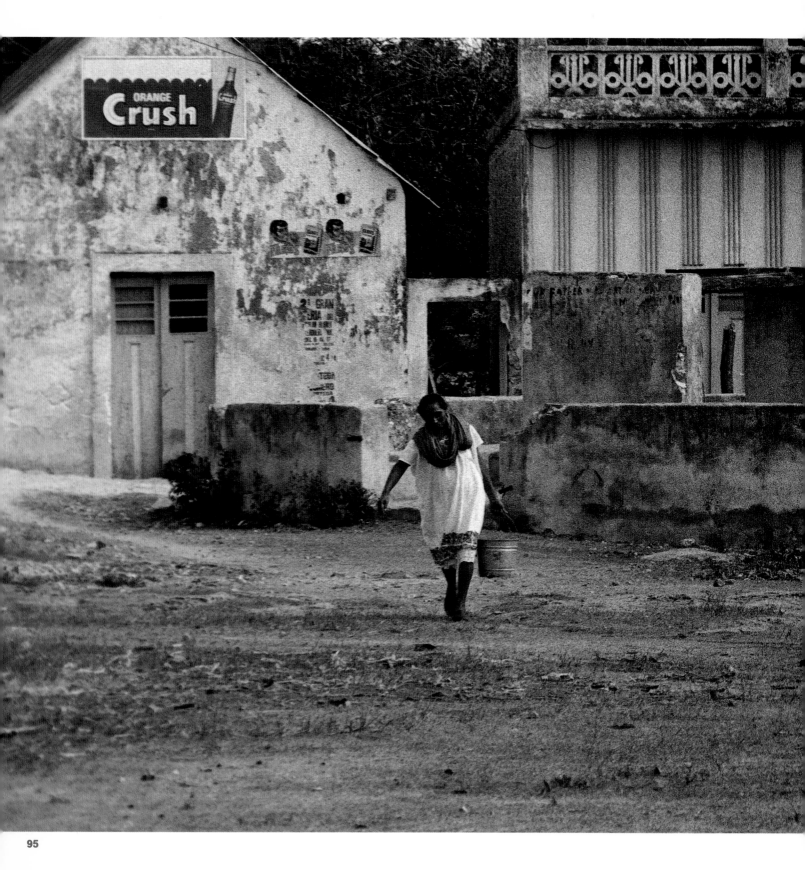

Cornelio wanted something more for Alicia. Alicia was intelligent, and he wanted her to become a schoolteacher.

Beginning in 1972, Alicia no longer accompanied her father into the jungle when he went off to work as a chiclero. She and her younger brother Felipe remained in Chichimilá with their mother so they could have an uninterrupted education. Veva operated a stand in the plaza,

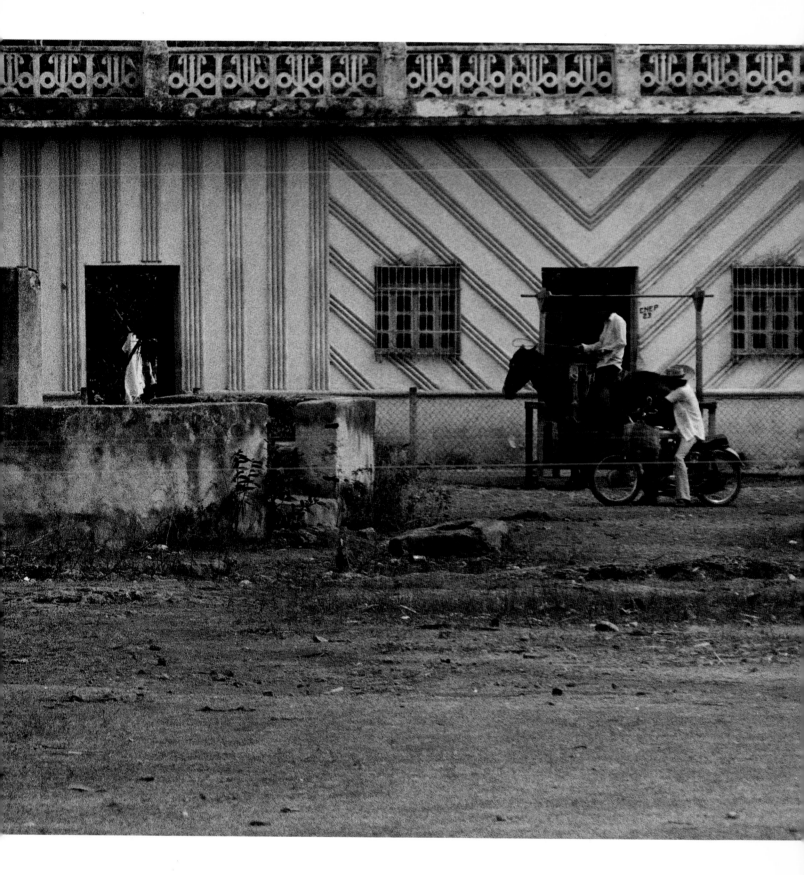

selling *refrescos* (soda pop), *licuados* (crushed fruit drinks), or *granisados* (shaved ices or snow cones). The stand provided the daily income she needed during the times Cornelio was away in his jungle camp.

Alicia did well in school. Veva worked very hard. I stayed with the Castros for several weeks after Alicia's fifteenth birthday and

95 *Veva carries a bucket of water from the large plaza cenote well back to her stand. Chichimilá, 1976.*

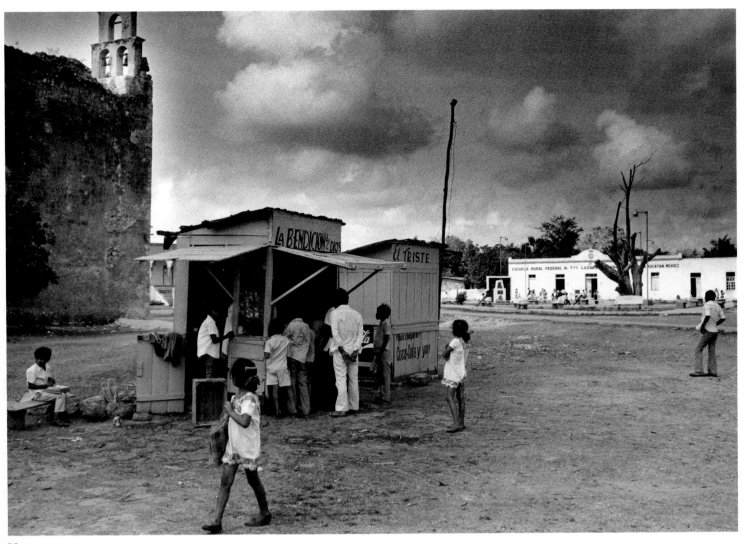

96

96 *Veva's soft drink stand is called "God's Blessing" (La Benedicion de Dios). Chichimilá, 1976.*

participated in the daily rounds. Veva typically rose at 5:00 A.M. and while the sun climbed and cast its shadows into the interior of her kitchen, she washed dishes, collected eggs from her chickens, and prepared a breakfast of black beans, scrambled eggs, and fresh tortillas for her family. By 8:00 A.M. Felipe and Alicia were at school, and Luis, Elmer, and Nelo, home from the jungle and the chicle season, had left for work in Valladolid.

Veva washed the breakfast dishes, then fetched water from the neighborhood well, filling the clay *ollas* (pots) in her kitchen. Cornelio helped her cook up the fruit syrups used for flavoring drinks and snow cones. He poured the syrups into bottles, corking them with corn cobs.

Veva combed her hair before picking up her pail of corn kernels that she had boiled and left soaking overnight, then joined Cornelio, walking into town together. The highway between Valladolid and Carrillo Puerto led through the large irregular-shaped plaza at the center of Chichimilá . The church, grade school, stores, corn mill, and stone houses were arranged around it. In the plaza were two *refresco* stands, one of which belonged to Veva

They wiped the counter, secured ice from a store on the plaza, drew water from the plaza well; then Veva left Cornelio to open while she went over to the corn mill. Inside, it was noisy and hot from the gas-

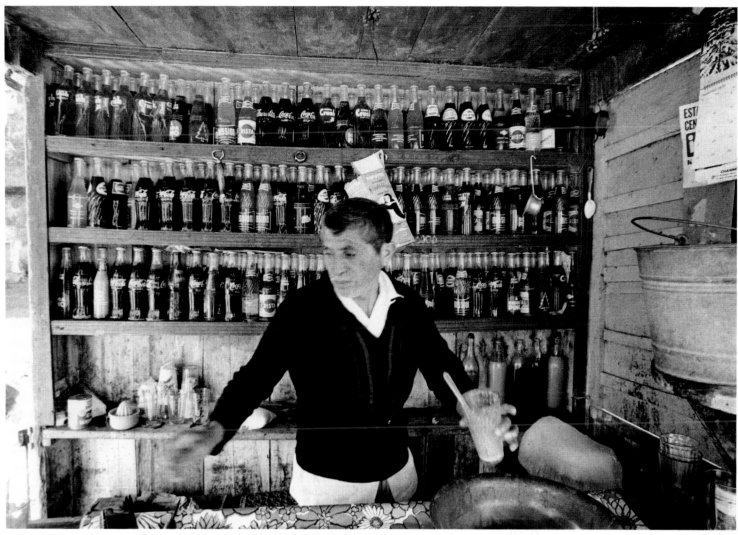

97

driven machinery. Veva got in line with the other village women and
listened to find out what had occurred in the last twenty-four hours,
especially if there had been any deaths, births, or fights.

Afterwards, she left the plaza, taking the corn just ground back to her
kitchen. She gathered the dirty clothes to wash them. I found it amazing
that women who work so hard and live with dirt floors not only wear
white dresses but somehow seem to keep them gleamingly clean—even if
they sometimes wear them turned inside out towards the end of the day.
Veva needed to wash her dresses often. She took her laundry outside to
her *batea,* a single piece of wood six and a half feet long, hollowed out
to provide a washing tub. It was secured at an angle so water collected
at one end.

Veva needed to draw more water from the well. A neighbor came by
and they talked as she scrubbed. Veva sometimes stopped, drying her
hands on her dress and wiping the sweat from her forehead and
brushing back a few strands of hair that kept falling across her face. It
took three hours for washing and rinsing the clothes. She hung them on
a three-stranded line of sisal. She'd twist open the strands, insert a
corner of wash in it, let go, and the tension held the clothes pinched
tight.

She prepared a lunch for herself and Cornelio, then walked back to

97 *Cornelio, back from the chicle camp, helps
Veva operate her stand. Chichimilá, 1975.*

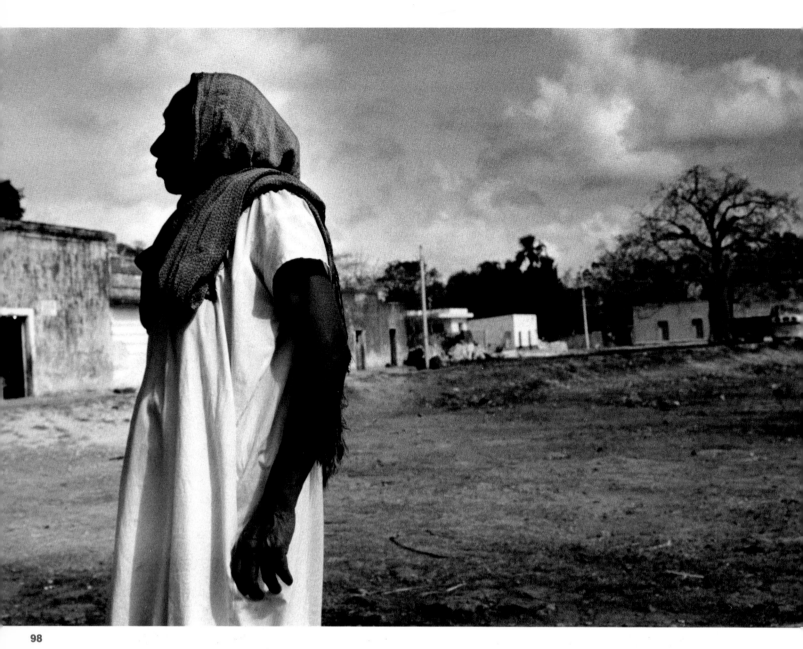

98

98 *Veva in Chichimilá's plaza, with a ceiba (yaxche) tree in background. Chichimilá, 1976.* 99 *Alba and Veva make tortillas, without Beatriz's help. Chichimilá, 1976.* 100 *Veva and Alicia share a bowl of beans, using tortillas for their spoons. Chichimilá, 1976.*

the plaza. She helped in the stand, wiping dust from bottles and washing glasses in a bucket underneath the counter while Cornelio sold drinks. Customers chose flavors from the bottles of syrup along the wall—strawberry, barley, pineapple, sweetened condensed milk, coconut, lime, rice, and tamarind. The dry season provided a constant flow of customers. For several days the temperature had reached over 100 degrees Fahrenheit. Everyone was thirsty and tired from the oppressive heat and often kept in the shade of the stand, exchanging gossip as they sipped on their drinks.

When school let out at three, Alicia and Felipe came over and helped with the flurry of business generated by their classmates, then returned home with Veva.

Felipe went off with his machete to collect firewood while Alicia helped her mother. Veva swept the dirt floors of the sleeping hut and kitchen with a corn shuck broom. Alicia drew water from the well for dinner and the evening baths, then helped Veva fold and put away the wash.

99

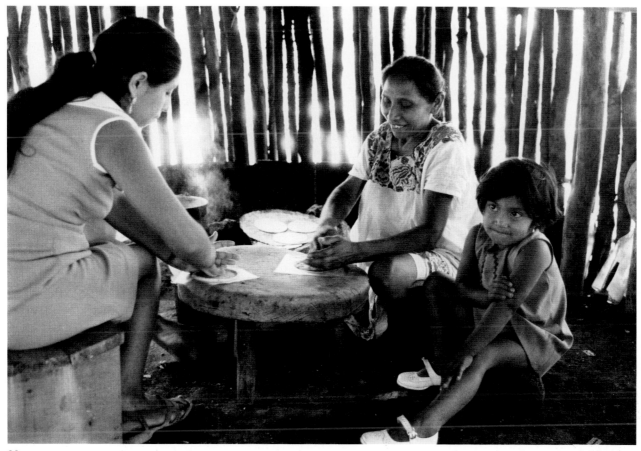

100

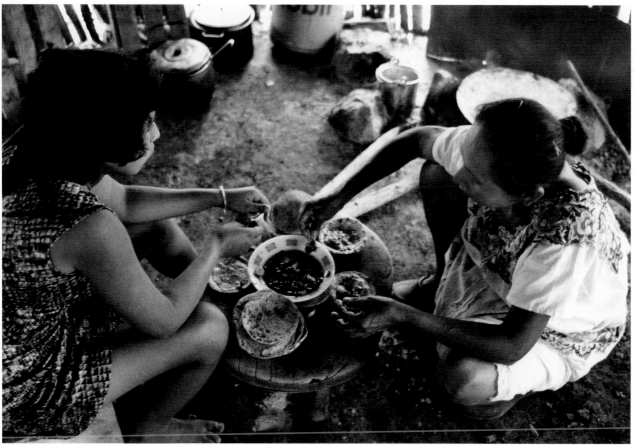

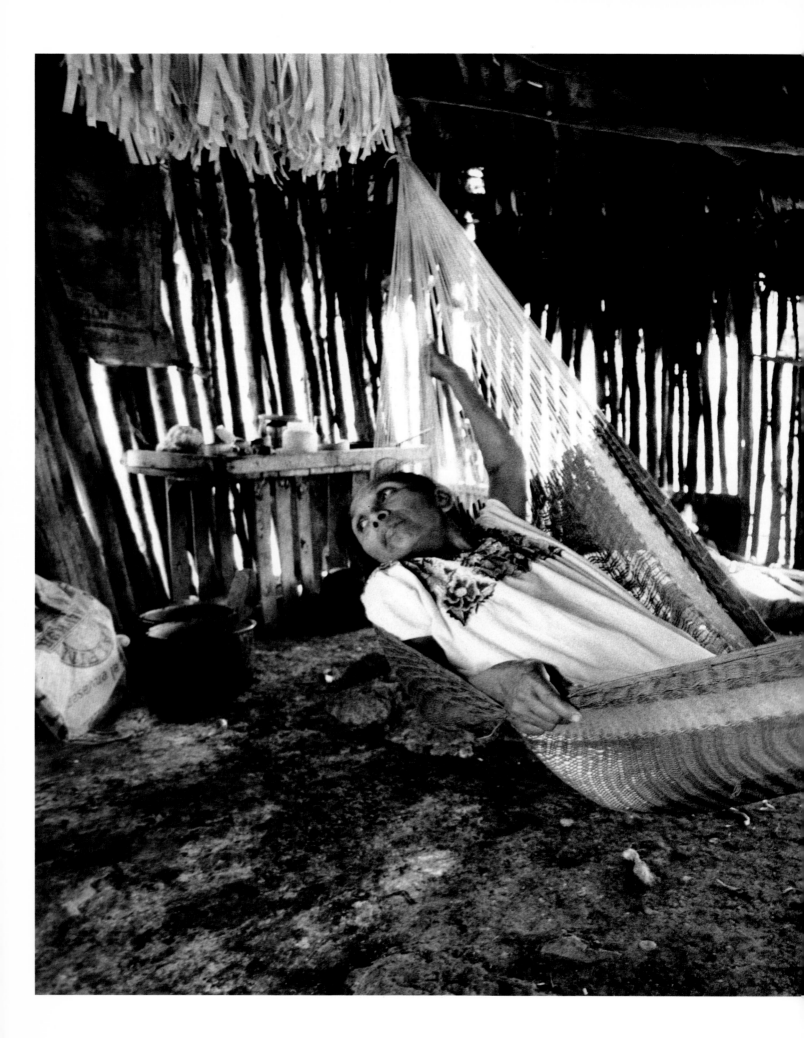

136 *Macduff Everton*

101

When those jobs were done, Veva stoked her cooking fire and started heating the beans and making tortillas for dinner. She sat at her small table, quickly patting out balls of masa, turning each one till it was round and thin. Then half-turning, she placed it on the comal, the metal griddle over the fire. She looked through the slits of the kitchen's pole wall, keeping an eye on the movement out on the street where taxis and buses picked up and let off her neighbors. Late afternoon sunlight passed through the walls in long, thin yellow ribbons, brightly striping the interior.

Alicia helped her mother at the fire. They put the hot tortillas into a gourd wrapped in cloth, which kept the tortillas warm for hours. Mother and daughter ate together before the men returned. Veva listened as Alicia told her about her school work. Afterwards Veva brushed out her long black hair and Alicia began her homework. When Felipe returned with firewood, he ate and started his homework. Veva went back to her cooking fire and boiled a pail of corn, then set it aside to soak overnight. Next she heated water for their baths, which they took in turns at one end of the sleeping hut, sitting on a stool behind a blanket stretched across for privacy.

Cornelio came home first. He waited for his sons before eating the dinner which Veva served them. She heated their bath water before getting into her hammock by 9 P.M.

Sometimes the men stayed out drinking. One night it was so quiet it wasn't hard to hear Luis coming home. A hundred yards down the road he swore loudly to let us know how drunk he was. Veva, Alicia, and Felipe continued talking with me as if they had heard nothing. When Luis began breaking beer bottles on the pavement in front of the house, however, they made derogatory remarks.

"What a fool my son is," my *comadre* tried to joke. When she saw I was staring out through the pole walls, she put her hand on my arm.

"Don't go outside," she told me. "He'll either go back to drink more or he'll soon fall asleep."

We tried to ignore him but had to laugh when he yelled insults at an obnoxious neighbor; the rest of the neighborhood remained quiet and dark as if everyone were asleep. Luis broke another bottle and swore at the darkness, then stumbled into the hut. He looked at us wild-eyed and awkward, stopped short by the bright light bulb hanging from a rafter. He squinted and leaned against the opening.

"Give me some water!" he said to Alicia, pointing toward the clay *olla*.

"No!" Alicia said. "There isn't any left. We used it washing dishes." She laughed.

Luis swore at us and grabbed the well bucket and rope. He moved with exaggerated drunken motions, stalking clumsily outside and loudly cursing his bad luck. We heard him fighting and cursing to put the rope through the pulley, then a descending scream.

"*Madre de Dios!*" Veva cried.

For a long moment we heard nothing more. We rushed out the door. As we ran, we heard him sputtering and spitting oaths, the sixty-foot fall down the narrow shaft not affecting his swearing at all.

From the neighboring houses men raced out, dressed in the clothes they slept in, quickly followed by their wives and older children. They lowered a rope and bucket and shouted instructions.

"Go away!" Luis shouted back at them. "I want to drown!"

The children giggled. What a great night, they told each other, the whites of their eyes shining in wide-eyed amusement. The women stood off to the side, bunched together and talking, pulling their shawls tight around their shoulders.

"Grab the rope," someone yelled down, "before you get too cold."

"I'm not cold, you sombitches. I want a drink!" Luis yelled back, but he grabbed the rope. When the men started pulling up though, he let go. They lowered the rope again and he grabbed hold.

"We have a bottle up here!" they shouted, "Come on up!"

"Luis," his mother beseeched, "stop being foolish and come up."

"Go to bed, old woman!" he cursed at her.

The neighbors giggled. I heard in their laughter a concern that Luis was tiring, but from their comments I realized they were more concerned about his contaminating their drinking water if he drowned than that he might die. My *comadre* stood near the well, her elbows tight at her sides, her hands up near her face, shivering. Alicia and Felipe stood near her, looking worried and not knowing how to console her.

Ten men crowded together, pulling on the rope. Luis arose sitting astride the bucket. As the men helped him down, the kids cheered and Luis laughed. He was handed a bottle, and he took a long drink. The crowd cheered and his mother laughed, relaxing, but later, when we were alone, she cried unashamedly; his drinking and his behavior hurt her deeply.

Alicia didn't have any role models in her family in her struggle to be a model student and to become more than a village housewife.

Veva was alone when I visited her in the fall of 1980. It was a very cold day. We went inside her hut and sat in hammocks to get out of the wind. Portions of the pole walls had been covered with cardboard, and someone had pasted pictures from popular magazines, comics, and newspapers on top. A framed photograph that I'd taken of Alicia's fifteenth birthday hung near the small mirror. The house was designed for the tropics, not for cold weather. It was humid and bone chilling. A flight of parrots circled around the house, chattering and squawking before landing in a couple of trees nearby. Even the daylight was cold. There wasn't any sparkle to the flowers, shrubs, and trees I saw out the doorway and through the cracks between the poles. Everything was colored gray, especially the clouds which were about to pour rain again.

We talked about the weather. I told her all the ports were closed due to the *norte*. Veva told me her house leaked through the roof and also the wind drove the rain in through the pole walls. She said she needed more *guano* palms to seal the roof, but Luis, who was supposed to have fixed it, had done nothing. Five girls passed outside, drawing water from the well. We could hear their murmuring and sudden laughter as they worked. The cooking fire glowed bright orange in the gloom of the hut. Veva massaged her fingers, then cracked her knuckles. I asked her if they

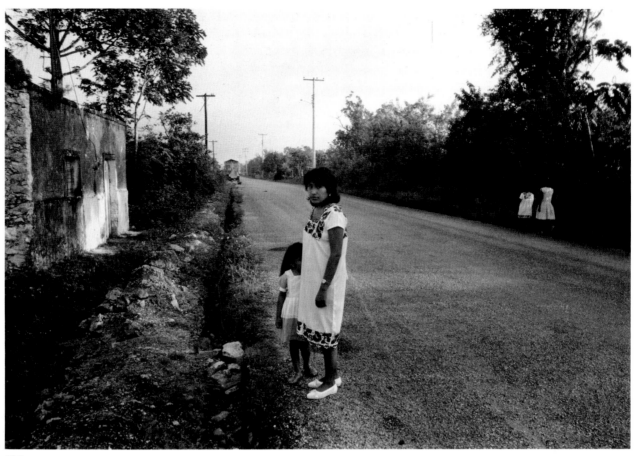

102

103

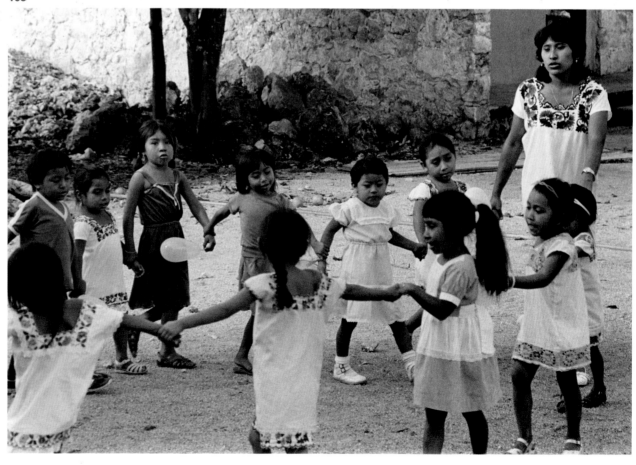

140 *Macduff Everton*

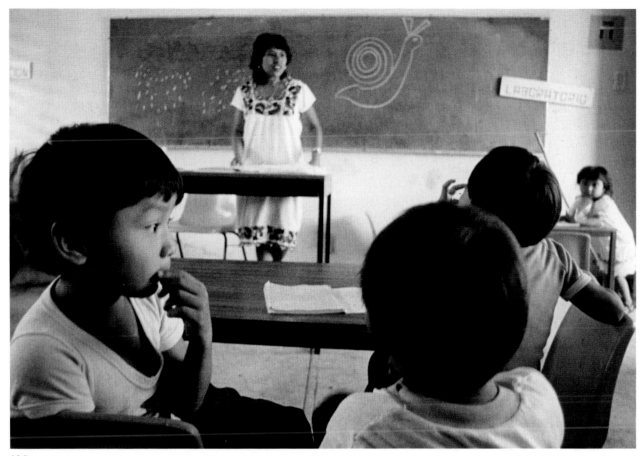

104

hurt. She looked up at me in surprise and told me it was just a habit.

Veva sat on the small stool next to her fire making me tortillas to go with the beans she offered. As she worked she mentioned she was having trouble supporting herself since Cornelio had died in 1976. She'd lost her concession for her refresco stand. Luis wasn't working much and drank what he earned. Elmer had married a girl from Piste and they'd just had a baby, so he couldn't help. Nelo was working back in Cancún after an unsuccessful attempt to chicle. He had complained that even the big trees hadn't given much sap. He also had a drinking problem so he couldn't send her much help. Felipe was still in school. Her real hope, Veva said, was Alicia, who'd begun working as an assistant teacher in the kindergarten at the village of Chan Cenote.

Doña Veva was smiling. This was her party. Luis was sitting next to her. Alicia and her husband, Juan, and their two children were there—Abril, who was almost five, and Josue, not yet two. Charles, Hilario, and I had picked up food in Valladolid and a package of balloons which we blew up and hung from the beams. For several years Veva was suffering from new pains and spoke of her death as imminent rather than an eventuality. She was very proud of her daughter and son-in-law who were supporting her, but the one thing she missed was her own home.

Alicia had married a soldier stationed in Valladolid in 1983 and built a stone house in front of the thatched hut she'd grown up in. Veva had moved in with them when her hut fell further and further into disrepair when she didn't have the money to fix it. In September 1988, Hurricane Gilbert had dealt it a final blow.

102 *Alicia, along with her daughter Abril, waits to take a bus to Tixcacalcupul where she teaches school. Chichimilá, 1988.*
103 *Alicia leads her students in physical education classes. Tixcacalcupul, 1988.* **104** *Alicia in her classroom has drawn a snail to illustrate a discussion about the previous night's rain. Tixcacalcupul, 1988.*

When Gilbert struck, Charles and I were in Santa Barbara, California, planning a tour of Yucatán for the local university. With the help and the urging of friends, we sponsored a benefit for the hurricane victims the night before we flew to Mérida. As it turned out, two hundred people showed up at the dinner and we were able to bring down over three thousand dollars. With $200, we arranged that Veva would have a new house.

The same hour the workmen were finishing, we hung hammocks and brought in a table, stools, and chairs for the celebration. The house wasn't big—twenty feet long, ten feet wide, two doorways opposite each other on the long side. The floor was dirt, the walls were poles, but Veva was overjoyed it was hers. For Charles and me there was a sweetness to the celebration that stemmed from being able to do something for someone that we'd known for so many years. Because Veva treated me like family, I felt she was able to accept the house without compromising her pride. So it wasn't strange that we started the evening reminiscing. Alicia still had the picture that I taken of her fifteenth birthday party on her wall, and I mentioned how surprised I had been when she'd cut her hair.

105

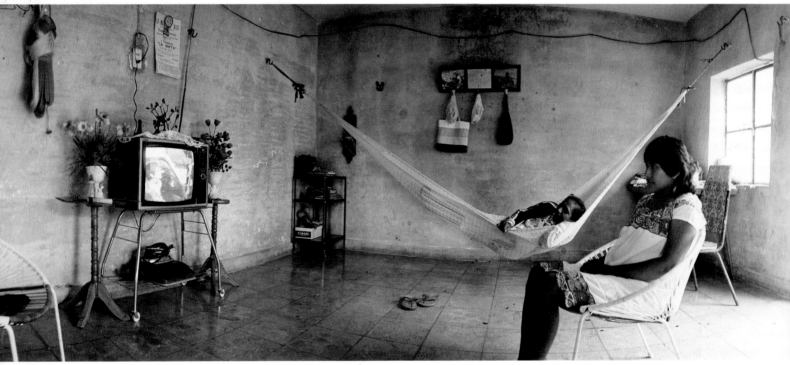

106

105 Veva and Alicia looking at a bas-relief carving of a ritual sacrifice at the ball court at Chichén Itzá. Chichén Itzá, 1975. 106 Veva and Alicia watching television in Alicia's house. Chichimilá, 1986.

"Tell me," Charles asked her, "how you decided to cut your hair? In Chichimilá, wasn't that really making a statement? For fourteen years you were a village mestiza with your huipile and your long hair, and then suddenly, when you cut your hair and put on a modern dress, you're a *katrina*, a city girl."

"I don't know," Alicia said. "Most girls who turn fifteen go into Valladolid, get their hair cut, and put on a dress."

"Not back then. You were one of the first."

"I think it was nothing more than imitating my friends," Alicia laughed. "One of the girls had relatives living in Mexico (anywhere else besides Yucatán), and she must have seen a fifteenth birthday party there

because she started it here in Chichimilá. We wanted to be fashionable."

"Will you become a *katrina* too?" Charles asked her mother.

"No, I'd be too embarrassed," Veva said, covering her face with her hands. "I could never do it."

Abril laughed and ran over to join her grandmother in her hammock. Josue followed, but was distracted by a balloon on the floor.

"I still wear a huipile," Alicia declared, "but now they take more time to make and cost a lot more to buy than a dress in a store. It used to be just the opposite."

"But some girls in the village are ashamed to wear their huipiles," Hilario said. "Or even to speak Maya."

"It's usually the parents who teach them that," Alicia said. "They think they're helping them—only letting them speak Spanish so they can get work in the towns or in Cancún. But take me for example. If I hadn't spoken Maya, I couldn't have gotten my job as a bilingual teacher. Our children are going to speak both."

"How many are you going to have?"

Alicia looked at Juan. "We're thinking just the two and no more."

"Really?" Charles asked, pausing a moment to get his statistics straight. "You had six brothers and sisters. Your sister Alba has had ten children so far, right, and another one isn't far behind? And you're only having two? That's a big change—you are certainly a modern family."

"We had to take into account how expensive everything is now," Juan said. "Before, a family could have ten to fifteen children and be able to eat on just the work of one man. Now we are seeing that both the husband and wife need to work to support the family—so if you have more children, life is more expensive. If we only have two, life is easier and better."

"You aren't alone," Charles agreed. "Your decision is being made all over. It's a big change for the world. Before, many families needed a lot of kids to help with all the work and chores. But working for a salary—no."

"Did you know ninety million children were born last year," Hilario said, "and scientists expect the population to increase another billion in the next ten years?"

Everyone shook their heads.

"And we have problems with just two," Juan joked.

"Life was easier before," Alicia said. "Obviously we have modern things which are beneficial, such as our refrigerator, but they often cost more than I make."

"I think education has improved," added Juan, 'but students are less focused now because of television and tape players and they are actually learning less."

"I was just talking with Dona Herculena, Dario's wife," Hilario said. "She surprised me when she said life is better now because before she never knew if she was going to have enough corn for the year. Now that Dario has a regular salary working in Cancún, she is assured of enough food the entire year."

"That might be true, but take me for an example," Juan said. "I make $44(US) every fifteen days working on a road crew. A shirt or a pair of pants costs around $16 and $18 each. The day I need to buy some for

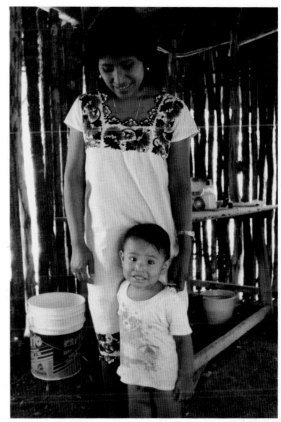

107

107 *Alicia with her son Josue. Chichimilá, 1988.*

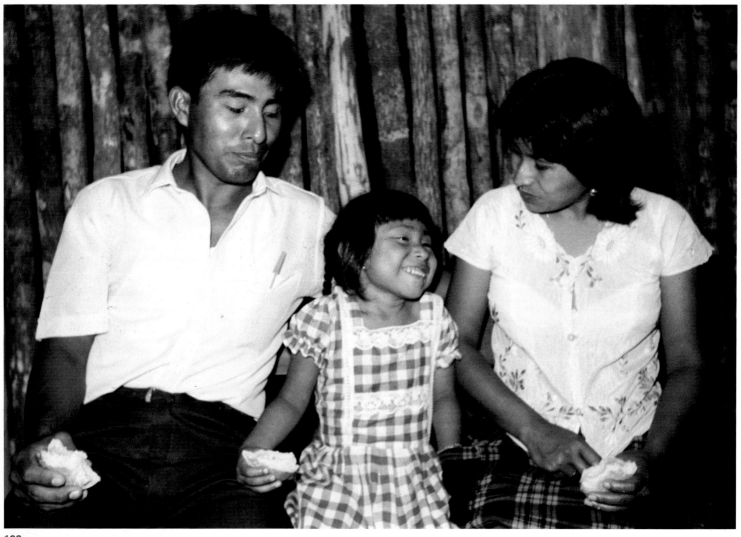

108

108 *Juan and Alicia with their daughter Abril. Chichimilá, 1988.* 109 *Veva with her grandson Josue. Chichimilá, 1990.*

work, that leaves me with roughly $10 for food." He looked around the room at us. "How much does a kilo of meat cost now? $4.50. And then you add the cost of condiments, beans and tortillas?"

"That's it—these days both husband and wife need to work to survive," Charles said. "That's exactly my problem raising a family in the United States."

I asked if there were problems with some men accepting their wives as their equals.

"Sometimes the husband is so jealous he won't even let his wife work," Juan said. "There is a lot of immorality today; you hear about it all the time, so it is on people's minds. But Alicia and I have mutual trust. She's not going to deceive me, and I'm not going to deceive her."

"So you're not jealous of each other?" I asked.

"Well, a little bit," Juan laughed, "but let's say good jealousies rather than bad jealousies that lead to shouting and blows. I've seen problems with other guys where the wife would start making more than her husband and it bothered him. 'I'm a man, you're a woman. Stop working,' he'd say. But Alicia and I have an agreement to discuss our problems. In our case, I make less than Alicia. I make $44 every fifteen days, she makes $80. We've agreed that everything we make goes toward family expenses, not just to the individual. We are concerned

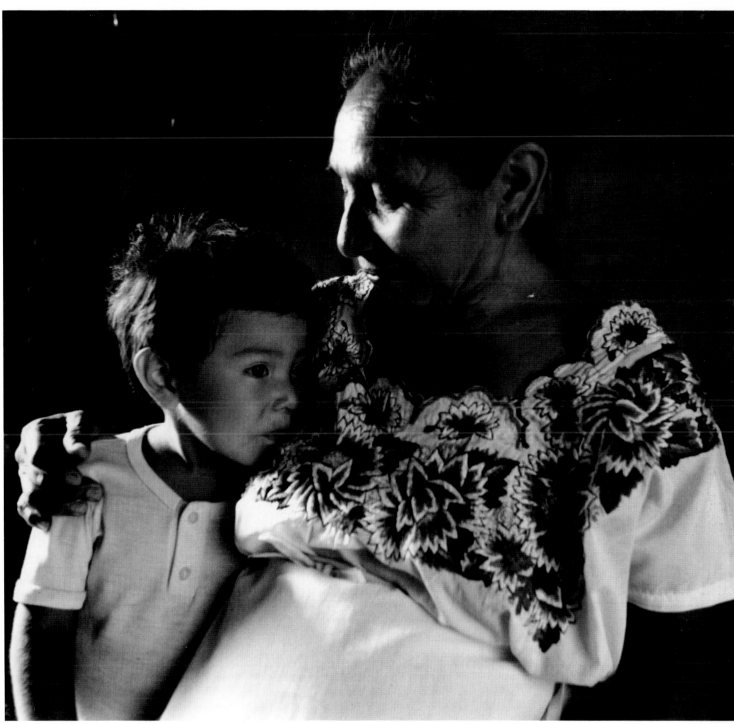

109

with our family's progress. So it hasn't been a problem for us like it is with some of the men I work with."

Hilario told them how impressed he was that they discussed these things and respected each other.

"Yes, that's a change in this village," Veva said.

Juan and Alicia both grinned at this double compliment.

"What about when you first met," I asked. "I grew up in a small town where everybody knew what everybody else was doing. Was there any reaction when Alicia started seeing someone that wasn't from your village?"

"There sure was," Alicia exclaimed. "Starting with my mom! She

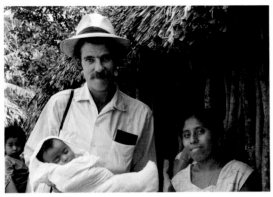

110

110 *Macduff Everton holding his goddaughter, Cecilia, with his comadre Alba. Valladolid, 1974.*

didn't want me to see him. She called him a *huach* (a derogatory term for an outsider usually applied to Mexican soldiers), and others in the village made up terrible stories about him so I wouldn't want to see him."

"You see, I was in the military," Juan explained, "and I first saw Alicia in the park in Valladolid. I didn't know anything about her, but I thought she was the woman I wanted to marry."

"Right then?"

"Immediately," he said, breaking into a big grin. He was enjoying the story. "I found a girlfriend of another soldier who was a friend of Alicia's so she could introduce us. Then I started jogging out to Chichimilá every day as part of my military excercises. At first I timed it so I would see Alicia when she went to the plaza to grind corn at the mill. It was there that I told her my intentions were marriage. I then asked Doña Veva permission to visit her daughter at her house because we were meeting in the streets and it wasn't suitable. I was afraid her neighbors would speak poorly of her and make assumptions that weren't true. Doña Veva said it was OK."

Veva looked over at me and nodded in agreement.

"I think that's when she started thinking better of me. Fifteen days later I came with my father—he was also in the military and stationed in Valladolid—to ask for Alicia in marriage and arrange the date of the wedding." Juan snapped his fingers several times. "Rapido! We didn't waste any time. But that's when Alicia played a dirty trick on me to see if I really was sincere.

Alicia and Veva were both laughing, but Alicia looked a little sheepish.

"Alicia visited me, and I told her again how happy I was to be marrying her. 'There's just one problem,' she said. 'What is it?' I asked her. 'I have a daughter.' She presented Cecilia to me. I didn't know she was her niece and your goddaughter, Macduff. But I told her it wasn't important—in fact I was happy that I would already be a father. That night I told my mother that Alicia wasn't a *senorita* but a *senora*. But it wasn't a problem."

"It was a test to see if he really loved me," Alicia said, "and he did." She put her arm around Juan.

"When you ask for the hand of a woman in Veracruz, where my family comes from, the custom is to prepare a lot of food and for five days you party—eating and drinking. This is just for asking for the girl. Five days of *fiesta*."

"It's the same here," Veva said.

"I asked around and found out it's generally just for a day, so we bought food and brandy and arrived in Chichimilá with my mom and dad, and friends and neighbors joined us."

"I was here with my *comadre*," Veva said, "and we both started crying and crying. . . ." She couldn't go on as she had started giggling.

"We had a great party," Juan said, "and that's how Doña Veva accepted me."

"And your neighbors?"

"They know him now," Alicia said. "Before they were suspicious and made up stories."

146 *Macduff Everton*

"There is a fellow," Juan said, turning serious, "who to this day doesn't speak to me out of embarrassment for things he said. It was lucky Alicia and I trusted each other. Some of the stories were really nasty. At one point we asked each other if there was anything the other should know about so we would hear it directly and not from another person. We hadn't done anything we were ashamed of—but you wouldn't have thought so from some of the gossip in this village. There were a lot of people who didn't want us to get married because I was a soldier and I wasn't from around here. Some of the guys even tried fighting me, but since I wasn't afraid, they didn't pursue it. If they'd sensed I was afraid, they'd have jumped me for sure."

"It's true. One time they tried to fight your *compadre* Benito in the plaza after he'd married Alba," Veva said. "Even though he's a Yucatecan, he wasn't from our village."

"Yes," Juan said with a sigh, "such are the stories of love."

We asked them what their plans were.

"We're going to stay here," Juan said. "Alicia told me she was born here and she wanted to die here so I don't want to ask her to move some place else if she wouldn't be happy there. I might have to work for short periods elsewhere, but we don't plan on moving. Once, before I met Alicia, I was here in Chichimilá for a baseball game in the plaza. I looked around and thought how tranquil the village seemed. I figured here was a place I could spend the rest of my life."

"What about Cancún?"

"I could make more money there, but our children would suffer. Sure, we could afford to give them clothes and food, but it's so easy for them to fall into bad habits there."

"One thing I've noticed," I said, "is that often the men returning from Cancún, on their day off, get drunk."

"It's true," Alicia agreed. "Their kids only know their fathers when they are intoxicated. One of our neighbors is only seven years old, but he's drinking. Imitating his father. On the other hand, our children have never seen their father drunk."

"Josue doesn't have any fear of me," Juan attested. "When I come home he runs to greet me. But a child with a drunk father knows fear."

"Not all drunks are nasty," I said. "I remember Alicia's father was a happy drunk. He liked to sing and dance and kiss his wife."

"He was never insulting," Veva added, smiling, "and he was never drunk out on the streets. He'd be home by six. If there was music, he'd take me dancing, even if we had to go to the next village."

"I never met him," Juan said. "I've heard stories about him, but I think I only really know him because of the photos you've brought, Macduff."

"If we didn't know you, we wouldn't have photos of him," Alicia said.

"Not even one," Veva added.

I changed the subject. "I think it's great that almost as long as I've known Alicia, I've been told she was going to become a schoolteacher, and now you are teaching in Tixcacalcupul."

"Sometimes her father and I would talk," Veva began explaining, "early in the morning before she was awake. Cornelio would stand by her hammock and he'd say to me, 'This is my daughter who will take

care of you when I die. She's going to be a teacher,' he told me. 'When I'm old and bent over walking with a cane and can only sit in the doorway guarding my grandchildren, this is the child who will support you.' I asked him why he thought Alicia was going to take care of us when we had sons. 'She's only a girl,' I told him. But he'd laugh when I said that. He said our sons would probably marry women who didn't know how to work and then we'd have to take care that our grandchildren didn't die of hunger. He said Alicia was smart. Very smart. I'd listen to him. No more than that."

"I didn't know any of this," Alicia said, amazed. "I didn't even plan on becoming a teacher. I first studied nursing, but I didn't like it. I looked around for work and that's when the opportunity to teach came up. I never remember him saying that he wanted me to become a teacher."

"That's what he said," Veva repeated, "and you are supporting me and now here I am, sitting by the doorway taking care of my grandchildren."

I had brought a box of pictures for them and several large empty frames with glass and backing. We got them out and started through the photographs, deciding which ones would go on the wall. Luis, who hadn't spoken much during the evening, suddenly became very animated and intrigued with the selection and began arranging them so they would tell a story. I brought out glue and scissors, and he was busy long after Alicia and Juan had left to put Abril and Josue to bed in their stone house.

Later that night, Hurricane Keith began sweeping across the Yucatán peninsula. It got very cold, and I couldn't sleep. I lay shivering in my hammock. Then Veva came over, bringing a couple of sticks from her cooking fire. She knocked off the burning embers onto the ground beneath my hammock. The heat immediately came up all around me, and I thanked her and fell asleep.

One of the problems with giving someone money is that it is not always appreciated later—and Charles and I wondered if the money we distributed from the benefit actually was beneficial. If Doña Veva is any example, we shouldn't have worried.

It was after dark when I arrived in Chichimilá in March 1990. Alicia immediately grabbed my hand when I came to the door.

"Look at Miriam," she said, leading me over to a hammock where a baby lay sleeping. Alicia told me she was born November 20. "I know we only planned on having two children," Alicia said sheepishly, "but isn't she beautiful?"

Miriam was not the only surprise. Veva then introduced me to her mother, Maria Cruz Cumul, who must have been in her eighties and whom I'd never met before. She lived at a rancho east of Tizimin and was visiting for a few days. I congratulated them that all four generations of women looked in such excellent health. Veva broke into a big grin and told me that—because of the money I'd given her she had gone to see a doctor about a sickness that had plagued her for several years, and she hadn't been ill since and now felt wonderful.

Now that Veva was happily living in her own house, Juan had turned

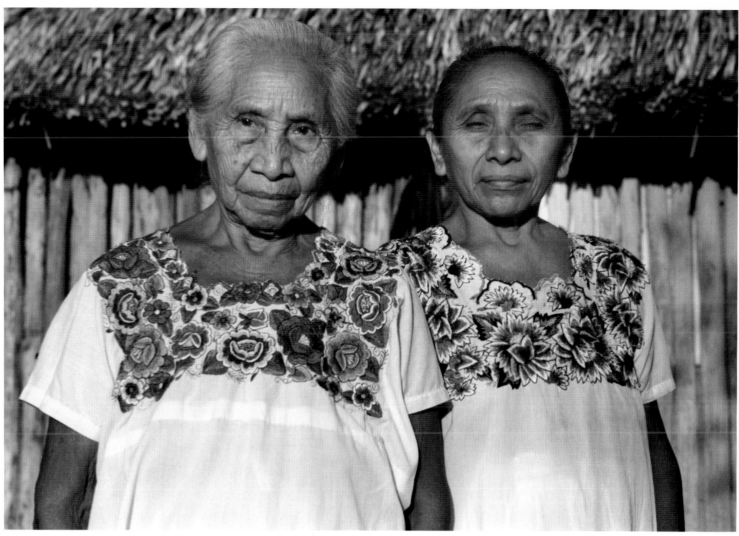

111

half of one of their two rooms into a neighborhood store—selling eggs, beans, tomatoes, chilis, sugar, baby food, Nescafe, cold drinks, soap, and other dry goods. He hoped this would allow him to stay home more so he could help take care of his children while Alicia continued teaching in Tixcacalcupul.

The next morning at 6:30 we decided to take photographs before Alicia left for her classroom. They all assembled in front of Veva's house, and then Veva disappeared to change her huipile. Abril then wanted to put on her new huipile, and then Dora Maria, Juan's sister who was visiting from Cancún, wanted hers, and then Veva went off to change into yet another huipile. The early morning sunlight was harsh, but it sparkled on the brightly embroidered yokes of their immaculate white dresses. They tried to look serious for the photograph, and I was pleased that, at least for now, it required an effort for them not to smile.

111 *Veva with her mother, Maria Cruz Cumul. Chichimilá, 1990.*

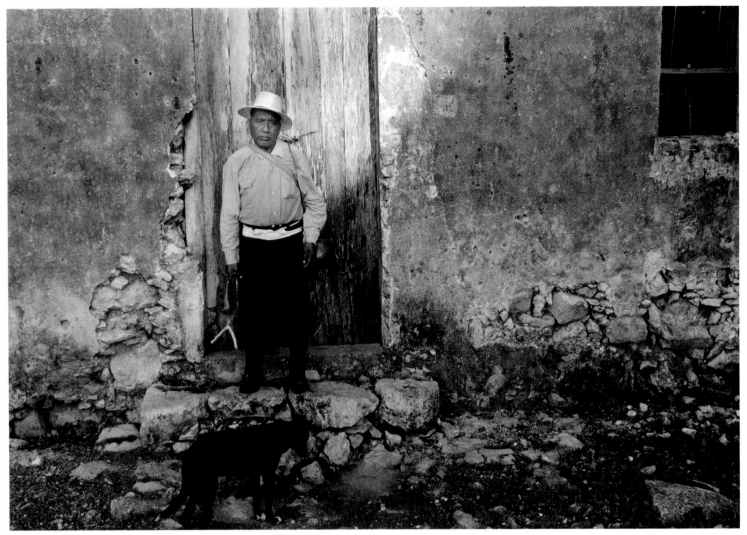

112

112 *Jesus (Chucho) Lopez Martinez in front of his house as he leaves for work at dawn. Ruinas de Aké, 1976.*

4

Henequen

⊡⊡⊡⊡⊡⊡⊡⊡⊡

The Decline of an Industry

When I arrived in Ruinas de Aké in 1976, I didn't know anyone or anywhere to stay. There were no hotels or restaurants in the village. Everyone I asked suggested I stay with Don Chucho—he had once put up another stranger in town. With a group of boys running ahead yelling out his name, I was led to his house in a row of stone buildings.

He came to the doorway, and as neighbors explained what I wanted, he held out his hand to me and said, "Jesus Lopez Martinez at your service." He was a dark, compact, grey-haired man who didn't smile, but he made me feel welcome. "You can call me Chucho," he added. "Everyone does."

He pointed to the end of his room and told me I could hang my hammock on hooks that were set in the stone wall. Rain began falling, doing nothing to decrease the heat but leaving the air smelling of wet dust. The crowd of neighbors drifted away. Chucho stood by the doorway staring outside, and I wondered what to say.

"Have you come to photograph the ruins?" Chucho asked.

"I'm more interested in taking pictures of the *henequeneros* (men who work in the henequen industry)."

"Huhhh," he said in the way the Maya acknowledge a statement. "You came to the right place. Everyone here is a *henequenero*. There is nothing else."

In all directions we were surrounded by fields of henequen, the agave

"All the state is for henequen, and outside of it is nothing."
—SERAPIO BAQUEIRO

151

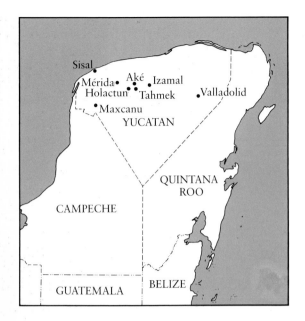

whose fiber is used for making binder twine, rope, and textiles. For the rest of the world, henequen is usually called sisal because when the bales were first exported abroad, they were stamped with Sisal, the name of the Yucatecan port the bales were shipped from.

As the uninvited guest I felt awkward. I wanted to find out what Chucho and I had in common, what we could talk about, and what his daily routine was so that I wouldn't be too much of an imposition. There were long pauses in our conversation. Chucho shuffled around his room, intent on what he was doing, and I wondered if he was thinking of what he was going to say next. He told me he was happy to have a visitor staying with him because I might be able to add a new perspective to his problems. He said there were things he wanted to talk about because he wasn't happy any more.

I didn't know what to answer, so I asked how I could help with food. Chucho said he already had a pot of black beans and tortillas but I could buy some eggs. He added that he liked Pepsi.

We walked to the village store where we bought the eggs and three liter bottles of Pepsi Cola. Chucho said he liked Pepsi better than Coca Cola. I told him real cowboys in the United States did too. It was easier sharing this information than trying to solve his problems.

Ruinas de Aké is a henequen hacienda—a company town—whose only work is cultivation and processing of henequen. Village homes define two sides of an enormous bare central plaza. Homes and the church mark the third side, and the stone building housing the rasping machine for the henequen crop closes the square. We walked past the entrance to the hacienda owner's house and climbed up a large mound which overlooked the village. The mound is part of the ruins that give Ruinas de Aké its name. It forms the western side of an ancient plaza. On the northern end is a low rectangular pyramid crowned with three rows of columns made of large drum-shaped stones stacked ten feet high. The modern village is built from stones taken from the ruins and the columns looked as if they were spared only because their size made them too heavy to remove easily. A heavy black slant of rain fell toward Mérida from dark clouds. Lightning jumped within the clouds on the horizon, but we couldn't hear any thunder.

The rasping machine started up, gathering steam like a locomotive leaving a station. Then the drive belts engaged, and we could hear the henequen leaves being fed into the machine.

"They're running it day and night to catch up," Chucho explained. "The machine has been breaking down."

The heavy thud-thud-thud—as steady and monotonous as a heartbeat—mingled with the clatter of the machinery and reverberated around the empty plaza.

The rasping machine broke down again while we were sleeping, and the silence awoke us. I heard Chucho rummage around in the dark before striking a match. He leaned out of his hammock and lit a candle, standing it on the damp dirt floor. It sputtered, then burned brightly. Chucho squinted at me while pushing himself up into his hammock, then slumped back, rocking back and forth, watching the flickering flame.

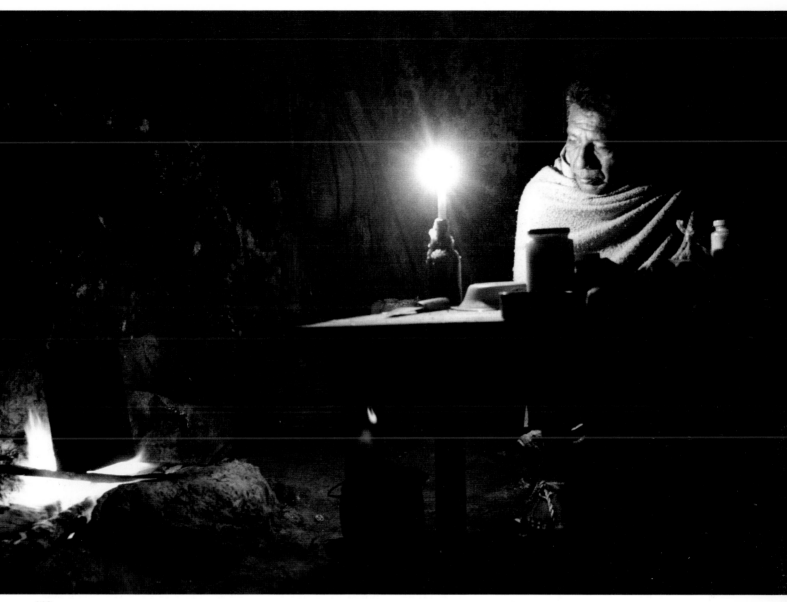

113

I pulled my blanket tighter around me, shivering from the damp cold. The room smelled musty and pungent, the smell of wet limestone.

"Buenos dias," I said.

Chucho acknowledged me with a nod. His hammock ropes creaked as he swung back and forth. Chucho didn't say anything and I wondered if he was getting up soon. I wished Don Chucho liked small talk. I didn't know him well enough to feel comfortable with his long silences.

When the engine started a few minutes later, Chucho sat up and adjusted the clothes he'd slept in. That finished, he stood up and knotted a piece of twine around his waist for a belt. Then he sat down again and stared off into the dark room.

"Morning," he said finally, pulling his cheap blanket tighter around his shoulders. "I'll heat up some water," he mumbled.

I watched from my hammock as he slipped on his sandals and shuffled over to the hearth with his candle. He soon had an open fire going. I got up and sat at the low table next to the cooking fire. I put my hands over the flames to warm up. The smoke from the fire began layering up, but Chucho ignored it as he sat across from me at the table.

113 *Chucho sits at his table waiting for water to boil on the fire. Ruinas de Aké, 1976.*

"It's cold this morning," I said, offering conversation. Small talk, but something on my mind.

"Huhhh," Chucho said, acknowledging that he'd heard me. He stared at the fire. I stared at the firelight flickering on the stone walls and looked around the room through the smoke. A broken guitar hung on one wall. Near it, tacked into the mortar, was a faded photograph of a group of musicians. Alongside a wall several water jugs sat on the floor. Our hammocks hung at the other end of the room, and there was a trunk where Chucho kept his clothes. There were a few cooking utensils, a pail, his tools. That was it.

Chucho made coffee when the water boiled, using a coffee substitute prepared from ground corn. He poured two cups, with slow, deliberate motion and handed me one.

"We'll eat when we get back from the fields," he said, looking over at me. "If it's all right with you."

I nodded.

"Huhhh," he said, then gazed at the fire.

Chucho's rib-thin black dog ran up to join us, jumping with excitement when we left for the fields. In the near darkness I slipped on slick rocks and weeds wet with dew. Stray dogs growled at us from empty houses that smelled of dank stone and garbage. From a few homes came sounds of activity—muffled voices of families getting up, a baby crying, a radio loudly competing with the noise of the rasping machine. Candlelight escaped from behind shuttered windows and slipped through the cracks in doorways and stone walls.

At the plaza Chucho entered one of the wide, twenty-foot-high doorways leading to the rasping machine. Forty-watt bulbs dangled from the high ceiling, supplying more shadows than illumination. The room shook.

Giant drive belts slapped the air above, transferring power from the steam engine housed in the next room to the rasping machine that stood on a ten-foot-high platform in the center. Below one end of the platform, workers threw bundles of leaves on a vertical conveyor that dumped the leaves onto a ramp. There men untied the bundles and spread the leaves on a horizontal conveyor belt that led to the rasper. The machine made a continuous fleshy thud-thud as the leaves passed through, the fiber burnishing the copper and brass parts of the machine that shone even in the low light.

Chucho talked to one of the workers underneath the platform who was monitoring the stream of water and plant waste plopping down from above into small hopper railcars. The man complained about the breakdowns and having to work day and night to make up for it, and having to fix machinery when the *ejido* (common land and the co-op that runs it) didn't have money to buy new parts. Chucho nodded in agreement. The dirt floor was puddled with water, sludge, oil, and grease, but the plant waste was a bright chartreuse that glowed in the morning gloom. It was hard to follow the conversation for the noise so they had to lean and yell into each other's ears.

We left by a back door, following a mule pulling a train of railcars loaded with plant waste from the rasping machine. We passed another

114

115

116

116 *The building housing the rasping machine,*
built in 1912. Ruinas de Aké, 1976.
117 *Workers toss cut and bundled henequen*
leaves onto a conveyor leading up to a rasping
machine on an elevated platform inside the
building. Ruinas de Aké, 1976. 118 *While*
one worker feeds the leaves onto the conveyor,
another pushes a hopper-car full of plant waste
from underneath the platform. A mule will pull
the car out to the garbage dump. Ruinas de
Aké, 1976

train coming back empty. The driver, loosely holding the reins, waved to
Chucho with his free hand. He balanced easily as the wheels jogged
back and forth on the track that was put together in sections like a toy
train.

We walked back through the ruins where we'd been the evening
before. A flock of sheep grazed on one of the ancient mounds, and the
ancient ball court was now a dumping ground for the plant wastes
which lay several feet deep. There were thousands of mushrooms
springing up from the recent rain. When we got to the end of the plaza,
Don Chucho looked back north at the rows of tall stone columns atop
the mound which burned red in the dawn's light.

"I like the early morning," he said. Chucho turned and led me along a
sacbé, an ancient Maya road that had connected Aké with Izamal. Now
it disappeared into a henequen field.

The field was heavily overgrown with weeds, and it was difficult to see
or even hear the other workers around us. Chucho worked methodically,
swinging his machete low and level with the ground in quick, short arcs.
He cleared an area and then stacked what he had cut. Around the
henequen plants he used a hook-shaped knife, or koa, propping up the

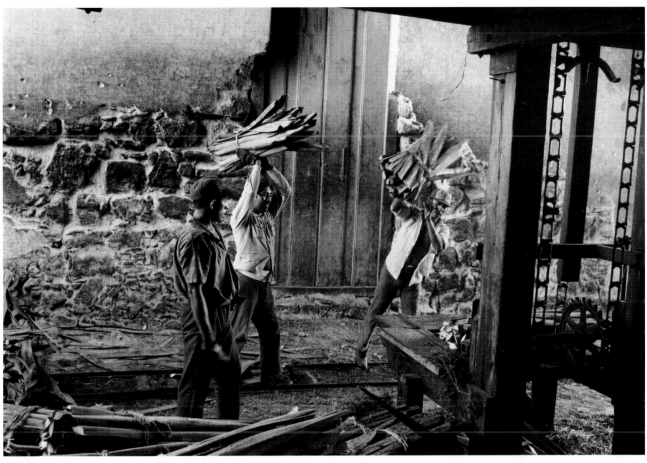

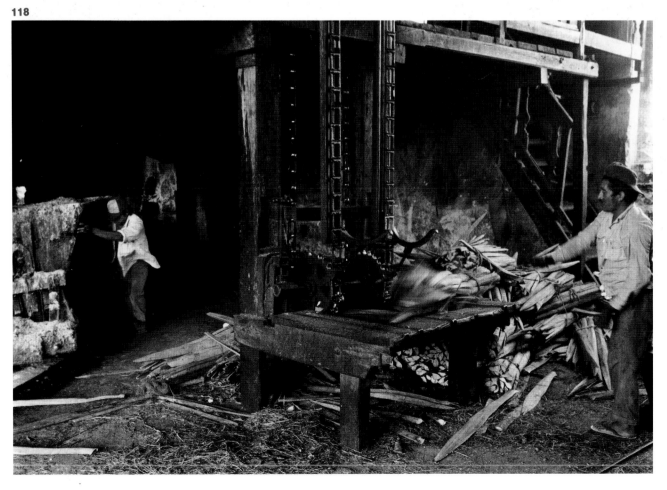

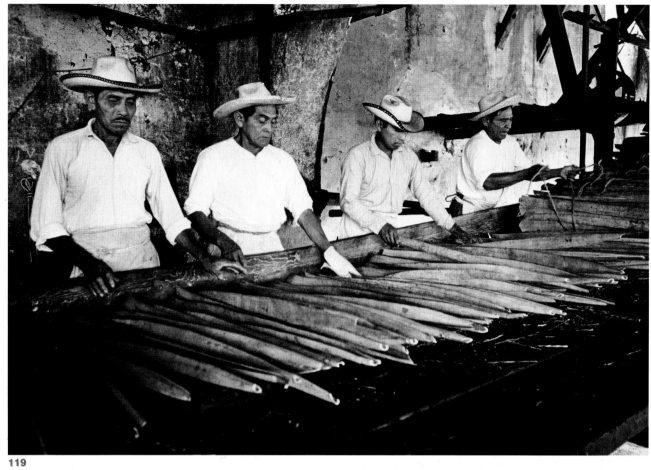

119

120

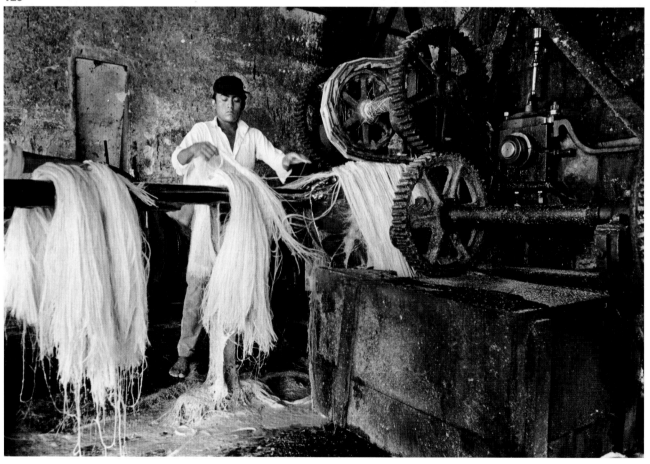

158 *Macduff Everton*

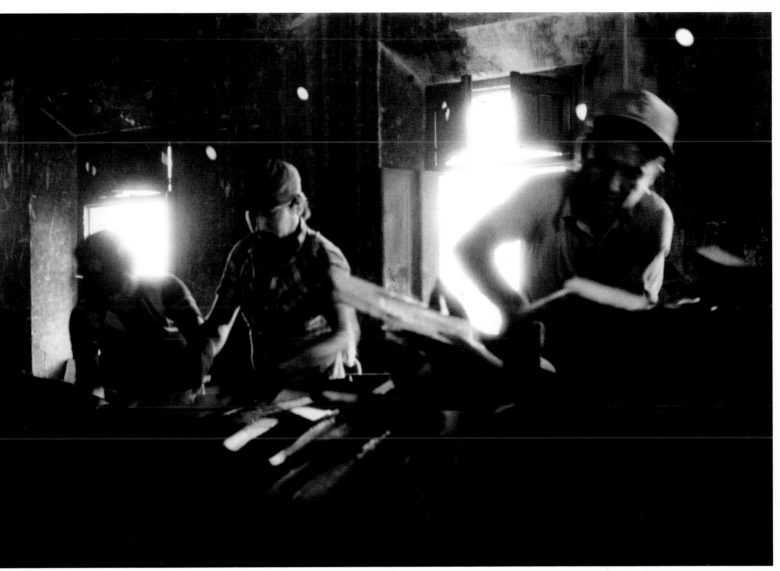

121

plants' lower leaves with a splayed-end stick. The spiny henequen leaves folded together into narrow green spears, tapering to black needle points.

The sun was soon hot in the open field, and there wasn't any shade. Chucho wiped sweat from his forehead and inspected his cleared aisle.

"The old days were bad, they were ugly," he told me, "but we took pride in our work. We kept these fields clear, and between the rows you found only grass. Today there's *chu kum, dzitil, cha, dzui che, bandarillo, pega-pega* . . ." he recited, pointing to the different spines, stickers, and weeds heaped in his piles. His expression tightened. "The others laugh at me when I clear my section well."

"Who's in charge? Don't they care?"

"We're all in charge. That's the problem. The government gave us the fields, and we're all part of the *ejido,* but we don't have a leader. Some work hard, some don't. It's not good," he grumbled. "I don't even like talking about it—it just makes me mad."

Chucho swung his machete at the weeds. "We got the fields now," he added angrily, "but no one taught us how to run them. When a lot of us work together without anyone in authority, that is, a respected authority, then at times someone starts making fun of another person

119 *Men untying the bundles and separating the leaves on a conveyor leading into the rasping machine. Hacienda Holactun, 1971.*
120 *Processed henequen fiber coming out of rasping machine. Hacienda Holactun, 1971.*
121 *Henequeneros* separate the leaves. *Ruinas de Aké, 1980.*

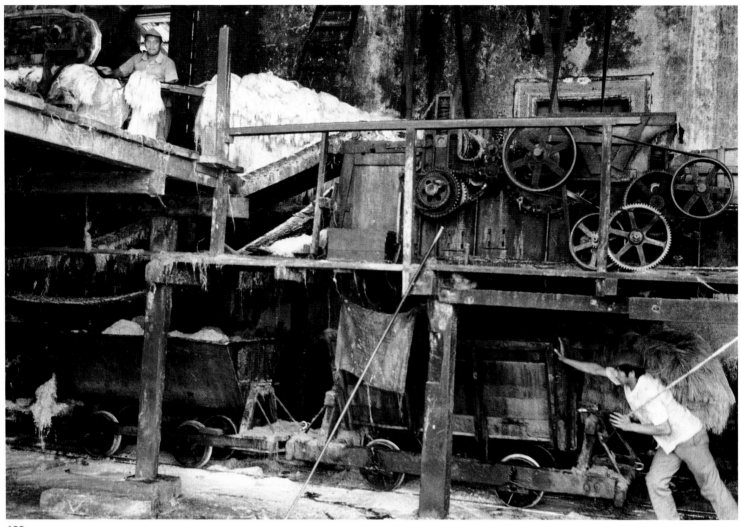

122

122 *Henequen fiber emerges from the rasping machine on the platform above while below a worker pushes an empty hopper to replace a full one underneath a chute delivering the plant wastes. Ruinas de Aké, 1976.* **123** *Inside the building, henequen workers, on the platform, toss the processed fiber down onto flatcars on the right, which will be pulled by mules to the drying racks outside. An empty hopper is in position to be pushed underneath the chute to catch the plant waste. This was shot from another rasping machine set on a platform at the other end of the room. Ruinas de Aké, 1976.*

who works harder than the rest, and little by little, the work sinks to the level of the laziest worker. Do you see the problem?"

"But you understand the problem. Can't you do something about it?"

"Maybe before, but not any more," he said, shaking his head. "I'm getting too old. The easiest way is to leave, look for work elsewhere, but I can't do that. I could get a job as a night watchman in Cancún, but my mother lives here and she wants to stay. What if I went away and she were to die and I didn't know it? So I can't leave. I am a widower so I married another woman, but she's working in Mérida because I can't even make enough money to support her."

"How often do you get to see her?"

"I don't, at least not much." Don Chucho paused and looked at me intently, then finally said, "I guess the best solution is if twenty or so of us could work together, people I know and respect. Good, hard workers, not these younger guys with big shiny belt buckles and long hair. And we'd want to see our profits, not be exploited from all sides. But the problems with working with a lot of people . . . well, it just doesn't seem to work for very long. We have good ideas, but we need education and someone with courage and strength.

"You know, we're promised many things. But it always seems the same. Previously, the *patrón* exploited us. Now it's the bank. There's little difference. Both are the enemies of the worker.

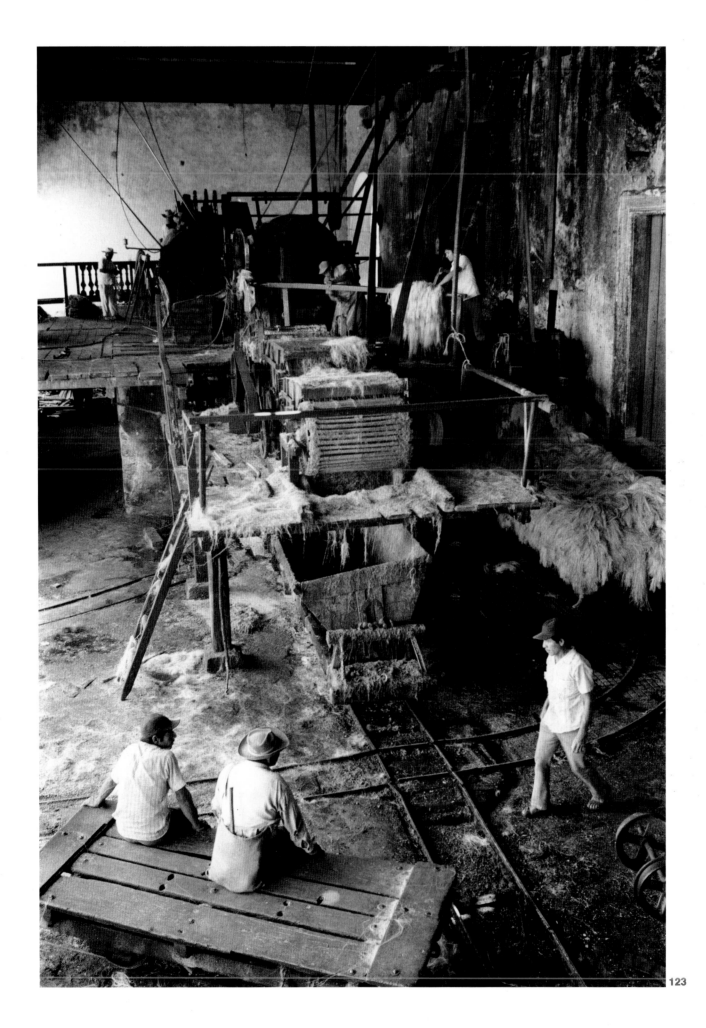

123

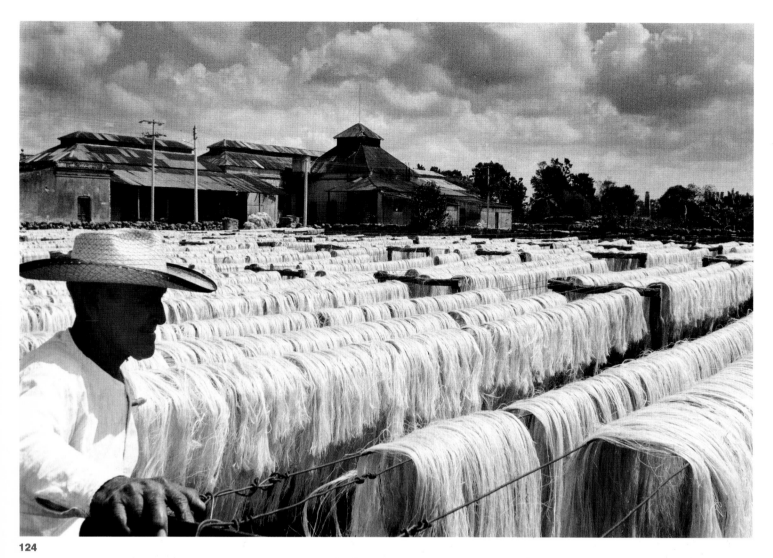

124

124 *The processed henequen is spread and dryed on racks behind the building housing the rasping machine. Ruinas de Aké, 1976.*
125 *A worker brings the dried fiber back from the drying racks. Ruinas de Aké, 1990.*
126 *Dried fiber is stored until it can be transported to the Cordomex factory in Mérida where it will be made into twine, rope, sacks, and other products. Hacienda Holactun, 1971.*

"When I was younger, I went to see the *patrón* in Mérida and asked him for higher wages and health protection. At that time, if a worker was hurt or sick, the *patrón* did nothing for the man or his family. Today there's insurance and medical help, but not then. I went to see the *patrón*, and he wouldn't help us. Finally I told him, 'You're rich from our work and you bathe in the sweat of the workers.' He had me thrown out."

Chucho actually laughed at this, and I saw he had a nice smile.

"What happened then?" I asked him, surprised and pleased.

"He came out to the hacienda later that year, and gave us a little speech. He told us the poor people were better off than he was. His life, he said, was full of terrible worries. His life was weighted with burdensome responsibilities. He told us we were healthier, we ate fresher and better food, our lives were free from worry. But when I asked him to trade places with me . . ." Chucho laughed again. His face seemed transformed, he was enjoying himself and looked happy.

"Well, he refused, of course, and I told him, 'You need us more than we need you. Without our work, you'd starve! You couldn't live!'"

"You must have been one of his favorites."

"He remembered me, that was clear, and I had to leave for a while. I worked as a dynamiter on a highway crew, but I came back later."

"And he didn't bother you any more?"

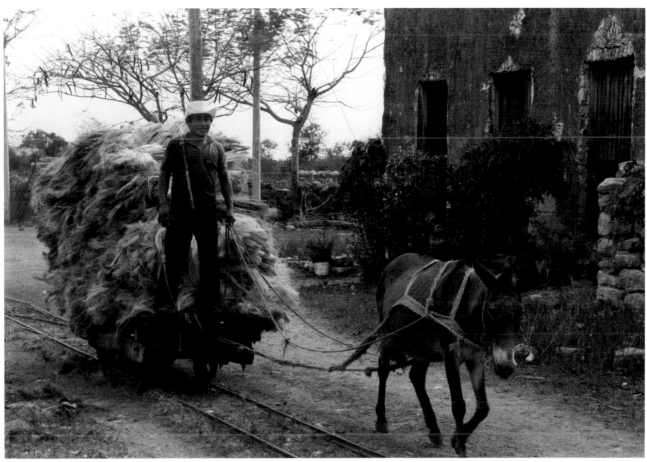

125

126

Henequen 163

127 *Henequen workers waiting for transportation home after a day's labor in the fields. Ruinas de Aké, 1976.*

127

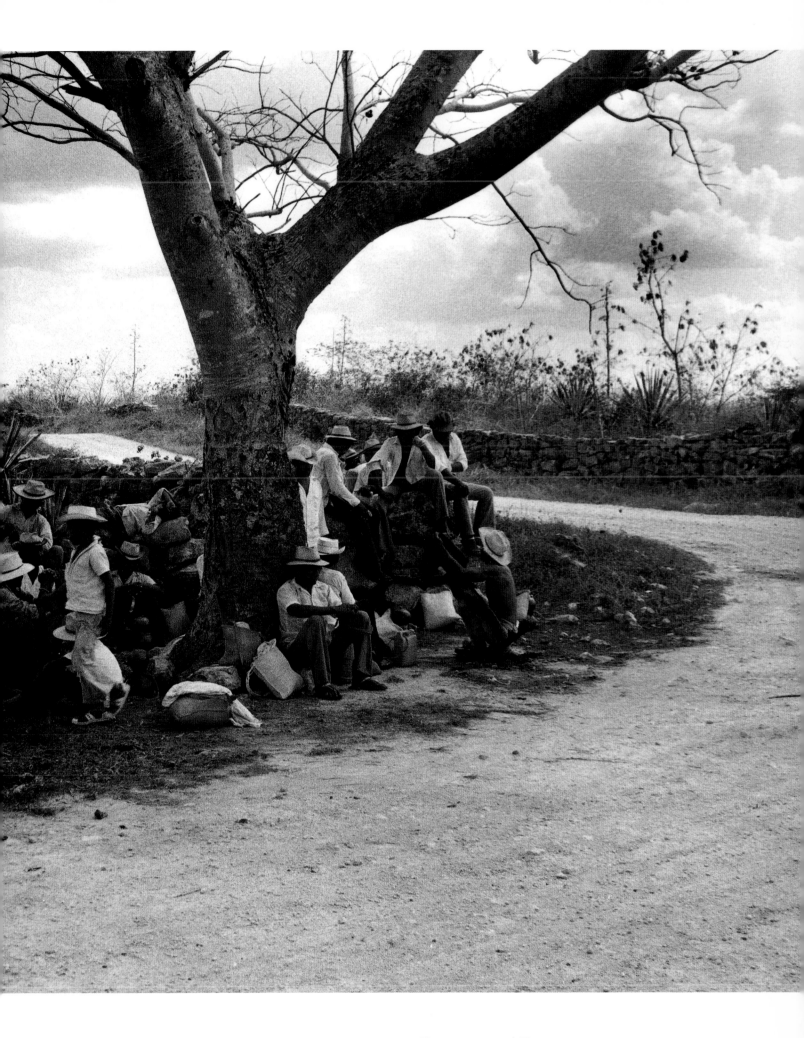

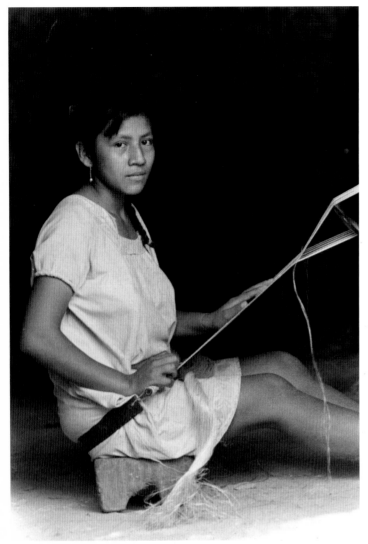

128

129

128 *Martina Martiniliana Pol Dzul weaving a sabokan (bag) from henequen fiber. Holcaba, 1971.* 129 *Dario Tus Camal weaves a hammock from henequen fibers. Chichimilá, 1976.* 130 *Francisco Puc Poot makes rope from henequen fibers in front of his home, using his toes as a third hand. The rope is for his sandals, laying unfinished near his left foot. Chichimilá, 1971.*

"I got the worst jobs."

"You had a lot of courage to speak out against the *patrón*. What makes you think you couldn't help the *ejido?*" I asked. "You have ideas that should work."

"I'm getting too old," he complained. "I'm just a poor old man."

"That's not true. You could be exactly what they need."

"No, I don't think so. What we need . . ." he started, but didn't finish. He tried again. "There's something . . . No. . . ."

He looked at me. I thought he was going to say something, but he turned away and looked at the ground. I waited for him to finish, but too much time had elapsed.

"It's sure hot today," I said, trying to ease the tension. "I wish there was some shade."

Chucho looked at his hands, studying his fingers that were rough and cut by work. Noticing a thorn in a callus, he pulled it out with his teeth. It started bleeding, and he sucked on it. He ignored me, then pulled a flat file from his back pocket, and putting his machete to his knee, pushed the file at an angle against the blade. Metal grated on metal, shiny flakes gathering on his trouser leg.

130

131

131 *Francisco Puc Poot rasping a henequen leaf by hand. Many village Maya grow henequen plants in their yards to satisfy their needs. Chichimilá, 1971.*

• • •

Succulent plants store water in juicy leaves, stems, or roots and can grow under harsh conditions. The best-known plants of this family are agave, aloe, cactus, and yucca. The ancient Maya cultivated henequen (*Agave fourcroydes*) for the fiber in its leaves, and used it to make an infinite number of things for their use. Even today, in rural areas, the Maya use it for making their sandals, tools, household utensils, rope, bags, and hammocks.

In colonial times, the Yucatecans produced rope from the plant, selling small amounts to the Spanish merchant marine. After Mexico's independence from Spain, the henequen industry grew and became so profitable that the landowners needed many workers. They induced the Maya to work on their haciendas (ranches or plantations). A self-perpetuating system of debt peonage for the Maya quickly evolved, which destroyed the old ways of the self-sustaining villages. Large areas of land were cleared and planted, and soon the henequen zone included almost all of the northwest Yucatán peninsula. No land was left for the Maya to plant their traditional cornfields. The Maya had created the greatest civilization in the Americas based on growing corn, and now Yucatán had to import it. Henequen offered nothing spiritual for a people whose religion taught them that their very flesh came from corn. A census of the 1880s listed a third of the population as indebted servants—all were Maya. Taken from their cornfields and forced to work in the henequen fields, the Maya had become dependent upon the landowner and were treated like slaves. The working conditions were some of the most oppressive in the Mexican republic, and the Maya peons were guarded by armed overseers and subjected to a brutal regimen.

Meanwhile, henequen exports increased at a dramatic rate. When McCormick's mechanical reaper mechanized American farming, it opened up a vast market for binder twine. By 1900 Yucatán was shipping eighty-one million kilos of henequen annually.

The capital of Mérida reflected the new wealth of the henequen growers. They built ornate Victorian mansions along newly paved streets and lit them with electricity at night. This wealth also attracted the American financier J. Pierpont Morgan, who saw an opportunity for a profit.

In 1902, Morgan arranged a merger of the leading farm harvesting equipment manufacturers into International Harvester Company. The new company's agricultural market for binder twine absorbed 80 percent of the henequen crop, and Morgan cornered the market and drove the price down until he almost bankrupted the henequen industry. World War I revitalized Yucatán—the price of henequen rose from three cents a pound in 1911 to over twenty-three cents a pound in 1918.

In 1915, General Salvador Alvarado became governor of Yucatán. He was a socialist dedicated to reforming the culture and economy of Yucatán. He set sixty thousand Maya and their families free from the debt law, ending 350 years of slavery. Alvarado stepped down in 1918. The economy of Yucatán collapsed with the end of World War I when the price of henequen plummeted to four and a half cents a pound.

Furthermore, Yucatán's world monopoly of the production of henequen was broken by new sisal plantations in British Africa and Java, where the richer soil produced a plant with longer fibers of greater tensile strength. By 1930 overseas yield of henequen surpassed that of Yucatán.

The market brought an all-time low of under two cents a pound during the worldwide depression, and Yucatán was near bankruptcy. Long lines of emaciated men begged for food and work at haciendas and towns. The situation of the Maya had become so desperate by 1937 that President Lazaro Cardenas (famous for expropriating the Mexican oilfields from multinational oil companies) expropriated the lands of the *hacendados* (hacienda owners), giving most of the plantations to the Maya to recreate the *ejidos* (common land) that they had lost a hundred years before. The Maya's lack of training and experience still left them at the mercy of the *hacendados*, who were allowed to keep a 150-hectare (370.65 acres) nucleus around the main buildings, which included the rasping machines. The *hacendados* charged exorbitant rates for processing the henequen, and finally in 1961 the federal government formed Cordomex, which erected modern rasping plants that handled 25,000 leaves an hour, and new processing plants that produced binder twine, rope, gunny sacks and cloth, padding for upholstery, and carpets and tapestries. But a government report in 1976 stated:

> The outlook for both raw and processed henequen production and exports is rather dim at this stage . . . the domestic henequen industry is faced with an excess of labor and high support prices to producers paid both by Cordomex and the official loan bank in Yucatán, making it necessary for the state government to absorb substantial subsidy losses. Some government sources feel that the industry requires a drastic cutback in both area and in producers, currently numbering 75,000 versus only 25,000 producers actually required to keep up the crop production. The widely announced release of 21 henequen rasping plants to the *ejido* sector has not yet materialized and will be difficult to implement inasmuch as the latter is rather unskilled both technically and administratively and will require considerable guidance from the Secretariat of Agrarian Reform. Hence, for all practical purposes, these plants continue in the hands of their former owners.

In the days that passed Chucho didn't say much, explaining he was depressed and tired, but he promised me we'd go for a swim at his favorite *cenote*. It was beautiful, he said, and the water was perfect.

One hot afternoon he decided we should go swimming. The path to the *cenote* led through a vast field of young henequen plants. Very little moved under the sun's heat except what we stirred up—a constant flik-flik of grasshoppers jumping ahead, and a group of ground doves that scurried before us. A hot breeze pushed the air uncomfortably against us. Hundreds of biscuit-shaped clouds scudded along in rows as neat as the row of plants in the henequen fields.

We walked steadily along, and when Chucho told me we were near a *cenote*, I was surprised. I didn't see any tell-tale sign of one, such as a large opening, a tree, or a depression. Chucho pointed out a small hole

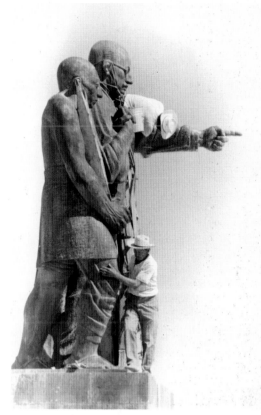

132

132 *A statue of General Salvador Alvarado leading a Maya carrying a henequen leaf. The statue, in front of the Cordomex plant, gets a cleaning for the visit of the governor of Iowa, a sister state of Yucatán. Mérida, 1971.*

Macduff Everton

133

Henequen 171

hidden in the rocky soil between henequen plants and a few spiny nopal cactuses.

Through the hole I saw a pile of stones ten feet below. I wondered about rattlesnakes. Chucho led the way down the shaft into a small and cramped cavern with a low ceiling. The water was gray underneath a film of dust. Chucho proudly swept his hand across the scene. I knew I was supposed to marvel at the spectacle, but I found it disappointing. It wasn't anything compared to most *cenotes* I had visited. But we were both sweating profusely, and I was happy to go swimming.

"It's very pretty," I said, trying to sound cheerful. "You must have a lot of memories here."

He nodded, then took off his shirt, spreading it out on a rock. Moving to the water's edge, he crouched on the narrow sandy beach. He dipped his hand in the water, brushing away some of the dust.

"I was just a little boy when I first came here. I was born in Maxcanu (a town southeast of Mérida) in 1921, but I've lived here since I was five. There was still some forest left. I used to fetch water for my father when he was burning trees for charcoal. I learned how to swim here. All the boys in the village would come here to play and swim.

"When we were older, we brought our girlfriends. It was really something then." Chucho smiled sadly. "A lot of dust down here now. Not too many people come here any more."

134 *Chucho preparing lunch in his house. Ruinas de Aké, 1976.*

134

"How old were you when you started working in the fields?"

"Nine when I started working full-time," Chucho said. "My father was sick, and there was no way my family could eat without my working. It didn't seem that bad. I learned reading and writing, and after work, we'd come here every day, all of us my age. We'd swim and play tag, and *pesca-pesca,* and we knew every part of this *cenote.*" Chucho indicated the back of the cave hidden in darkness.

"I really do know this place. Back there is a rock that's hollow. It rings like a bell if you knock on it!" He picked up a rock and threw it in the water, scattering the dust. Following his example, I threw some rocks in too. Reflections from the disturbed water danced on the ceiling.

"You see how clear the water really is?" he said happily. "There's even fish."

The water was so clear I couldn't tell how deep the *cenote* really was. Small silver fish glided over the rocky bottom.

"When we came here after work," Chucho continued, "we'd all leave together at the same time. Nobody could leave early. If someone tried, we'd hit them with a glob of mud." Chucho laughed at the thought, and I laughed with him. "Well, they couldn't leave covered with mud, could they?" he asked me. "Of course not! They'd have to jump back in."

"Of course they would," I said. I enjoyed being with Chucho when he was talking, but when he smiled, it was wonderful. I wished when I smiled it would have the same effect on him. "It sounds like a wonderful time."

"It was. Later, as we got older, we brought our girlfriends and sat around the water, playing our guitars and singing, the music echoing through the cave. It was beautiful, especially at night."

"Did you sing and play too?"

"Certainly. For years I played guitar. I even had a seven-man *conjunto* (band), and we performed all around. In those days we played all the time, for parties and dances."

"Do you still play sometimes?"

"Not any more. That was another time, and I don't have enough money now. Things change, and now my guitar is broken."

"You must love music . . ."

"Look," Chucho said, indicating the opening, "it's raining."

Raindrops sparkled and fell in the beam of sunlight coming down the shaft. The afternoon shower increased the humidity in the cave, making us feel hotter. We stripped to our shorts and Chucho dove into the water. He swam to the center, pushing the dust in front of him and into the corners. He started splashing, burying the dust beneath the waves.

"Come on in," he said.

I swam to the back of the cave, splashing and looking for the bell rock. My eyes adjusted to the dark, and I found a stalagmite growing out of the water, shiny and slippery, almost like ice. When I finally got on top, I looked for Chucho.

He had swum over for the bar of soap he'd brought. Up on the beach he was lathering up, covering his whole body in suds, scrubbing himself clean. Stopping, and looking around, he discovered me watching him. He laughed, and threw the bar of soap into the middle of the *cenote.* We both dove in chasing it. I didn't tell him he was contaminating the water with his soap, not while he was still laughing.

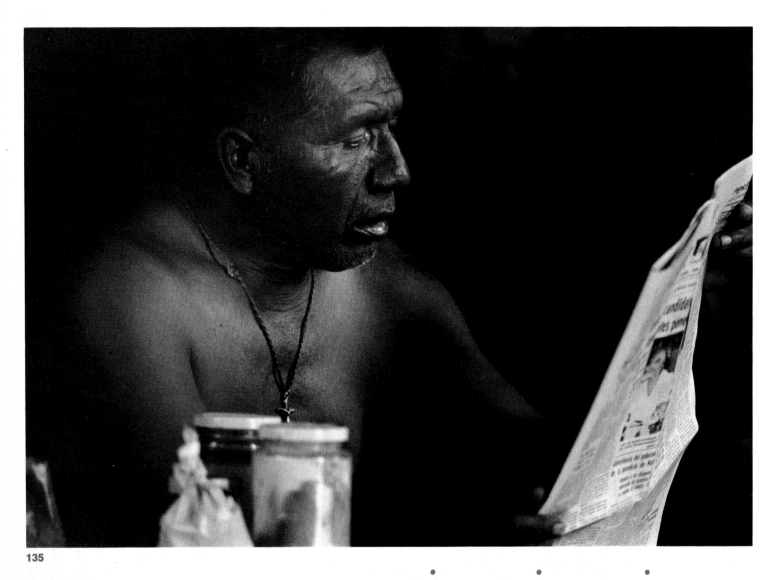

135

135 *Chucho reading at lunch. Ruinas de Aké, 1976.*

• • •

Chucho was depressed. The village was economically depressed. If I stayed any longer, everything was going to look depressed to me. I didn't feel I was helping. It was all right to talk fondly of the past, but not the present. Chucho was too old, things were too expensive, things were changing. . . . Maybe he was right, but it sounded like self-pity. The heat made me tired, and I was tired of every conversation with Don Chucho becoming *pesado* (weighty). I decided to leave.

Two kids from next door came over with a plate of barbecued iguana. They'd shot it that morning with slingshots. We thanked them, and added the meat to our lunch of beans, eggs, tortillas, and Pepsi.

When the boys had left, Chucho looked at the plate. "Look at that! People even eating iguana now. Things have changed—there's so little game around. Not like before."

"At least it tastes good," I said, trying to be positive. "It tastes very good."

"Huhhh," he said, picking up the day's paper. It was delivered everyday from the capital by the morning bus. For a person with little formal education, Chucho was remarkable for his interest in and concern about keeping abreast of national and world news, but it reinforced his feelings that times were bad. Not only was he always serious but he never seemed able to enjoy little pleasures without

remembering how many terrible things had occurred to him, his neighbors, and the world.

I ate my lunch in silence. The eggs were cooked in too much pig fat for my taste but I couldn't tell him that. I didn't want to complain. He was doing enough of that for both of us. I wondered why his wife had left, and if he ever saw her.

"Look at this," Chucho said, looking up from his paper. He pointed to a picture of Lopez Portillo, the PRI party presidential candidate, who was campaigning in Yucatán. "Another politician, another promise, and my community is falling apart. My neighbors buy televisions on credit and dream of leaving the village. How do we know what to do? We're told this, we're told that. They call something progress, but it always means a new hardship, doesn't it? They announce it's for our benefit but . . . where do we find direction? Some people say we should vote for the Communists but I distrust them just as much as PRI."

Chucho searched my face for an answer. "Somehow," he said, "I feel I'm supposed to start all over again. But I'm too old." He looked over at me expectantly. I nodded my head. He wanted me to agree how bad his life was now. I was tired of that. I finished my bowl of beans instead.

"I'm sorry," he said, noticing my plate was empty. He spooned out more beans from the pot on the fire and poured the leftover pig fat on them. It was a special favor, as he enjoyed it very much himself.

136

136 *Chucho walking on the streets of his village. The water pump behind him was manufactured in Beatrice, Nebraska. Ruinas de Aké, 1976.*

I took down my hammock and put it in my *mochila* (large bag with drawstrings) as Chucho watched. I thanked him for my stay in his home and for the meals we had shared.

"You know," he said, "I'm alone here. If other of your countrymen would like a place to stay, I'd enjoy very much talking with them. They can stay here. We can share our meals and talk."

"I'll tell them," I promised.

I shouldered my *sabukan* (bag with shoulder strap) and *mochila* and headed for Tahmek, twelve kilometers away. At the outskirts of town I looked back. Chucho stood in the bright, empty street, the saddest man I knew in Yucatán. We waved. I turned and started walking, feeling alone under the hot sun, between rows and rows of henequen and deserted ruins.

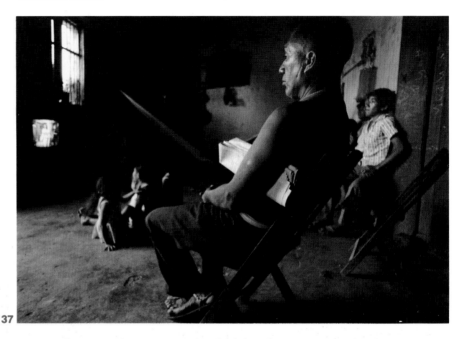
137

In 1980 I returned to Ruinas de Aké after four years to see Don Chucho, bringing along my son and some friends. His house was empty. Chucho had moved a few blocks away, his neighbors told me. They said he was living near the plaza with his wife.

I found a house where flowers were growing in window boxes. A woman answered the door. Chucho grinned when he saw me and gave me a big hug. He proudly introduced his wife Eleodora.

"I've told my wife I had a friend from the United States. And now a whole carful shows up! I think she thought I was making you up, I've talked about you so many times. She said I was probably so depressed I was inventing friends."

His wife nodded her head in agreement. "Because of his smoking and drinking, I left him for seven years," she confided. "We'd only been married two years when I left, but when he gave up his bad habits, we've been together ever since."

I gave him an album of photos I'd taken of him. He sat in a hammock and turned each page, explaining to Eleodora all the things we'd done. "This is wonderful," he said, laughing at some of the memories.

I brought in several liter bottles of Pepsi, and Chucho laughed again. He brought out his mended guitar, and sitting close together, he and his wife sang duets for us, looking into each other's eyes.

"He should never have given up playing music," she said, and Don Chucho smiled again. "Who knows how many guitars he broke when he was drinking."

Six years later, I visited Chucho and Eleodora, again bringing more friends and photographs from the last visit.

After a lunch of scrambled eggs, tortillas and Pepsi, I asked how the Mexican peso devaluation was affecting them. Eleodora finished wiping off the plastic tablecloth and sat down next to Chucho.

"I'm making 5,750 pesos every fifteen days," Chucho answered. "It is not very much. Let me tell you how expensive everything is. A kilo of corn costs 59 pesos. A kilo of chicken costs 580 pesos. A soft drink costs 55 pesos. An egg costs 25 pesos, and a kilo of lard for cooking costs 800 pesos. Five thousand pesos doesn't buy much. A little here, a little there, and it is gone. There are men working with me that have four or five children. They can only make 5,750 pesos every fifteen days—they can't make any more. In all honesty how can a family survive?"

"You read the paper and the politicians tell us the economy is faltering right now and it is necessary to tighten our belts. Our belts have always been tight. The village is dying of hunger, but the politicians are eating well. If only our politicians will learn a lesson from Marcos—it is exciting following the events in the Philippines each

137 *Chucho watching television at his next-door neighbors'. Ruinas de Aké, 1976.*
138 *Eleodora talks with a neighbor. Ruinas de Aké, 1990.*

138

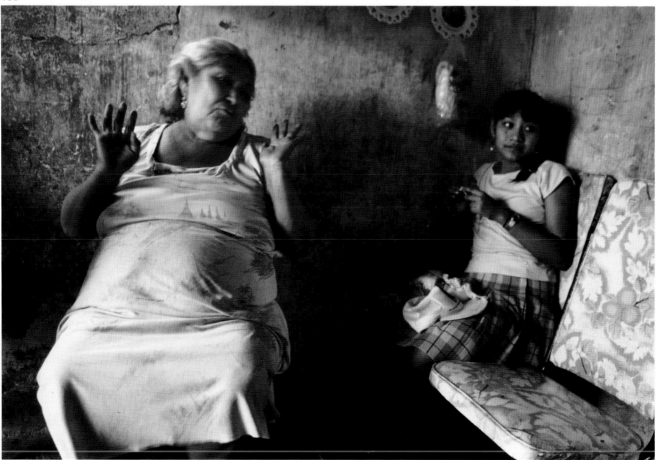

day in the newspaper. Meanwhile, here in Mexico, while the politicians are living it up, we are suffering. We are even worse off now than when you first visited me."

"What are you going to do?" I asked.

"There are experiments. There are ideas and there is no new work. We've asked to do other work, but our proposals haven't been accepted. The government talks about development, but there is no money for credit. There is more money in industry. A worker at the Cordomex factory makes $2,500 pesos a day. In three days they make more than we do in fifteen days. But there aren't enough factory jobs for all of us. The life of the workers of the henequen field is hard. *Es duro . . . muy duro . . .*"

That night Chucho and Eleodora went to church, something they now do every night. Chucho accompanied the hymn singing with his guitar. There was scaffolding set up inside, and half the church had been refurbished by donations from the villagers of Ruinas de Aké. Contributions were small, and they didn't know when the work would be finished.

Chucho said there were no simple solutions, and he was tired.

In 1988, Chucho retired at the age of sixty-seven with a pension which paid him less than $15 a month to live on. There was no work available in Ruinas de Aké to augment his pension so he and Eleodora were forced to live with her son in Mérida. Chucho found work as a night watchman at Restaurant Le Gourmet, a fancy French eatery and earned $80 a month working from 11 P.M. to 7 A.M. six days a week. I found Eleodora and Chucho in Ruinas de Aké when I visited them in October 1988. It was Chucho's day off, and they were working on repairing damages to the house from Hurricane Gilbert. The wind had ripped the wooden shutters used as windows from the house walls and knocked over trees in their yard. Across the plaza the wind had toppled the bell tower of their church, and the masonry was still scattered on the mound. Signs of the hurricanes destruction were still everywhere. They had very little money for repairs.

Through the generous help of a friend plus some money from the hurricane benefit we had held in California, I opened a bank account for Don Chucho. As we walked back from the bank with his new passbook in his hand, Chucho couldn't contain his excitement. He almost jumped and clicked his heels. When I visited him a month later Chucho brought out a guitar he'd just bought. He played me a song. Eleodora leaned over to me and whispered loudly, "This is the way he impresses the girls." She laughed and looked over at Chucho, who smiled and continued playing.

In May 1989, I received a letter from Chucho telling me his condition was very grave, and that he and his wife had returned to Ruinas de Aké. He said he hoped I could get back to Yucatán soon. Hoping that he wasn't dying, I wrote him that I couldn't come right away, but that I was getting married in August, and would honeymoon in Yucatán so they could meet Mary. It wasn't until March 1990, that we actually visited.

Eleodora answered our knock. Her husband was in Mérida, she told us, but would soon be back. They were living again in Ruinas de Aké,

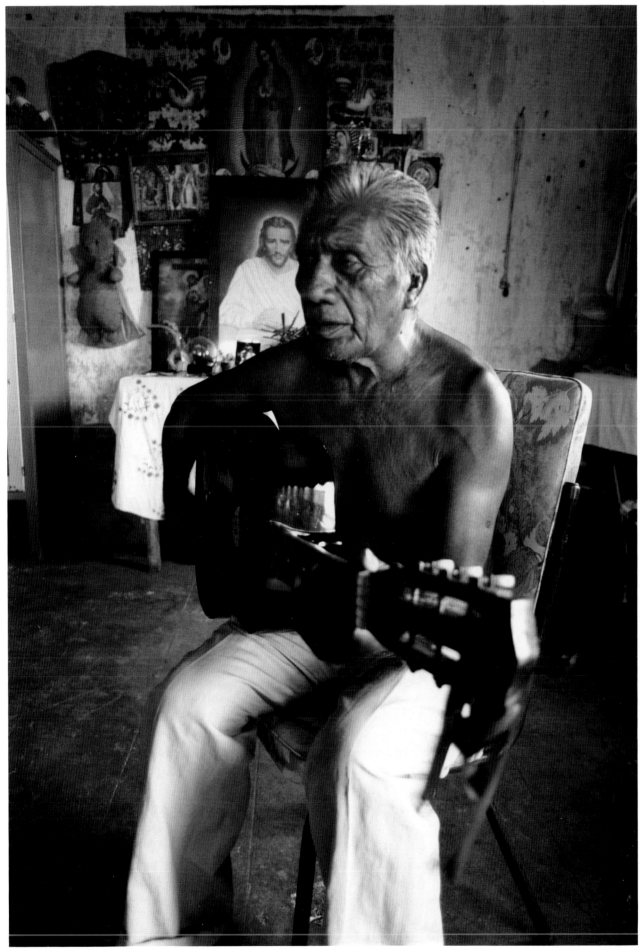

139

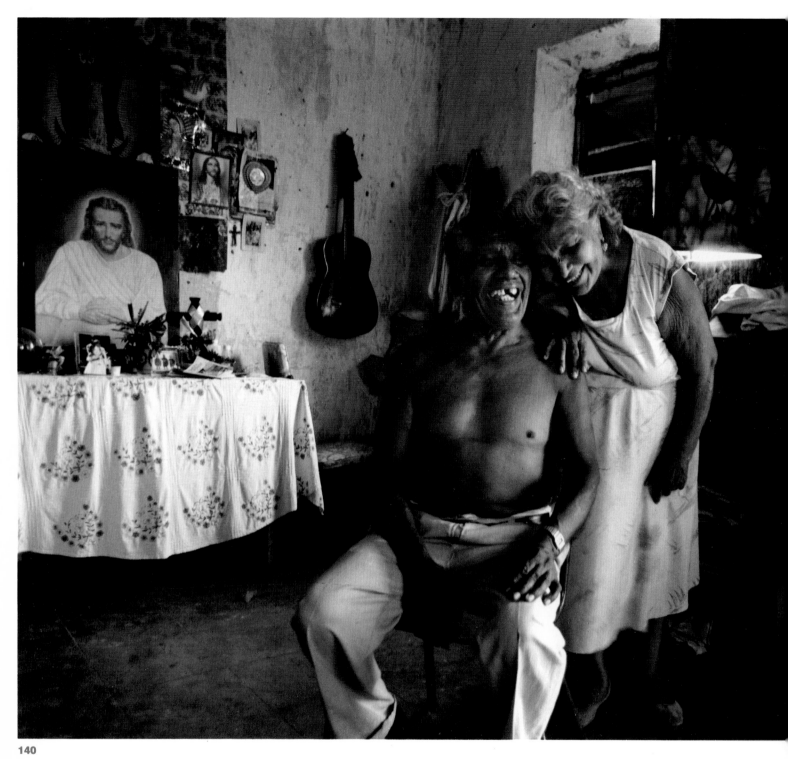

140

140 *Chucho and Eleodora inside their home. Ruinas de Aké, 1990.*

but Chucho was still working as a night watchman in Mérida, now for a department store. He spent sixteen hours six nights a week commuting and working, earning $4 a night. He had been able to keep a million pesos in his new bank account, and the monthly interest had helped them get by—enough to help repair the hurricane damage on their house and to buy a small black-and-white television set which Eleodora had enjoyed during their stay with her son in Mérida.

Eleodora told us how glad Chucho was going to be when he saw us. It turned out that my letter (which I had sent trying to cheer him up during his illness and give him something to look forward to) had inspired him to prepare a party for us. We had sent them an invitation

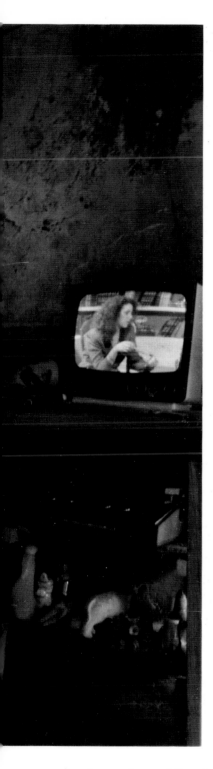

so they knew the wedding date. He and Eleodora had killed a twenty-pound turkey, had cooked and baked and then waited for us to show up for our honeymoon. All day they waited and into the night.

There was no way we could apologize sufficiently for this. Chucho, when he arrived, was a perfect gentleman. He got out his guitar and, for over an hour, he sang love songs for Mary, appropriate for a honeymoon. They were gracious enough to laugh with us as we explained that we were hoping our honeymoon was never going to end and that we were still on it, but I felt terrible. Chucho and Eleodora laughed and told us we had missed a great meal.

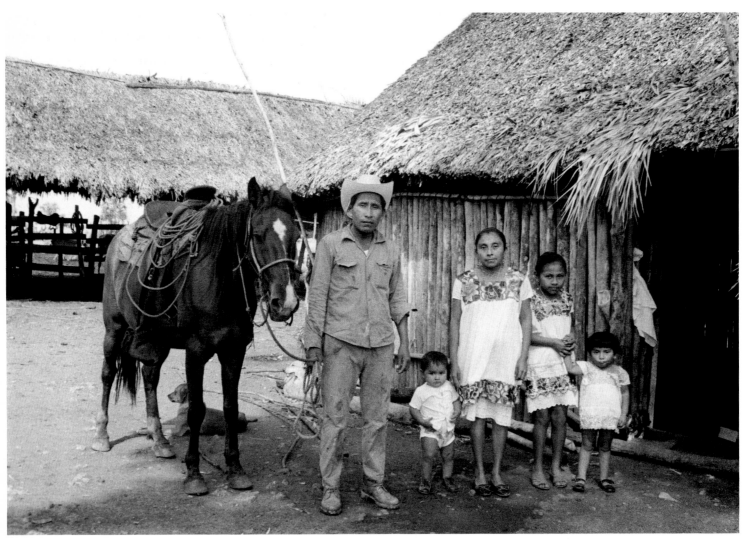

141

141 *Elutorio Noh Ceh and Juliana with three of their six children. Rancho San Manual, 1976.*

5

Cowboys

Corn
to
Cattle

I never thought I'd find Elut crippled and his wife dead. Their life had seemed so idyllic. I remember how I had met them. I wanted to visit a ranch in Yucatán. Negro Aguilar in Valladolid suggested I talk with Licho Centeno, the second baseman for the Valladolid baseball team that Negro coached. Licho's family had a ranch in the north, beyond the cattle town of Tizimin. Although I'd known him for years and sometimes played baseball alongside him, Licho had never mentioned the ranch. His main pursuits were chasing women and drinking. When I told him I was interested in visiting it, he readily agreed. We arranged to meet at the Bar Conquistador to discuss the details.

I arrived first and ordered a beer. In many bars in Mexico, and especially in Yucatán, the waiter brings small plates of spicy food, called *botanas,* with each beer. Depending on the bar and the locale, the *botana* might be anything from bean dip and chips to fried meat or fish, ceviche (raw fish in lemon juice), conch, lobster, deer, liver, *chicharones* (fried pig skins), pickled vegetables, squash, and fresh fruits.

Negro often warned me to never trust the food of a skinny cook. This bar employed a grossly fat cook and a bartender who was friendly and talkative. So I ordered another beer for the *botanas* that would come with it.

The bartender came over to the table where I was sitting. *183*

"I have something you have to try. I've just invented a new drink and I think it's my best ever. It's the ultimate. *Garantizado!*"

"What is it?" I asked.

"*El Meg-a-ton!*" he said, pronouncing each syllable as if they were separate words. "You want to try it?"

"El Megaton?" I laughed. "Is it supposed to knock me out?"

"You tell me," he said. He went to the bar and quickly returned with a shot glass. "It's on the house. I want your reaction. Tell me what you think of it."

"What's in it?"

"Drink it first, then I'll tell you—but don't worry, it's good."

I downed the drink and put the glass back on the table.

"*Muy fuerte, huh*," he said, reaching across and slapping me on the shoulder.

"It's not a casual drink," I agreed.

"Casual? Hell no! I used five parts brandy, five parts 151 proof rum, and two parts tequila."

"It's serious."

"Exactly," he said. "That is why I like it. I think it will attract the serious drinker. El Meg-a-ton!" he intoned proudly. "It's a real killer, isn't it?"

Licho arrived an hour late. He apologized by boasting that he'd just gotten up after dancing until 6:00 A.M. with an American girl he'd met. Valladolid was celebrating its annual Feria de Candelaria fiesta, and Licho wanted to know if I was serious about going to the ranch. He thought it would be much better to continue partying. Finally he agreed to pick me up at 5:30 A.M. the next morning.

We drank another beer, then went to the bullfights to join Negro and some other ballplayers as they fought one of the bulls. It was the hour of the *aficionado*—anyone could enter. Although we were amateurs, the bulls were professionals. A watermelon vendor, thinking the bull would be distracted by so many people in the ring, tried taking a shortcut across the plaza. The crowd was delighted when the bull crumpled his tray with his horns.

Licho arrived at 6:30 A.M., driving a large truck loaded with supplies and returning workers who had attended the fiesta. Most of them had been at the bullfight the day before and recognized me. Joining us in the cab were Eulotorio Noh Cen, the ranch foreman, and his wife Juliana, who had their three-week-old baby in her lap. I tried talking with Elut, but Licho usually answered for him and pestered me to give them all English lessons so he could converse with the American girl he'd danced with.

We drove through a low fog past Tizimin to where the pavement ended. We passed high jungle and then wide stretches of savannahs, with fewer and fewer pockets of jungle.

We entered the wooden gates that announced Rancho San Manual. The driveway, flanked by fruit trees, led to a group of Maya huts clustered around corrals and holding pens. Orange and lemon trees grew near the huts.

Licho used his truck—there wasn't one on the ranch—to bring in

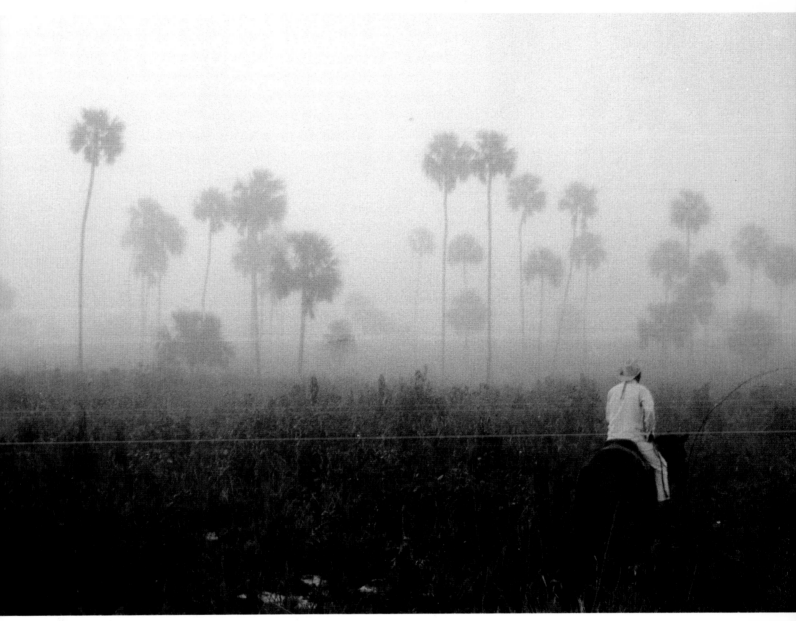

142

sacks of corn and squash that the workers had harvested. After a few hours he wanted to leave. He didn't believe that I really intended to stay. He told me that ranch life was too unhealthy and rustic—no single women or cantinas around. He felt sure that I would regret staying and would hold him responsible. Once I hung up my hammock, however, he saw I was serious, and he ordered Elut to see that I ate well and to provide me with a horse.

Elut offered to take me on a tour. We saddled up two horses and followed a dusty path between stretches of fenced pasture. I asked him where he was from and how he had become a *vaquero*.

"I was born in Ebtun (a small village west of Valladolid) in 1944," he explained. "As I grew up, I helped my father in his *milpa*, and then I had my own. But after I got married, cars and trucks started passing by the village more often. It disturbed my sleep. Sometimes I would lie awake all night, unable to rest just because of the traffic. So I said to my wife, '*Querida*, we can't stay here any longer. Tomorrow I will go to Valladolid to look for work.'

142 *Elut rides out at dawn to round up the cattle. Rancho San Manual, 1976.*

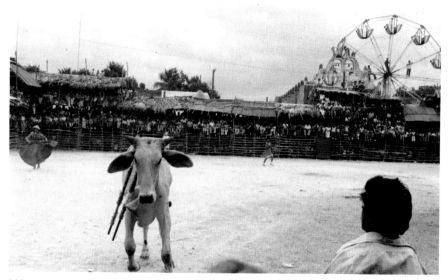

143

"'What will you do?' she asked me. 'What type of work will you seek?'

"'I don't know,' I answered her, "'but I trust God will help me.'"

Elut smiled and continued to tell me his story. "The very first man I met was Don Humberto Centeno, Licho's father," he said. "He asked me if I knew anything about cattle. I told him no. He said that would be all right because there was other work to be done on his ranch. He warned me that many of his workers had quit because they grew restless from the quiet. 'My ranch is very rustic,' he told me.

"I was overjoyed to hear this. We moved to the ranch. I cleared land and planted fields of corn, squash, and beans. Don Humberto noticed how hard I worked, and told his ranch foreman to teach me about cattle and horses.

"I didn't know it, but Don Humberto was dissatisfied with the way his foreman treated the animals. I learned quickly and within a year he fired the man and made me foreman."

"You must be very proud," I told Elut.

"Don Humberto is a good man to work for, and I like the ranch. Our only disappointment is that there are no schools nearby. Our two eldest sons live with my in-laws in Ebtun so they can study, but they return every summer. We still have four children here with us."

"Do you leave the ranch much?"

"Maybe once a year, sometimes twice. We always go to the fiesta and bullfights in Valladolid, and we visit our families in Ebtun. But if we're gone for more than a few days, the children start crying at night." Elut looked at me and grinned. "The city disturbs them," he said.

As we rode, Elut told me more about the operation. Don Humberto Centeno had started the ranch in 1961. It was sixteen square kilometers in size, four kilometers on each side. Eustaquio Noh, from Chemax, helped as a ranch hand with the cattle, and another dozen men worked in the fields. Each year more forest was cleared on the ranch. First it was planted with corn, beans, and squash. After two years it was seeded with grass to provide more pasture. Much of the food produced was used by the ranch for feeding the workers and the animals.

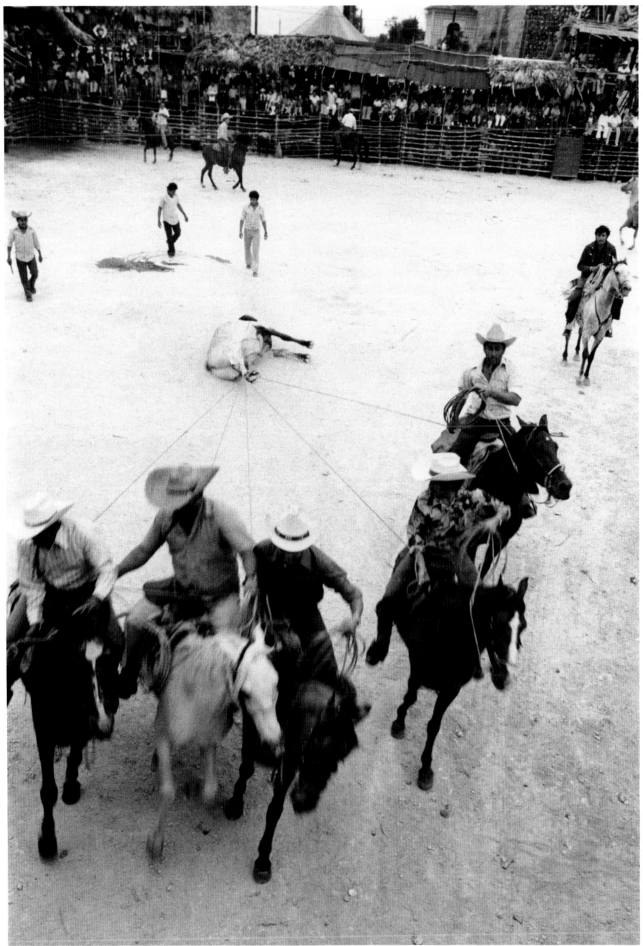

144

Don Humberto raised white brahmas and, to supply the ranch with milk, several Swiss and Holsteins. These were born to brahma cows through artificial insemination. Don Humberto was always improving his cows, selling off the poorer ones. He sold the novillos (steers) when they were two years old at the end of the rainy season when the cattle were fat and healthy. Two months earlier, in December 1975, he had sold over 200 steers, each averaging between 400 and 500 kilos, for $0.76 a kilo in Tizimin. He earned about $70,000.

Don Humberto's ranch was located on savannah land on the flat and salty coastal plain that stretched to the north coast of Yucatán. Don Humberto took pride in his ranch, unlike some other ranchers I'd met to the south, who were primarily businessmen interested in government subsidies that promoted the conversion of "economically unproductive" forest land to cattle production. Besides the tremendous ecological loss from cutting down large tracts of tropical forest, this policy ignored the local Maya dependence upon the jungle for their subsistence living. A Maya farmer cleared his land in small plots and cultivated his year's supply of corn, squash, beans, and fruits. His contribution to national food production was meager beyond satisfying his own needs. Cattle ranching contributed directly to the national economy, but it deprived the local communities not only their food, but also their building supplies, firewood, herbal medicines, and game. The local men were

145 *A spur worn by Seurbulo Ay. Chichimilá, 1976.*

145

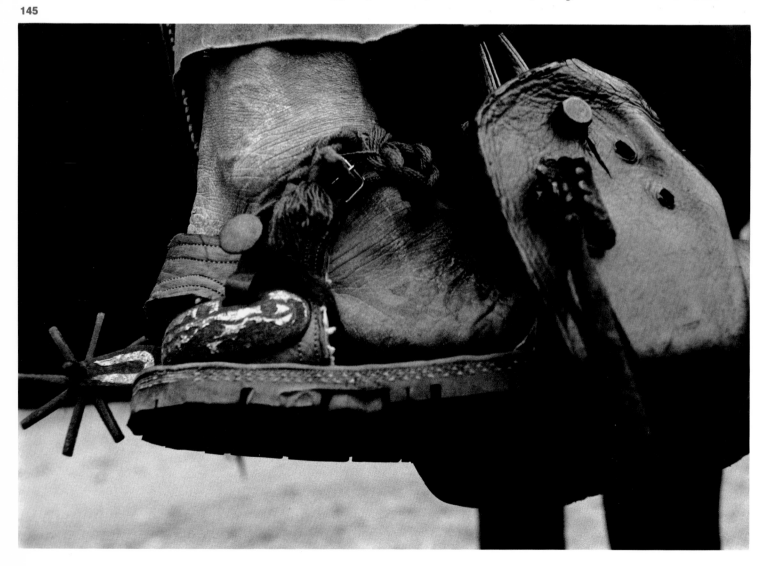

Macduff Everton

forced to find work on the new ranches, go to towns and cities such as Cancún, or migrate hundreds of kilometers to cultivate remote areas. Women and children remained in their villages, economically widowed and orphaned, save for Sunday visits from the men.

I shifted in my hammock when I woke up, looking through the pole walls to see if there were any fires or movement outside. A transistor radio was switched on in an adjoining hut. Syllables rolled quickly off the Honduran announcer's tongue as he tried waking up all of Central America. He boasted 50,000 watts of *potencia* and, as the volume went up with an advertisement, the dogs started barking and a rooster joined in. I put on my hat and dressed quickly. The announcer dedicated a fast *ritmo tropical* (tropical rhythm) to all the truck drivers who hadn't slept that night.

When I opened the door several pigs snorted in surprise and scrambled away, bouncing off each other as they disappeared into the darkness and morning mist. Near the cattle pens I met Elut. We saddled up our horses, using gunny sacks for saddle blankets, and spoke softly to them. I could feel my horse standing wide awake as he listened to the ranch come alive.

Elut invited me for coffee, and I followed him to his house. One of his daughters ran over and hugged his legs. He scooped her up and swung her into the air. Then they both walked over to look at his tiny son lying asleep in a hammock. Juliana was at the cooking fire. She lit a candle for us and brought it over to the table, along with fresh coffee and bread bought in Valladolid. Juliana and I shyly exchanged good mornings, and she glanced proudly at her husband. They smiled at each other in a way that made me feel I was intruding on a honeymoon, so I drank my coffee and went back out to the horses.

It was still dark as we rode out on the savannah. The low fog seemed to mute the sound of our horses. It was a very private, still moment so we didn't say anything to each other until a mist-colored brahma cow streaked by us. Our horses shied violently, but it happened so quickly we had to ask each other if we'd seen it.

The sun rose, imbuing the fog with a diffused yellow light. A flock of parrots broke the silence, shrieking raucously as they rose from tree tops. We came to a large fenced pasture of low rolling hills covered with palm trees and belly high grass, where we spread out to round up the cattle that were grazing in small bunches. Each day Elut herded the cattle into holding pens near the ranch houses where fresh water was pumped up by windmills. Although the ranch was sixteen kilometers from the ocean, all the *aguadas* (natural watering holes) were salty.

The mist burnt off as we worked, adding to the humidity. The cattle were used to the daily roundup, and most of them started moving as soon as they saw us. We prodded a few bunches with whoops and shouts and chased them in the right direction. As the brahmas lined out, we followed them slowly. Halfway back we were joined by Eustaquio, who was bringing in cattle from another pasture. Dust raised by 3,200 hooves stuck to us as we sweated. It was already hot and humid. The magic of the early morning was gone.

At 9:00 A.M. we had the cattle in the corral. They milled around,

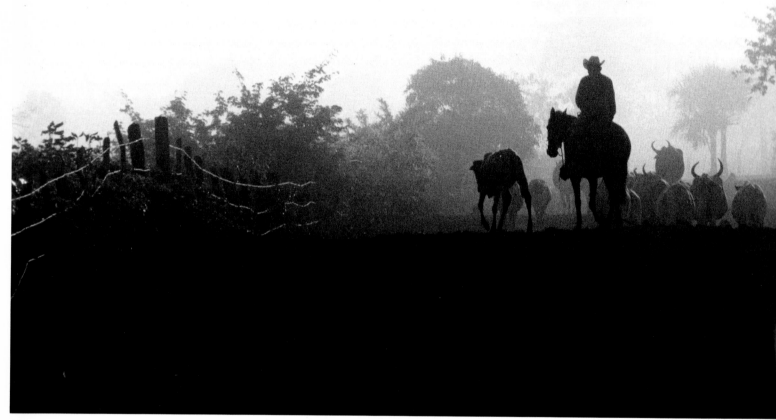

146

146 Elut brings the cattle in each morning. Rancho San Manual, 1976. **147** *A cow prepares to jump in and swim the tick bath. Rancho San Manual, 1976.*

many lying down to wait out the heat of the day, while others nuzzled each other. A few fights broke out until the proper bovine order was reached. Before tying up our horses, we checked the water level of the troughs.

A loose herd of hogs ran to greet us, grunting and squealing with anticipation, and they followed us to a storage hut where squash was piled high within a bin. It was cool and dark inside.

We cut the squash in half and threw it to the pigs after digging out and removing the stringy seeds, to be dried and planted in the new fields.

We entered Elut's hut to eat breakfast, surprising a brahma calf. Juliana was feeding soaked kernels of corn into the gas-powered corn mill in the center of their hut, surrounded by a hungry circle of

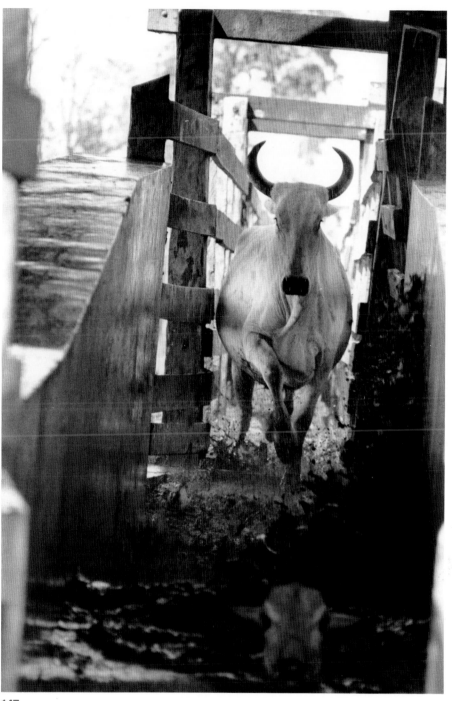

147

chickens, turkeys, hogs, ducks, cats, dogs, and the pet calf waiting for
bits of corn to fall to the ground. Juliana smiled as soon as she saw us
and shut off the mill. Elut and I shooed the animals away, the children
joining in the fun. Juliana went over to the fire to prepare our breakfast.
She always seemed to be smiling, especially when Elut was in the room.
All her upper front teeth were gold, turning her smile into a glow.

Juliana made us hot tortillas as we ate black beans, tortillas, chiles,
fried eggs, and coffee. After breakfast we started bathing the cattle in an
antitick solution. This had to be done every fourteen days. We put all
800 brahmas into one corral and worked the cattle on foot instead of
on horses. The tick bath was a narrow thirty-foot-long trough that was
six feet deep at one end and tapered up at the other. The cattle exited to
a small concrete pen where the excess tick solution dripped from the

(following pages)
148 *Elut herds cattle on foot in the holding
pen. Rancho San Manual, 1976.*

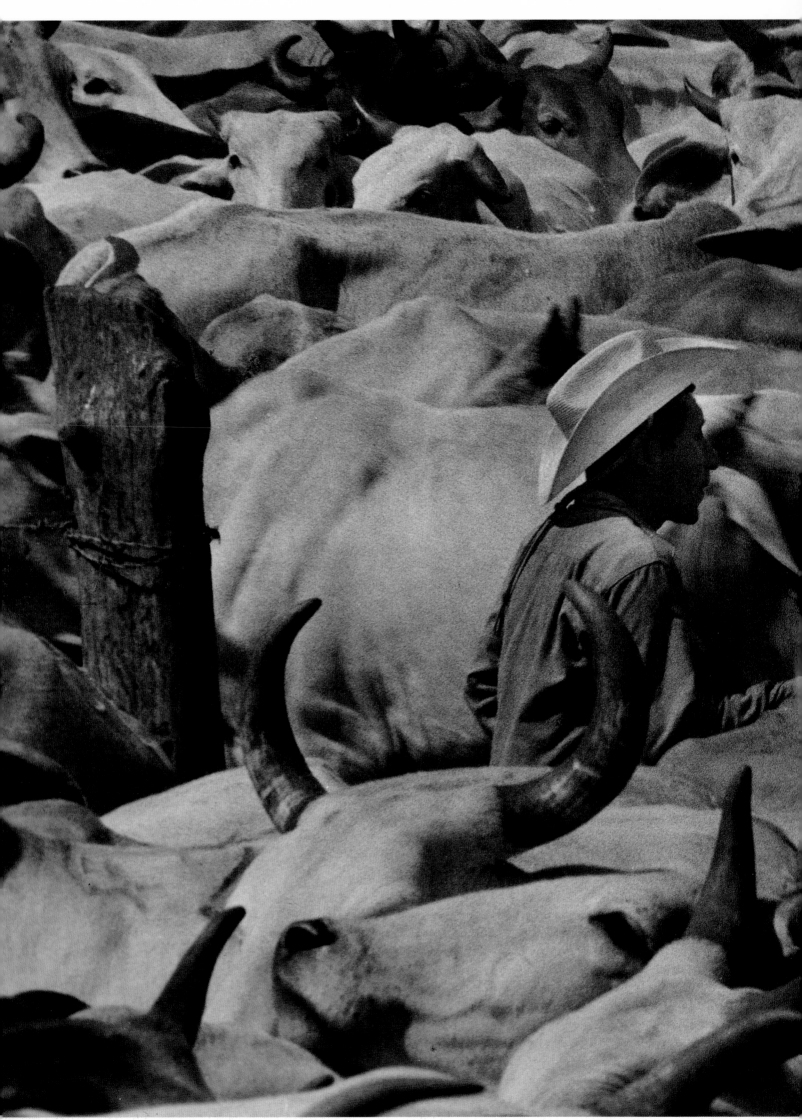

149 *Elut confers with ranch owner Humberto Centeno. Rancho San Manual, 1976.*
150 *Licho returns to the fire for a branding iron while Elut works from horseback. Rancho San Manual, 1976.*

149

150

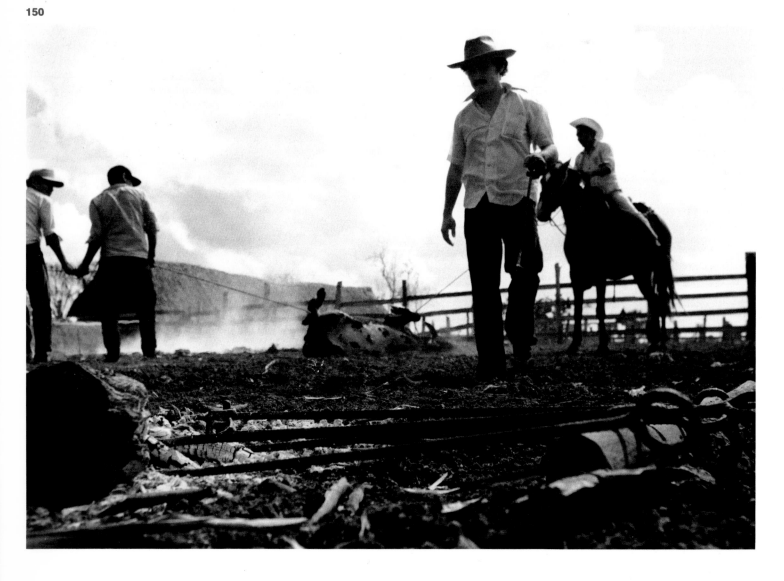

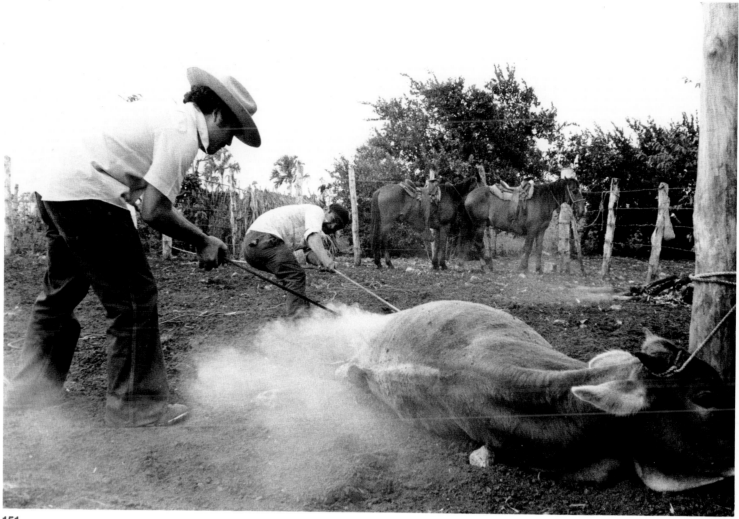

151

animals and drained back into the trough. We broke off twenty steers at a time from the herd and put them into a pen with a chute leading into the bath.

We used poles and our voices to prod the cattle into the bath—Eustaquio and I pushing from behind, Elut working the chute. The steers bellowed when they jumped into the solution, and holding their heads high, they swam the short distance. Afterwards, we'd turn them out into an adjoining corral separate from the rest of the herd.

The cattle stood looking around at us as if bewildered by the bother and noise, the loose skin on their chests flapping back and forth whenever they moved. They were all shades of black, white, tan, coffee, red, sienna, umber, blue, and gray. We all wore a light film of red dust. Their large ears looked like tropical flowers. Elut, wearing red pants, a pink shirt, and a green baseball cap, looked like a tropical blossom himself.

Sometimes a calf wouldn't swim once it had jumped into the bath, so Elut would run to close off the chute, preventing other cattle from jumping on top of it. He'd grab the calf by the ear and drag it to the end of the trough. Once it felt the bottom, it would try standing up, legs buckling, and then shake itself like a dog and run to join its mother.

Even though the cattle regularly went through this, they didn't cooperate any more than if they'd never seen it before in their lives. We

151 *Licho brands a steer. Rancho San Manual, 1976.*

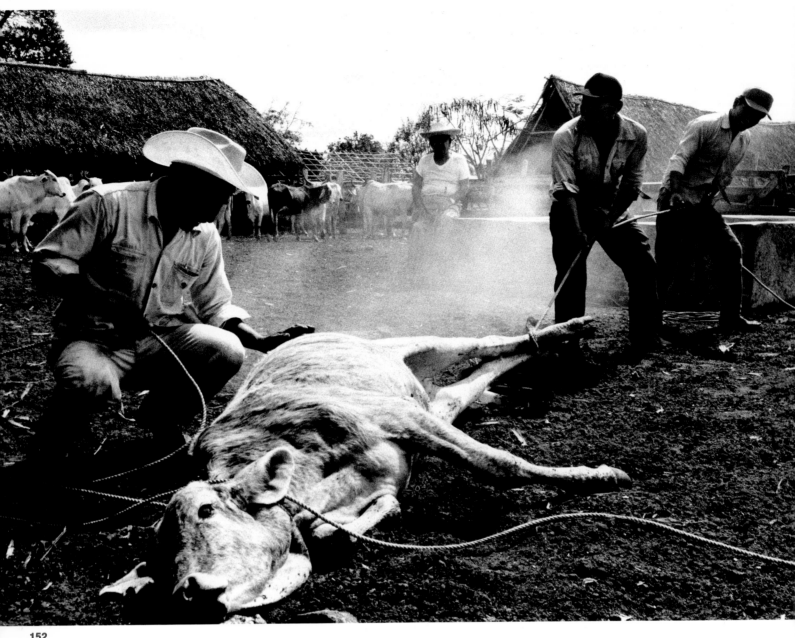

152

shouted at them in Maya, Spanish, and English, and the brahmas bellowed back and would often would run at us. We turned them back by yelling, waving our hands and, when they got close enough, by hitting them with our poles. Most of this dance was bluff, but we had to climb the corral fence several times when the cattle didn't stop. Our work went smoothly for over two hours until one steer really resisted the idea of bathing.

He was among twenty head we cut out from the rest of the herd. The angry steer fought going into the small pen and got the others all milling in a rough semicircle. They snorted, threw their horns and heads angrily, and kicked up dust. I saw the steer charge between Elut and me, trying to get back to the main herd. We both tried closing off his escape by running towards him, beating him on the head and sides with our poles. But at the last moment he turned and crashed into the fence—the only part that was barbed wire. The others followed, leaving a gaping hole.

We weren't happy. Not only did we have to repair the fence, while

not letting any of the rest of the herd out, but we also had to round up the loose cattle and doctor a few nicks and scratches. But we were grateful the cattle had run through the fence instead of us.

"Does it ever bother you walking around with so many cattle?" I asked Elut.

"No," he answered. "I'm not afraid, but maybe I have been lucky."

"Why aren't we using the horses to do this," I asked.

"I've never done it that way," Elut said. "Maybe it would be better," he added.

I realized that Elut's value to the ranch was his ability to learn exactly what he was shown, and to do it well. Elut was typical of the Maya I had met in that virtually all of his learning came through experience rather than books. He could make rapid transitions because he was confident and not easily awed. But every once in a while I was aware that Elut was raised a corn farmer.

Each evening after I'd taken my bath from a bucket of hot water, I'd meet Elut outside of his hut. We would smell of soap and talcum powder. Leaning back against the pole walls, we'd watch the palm trees lose their outline against the coming night. Eustaquio and the other ranch hands would drop by and join us, grabbing rough-hewn benches to sit on. We would pass out cigarettes and blow smoke at the mosquitoes hanging around our heads.

This was a time for Elut to get reports from his hands and to review what had happened that day on the ranch. I'd often get distracted by the sounds of Juliana inside making tortillas for supper. I liked the aroma of black beans boiling on the fire—it always made me hungry.

One evening Don Humberto visited the ranch and sat with us. He was deaf, so we had to yell in his ear. He told Elut to put cement floors in the hog pens to keep them cleaner and to start feeding the hogs a special corn diet. Even as he spoke of the improvements, he stressed that he wanted the ranch to remain rustic.

"Do you like my ranch?" Don Humberto asked me.

"I like your ranch very much," I yelled."A lot of the ranches in my country are rustic."

He smiled at me, and then said, "I wish my sons felt the same way. I can't even get them to spend the night here. Licho can't bear to leave Valladolid for more than a day, unless it's to go to a bigger town. That's no good. He drinks too much. But you are his friend—you play baseball together. Can't you show him how wonderful this is? He respects you because you are an American."

"He thinks I'm crazy to stay out here," I shouted. "He jokes about the cold beers and the women I'm missing. If he could find a girlfriend who loved country living, he might be more sympathetic to it."

"His wife likes the city too," Don Humberto said.

"Huhhh," I said, finding out for the first time that Licho was married. He'd never mentioned or acted like it.

"I wish he would learn from Americans. I think Franklin Roosevelt was a marvelous man—he had vision as well as compassion."

Don Humberto continued talking about FDR for another half hour, but because of his deafness, he didn't hear the ranch hands ask who

Macduff Everton

153

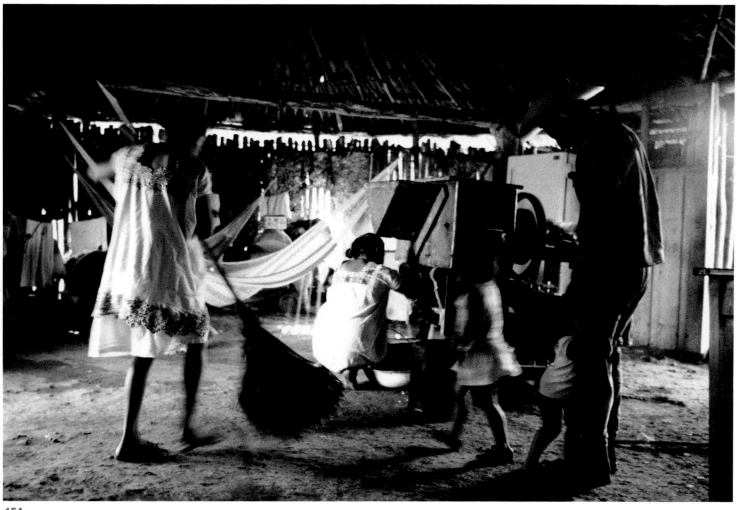

154

154 *Inside Elut and Juliana's house is the gas-powered corn mill for the ranch. Rancho San Manual, 1976.*

FDR was. When Don Humberto left, one of the workers kept looking at me and finally spoke.

"Is Castro really tall?" he asked.

"I think he's about my size," I told him, realizing I was very tall compared to the Maya sitting around me.

"Huhhh," he said. He tilted his head and thought for a moment. "Well, then, he must be very fat, no?"

"Not at all," I said. "He's in good shape."

"Ahh, you mean like Charles Atlas?" another ranch hand said.

"Yes, like Charles Atlas," the first man repeated. They knew of Charles Atlas from advertisements in Mexican comic books.

"No, not really," I said. "Why do you ask? What do you want to know?"

The ranch hand puffed on a cigarette and blew out the smoke quickly.

"I was lied to," he said. "When I was in Valladolid a man told me that Castro was *el hombre mas grande del mundo*—the biggest man in the world."

"Maybe he is," I said, trying to cheer him up. "Maybe he is for some, but your friend meant it as a figure of speech. It's an expression."

"Huhhh," the ranch hand mumbled. No one said anything. They all looked away and slapped at mosquitoes. An eight-foot-tall muscled giant would have been much more interesting to talk about than a figure of speech.

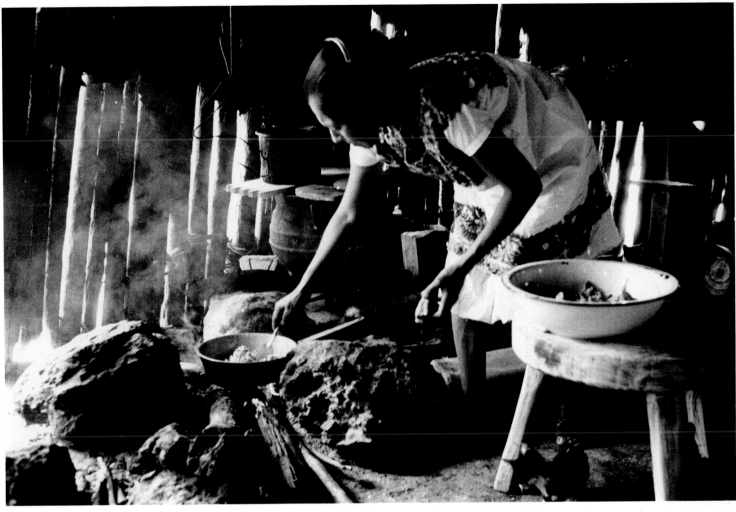

155

155 *Juliana in her kitchen preparing lunch.*
Rancho San Manual, 1976.

In July 1988, I returned to see Elut. I heard in Valladolid that Don
Humberto had died. I started looking for Licho and was told that his
brother had been elected town mayor. I found Licho at his house early
that evening just after a rainstorm had passed. When I knocked, I
stepped into a mass of stinging ants that had come up out of the wet
ground onto the sidewalk. Licho's wife answered and called him to the
door. He didn't invite me in, so we stood in the street, away from the
sidewalk, slapping at the ants whose bite stung and then burned. Truck
after truck bound for Cancún rumbled by, forcing us to shout to be
heard above the traffic.

"Are you still playing baseball?" I asked him.

"No," he laughed. "I'm playing tennis now. You just need one person
to play with and with baseball you need a lot more." He looked at me
appraisingly. "Do you play tennis? You want to play tomorrow
morning?"

"No," I said. I tried bringing up some good recuerdos (memories) of
playing baseball with Licho, but he interrupted.

"Did you remember the time we went to the dance in Chichimilá?
You went off with your *compadres* while I went off with that girl and
forgot to give you a ride back to town." He laughed and hit me on the
arm. "At 4 in the morning you had to walk all the way back to
Valladolid."

It was like Licho to remember this as one of the highlights of our relationship. Like many of the Valladolid gentry, he considered friendship with the Maya to be beneath him. The fact that I had chosen to party with my Maya *compadres* instead of drinking with him and his friends at their table amused Licho to no end. It was easier to brand me a crazy American than to deal with the chasm that exists between workers and bosses, white and Indian. Licho believed the Maya could join the mainstream economy as his laborers but never as his equal.

I chose this time to ask about Elut as I hadn't seen him for several years. Licho said Elut had quit—"He was tired of the rustic living"—and had returned to Ebtun, but if I wanted to see him, he'd be happy to help me look for him. He'd pick me up in the morning, around 9:00 A.M., after he played tennis.

I had my own car. I left early the next morning to find Elut on my own. Licho hadn't changed. Several people had already told me that, now that his brother was *presidente,* he drank as much as ever, but now never even paid for his drinks. Licho was the first acquaintance I'd visited in Yucatán who hadn't immediately invited me into his home. I had a feeling I wanted to find Elut without Licho being along.

Ebtun is only a village, but it took me a while to find Elut's house. I'd never been there before, and there is a natural reservation among the Maya to direct a stranger to a neighbor's house without first finding out that the stranger doesn't pose a threat. It was while talking with his neighbors that I found out Juliana, Elut's wife, had died.

At his house there was only a young woman who informed me that Elut was her father-in-law. She didn't know exactly where he was— somewhere on a ranch near Kaua, a village twenty kilometers west of Ebtun. His daughter would be back within a day or so and she could tell me.

I tried finding him in Kaua that morning, but, having no luck, returned to Ebtun the next day. Elut's daughter said her brother, home for the weekend from Cancún, could show me where their father was working. We found her brother watching a baseball game in the village of Dzitnup, and both children decided to join me. We bought loaves of fresh baked French bread and bottles of soft drinks—a real treat out in the jungle—and took a dirt road that got worse as we drove on. After nearly an hour we arrived at Elut's the same time as a rain and thunderstorm.

His hut sat on a small hill. On another small rise were several thatched huts with open sides, and a windmill spinning in the wind. After introducing me to his mother, who had come to live with him, Elut showed me around the ranch in the rain. As we walked, I told him I couldn't believe that he'd tired of the ranch as Licho had told me. He and Juliana had seemed so happy when I'd last seen them. I asked him what had happened.

"I haven't worked for Licho for three years. But I didn't quit," he explained. "A horse fell on me and crushed my foot. The doctors didn't think I'd be able to use my foot again. I was confined to my hammock for a year, but I got better."

"And Licho helped you?"

"He abandoned me. If it wasn't for my son, who is working in Cancún, I couldn't have survived."

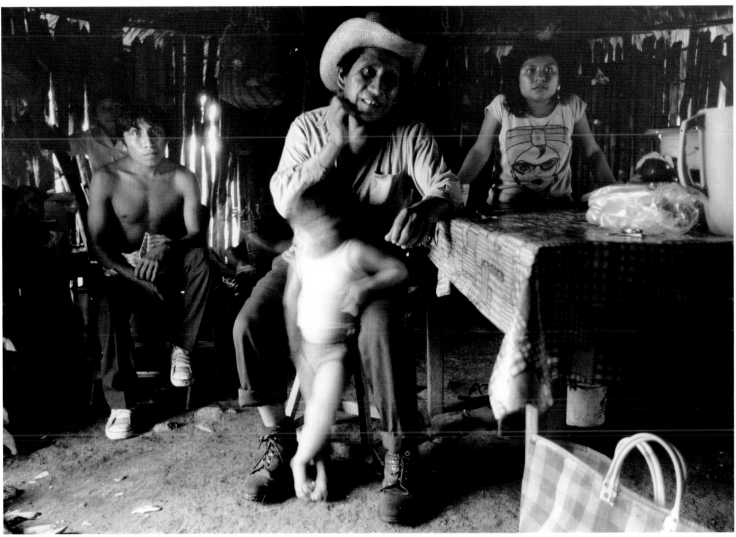

156

156 *Elut with his children in his new house (pre-Gilbert). Rancho Bok Chen, 1988.*

"Are you serious? After all the years you worked for the ranch, they didn't give you anything?"

"Nothing," Elut emphatically replied. "I worked for them for eighteen years. They didn't pay for the doctor, or for food for my family. I got along well with Don Humberto. He told me several times that he wished to give me a portion of the cattle. I was always told they would look after me."

"Was your accident after Don Humberto died?" I asked, finding it hard to believe that Licho's father would have let this happen.

"No, he was still alive."

"Maybe his sons didn't even tell him. He was very old."

"I heard that when he was dying he sent for me, but his sons didn't tell me until after he died," Elut said. "Juliana died also."

"I'm very sorry. I just found out."

"She was sick, so I brought her to see a doctor in Valladolid. I was taking care of her, but Licho told me I had to go back to the ranch—he said they couldn't get along without me. So I went back because he promised to look after Juliana. He didn't and she died."

"Son of a bitch," I said.

"Yes," Elut agreed.

157 *Elut shows off his cornfield in a rainstorm one month before hurricane Gilbert destroyed it. Rancho Bok Chen, 1988.*

●　　　　　●　　　　　●

When he could walk again, Elut had gone to Cancún for work, but he didn't like it. Sometimes, he told me in amazement, the restaurants didn't even serve tortillas. Elut returned to Ebtun. His uncle, who had a restaurant in Valladolid, had just bought Rancho Bok Chen. Elut began working and making improvements on the ranch. They raised some pigs, chickens, turkeys, and a large field of corn. The pigs were kept in thatched-roofed pens with cement floors that drained off the hill. Mud was all around from the rains, but the pigs and their pens were spotless. Elut and his son knocked down several coconuts and we took them back to his hut to open.

"Are you running cattle here?" I asked.

"No, not yet," Elut said. "My uncle doesn't have much money to invest. We're raising corn. Maybe you can take a picture of me in my *milpa*." Elut smiled shyly. "It is beautiful."

Lightning hit nearby, lighting up the inside of the hut like my flash, followed quickly by a roar of thunder.

"Chaak is speaking," I said, as another crack of thunder sounded further off. "Do the *milperos* here still practice their *Ch'a Chaak*?" I asked.

"Yes," Elut said. "All the villages around here have their ceremonies every year."

"Do they even have boys croaking like frogs?" I asked.

"Yes," Elut said. "The boys crouch at the altar where they place the ceremonial bread loaves. I just participated in a *Ch'a Chaak* at the ranchito nearby."

"I have to come back then—I'd love to see that," I said. "I've always wanted to participate with the frogs calling Chaak—but they haven't been doing that for at least twenty years in Chichimilá."

Elut smiled and told me I was always welcome. He cracked open the coconuts with his machete and his son poured the milk into a red plastic bucket. Elut's mother had put a pot of beans on the fire and was grinding corn in a hand grinder. When she finished, she started making tortillas with the fresh masa.

"When my uncle first bought the ranch," Elut said, "we brought an *(ah) men* from Ebtun to perform a *Loh* (literally "redemption" in Maya)—a cleansing of the ranch. Don Nicolas set up his altar underneath the big tree in front of the house. He brought some ceremonial *balche* wine which had fermented for three days, and we bought him four bottles of *anis* (anise liquor), candles, dried chiles — everything he needed. We killed four turkeys and four chickens, and my mother boiled them to make a broth. My uncle and his sons came, and we prepared an earth oven and baked breads (the large breads with layers of pepita powder).

"When did you start?"

"At dusk, about eight. Don Nicolas walked around the ranch burning chile at the crosses. He had little packages tied up and he buried them at each cross."

"How many crosses are there?"

"Nine. There are two for each direction and one here. He poured a little anise on each cross and we drank some too. We lit candles and

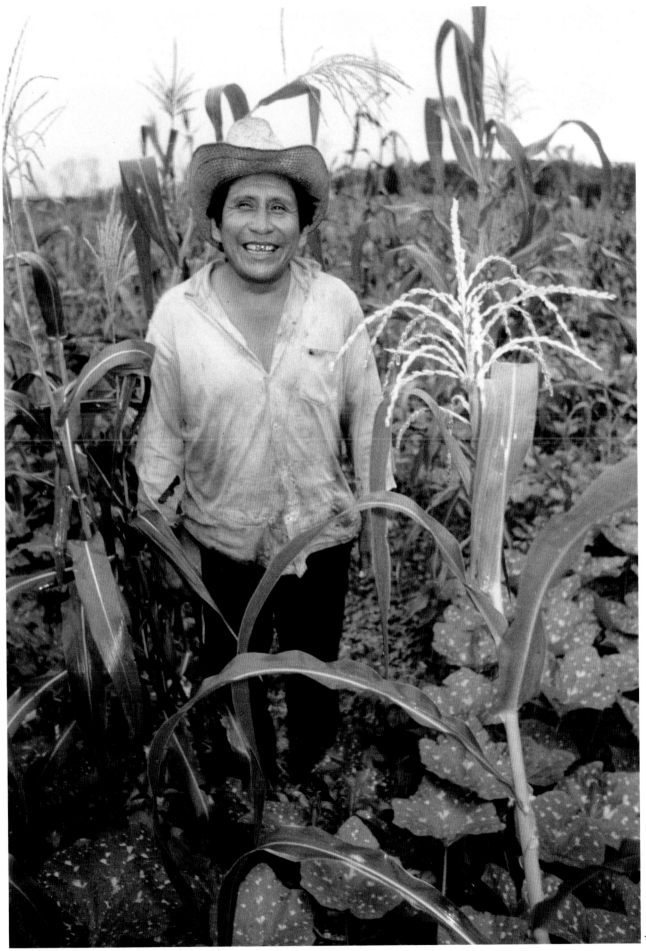

157

went around nine times. About 10:00 P.M. we opened the oven and made a *sopa* (made by mixing the bread, meat, and broth).

"Don Nicolas prayed at his altar and he worked with a crystal ball in front of a candle. He used thirteen pieces of corn to see if the feast was accepted by the spirits and God. He prayed until about two in the morning."

"Is this something that is traditionally done?"

"Well, what happened was that a lot of the pigs and chickens died when we first came here. That's why we asked the help of an *(ah) men*. He said this was an old ranch and we needed to perform a *Loh* at least every five or six years. Since the ceremony two years ago, we haven't had a single pig die."

Elut's ranch reminded me of Yucatán when I first came in 1967. There wasn't any electricity here, the thatched huts at the ranchos we'd passed coming in didn't have locks on the doors, and even some of the doors were woven from jungle vine and sticks as in the old days.

At Cancún and along the highway you see so many changes. Away from this, however, the traditions seem even stronger than they were ten years ago. In the mid-seventies, Cancún was something new and exciting, and people left to take advantage of the better pay and to experience a new way of life; but now more and more people have seen the Cancún alternative and are deciding to remain Maya and continue with their traditions. Not everyone, however.

It was still raining when we left the ranch in the evening, but my rented VW had little problem negotiating the mud and ruts. I had noticed a change in Elut's son. He'd been polite but reserved when he offered to take me to his father. But on the way to the ranch, as we talked, he realized I wasn't going to ridicule Elut as some of the other *dzul* (white men) he'd had contact with in Valladolid and Cancún had done. It was obvious that he enjoyed himself while at the ranch, and I asked him if he planned on going to work there.

"No," he said. "Now I'm accustomed to Cancún. I get bored when I return to my village on weekends, unless my friends are around. There's nothing happening in Ebtun. In Cancún, there is always something to do. I like it."

Three months later I returned to the ranch. I found out Elut had been in his house with a daughter and two sons when Hurricane Gilbert struck. He could hear the winds twisting his windmill into a corkscrew when his own hut collapsed. He and his children fled to a cave three hundred meters away and waited out the storm. They weren't comfortable as the cave flooded—water cascaded in at the opening and, wide as a river, ran deep until it fell over a cliff into a *cenote* hidden in the darkness. However, after only a month, Elut had rebuilt his home and when he showed me the high-water mark in the cave, he could find humor in his predicament.

We spent another hour surveying more of the hurricane damage at the ranch, and Elut never once mentioned his own plight. I finally asked him how his corn crop was. He told me he had lost everything. It was so different from the United States where you often find out immediately what someone's problems are. With the Maya it is a combination of

pride and respect. They respect that maybe you aren't interested in their problems. When I gave Elut half-a-million pesos ($200) of the hurricane benefit money, I felt like the opening character in the early T.V. show *The Millionaire*, who went around knocking on doors and handing out money. Except the T.V. character didn't know any of the recipients and I did. They needed much more help than I was able to give.

"After my last visit here I talked with some of my friends in Valladolid," I told him later. "I asked them about Don Humberto. He fooled both of us."

"What did they say?"

"Everyone agreed he appeared to be a warm man but he had a reputation of promising many things and rarely delivering on any of them. They told me Don Humberto was a politician, and his sons learned how to deal with people from their father. Even my barber told me they probably didn't have a conscience."

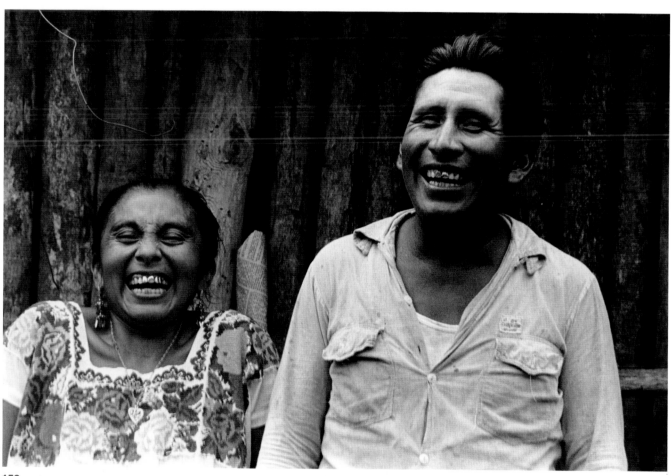

158

"Huhh," Elut said. "After the hurricane, a group from here went to Valladolid to ask for help because we'd heard the government was providing some basic necessities. But Licho's brother, *el presidente*, became unavailable and nobody got anything. They say he stole it all.

"You know Licho just came out to visit me," Elut added. "He wanted to know if I'd work for him again."

"You're kidding?" I said. "Did he apologize or say anything about not helping you?"

"No," Elut answered, "he has his bad ways."

158 *Elut and Juliana. Rancho San Manual, 1980.*

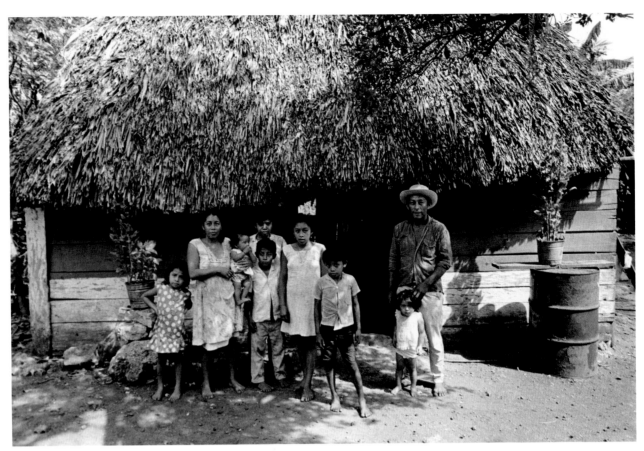

159

160

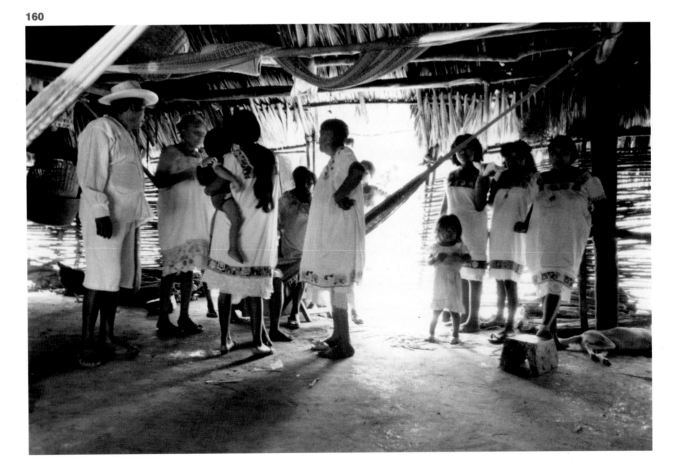

6

The Cruzob

𐃘𐃘𐃘𐃘𐃘𐃘𐃘

The Rebel Maya

Charles, Hilario, and I arrived in X-Cacal Guardia at dusk on Good Friday of 1974. On the drive down from Chichimilá, we'd seen large crowds at village churches and had to stop as pedestrians leaving the evening services flooded across the highway.

A different kind of celebration was planned in X-Cacal. Since no one would give a definite answer when it would begin, I slept outside so I wouldn't miss it. At 4:00 A.M. I woke up and alerted Charles and Hilario who were sleeping inside a guard hut.

Three men crouched in front of the Maya church, beginning the new fire ceremony—*suhuy k'ak'* or *tumben k'ak'* (literally virgin or new fire). In pre-Columbian times, all the fires in the villages and cities were put out once a year and a new fire was kindled, then distributed to all the people. Every fifty-two years, at the end of a calender cycle called the *mai,* not only were the fires put out, but tools, buildings, sculptures, and even households were destroyed and rebuilt. It isn't surprising then, with the mixture of ancient religion and the infusion of Roman Catholicism, that the ancient rebirth and renewal rituals were now being celebrated at Easter, the Christian time of rebirth.

The village commandant, Marcelino Poot, and the leader of the church, Roque Dzul, were joined by another man from the village, Francisco Tamay. They took turns "drilling the fire," briskly twirling a

159 *Pablo Canche Balam with his wife Ophelia and their children. Tulum, 1971.*
160 *Marcelino Poot and his family. Xcacal Guarda, 1988.*

209

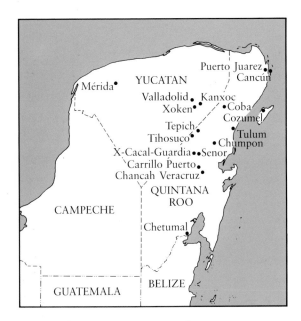

161 *Roque Dzul (l) and Marcelino Poot (r) talk with an acolyte at the Roman Catholic church in Carrillo Puerto, formerly Chan Santa Cruz. Carrillo Puerto, March 1974.*
162 *Villagers prepare offerings in front of the Maya church. X-Cacal, March 16, 1974.*
163 *A farmer decorates ceremonial breads with powdered squash seeds before wrapping them in leaves. The breads will be placed in an earth oven. X-Cacal, March 16, 1974.*
164 *Offerings to God include earth-oven baked breads, meats, and eggs. X-Cacal, March 16, 1974.*

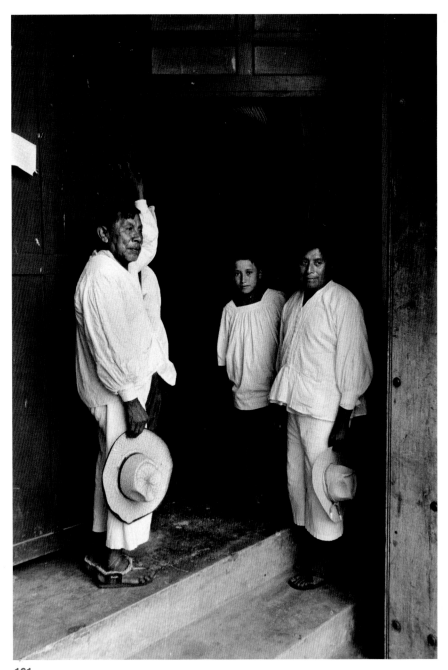

161

stick of hardwood between their palms into a receptacle made of *chac ka* wood.

After about an hour, Francisco suggested they use longer fire sticks. Marcelino borrowed my flashlight and went off to find some. Soon after they began working again, tiny embers appeared. The men fanned them and quickly added bits of native cotton which burst into flames. They built a fire and Marcelino lit a candle from the new flames. He carried it into the darkened church, removing his sandals at the entrance, and lit the altar candles.[1] We followed him into the sanctuary.

The church is a long, one-room thatched-roof building with plastered walls, rounded ends, and tiled floor. The inside walls are painted a pastel blue and green and decorated with freehand drawings of crosses, flowers, and vines. The altar is at the far end of the room, entered through an arched opening in a wall that has reversed arches topped with crosses.

162

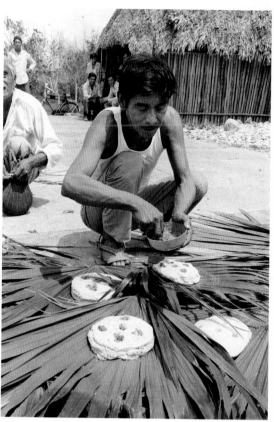

The entrance is piled high with branches stacked from floor to ceiling so that entering the *gloria* is like entering a jungle cave of vegetation. Just inside stands a narrow rough-hewn table for placing lighted candles. The altar itself is covered with embroidered cloth and the crosses upon it are draped in huipiles. In many ways, the *gloria* resembles the sacred rooms of the pre-Columbian temples, and the contemporary ceremonies can perhaps give us an idea of the Mayas' religious practices prior to the coming of the Spaniards. The Cruzob Maya (literally, 'those of the cross') have added Roman Catholicism to pre-Columbian ceremonies and created their own faith. X-Cacal Guardia is one of their religious centers.

164

163

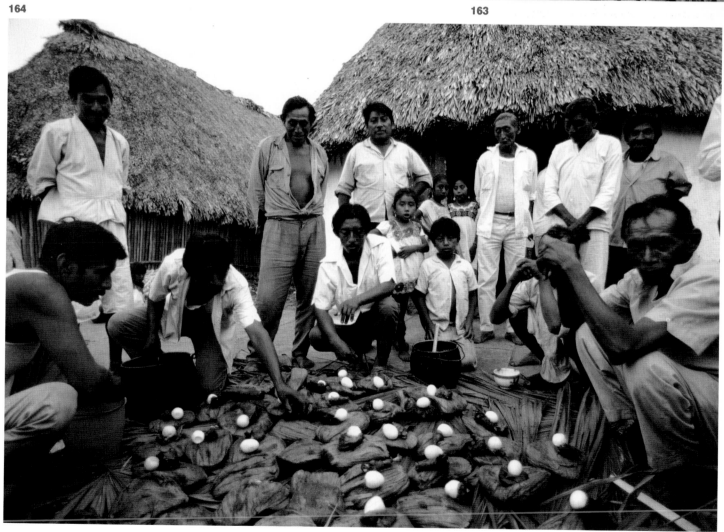

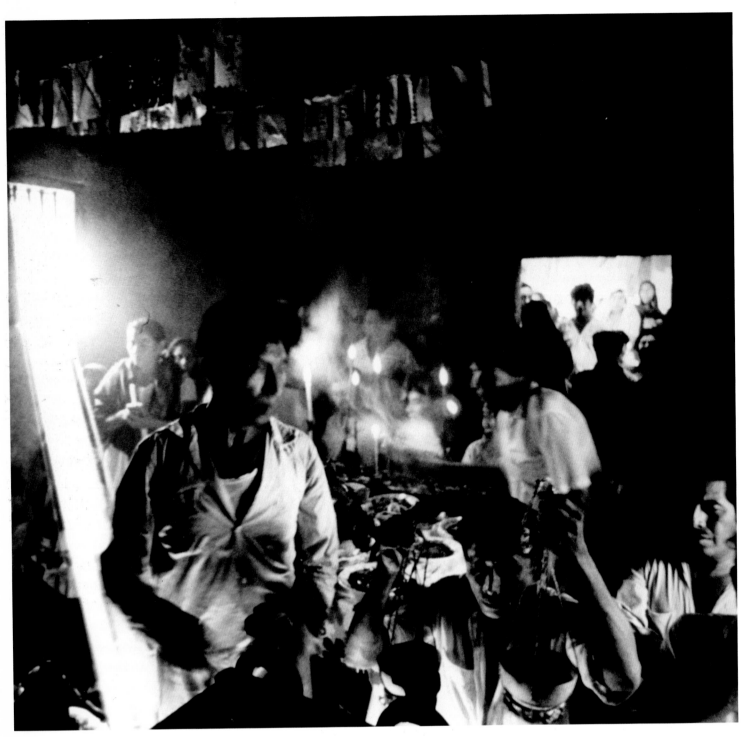

165

165 *A religious celebration at the Cross of the Center of the Earth. Xoken, February 18, 1974.*

The Cruzob are descendants of the rebel Maya who almost succeeded in driving everyone else out of the peninsula during the last century. When they began losing their struggle, they retreated deeper into the jungle and set up their own society. They created their own religion featuring a speaking cross that talked to them in Maya and helped direct their war effort. The Cruzob never officially surrendered and continue to this day to threaten to rise up again against all outsiders.[2] Of all the Maya in Yucatán, they are the most resistant to change. Visiting the Cruzob can be difficult because of their distrust of outsiders.

Nevertheless in 1988, I made arrangements to visit the Maya of the Cruzob zone. They continue to practice their modern-day Maya

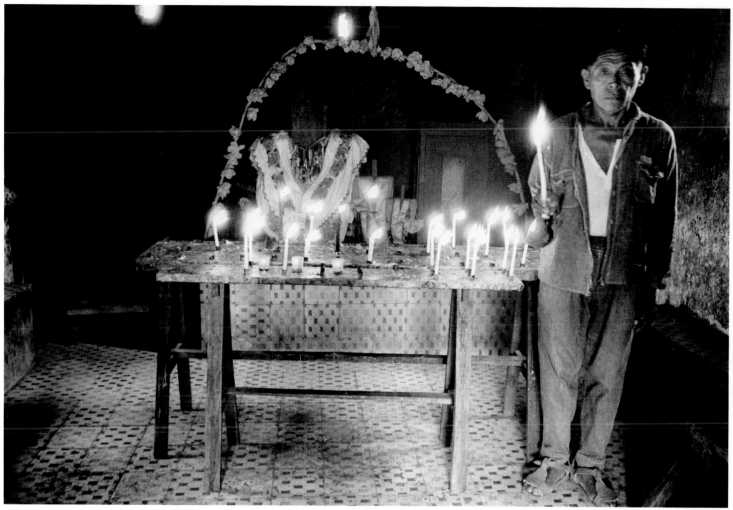

religion, worshipping their crosses at the sacred shrine villages of X-Cacal Guardia, Chancah Veracruz, Chumpon, and Tulum—whose geographic positions roughly define the territory of the Cruzob.³

The Cruzob struggle to retain their cultural autonomy. Their world view is characterized by an ethnic identity of "us" versus "them" (anyone else). Each shrine village has its own sphere of influence, with dependant villages that assist in ceremonies, fiestas, and guard duty, and together they make up the remnants of the Maya nation.

After traveling all night, I arrived in Tulum to meet up with Charles and Hilario. I came in on the narrow highway from Cancún early in the morning of November 9, 1988. I first passed the airport and then the turnoff to the beach and ruins. A motel, a couple of restaurants, bus stop benches, and a gas station were clustered at the intersection. One kilometer later two more roads led off to the beach and to the ruins of Cobá in the interior. The entrance to Tulum Pueblo was flanked by auto mechanics, and stores selling dry goods, curios, fruit, and cold beer (advertised in Spanish and English). Restaurants and cantinas offered food and drink, while a tortilla factory whined nearby. Empty broken bottles, cans, paper, auto parts, and other trash littered the roadway and verges. Jungle grew to the back doors of many of the businesses.

There were long lines of trucks parked along the road. The truck

166 *Teodócio Nahuat Canche in front of the Cross of the Center of the Earth, a pilgrimage site for the Cruzob and the Maya of Yucatán. Xoken, 1971.*

167 *Charms* (milagros) *fashioned from wax and metal hang around neck of the cross, placed by pilgrims requesting help. For example, someone with a sore leg would leave a charm of a leg. Xoken, 1971.*

167

drivers came from all over Mexico, and their ideas of life were frequently shaped by popular movies, television, and the *foto novelas* (photo comic books) rolled up in their back pockets. If it was late in the day, the drivers often suspended a hammock under the bed of their vehicle and spent the night so they could arrive in Cancún the next morning. Sometimes enterprising ladies from distant cities solicited work while the drivers relaxed. Thus, the Tulum Cruzob, whose first contact with the Mexicans had been with soldiers, now mixed with truck drivers, politicians, and whores. They still didn't think much of the Mexicans.

Only a block from the restaurants, cantinas, and the highway was the village plaza and the thatched-roof church where the Cruzob worship and pray. Protecting the church's entrance was the guardia, a large hut where the Guardians of the Cross stay. The guardians include Maya from surrounding hamlets and ranches as well as local villagers. Pablo Canche Balam, a sergeant in the church, was in charge of guard duty when I arrived. He had arranged for a group of men from small ranchos south of Chunyaxche to serve with him. The guards considered their eight-day shifts a religious service, as well as a vacation from their daily hard work. When not maintaining their vigil inside the church, they relaxed in hammocks strung from the rafters of the guard hut.

Charles told me to grab an empty hammock while we waited for Pablo to return, then he introduced me to the guards. One man explained his devotion to the cross and told me he'd given a pig to the church. Charles wanted a photo of all the hammocks because there were so many so I got out my camera. No one seemed to mind so I started shooting.

One of the guards came in with hot tortillas wrapped in a cloth and another brought in two cans of sardines in tomato sauce. They opened the cans with a machete and poured the contents into a bowl, found several chilis to add to the meal, then spread the cloth holding the tortillas out on the floor. Nine of us squatted around the bowl to eat, tearing off bits of the chilis to spice up the meal.

Charles and I went out onto the plaza to buy soft drinks and a few more cans of sardines for the guards. Two large pine trees were lying on the ground, cut up into short sections. I was sorry to see the trees chopped down. Charles told me they had survived Hurricane Gilbert but some of the church leaders were afraid they might fall on the guardia. So they were cut down. Everyone was still debating whether it was the right thing to have done. Usually decisions are reached by consensus in the village, but the trees were cut down by decree. This change in procedure was matched by the chainsaw cuts in the trees; in the past, trees were always felled with an axe.

When Pablo arrived I asked him where I could hang my hammock. He offered me a hut behind his house across the street where it was quiet and calm. I walked over and spoke with his children. They were gathered around a table in the backyard preparing offerings for the evening's ceremony ending a week-long celebrations of the Day of the Dead. They patted out corn dough and added shredded chicken, tomatoes, epasote, then wrapped the rectangular cakes in banana leaves.

I hung up my hammock and rested. Chickens pecked around the yard

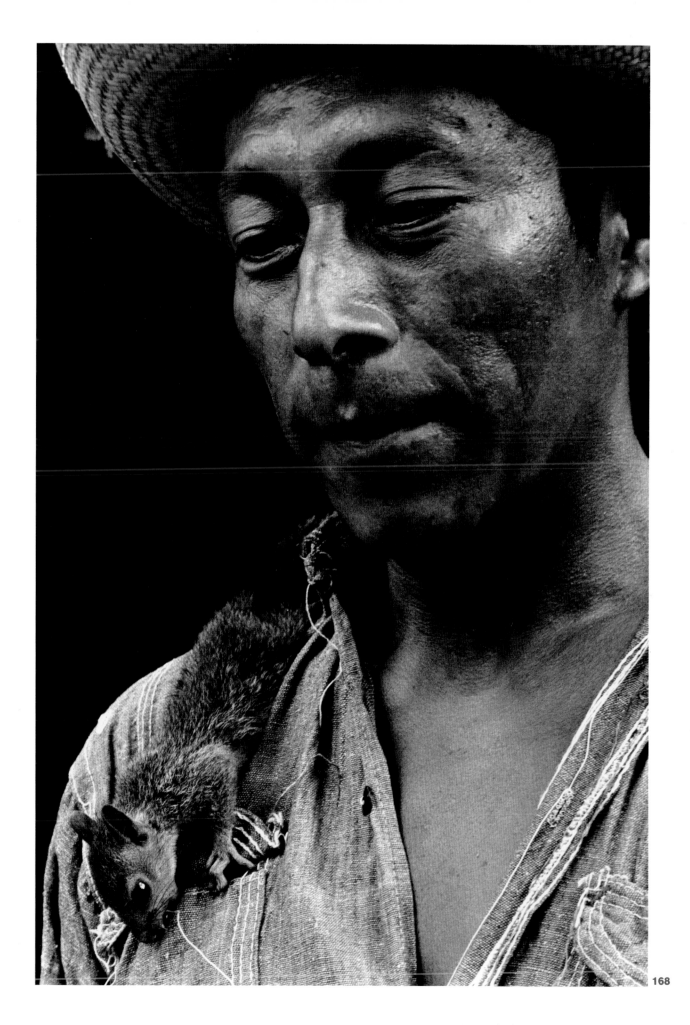

168

The Cruzob 217

169 *Pablo's son Fidel with his pet iguana.*
Tulum, 1971.

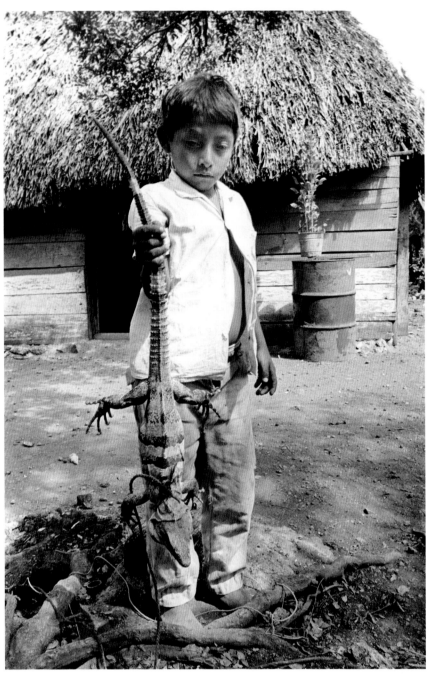

169

while a rooster crowed. Strips of light came through the slats of the pole walls along with a cool ocean breeze that rustled the bottom guanos in the thatch-roof. Children were playing and running by outside—their sandals slapping against the soles of their feet.

I'd met Pablo when I'd first come to Tulum in 1969.[4] The government was building a road south along the coast from Puerto Juarez, opening up miles of beautiful beaches and the Maya ruins. Tulum soon attracted the best and the worst of hippies, foreigners, Mexicans, and soldiers. The road allowed visitors to bring much of their own culture with them, crammed in Airstreams, Winnebagos, trucks, converted school buses, VW vans, and tour buses. Few visitors knew of the village's importance to the Cruzob.

Enterprising villagers built camping places along the beach for the

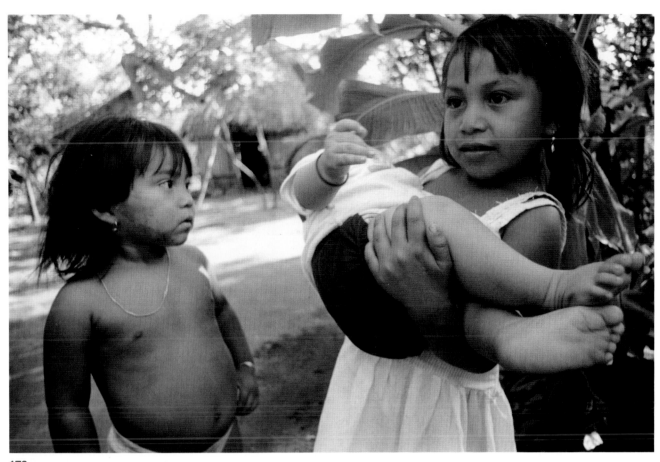

170

new visitors until, with the development of Cancún, the government expropriated most of their land for their own tourism schemes.[5] Some tried to fight for their land, but found themselves powerless in a foreign Mexican system. One of the first moves by the Mexicans during the early 1970s was to wrestle civil authority away from the Maya. They recruited *diputados,* enrolling the more ambitious of the villagers into the Mexican political system. For centuries, the villagers had policed themselves and settled their own problems. Now outsiders were making village policies, which further disenfranchised the Cruzob.

Pablo, confiding to me in the mid-1970s, could have been speaking for any of the villagers. "I'd like to resolve things once and for all," he said in a slow, weary voice. "If they [the government] take all my land, it doesn't matter to me. I just need to know what to teach my children—to fish and to learn to work with the tourists or to go farther into the jungle as my grandfathers did. In the meantime we must make petitions, and not just one, but many. If a governor sees a paper on his desk, he may not pay attention. But if next week he sees ten papers, and then fifty, and then a hundred, and the stack keeps growing larger, it doesn't matter how big a governor he is, he is going to have to attend to us.

"We are forced to walk a path with others now and we must watch out—and watch ourselves. But I feel it will be very, very, very sad," he said, even more slowly. "We are not accustomed to so many people coming here and to the type of people. They are thieves, and even those who murder. There was a group of *colonos* (colonists) brought in from the north. They were used to the desert and didn't even know these

170 Pablo's grandchildren play in his backyard. Tulum, 1988.

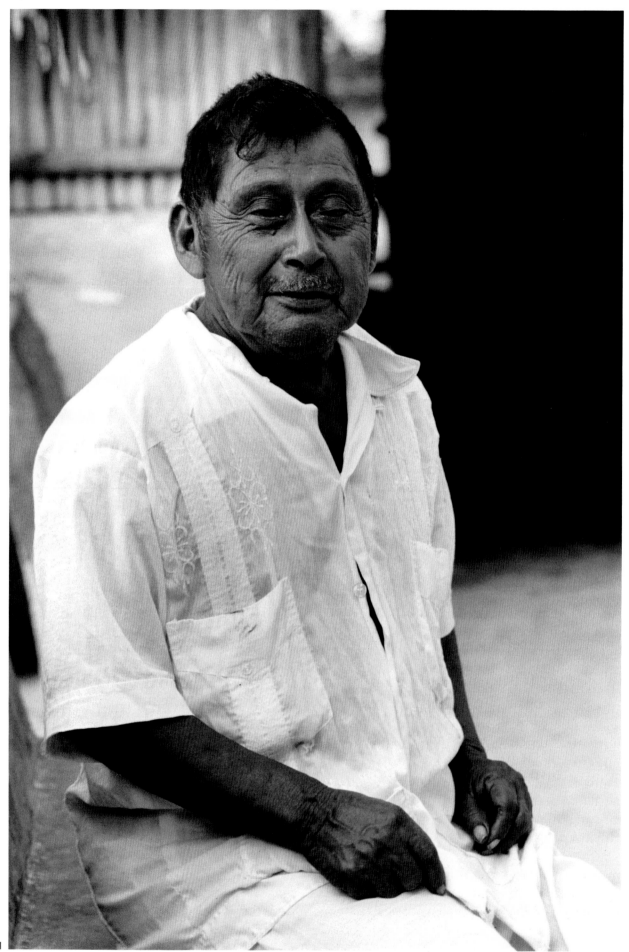

171

parts. They did not know how to farm and what to eat, so they stole from our *milpas*—our corn, our squash, our food.

"When the road was built to Cobá, men from Mérida, hunting at night with huge lights on their trucks, would shoot five or six deer each evening and many wild turkeys. They would sell the meat in Mérida. Now there is no game. For us to hunt, we have to go very deep into the jungle. It is a journey. It is all very, very sad for us."

The only thing the Cruzob still control is their religion.

The year 1988 was an exciting one for the Cruzob in Tulum. When Hurricane Gilbert hit, the Maya opened all the doors of their church. A few candles blew out, but the church suffered little damage. A block down the street in the new plaza the Mexicans were building, the roof was blown off the Roman Catholic church. The Cruzob didn't gloat over this, but they believed their salvation was a sign. (Obviously it wasn't just the wind that caused this damage, but everyone knows bad talk only invites trouble.)

Another recent event was the return of Tulum's cross. Juan Ek, the Guardian of the Cross, had emigrated to X-Cacal Guardia as a young man. Ever since, the Cruzob of Tulum had pilgrimaged to X-Cacal to worship their cross. Now he had returned, bringing the cross with him. He is a small, elderly man who is sometimes hard to understand because he occasionally rambles when he talks. Charles and I asked him why he had decided to leave X-Cacal Guardia.

"It's too political there," he replied. His friend Roque Dzul (leader of X-Cacal's church) had died, Juan told us. A power struggle had ensued for leadership of the village, compounded by the election-year squabbling of Mexico's political parties.

We were interested in the Cruzob's apparent obsession with secrecy.[6] Tulum's crosses are often covered with a shroud. We asked Juan Ek about it.

"Would a king appear naked?" he replied incredulously. "Before, the cross used to speak, but not anymore. Still, the cross and God are related—it is as if when you have a problem here, you first go to the mayor, who might refer you to Carrillo Puerto, and then to the governor, and then maybe to the president of the Republic of Mexico. The cross serves the same purpose. To talk to God you need to ask the cross."

Juan Ek knew about the governor and president. He told us he was part of a delegation of Cruzob that had been invited to Mexico City to meet President de la Madrid. They were bused to the capital, where they stayed just long enough to be photographed with the president and local party leaders from Quintana Roo. Then they were placed on another bus for the nonstop, twenty-four-hour ride back to their villages. Juan and the other Cruzob *tatichob* were appalled when they were asked to pay for a copy of the photo. Although they'd had the opportunity to talk to the president, they felt they had been used by the PRI political party for their own propaganda. At the end of the story, Juan asked us if we could get him an aluminum pot in which to cook his beans.

That night Charles and I went to the service at the church. There was a lot of activity in the plaza. Children shouted on the basketball court,

172

171 *Juan Ek, Guardian of the Cross, in front of the Maya church. Tulum, 1988.*
172 *Pablo Canche surveys damage from Hurricane Gilbert to his houses at the beach ranch he has worked for twenty-eight years. Tulum, 1988.*

among them a tall Mexican girl who made a string of exceptional shots from more than twenty feet out. All the stores were open, most with televisions or radios playing. There were a couple of cars parked alongside the plaza bearing foreign license plates. One group included four Japanese men who struggled in English, which was translated by a German who struggled in Spanish. They left in an Olds Cutlass with Kentucky license plates.

Everyone seemed to ignore the church in the middle of all this bustle. It was a nondescript building sixty feet long with a roof of guano palms and cement block walls painted white with a band of green at the bottom. The church was aligned so the altar faces east and the main doors opened to the west. Several Cruzob congregated in the corridor between the main entrance and the *guardia,* where off-duty watchmen lay in their hammocks.

At the doorway, Charles and I took off our sandals, adding them to a large pile. Everyone entered the church barefoot. Crossed palm fronds created an archway at the door behind which stood two young guards with crossed switches. We entered a large open room with a raised cement floor and benches along each side. At the far end, a seven-foot-high cement block partition separated the altar, where two more guards sat holding switches crossed over the entrance.

We sat next to the musicians. The lead violinist explained that, each week, he conducted a lesson for the young musicians of the village, teaching them to play the Maya music which accompanies ceremonies and prayer. Two boys played snare and bass drums, and another was on violin. The music they played was based on the *jarana,* a fast dance music introduced several centuries ago by the Spanish. However, the Maya had changed it into their own monotonous, mesmerizing sound, again illustrating how the Maya take something foreign and make it their own. The music also gave us a hint of what pre-Columbian Maya ritual music may have sounded like—no beginning, no end, and few special passages—an auditory background for the special occasion.

I was pleased to note the absence of a trumpet. For several years, a Cruzob band from the village of X-hazil had been featured at some of the sacred fiestas. I had found their trumpets an unwelcome addition— overly loud, entirely dissonant, and distracting. Many of the Cruzob, however, found them progressive and exciting. Perhaps they had precedent in the conch shell trumpets used by the pre-Columbian Maya.

The church was dimly lit. Sixty Indians, most of them women and children, were crowded into the *gloria,* kneeling before an altar adorned with covered crosses, wooden shrines, herbs, and offerings.[7] Every so often, the band began to play. The worshippers stood and listened to the music, bells, and prayers.

Juan Ek ended his oration and stepped quickly to a side door. We thought he was leaving so we followed him, carrying with us the aluminum pot he had asked for. As it turned out, he was only clearing his throat. He leaned out the door and spit several times before returning to lead the prayers. Pablo's daughters-in-law looked at our shiny aluminum pot and asked if it was for sale.

The *resa* lasted another forty minutes. As it ended, we went into the *gloria* to light our candles. Thirty candles flickered and our shadows

jumped along the walls. The small room was hot from so many people packed into it. Everyone was on their knees in front of the altar, paying their respects to crosses that spanned the width of the room. In front of each cross, they crossed themselves with elaborate ritual and great devotion and kissed their thumbs, before crawling a few more paces to the next one.

We gave Juan Ek his aluminum pot. He looked quite pleased and left saying he was going home to cook with it. Hilario, Charles, and I prepared to leave Tulum to visit the three other sacred villages. It had been a while since I'd last been to all of them, and I wanted to see what changes had occured. We invited Pablo to come with us and he readily agreed. As a religious leader, he welcomed this chance to mantain contact with the other shrine villages. Charles and I had decided to distribute most of the money from the hurricane benefit to the Cruzob because we suspected they would get the least relief assistance from other sources. We felt giving money to the Maya churches in each shrine village would be an effective way of helping. Maya religion stresses community involvement—its particular mixture of pre-Columbian and Catholic rituals embodies the spirit of Christianity. Members give what they can and share in the fruits of their labors. The Cruzob are actively their brothers' keepers—nearly every church service includes feeding all the celebrants.

173 *School children exercise in the village plaza, in front of the Maya church and its guardhouse. Chumpon, 1988.*

• • •

173

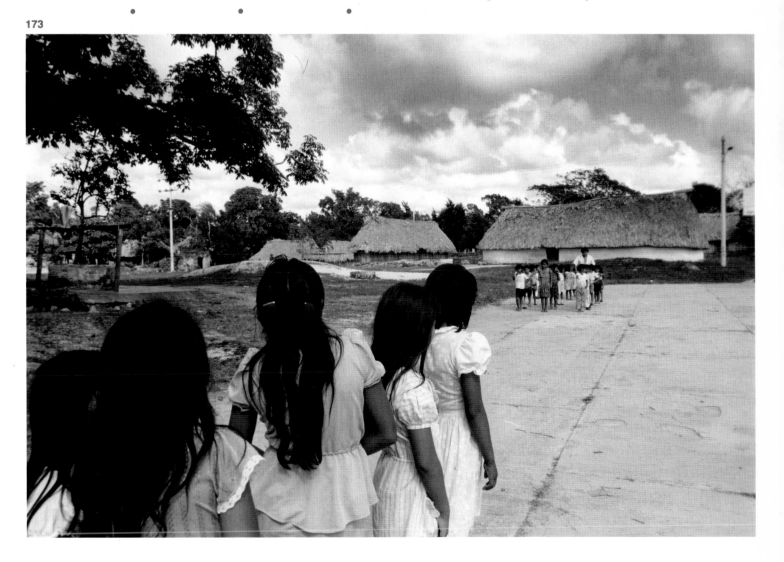

Chumpon has a reputation for violence. Its inhabitants are considered to be the renegade Cruzob Maya, and many are belligerent in their distrust of outsiders. Mexico's response has been one of intimidation. Not long before our visit in 1988 helicopters landed on the basketball court in the center of the village, and soldiers moved through town, shooting pigs and chickens, ostensibly looking for marijuana. When I first visited Chumpon fifteen years earlier I had heard similar stories. Mexico's actions only deepened the villagers distrust.

We arrived in Chumpon at midnight. There were only two men in the *guardia,* next to the church. They treated us as pilgrims, inviting us to hang our hammocks in the large thatch hut.

In the cold before dawn, the two guards arose and went over to the church to light candles and ring the morning bells. The smaller bell had a high pitch and was rung rapidly, the large one was played slowly. Together they sounded like a steam locomotive approaching a crossing guard. The sound carried throughout the small village.

I walked over to the church and went in through its green double doors on the west side. The inside was beautiful and simple—a single long room with a partition at the far end for the *gloria.* The stone walls were rounded at the ends, plastered and painted white. Heavy posts and beams held up the palm roof. The floor was laid with yellow and red tiles merging into green and red ones at the altar end of the sanctuary. The partition separating the altar was a low wall with an arched entrance crowned with a cross.

Benches and chairs lined the walls. The two bells hung from a pole, along with two drums suspended from posts. A mass of paper flowers, piñata like, was suspended from the roof. The altar was covered with a plastic table cloth, blue with printed multicolored flowers, and several other brightly colored and embroidered cloths added to the decoration. All the saints, shrines, and crosses were covered with cloth, and mirrors hung from the necks of the crosses.

Pablo, Hilario, and Charles came in with the patron of the church. After we lit candles, I sat down next to one of the guardians. He was the son of Don Secundino, the chief I'd met in 1974. I asked him how many people regularly came to church. Four hundred people lived in Chumpon, he said, and 396 attended the Maya church. The other four were Protestant evangelists from Carrillo Puerto, he laughed, who had yet to succeed in converting anyone. He asked me if I was coming back for the Day of the Cross, Chumpon's big ten-day fiesta in May. He said the last fiesta had drawn celebrants from all over, including Tihousuco, X-Cacal Guardia, Chancah, Tulum, and even Cancún.

I told him I didn't know, but I always enjoyed the fiesta. The Cruzob fiestas were special. There was no distinction between participant and spectator—everyone was both. The fiestas were a time to eat, to drink, to be foolish, to boast, to get drunk, to dance, for matchmaking, to be happy and sad, to renew friendships, and to pray to God and thank Him for life in its manifest forms.

When Charles, Hilario, and I had attended Chumpon's fiesta in 1974, the entire village had been transformed—the plaza alone looked like an Indian pow-wow. Smoke drifted from outdoor cooking fires, as men and pack animals brought in loads of firewood. A group of men constructed

the bullring. Men with tumplines carried in more supplies, while brigades of women drew buckets of water from the well. There was a lot of bantering among friends who saw each other only at these celebrations. A person known as the *nohoch kuch,* or load carrier, was responsible for providing food and drink to the pilgrims taking part in the religious feasting. The responsibility shifted each day, generally to wealthier members of the village who had volunteered their services. Each group brought something, and all the responding villages had representatives. Everyone contributed and shared in the labor; there was no charge to anyone for the feast.

We helped butcher eleven pigs. While they screamed we held them down, thrust knives into their hearts, and jammed buckets against their chests to catch the blood for making sausage. We singed their skin with burning palm fronds before making chicharones (cracklings) in big black cauldrons of boiling fat. As some men stirred the pots, others cut up the meat and hung it from trees and temporary scaffolds. Dogs ran around trying to lick up the blood where it fell on the ground. The sun seemed harsher and more intense than ever—you could hardly see the flames of the fires.

Groups of women, wearing clean huipiles with bright ribbons in their hair, worked nearby, cooking small mountains of freshly ground corn tortillas. At night we took turns grinding cauldrons of boiled corn in handmills, an exercise sometimes lasting for hours. All food would be carried in a procession of worshippers and musicians to be offered and blessed at the altar of the church.

Each afternoon there was a *pay wakax che,* a bullfight different from any I'd seen. The Cruzob, who neither raised cattle nor had the money to buy bulls for their fiestas, had adapted the spectacle to their own use. They carved a bull's head from wood and mounted it on a frame covered with burlap. Suspender-like straps enabled a man to wear it. Whoever put on the bull's head actually took on the part and mentality of a bull. When they were turned loose, bullfighters had to be wary. The men turned into wild and tough animals, moving their bodies and heads like a bull. They were tied to a pole in the center of the ring, given a couple slugs of rum, and then set loose amid a barrage of firecrackers. The participants loved it, carrying on all afternoon through dusk, everyday, as long as the fiesta lasted. Sometimes a "bull" would escape from the ring and run through the plaza, knocking over people and creating havoc until it was roped and tied up. You couldn't just yell to the "bull" to stop being the bull.

Drinking went on nonstop. Men would pass out and start drinking as soon as they reawoke. Night or day. During fiesta, all the men seemed to smoke as well. Whenever they did, they'd offer cigarettes to everyone around them.

I had just given up smoking, but soon I was drinking rum, beer, and aguardiente with everyone else. I would have loved a cigarette, but refused them whenever they were offered to me. Anyone who has quit knows how hard it is to do.

On the third day, before the first bullfight, I joined some men carving the bull's head. About twenty of us walked over to the side yard of a house where several large rounds of cedar wood were stored. After

174

174 *Meat hangs from the rafters (center, rear) while men cook in the large pailas during Day of the Cross festivities. Chumpon, 1974.*

175

175 *An escaped bull runs along the road during a* pay wakax che *bullfight. Tulum, March 9, 1974.*

much discussion, one round was blocked out using a pencil to sketch an outline, and the men took turns shaping it into a head with an axe.

The first attempt failed. The wood split at an awkward angle and another round had to be selected. It was hot. We sat on the ground in the shade of a stone wall. We passed around a bottle of cane alcohol, which rapidly evaporated. I brought over a case of beer and passed the bottles around. One of the men took out his cigarettes and offered me one. I took it and stuck it behind my ear, a common enough practice when you wanted to smoke it later.

"Let me light it for you," he said.

I raised my hand in a small salute. "No thanks," I said. "I'm feeling sleepy. I'll smoke it later."

He staggered over and rested both of his arms on my shoulders. He leaned back to get a better look at me. He was very drunk.

"Smoke it now," he said.

"No, really, no thanks," I answered.

"Smoke it," he demanded, breaking away. He grabbed the axe from the man using it and waved it around menacingly as he advanced towards me. I knew he was skilled, like any jungle Maya, in the use of a machete or an axe. I had only my words to defend myself.

"We're brothers in the eyes of the Lord," I blurted out, "and the Lord says we can't kill our brothers. This is a *santo fiesta* and we are all

226 *Macduff Everton*

working together. We'll spoil the fiesta for everyone if we fight."

I didn't stop talking until he put down the axe. He came forward and we embraced. We slapped each other on the back several times and hugged. He became embarrassed and handed me another cigarette—I stuck it behind my other ear. We embraced again.

One of the men picked up the axe and resumed working on the bull's head. I still don't smoke cigarettes to this day, but I can't help remembering that quitting almost killed me quicker than cancer.

The *pay wakax che* wasn't always limited to the Cruzob fiestas, as it is today. Villages throughout Yucatán used to stage the make-believe bullfights. But as Dario told me, they aspired to buy bulls and conduct the real thing. Most of the small villages, however, cannot afford to import professional bullfights. The resulting spectacles are more befitting to a circus than to old Spanish tradition, featuring local amateurs who are very bad, but—in their own way—entertaining.

Hilario claims the best bullfighting around Valladolid is at the fiesta of Kanxoc. Groups of Maya rush into the arena carrying lances and swords. Amid general mayhem and pandemonium, they chase the bulls, sticking and hacking away at them until all the bulls or steers are dead. The meat is then blessed in the church and fed to everyone attending the fiesta. This carnage as entertainment must be an incredible sight and

176 A pay wakax che *bullfight during Tulum's March fiesta. Tulum, March 9, 1974.*

176

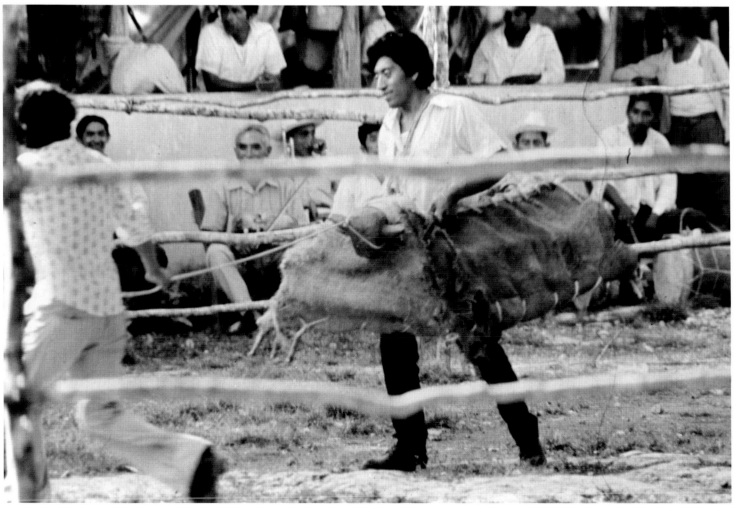

makes you wonder if the Indians are imitating their Spanish conquerors.

Charles really enjoyed participating in the fiestas. "Amid the drunken revelry," he told me later, "I started seeing an order to the events which were going on day and night. In the yearly fiestas of each of the sacred villages, certain events always took place. The planting of the *yaxche* particularly interested me."

"At least thirty men would go out into the jungle. They'd cut down a tree and carry it back on their shoulders, whooping, shouting, and passing around bottles of rum. By the time they reached the edge of town, the band would be waiting for them. The whole procession marched to the center of the plaza and erected the *yaxche*.

"At first I thought they were planting a young ceiba, which is called *yaxche* in Maya. It is that grand, singular tree around which many Yucatecan villages are built because you can always count on finding a good vein of water at its base. Then I noticed it wasn't a ceiba at all, but a zapote tree they planted.

"Charles was keen on connecting the modern practices to the rituals of the past. "I realized that Maya words often have a double meaning," he continued, "and *yaxche* literally means "first tree." I knew *yaxche* was the sacred tree of the ancient Maya—first tree, the tree rooted in the underworld that reaches into the heavens, the tree of abundance. Then I found another connection. Linda Schele told me the decipherment of the Maya glyph for erecting a stela was 'to plant a stone tree.' Perhaps the planting of the *yaxche* is the contemporary Maya version of erecting stone stelae in commemoration of important events."

We headed for X-Cacal Guardia on a new dirt track that went through the jungle from Chumpon over to the Valladolid–Carrillo Puerto highway. We ran into old friends like Don Ynez Tuyub of Zapotal, an elderly prayer man who always showed up at Chumpon's fiestas. At the remote ranch of San Antonio Nuevo, we met a whole family of Maya girls with blue eyes. We could only wonder if they were descended from hostages taken during the Caste War.

Pablo traveled with us as we gave out food and money, and he was enjoying it. I felt it was a sign of his character that he didn't try to control the situation. He never questioned whom we gave it to, or told us to give to one person rather than another. He never asked that we give money to his family and friends. When we helped someone, he would catch our eye and nod his head approvingly. We all realized that, even if we had been able to give something to everyone, it still wouldn't have been enough.

In past decades, X-Cacal Guardia had been singled out by anthropologists as the most conservative of the Cruzob shrine villages, and ethnographers had at times taken up residence nearby. The people of X-Cacal had had their share of experience dealing with patronizing government officials, as well as anthropologists. They've learned that not every outsider is against their interest. They remain suspicious, but deal with intruders in a more sophisticated way than the usually paranoid Chumpon villagers.

We reached the village after dark. A group of men was standing in the street as we drove up. One of them was our friend Marcelino Poot, who

had conducted the New Fire ceremony years before. He greeted us like old friends, shaking hands and inviting us to his home. I was surprised by his handshake. I expected a limp-fish type handshake—handshaking was not a Maya custom especially when greeting strangers—but Marcelino, obviously happy to see us, gave us each a power handshake that was only missing a high five at the conclusion. He'd gotten older and had a shock of white hair on the front of his scalp that contrasted with his otherwise black hair. He looked very contemporary—as if he had peroxided punk locks. Marcelino was one of the few Cruzob who still dressed in the old style—white shorts that tied at the waist, with no pockets and two revealing slits above the buttocks, and a white shirt with pleats like a *guayabera* and a long strip of functionless buttons down the center.

177 *A young blue-eyed Maya girl, probably a descendant from a union between a Maya and a prisoner during the Caste War. Rancho San Antonio Nuevo, 1988.*

177

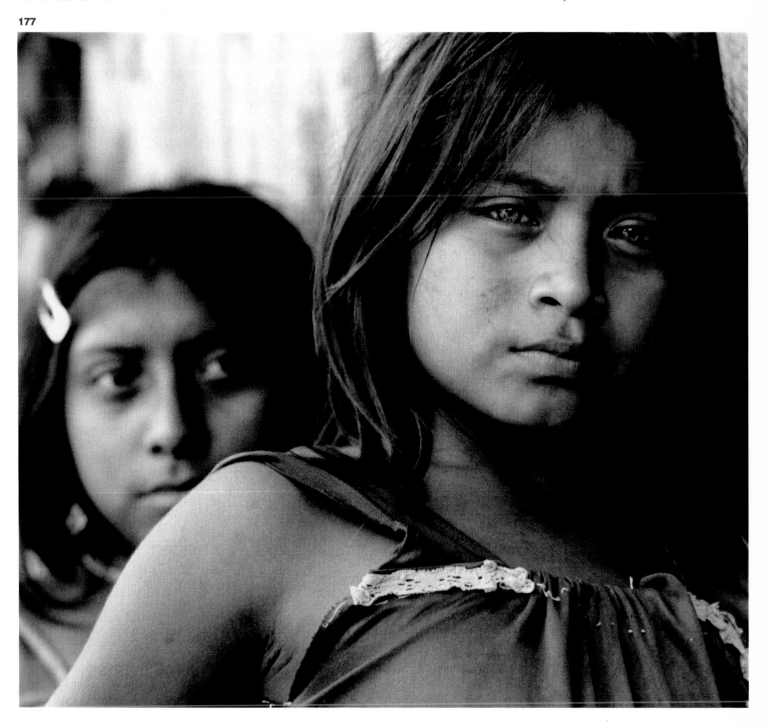

178

178 *Pablo Canche and Marcelino Poot meet in Marcelino's house. X-Cacal, 1988.*

Marcelino had many daughters, and his large house was full of children and women. He had added a thin, raised cement floor to the room, where the children played under a bare light bulb. Smoke from cooking fires had left the palm roof coal black—the soot looked thick enough to draw with. Electricity had come to the village and cold beer was available, so we sent Marcelino's son for some bottles to clear the dust from our throats.

We quickly learned there was a rift between Marcelino, the *commandante* and secular leader of X-Cacal Guardia, and the new *nohoch tata* of the church who took over when Roque Dzul had died. Don Roque and Marcelino had been ruling the village together for the past two decades and were very close in friendship and outlook.

The new, younger head of the church no doubt had opened up the eternal debate among the Maya of whether to enter more into Mexican society or steadfastly cling to traditional ways. Juan Ek had not enjoyed the dispute, which was why he had brought his cross back to Tulum.

Marcelino was happy to see Pablo and sat down next to him. He wanted to know how Tulum's cross was. I brought out some photos, and everyone got excited about several portraits of the late Don Roque. We talked about music, and Marcelino showed us the violin we had given him years before. It was ruined. He wanted to know if we could fix it, telling a story of walking in the mud and how he had slipped and fallen. Charles examined it and advised finding another one.

Charles showed Marcelino the violin he'd bought that morning in Chumpon, hand-made in that village by an old master from jungle materials. It didn't have any strings on it, so we took a few from the broken instrument while Marcelino brought out his good violin. He started to play for us. I'd taken violin in grade school and had been taught to tuck the violin in underneath my chin, but Marcelino held his out from the chest. If nothing else, his style made it easier to play while sitting in a hammock.

I'd never heard the Maya music played outside of its ceremonial context. Now here I was in the midst of a musical jam session. I showed Charles what I knew about violin playing and shortly he was playing as well as I was. We sent out for more beer. We played the violins and talked into the early morning. Marcelino knew Hilario well and had even visited him at his home in Chichimilá. He wanted to be brought up to date on Hilario's life.

Pablo and Marcelino also had a lot to talk about, and here they weren't interrupted by televisions, which were becoming almost as ubiquitous in Yucatán as in the United States. Neither man owned one. They began the evening sitting in two different hammocks and ended it in the same hammock. They agreed they should get together again, so Pablo invited Marcelino to Tulum to pray to the Virgin of Guadalupe on the twelfth of December.

We slept in the same *guardia* building we had stayed in the night of the New Fire ceremony fourteen-and-a-half years earlier. We woke up to the laughter of men in an adjacent *guardia*, who offered us atole to drink.[8] Afterwards, we walked over to the church to pay our respects.

The center of X-Cacal Guardia, even with its rustic buildings, felt like a capital. The church was an imposing white building. All around it, like

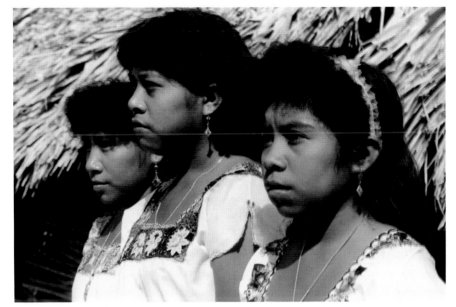

179

embassies, were the *guardias* belonging to the different responding villages. This area was supposed to be protected from evil winds and other dangerous influences by the four crosses set at intercardinal points of the compass. However, the symmetry and the beauty of the plaza had recently been ruined when the government built a road through the center, bringing concrete power poles and electrical lines. They were as out of place as power lines and a road across the White House lawn.

On the way to Chancah Veracruz, Pablo and I sat in the back of Hilario's truck. Pablo had a smile on his face as he watched the countryside. Pablo said he enjoyed traveling. "I don't know how long we can exist in Tulum," he said in his deep voice. "If things get worse we're prepared to move thirty kilometers deeper into the jungle. We've already picked the spot. But in the back of my mind I've been wondering where there was better land." Pablo was taking on more and more responsibility at the church in Tulum and was disturbed by the disrespect shown it by many of the young men of Tulum, who were more interested in the gadgets of modern life. He thought often about retreating to Angelita, his *milpa*—an idea, not lost on Pablo, that wasn't much different than what the Cruzob had done over the last 140 years.

A lot of my friends were moving. Several farmers I knew in Chichimilá had headed south into undeveloped jungle, farming milpas and establishing ranchos that were now growing into villages that were appearing on maps. On the other hand, people like Dario were leaving their villages for modern life and the hope of a better existence less dependent on nature for their daily meals. Some left to escape the restrictions of small village life.

Fina is a good example. She left Chichimilá several years ago and moved to Cozumel, where I made a point of visiting her.

I arrived early in the morning. As Fina cleaned up after her children's breakfast, I stood near the open doorway and watched the shadows disappear as the clouds quickly gathered. It began raining, the water running off the *carton* roof, splashing on the concrete apron around the

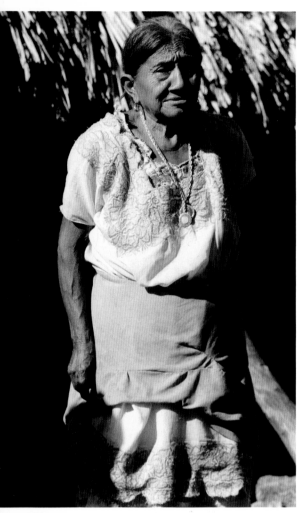

180

180 *The wife of the violin maker. Chumpon, 1988.* **181** *A violin maker smoking a cigarette in front of his house. Chumpon, 1988.*

hut and puddling in the depressions. Raymundo started crying. Fina went over to her baby and rocked his hammock gently, cooing in Maya. She asked me to put an album on the portable record player. I chose one by Los Cadetes de Linares and sat down to read the liner notes.

"It's their best album," Fina said over the sound of the rain and her child. She rocked the hammock and watched the tropical storm. Raymundo stopped crying. Fina absently brushed back her short hair and patted it into place. It was hard for me to get used to her without long hair and huipile.

"How do you like it here on Cozumel?" I asked her.

"It's fine," she said, turning from the doorway and picking up a pile of laundry. She brought it over to the bed where I was sitting and began sorting and folding the freshly laundered clothes. "There's so many things to tell you since you've been away," she began. "It's a lot different than living in our village."

"Such as . . . ?"

"Well," she started to explain but then picked up a pair of boy's trousers and carefully folded them. She picked up another, smaller pair and carefully folded those too. Then she looked up at me.

"I don't know what to do about my sister," she sighed. "Maria is living with a man."

"It's about time, isn't it," I said, remembering the last time we'd talked, Fina had been worried that she wouldn't find one.

"But this man is already married and has two kids!" Fina shouted. She covered her mouth with her hand and anxiously looked over at Raymundo to see if she had awakened him. He didn't move.

"His wife is also here in town?" I asked. "How does he manage that?"

"No, she's not here," Fina said, almost smiling. "He left them in Chetumal. He came here to make more money and he sends them something every couple of weeks."

"And in the meantime Maria cooks and cleans for him?"

"Yes, and he lives with my sister as if they're man and wife when they can't possibly be," Fina said, waving her hands. "He doesn't buy her any nice things—says he has to save his money. He doesn't take her out. She cooks his meals and washes his clothes. And he saves his money and sends it to his wife and children." Fina threw a pile of neatly folded clothes back down onto the bed.

"This doesn't bother Maria?"

"It's me who worries! Every day! But I have to be careful not to say the wrong thing." Fina began putting away the clothes in wooden chests and metal footlockers. I went over to the stereo and put the needle back to replay a cut. "I think that's their best song" I said.

"Have you talked to her about birth control?" I continued. "I mean, the situation could certainly become more complicated, and I wonder if she knows anything about it? I mean, she's always been your little sister."

"Indeed," she said. "I've tried talking to her about this, but it's such a very delicate subject between us."

"And?"

"Look," Fina said, pointing at the doorway, "the rain has stopped. I need to feed my pigs. You want to come with me?"

181

We crossed the yard, passed their well and walked into the jungle on a stone path raised above the rain water that would sit for weeks before percolating through the limestone surface. "The thing that happens," she finally said, "is we have these little talks and I don't know if I can believe her answers or if she knows what she is talking about. I can only pray that she's really taking such precautions and that when she leaves this man, the only thing she's carrying is a little wisdom."

"Good luck in your talks," I said. I didn't know what else to say.

The pig pen had a raised cement floor, and its sides were made of poles and saplings lashed together with vines from the jungle. The pigs came over and Fina threw them corn and tortillas from breakfast. They rooted after the food, often pushing the tortillas into the dirtiest areas of the pen.

"Pigs are supposed to be intelligent," I said.

"I've heard that said."

"They're supposed to be smarter than dogs or most other animals."

"They're probably smarter than some people too," Fina laughed. "Remember my pigs in Chichimilá?"

"Of course. I wouldn't forget them. You always had some fine ones."

"Well, before we moved to Cozumel, I had more than forty. They were fat and beautiful, as big or bigger than these two here right now," she said pointing to a pair of large sows. "One day, while my husband was away on a trip, my brother Nado came and told me, 'Fina, you know there's a disease killing pigs. You must sell them all right now. Immediately.'"

Fina threw the last of the tortillas into the pen. She leaned against the poles to watch the pigs, leaning her chin on her arms." I told my brother I didn't want to sell them," she continued. "I knew my family was jealous of me for having so many pigs. I thought they wanted me to sell them so I wouldn't have them anymore. Don't ask why my family was so jealous of me, I don't know. So I decided I'd put my pigs in the hands of God. At least He wasn't jealous of me, I thought. But Nado kept after me. 'Listen,' he told me, 'if you won't sell them, at least vaccinate them.'" Fina looked over at me and shrugged her shoulders.

"I told him I didn't have that kind of money lying around, but he said it wouldn't cost much, one bottle could vaccinate them all. That wouldn't be bad, I thought. God gives us intelligence to make our own decisions. This sounded like a good idea. So I told my brother all right. He said he would take care of everything early the following morning."

"Nado arrived at 6:00 A.M. I gave him money. He left on the bus to buy the vaccine. You know the heat in my village. Nado didn't take a cooler with him. He didn't have anything to put ice in to keep the vaccine cold. I expected him to return by 9:00 A.M." Fina grimaced, then shouted, "At ten he wasn't back! Not at eleven either. Not at twelve noon. It was very, very hot, but not until four in the afternoon does he return. You know what that son-of-a-bitch had done?" she asked, hitting the side of the pig pen with the palm of her hand. The pigs jumped back, squealing and looking up at us. They grunted and complained loudly but came back to eat.

"That wonderful, helpful brother of mine had bought the vaccine at eight and then went out to have a beer. He said it was already so hot he

needed one. He then met a friend and they met another friend and suddenly it was late afternoon. Here he was, drunk, staggering around and insisting that there was no problem. I grabbed the bottle from his hand and felt it. The vaccine was hot, and I knew it was no good. I went to throw it away but Nado yelled at me to put it in a cooler with some ice. 'It'll be fine,' he told me. 'Then I'll vaccinate your pigs for you,' he said." Fina shook her head.

"I told him no, to go home, he'd already wasted both our days. I didn't want him to ruin my evening too. He got angry. He shouted at me. He called me little sister and told me he certainly knew more about these things than I did. He ordered me around and I tried to stop him but he vaccinated my pigs. And then they all fell dead."

Fina and I started laughing and she put her arm around my waist playfully as we walked back. It began raining anew and we raced the rest of the way to the hut. In the doorway, Fina laughed again, shaking raindrops from her hair. "Anyway, you asked me how I like it here. For reasons like my pigs, I have no immediate desire to leave."

Chancah Veracruz shows the effects of a sustained effort by the Mexican government to integrate the Cruzob into the national scheme of things. Chancah's location between the former, conquered Cruzob capital of Chan Santa Cruz (now the bustling town of Carrillo Puerto) and the state capital of Chetumal has brought it into contact with predominantly Mexican, rather than Yucatecan, influences.

The region has some of the richest soil in Yucatán. Logging is a significant industry, and irrigation projects have encouraged many Cruzob to relocate to state-sponsored farm projects. The farmlands of the area have been assigned to several different *ejidos,* or farm cooperatives, seriously affecting the social and territorial unity of the shrine town and it corresponding villages.

Programs of modernization have probably had their greatest impact in the area around Chancah than anywhere else in the Cruzob zone. Many villagers leave their homes to pursue salaried jobs elsewhere, attracted by bright-colored clothes, tape decks, and televisions. Numerous Cruzob children now attend state-sponsored boarding schools, where they are prepared in bilingual classes to return to their villages. Indeed, some become teachers themselves, speeding up the process of integration.

Not all the young people abandon their traditions. Those who do, however, are sometimes torn between two cultural frames of reference— the one they were born into, and the one to which they aspire, awkwardly and often with feelings of inferiority.

Like Chumpon, Chancah has a reputation for violence. But, whereas the villagers of Chumpon maintain a sense of unity, the Cruzob of Chancah strike out like a people unsure of their future, desperately protecting their territory and cultural identity.

It can be hard to find out who is in charge in Chancah. When we arrived at dusk, there was no *guardia* on duty. The church was locked. A man in the plaza recognized us—we'd met the day before in X-Hazil. After ten minutes the *capitan* of Chancah showed up and opened the church for us. Charles and Hilario explained our mission while I carried

182 *The new cement block church in Chancah Veracruz. Chancah Veracruz, 1988.*

182

in the sacks of corn we'd brought for the village. Since I spoke the least Maya, I carried the corn.

It was the first time I'd been in the new church. It was built like a fort, looking a little like the *Balam-na* of Chan Santa Cruz built by the Cruzob during the Caste War. The previous church had been beautiful—a long, tall, thatch-roof building that had the grace of a sailing ship. The new one was built more like the Merrimac. Above the entrance were three crosses, one above the door and one on both ends. A plaque recorded that the church was built, with Mexican government help, from June to December 1976, and was inaugurated on May 12, 1977.

The church was very hot and musty. Once the main doors and the side door were opened though, either the air cleared or I got used to it. I laid down a sack of corn and looked around. I felt like I was inside a prison. This sanctuary didn't compare favorably with the old church, which had the airy feel of a South Sea community building—the largest I'd ever seen—and whose roof was supposed to have had over 152,000 palm leaves. In contrast, the new church had a flat ceiling featuring exposed cement beams separated by one width of unplastered cement block. Windows had originally been included in the walls but now they were bricked up.

Inside the main doors were a stack of cauldrons and a roll of chain link, left over from the fence surrounding the church. Half-way into church, suspended from the ceiling hung tissue paper decorations with stencil-cut designs of birds, flowers, cactus, and animals—I found out they were a gift from the governor. The wall separating the *gloria* from the rest of the church was low and flat, and a large green curtain suspended from the ceiling forced everyone to duck before entering.

Pablo, Charles, Hilario, and I entered and lit candles before passing in front of the altar which extended almost the width of the back wall. A large Jesus Christ on the cross towered over us—exactly the sort of crucifix you'd expect in a Roman Catholic church—except that beneath it the altar was very Indian, overflowing with saints, icons, crosses, herbs, plastic tablecloths, embroidered cloths, and plastic flowers. A few of the icons were draped in cloth, but otherwise the crosses and saints were not hidden under shrouds. All the saints wore garments. Perhaps they were supposed to be robes, but they all ended up looking like dresses. A couple of bearded saints looked like Venetian gondoliers in jaunty blue-and-white striped garments and straw boaters on their heads. The saints carried sweet basil in their hands.

We sat down with Faustino Santa Cruz, the *capitan*. I asked him how

many saints they had, and he answered more than thirty. Earlier in the
year a man from X-Cacal Guardia had begun insisting that Chancah
should give them a saint for their church, since Chancah had so many.
But he had quickly repented when his was the only house in the village
damaged by Hurricane Gilbert.

We'd heard the story already, but listened as Faustino told it. He told
us there were seventy families living in Chancah and, counting the
villagers in the responding area, more than four hundred people used the
church. Faustino emphasized that everyone was united, pointing out
that there weren't any Evangelists, Mormons, or others in the area.
"Somos muy Catolicos, muy Cristianos," he repeated. This was
something we heard at all the sacred villages. "We are very Catholic,
very Christian."

I was intrigued by the little chairs placed at either end of the altar.
They were child-sized and adorned with handkerchiefs and other
decorations. Little arches made from jungle vines rose over the back of
the chairs; they looked ceremonial rather than for the use by the
congregation or the guards. I asked Faustino about them.

"It's the custom," he said, an oft-heard reply that was usually a
complete answer, making me wonder just how much the Maya knew
about what their customs represented.

"What for?" I pressed. "What custom?"

183 *The musicians sit near the entrance to the old church. Chancah Veracruz, April 2, 1974.*

183

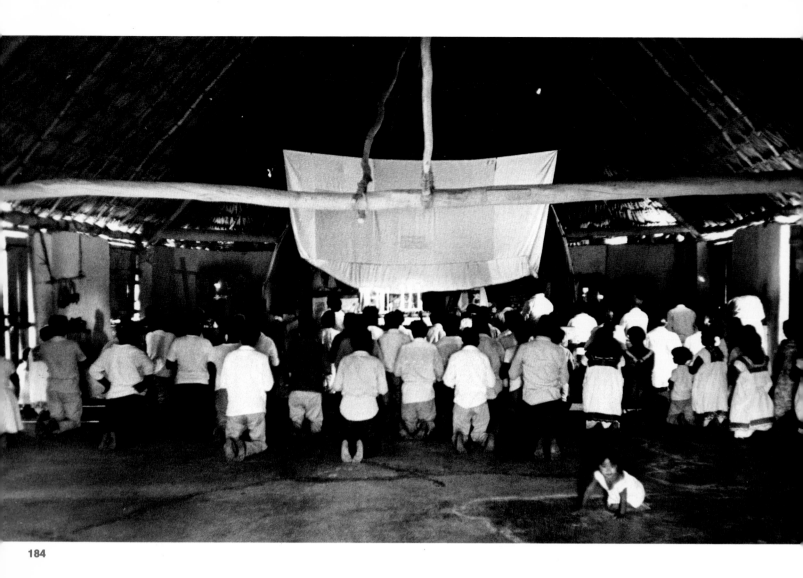

184

184 *Cruzob praying in front of the altar of their church, partially hidden by a suspended cloth sheet. Chancah Veracruz, April 2, 1974.*

"They're for saints who want to come to visit. The saints come in on the wind and we can't see them. But just as we have benches, the saints should be comfortable too."

I wondered if they were for the Holy Ghost.

One of the young men of the village joined us, sitting in the position reserved for the guard at the entrance to the *gloria*. While we talked, he lit up a cigarette, something I'd never seen in any of the other churches.

The room was cooling off. We could hear a game of soccer being played outside, the participants shouting back and forth. We told Faustino about the hurricane benefit and how our pueblo wanted to help his. We were here to present the church with money to spend on food for the village, as we had done in Tulum, Chumpon, and X-Cacal Guardia. Faustino thanked us, then told us of an incident that had occurred several months before. The governor of Quintana Roo had showed up in Chancah with a group of foreign journalists who wanted to take pictures in the church. The villagers immediately refused permission, and appeared in their doorways bearing rifles and shotguns.

Faustino laughed and said, "I don't know what language the foreigners spoke, French or German or who knows what, but they understood us when we said 'no fotos.' We told them that anyone of good heart could enter the church, but they couldn't do stupid things

238 *Macduff Everton*

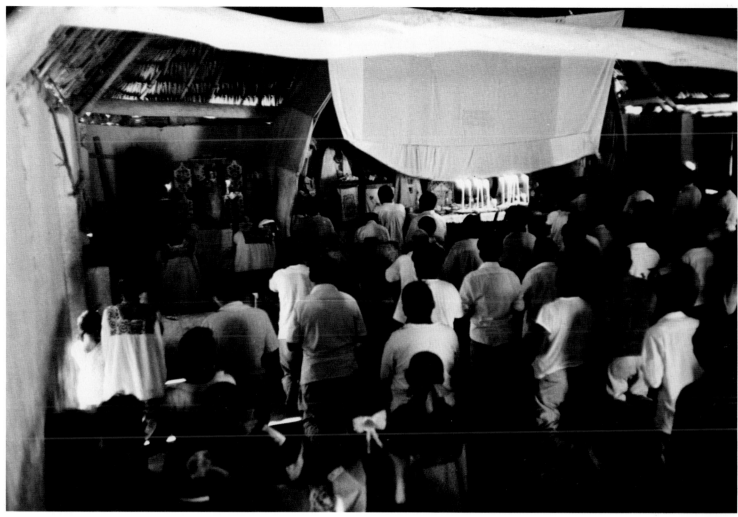

185

inside. We don't want anybody taking pictures here. It's not allowed and it won't ever happen!"

185 *Cruzob pray in front of their altar.*
Chancah Veracruz, April 2, 1974.

I didn't tell him we'd already done it years before. Hilario and I had arrived in Chancah for the fiesta. The church at that time was of native construction and beautiful. A tropical pine grew near the doorway. We were given permission to place our hammocks in the school outbuilding with the X-Cacal Guardia group.

On the first day of the fiesta I photographed everywhere but inside the church. I wish I could have because that night almost everyone danced inside the church to the music played by the Maya band of violins and drums. A drunk had started the dancing, with elaborate and overemphasized motions, and Hilario, who loved this sort of thing, quickly joined in, bringing others with him. It's the only time I've witnessed dancing inside the church, although it's regularly done in a corridor outside the entrance.

The next day, everyone was in a good mood and gave me permission to photograph a ceremony in the church. The *nohoch tata* gave permission, as did the guardian. Once the ceremony began, however, everyone revoked their consent—to save face. But they complained to Hilario instead of me. Oblivious to the change of heart, I moved around

The church altar includes many saints who are hostages from the Caste War. Chancah Veracruz, April 2, 1974.

186

with my tripod and camera, and no one seemed to mind. Afterwards, I was told they hadn't really given permission, but, since I'd photographed anyway, to bring copies when I returned.

The incident caused such a scandal in the following months that when I showed the photos to Pablo upon my return, he advised me not to show them to any of the other Cruzob. I filed them away.

But I think it is about time to bring them out again. I think the Cruzob would be excited to see the inside of the old church. Villagers are already forgetting what it looked like.

The Maya have always had someplace to escape to. When the Spaniards first came, they retreated from the coasts. During the Caste War, they went further into the jungle. Now that very jungle is threatened by large-scale clearing.

There are obstacles to Mexico's plan to incorporate the Maya quickly. The country's enormous foreign debt—over a $100 billion, second largest in the Third World—has slowed or stopped many road and agricultural projects that might affect the Maya, although for this very reason large areas of the remaining forest might be cut for tropical hardwoods and cattle pasture in order to pay off the debt.

Yucatán has no major industry besides tourism for men leaving the villages—nothing has replaced henequen as a major cash crop. Poor management and a lack of marketing skills have plagued attempts to launch new industries. Recently the government invested in a program which encouraged the Maya to grow the wonderfully hot and flavorful habanero chili. The Maya enthusiastically cultivated them—only to find no market had been developed for the tons and tons of chilis.

Ideally, more biologically diversified agricultural and silvicultural systems and viable small regional industries will emerge instead of another monolithic industry, such as henequen, that is unresponsive to the cultural needs of the Maya. There have been several successful experiments in reintroducing pre-Columbian agricultural techniques which prove to be environmentally sound while also providing an excellent crop yield. Walter F. (Chip) Morris, with organizational and marketing skills learned promoting Highland Maya weaving in Chiapas, hopes to repeat his success with the Lowland Maya in Campeche. He will begin work in 1990 to link village craft industries to the tourist market.

The governments of Mexico, Guatemala, Belize, and Honduras talk of making it easier for tourists to visit the extensive Maya ruins and see the curious living Maya. For many years there have been plans to operate a vehicle ferry from Florida to Progresso (above Mérida) and Puerto Morelos (near Cancún), which would encourage many more people to come down and motor La Ruta Maya (The Maya Route). Will the governments take into account whether the Maya and the environment will benefit? What will be the effect of roads and tourist facilities in the undeveloped regions? Tourism may be considered a clean industry, relieving the Maya of their traditional back-breaking labors, but will it give them the opportunity (plus the necessary technical and economic support) to operate their own lucrative concessions that accompany the tourist trade?

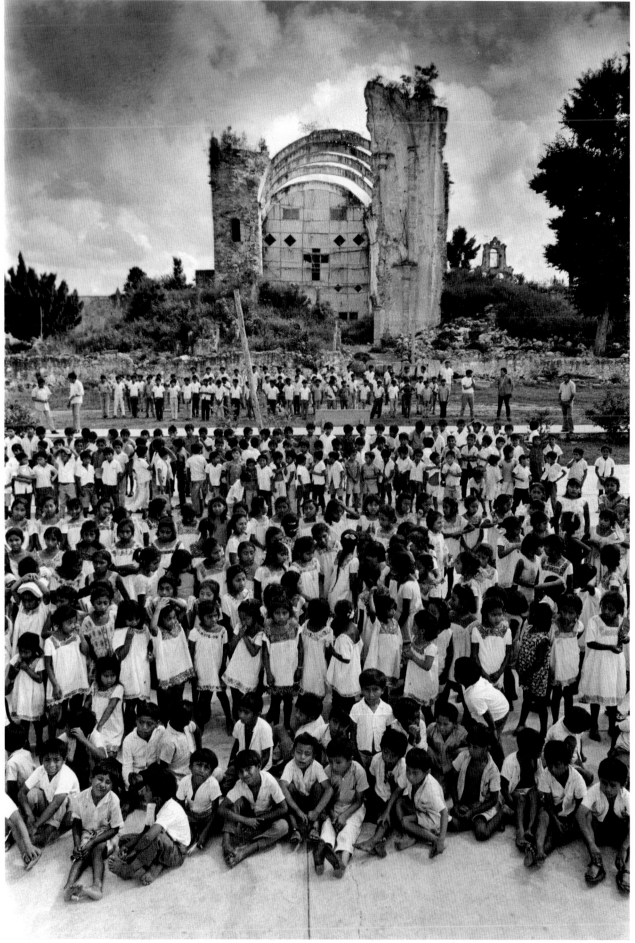

187

The Cruzob 243

Already we are seeing the results of a sudden influx of tourists. The ongoing development from Cancún south to Tulum along the Caribbean has created an undisciplined, opportunistic corridor placing the hotels, condominiums, malls (it amazes me no one has created the Ux Mall yet), shopping centers, and the second homes for the wealthy on the beach while the shantytowns of the workers spread alongside the highway. Any problems developing from the polarity between the rich and the poor living so close together are too often answered with plans to build fences and walls so tourist won't see the slums. Wildlife is being affected, such as the endangered marine turtles that lay their eggs on the previously deserted beaches, and no one has answered the question of how long sweet water can be pulled out of the ground for so much development before the water table drops, a problem occuring in Florida, another overdeveloped limestone plateau.

Until recently, Cancún had the only slums in the Maya zone. Mérida is expanding so rapidly it now has them too. Beginning from a few fishermen's shacks fifteen years ago, Cancún's population is a quarter of a million, and the city has drawn workers from all over Mexico. Cancún became a good destination for someone escaping from jail or on the lam. The Maya hadn't dealt with an invasion of outsiders and criminals like this since the first prison conscripts came into the jungle as chicleros.

Doña Veva's son Elmer complained that when a murder took place near his house the police didn't show up for several days—their main concern was serving the tourists. Cancún also discovered many of its police were hired without background checks and enough turned out to be criminals from other parts of Mexico that it caused a small scandal.

In many ways, the worker system of the tourist industry is like that of the hacienda. The Maya have been the menial workers as the better jobs go to Mexicans from Mexico City, Aculpulco, and Guadalajara—although in March 1990, while on an assignment for a magazine, I found a new generation of village Maya was speaking English and now working at the reception desks at a number of hotels in Cancun, Cozumel and Isla Mujeres, proving that—given a chance —they were intelligent and capable workers.

The housing for the Maya is below standard, and provisions are expensive because everything is brought in from outside; nothing is grown in any quantity in the area. The new "hacienda" system is different because although the Maya develop an economic dependency on their jobs, modern transportation allows them to return to their villages each weekend. Employers understand each employee will take off once a year to attend his village fiestas. Dario estimates that half the men in his village are working in Cancún, but he claims to see them all whenever there is a dance or fiesta in Chichimilá.

There are a number of Maya who are not interested in Cancún. They are moving farther away from their villages and deeper into the jungle. They don't have schools and other advancements, so at least another generation of Maya is continuing to learn contemporary traditions. Many of the Maya I've met in the last few years seem more proud today of being Maya, and speaking Maya, than I've ever seen before. It makes me wonder if the Maya church might even spread if a sense of cultural

displacement threatens the Maya and they search for something Mayan to identify with.

There have been a lot of changes over the last two decades. There are more roads, more televisions, Cancún has appeared, the women's huipil is now often replaced by a dress made of synthetic material, the sandal has been replaced by rubber flip-flops—but the essence of who the Maya are remains. They are adapting to changes and adapting changes to themselves. There are some marked improvements. More Maya now enjoy better health care and education. They are concerned with rising above the poverty level and enjoying a sense of security regardless of drought, plagues, and hurricanes.

These are not trivial concerns. In 1988 two different plagues were affecting henequen plants and coconut palms, while Hurricane Gilbert had destroyed most of the year's corn harvest. In the past, when a hurricane hit, there had been no one to pay for repairs. Now, as Pablo pointed out, the tourist industry provided a lot of jobs to the Maya in order to open for the winter season.

But when looking at individual Maya, it would be hard to say they are better off. Dario, the quintessential family man, sees his wife only on weekends. Diego is worried about his future now that he can't work as hard as he used to. Veva is dependent on her children, most of whom have moved away to Cancún. Alicia and Juan both have to work in order to raise their family. Chucho is retired on a monthly pension which is less than a tourist will spend on one meal in Cancún. Elut was deceived by his employers and lost his wife to their callousness. Pablo is thinking of going deeper into the jungle. One question unanswered is what will happen to the Maya if they stop raising corn, as it is so inextricably connected with their culture. Even without more government subsidies to turn land into pasture, Mexico's population is expanding so rapidly that soon there won't be enough land to support present slash-and-burn techniques.

Charles complained to Pablo how Dario's daughter wasn't speaking Maya but only Spanish to her children—and not good Spanish at that—but Pablo asked where he had seen this. Charles replied in Chichimilá and Pablo laughed. "Don't worry," he assured him. "My daughter is doing the same thing and I'm seeing to it that my grandchildren speak Maya, just as Dario and Herculena will do the same for their grandchildren."

Negro Aguilar and I had recently walked down the streets of Valladolid at 6:00 A.M. It was cool and quiet; there weren't even many roosters crowing.

"Everyone has learned the ways of getting up late," Negro explained. "It's not like before. You and I remember when you could go to the market at 5:00 A.M. and it was full of people. You could buy meat, vegetables, fish, anything you needed. And out on the streets Maya from all the surrounding villages would be selling their hammocks and produce along the sidewalk."

I told him I went to the market the day before and the meat sellers didn't arrive until 7:00 A.M.

"Yeah," he said, "I still get up at 5:00 A.M. and there's nothing to do now. It's not like before. We've learned the new ways."

1. The whole ceremony was quiet and matter-of-fact, typical of many of the ceremonies the Maya perform today. Marcelino recalls the time when all hearths in his village were extinguished and replaced by virgin fire. Now several families decline to participate in the ritual, reflecting the tug-of-war between modern thought and tradition. Nonetheless, after dawn, we noticed a steady stream of villagers arriving at the church to carry flames from the new fire back to their huts.

2. The Maya revolted against the descendants of the Spanish conquistadores in 1847. The Caste War of Yucatán, as it became known, didn't begin as a racial war but rather as a social conflict.

Mexico had gained its independence from Spain in 1821, and Yucatán was enjoying an agricultural boom extending into its jungle frontier, the new plantations and industries producing cotton, sugar, rice, henequen, livestock, salt, tobacco, and logwood. At the time, the state of Yucatán encompassed the entire Mexican peninsula, including the modern states of Yucatán, Campeche, and Quintana Roo, but almost all the population lived in the northwest around the cities of Mérida and Campeche, the hub of Spanish and Mexican influence.

The rapid growth of towns and commercial agriculture in new areas was at the expense of previously isolated Maya communities, who had their communal farm lands, crucial for rotating their *milpas*, taken from them, appropriated for the new plantations. The government increased taxation on peasant agriculture and supported debt peonage to supply the new haciendas' demand for workers.

Most of the Maya in the northwest who had been acculturated over the previous centuries were already used to such exploitation. But it was too much of a shock for the frontier Maya, and it sparked their resistance. They felt the existing laws should apply equally to all peoples—that land should be available to everyone, and no one group should be able to abuse physically another group.

When negotiations broke down, the Creoles (born in the Americas but of European ancestry, the self-proclaimed *"gente decente,"* or decent folk) opposed the Maya. It was the execution by Creoles of a Maya man from Chichimilá, Manuel Antonio Ay, that led to the Maya attacking the town of Tepich. This attack was the official beginning of the Caste War, and the social revolution soon turned into a savage racial war.

The fighting began along the frontier south of Mérida where the Maya enjoyed immediate military successes and captured many important towns. The Creoles, already embroiled in political intrigue and attempts at independence from Mexico, responded by offering Yucatán's sovereignty to the first country that would come in and wipe out the Indians. Invitations were sent out in March 1848 to the United States, Great Britain, and Spain. President Polk declined the offer and invoked the Monroe Doctrine barring anyone else accepting, but a number of American individuals did. The first North American filibusters came to Yucatán in 1848, led by Colonel Joseph A. White, with dreams of re-creating in Yucatán what the Americans had just succeeded accomplishing in Texas. The Yucatecans even invited these soldiers, offering eight dollars a month plus 320 acres of land to settle on; 938 volunteers sailed from New Orleans to Sisal.

Years later, Leandro Poot, son of one of the Maya leaders, told the American consul to Yucatán, E. H. Thompson, what the Maya thought of the American soldiers.

> It was easy to kill the strange white men, for they were big and fought in a line, as if they were marching, while the white men from Mérida and Valladolid fought as we do, lying down and from behind trees and rocks. . . . Their bodies were pink and red in the sunlight and from their throats came a strange war cry, Hu Hu! (Hurrah!) They were brave men and shot keenly. . . . We hid behind the trees and rocks wherever we could, that they might not see us, and so we killed them. They killed many of us, but we were many times their number and so they died. . . . Brave men, very brave. Some died laughing

and some with strange words in their own tongue, but none died cowardly. I do not think any escaped. I think they lay where they died, for in those days we had no time to eat or sleep or bury the dead.

As the Maya advanced towards Mérida, the Creoles were gripped by a fear that they would all be slaughtered by machete-wielding savages. Many fled to the west coast, emigrating on anything that could float.

The Maya surrounded Mérida in late May, and the few remaining Creoles didn't entertain much hope for survival. To their surprise, no attack came, even though the Maya were within days of winning back their ancestral home. Instead they disappeared.

The stunned Creoles later claimed that their bravery and soldierly skills had won this victory. Leandro Poot told a different story.

> When my father's people took Acanceh they passed a time in feasting, preparing for the taking of *T'Ho* (Mérida). The day was warm and sultry. All at once the *sh'mantaneheeles* (winged ants) appeared in great clouds to the north, to the south, to the east and to the west, all over the world. When my father's people saw this they said to themselves and to their brothers, "*Ehen!* The time has come for us to make our planting, for if we do not we shall have no Grace of God (corn) to fill the bellies of our children."
>
> In this way they talked among themselves and argued, thinking deeply, and then, when morning came, my father's people said each to his *Batab*, "*Shickanic*"—"I am going"—and in spite of the supplications and threats of the chiefs, each man rolled up his blanket and put it in his food-pouch, tightened the thongs of his sandals, and started for his home and his cornfield.
>
> Then the *Batabes*, knowing how useless it was to attack the city with the few men that remained, went into council and resolved to go back home. Thus it can be clearly seen that Fate, and not white soldiers, kept my father's people from taking *T'Ho* and working their will upon it.

The Maya, who are first and foremost corn farmers rather than soldiers, never regained their confrontational advantage. The Creoles began winning back territory, and the Maya retreated deeper into the southern jungle, closer to the British in Belize who supplied them with arms and munitions. The retreating Maya established their base at Chan Santa Cruz (Little Holy Cross) when a cross was discovered there that spoke to them in Maya, a miracle they readily found believable because their recent ancestors had worshipped speaking idols and frequently communed with the spirit world through religious rituals.

The rebels established an independent society in the isolated jungle, finding solidarity in their rejection of Creole dominance. They appropriated ideas from their ancient culture and from the society which they rejected. Religious worship centered around the devotion to the cross—only theirs was a Maya cross, personified like the gods of old. It spoke to them in their own language and urged them to reject the hypocrisy and exploitation of their Creole Roman Catholic oppressors.

The rebels called themselves *masewalob*, "the people," but became known as the Cruzob (the Maya plural suffix "-ob-" added to "cruz-," the Spanish word for cross). Colonization had ended for them, and led to a reintegration of Maya culture in economic, social, political, and religious terms. The Cruzob built their own world in freedom from Creole domination, drawing on both their pre-Columbian and colonial backgrounds.

Extremely devout, they reinterpreted the symbols of Roman Catholicism and made them relevant to themselves. They created a new religion, wherein the Maya were the masters and the Creoles were the unworthy. The Cult of the Cross gave the Maya the self-identification, security, and higher authority necessary to continue fighting and produced a theocratic-military society commanded by the *Tatich*, patron of the cross. Chan Santa Cruz became both a holy city and the political center.

When the cross was captured by Creole forces, three new crosses miraculously

appeared, "daughters" of the original cross. The arms of the crosses were draped in huipiles in deference to their sex. Even when they discovered that the cross spoke through a ventriloquist or a man hidden in a pit behind the altar, the Cruzob continued to worship God through their *santa cruz*.

The Caste War was the first native rebellion in the Americas where the natives hadn't lost. The Creoles and Cruzob invaded each other's territory, pillaging, plundering, and burning whenever possible. The war left the more fertile but dangerous frontier zone between the two cultures a no-man's land, resulting in the rapid growth in the northwest of the henequen monoculture which was suited to the area's drier rocky soil. The entire eastern secion of Yucatán was conceded to the Cruzob, and the war continued until the twentieth century.

The Creoles displayed a remarkable sense of European logic when they declared the Caste War ended in 1855. They decided that if they couldn't win the fighting outright, they would simply ignore it. To that end, they declared Chan Santa Cruz a sovereign nation—further skirmishes could no longer be considered internal revolution.

Ironically, it was the Creoles who armed and trained the Maya in modern warfare. The post-Independence era of Mexico was unequaled in its history for instability and corruption. Between 1821 and 1855, Mexico underwent forty-two changes of government. The Maya were first given guns when pressed into serving as soldiers in the political skirmishes of the *gente decente* who preferred not to get shot themselves.

Political intrigue, in the company of well-dressed gentlemen and ladies, was much more exciting and remunerative than dying in the fetid Yucatecan jungle. Also, there was the problem that when a commander went out against the Cruzob, he wasn't sure to what government and political party he and his troops might return.

In 1901 the Mexican Army took Chan Santa Cruz, and the Maya fled once again into the jungle. The next year the Federal Territory of Quintana Roo was created. Still the Cruzob didn't surrender. They never returned to their desecrated holy city but continued worshipping the cross in their jungle villages, staunchly defending their land by killing trespassers.

It wasn't military might but chewing gum that ended the Caste War. Wrigleys of Chicago sought chicle, the sap of the zapote tree found throughout the Yucatán peninsula, as the natural latex base for their chewing gum. In 1917 the Cruzob granted concessions for chicle collecting in their jungle. For the first time, instead of killing outsiders, they worked along with them as chicleros, making very good incomes.

The Cruzob wore pants with no pockets—they didn't need them for carrying money because theirs was a barter society. But their sudden cash wealth attracted Lebanese and Chinese merchants to the jungle paths, bringing mules loaded with such valuables as guns and ammunition, whiskey, silk shirts, cloth, jewelry, sewing machines, flashlights, and Victrolas.

Although chicle ended the Caste War, this influx of sudden wealth served to deepen the Cruzob's distrust of the Creoles when the worldwide economic depression hit in the 1930s. The more conservative Cruzob founded the new village of X-Cacal Guardia, and believing themselves to be the most pure of the Cruzob, called themselves "*Los Seperados*," The Separate Ones. They resisted any contact with the outside, wishing to be left alone to continue the cultural patterns of the past. They hated Mexicans, but were more friendly toward the occasional British or American archeologists, anthropologists, and missionaries who they hoped would supply them with modern weapons to renew their struggle against the Mexicans.

3. The Cross of the Center of the Earth, near Xoken and Chichimilá, is outside of the zone, but the Cruzob consider it a very sacred place. Many of them have made pilgrimages there to light candles. The story we heard many times is that this cross existed before the Conquest. When the Spanish heard of it, they had tried to move it, but couldn't, as it extended to the center of the earth. The cross was as old as Jesus Christ.

The Xua Xim ceremonies are held in February and continue for several days.

There was a fifth sacred shrine village known as San Antonio Kah. The

inhabitants of this community moved out to the highway at Nuevo X-Can.

4. Pablo Canche Balam is unique among the Cruzob. He was the grandson of an important shaman in Tulum. For several years he had raised his children on the beach, where he had cultivated a coconut grove and had come into contact with the wave of foreigners who had arrived with the roads. He was the subject of a couple of books written by adventurers and was featured in the film *Chac,* a midnight cult favorite in which he had the title role. Pablo had traveled to Chiapas for the shooting, and even to the United States to attend the premier of the film. But Pablo does not feel all this contact has been of much benefit. He still has not regained title to his land since the Mexican government took much of Tulum's *ejido* land for their Caribbean development schemes in the 1970s. And although he'd made some money from his film work, he has received nothing from the books and is wary of anyone · else asking him for information. He feels he has been used. He knew I was working on a book since I'd first arrived in Tulum in 1969, but at least I'd continued bringing photographs that he wanted.

Though he wasn't aware of it, Pablo was also in a strange position. Contemporary anthropologists were skeptical of some of his information precisely because of his contact with the outside world. One archeologist confided to me that she questioned whether Pablo had heard the story of the Hero Twins, chronicled in the pre-Columbian epic, the Popol Vuh, from his grandfather or had actually learned it while filming *Chac.*

When I asked Pablo, he was interested in the question. He said that he had learned the story as a youngster, but he'd been reminded of it again when filming *Chac,* and that the film had awakened an interest in his past. This made me think that while some anthropologists might be searching for Maya untainted by exposure, the Mayas' future as a culture will depend on people like Pablo who are able to bridge both worlds, and realize the value of both.

5. I've always avoided certain aspects of tourism, including the nightly sound and light shows at Chichén Itzá and Uxmal. One evening we'd been in deep conversation with the bartender at the Hacienda Uxmal, who proceeded proudly to show off his own creations—culminating in Los Siete Diablitos. I never was clear why it's The Seven Devils because it's made with only a half ounce each of tequila, rum, gin, vodka, and sugar water, mixed with lemon juice, ice, and very cold mineral water. When a large party of touring Germans placed their order, we decided to go for a walk before resuming our conversation.

The gates to the ruins were open and unattended. A Sound and Light show was in progress, so we went in. As we walked around, the buildings were alternately bathed in yellow, red, blue, and green lights, set off against a moonless black sky. I suddenly realized what the Mexican government had created. The world's largest black velvet paintings.

6. I am sometimes disturbed by the intransigence of the Cruzob's views. Their religion is inextricably mixed in with who the Maya are. Maya religion is theirs, and they feel it is better than any other. Secrecy, tradition, and a distrust of outsiders form their views. It seems as if there are no Maya theologians defining the Cruzob church and re-examining their beliefs as the world around them changes. Some of their actions—or reactions—remind me of religious fanatics who have forgotten that God has a sense of humor.

7. Most of the crosses are either completely covered or have only their necks bare—their arms and lower body parts covered with embroidered dresses. There also were seven vases of sweet basil on the altar.

To the right of the entrance to the *gloria,* candles burned on a wooden slab stand whose legs were the original tree limbs extending from the inverted crotch of a tree. A new, narrow concrete slab for holding burning candles, supported by three wooden posts, was in front of the altar.

8. They were from the villages of Chan Commandante and Senor, and one was the son of Paulino Yama, a friend of ours who had died recently. He told us his father had been Chinese.

Nelson Reed wrote that a group of Chinese coolies were brought from Amoy to Belize in 1866. A hundred of them escaped the terrible working conditions and fled

188

188 *Paulino Yama shows Marcelino Poot a portrait of Princess Margaret, whom they hoped would help them as Queen Victoria had in the nineteenth century, in their struggle against the Mexicans. Senor, 1974.*

north. Most were captured by the Cruzob and eventually became fully integrated into Cruzob society. Four made it all the way to Mérida, where they opened a laundry.

Marcelino introduced me to Paulino Yama when we visited him at his home in Senor. It was a hot day and we went to talk in the shade of the trees in his backyard. After a while, Paulino excused himself and returned with a rolled-up copy of a very regal photograph of Princess Margaret. He told me she was the queen of England, and that the queen was going to help the Cruzob again. She could send them arms through Belize as Queen Victoria had done.

As late as 1976 some of the Cruzob asked me to secure arms and ammunition or confided they were waiting for shipments from Queen Victoria. The Mexican government was less concerned about the Queen of England coming to their aid than nearby Cuba. They built roads and the army and marines installed bases. The military presence in Tulum had the effect of intimidating the Cruzob pilgrims enough that by 1973 the village leaders of X-Cacal Guardia refused to bring the sacred crosses to Tulum.

But in 1988 I noticed a change. I wasn't asked for guns. The Cruzob didn't seem as dislocated, schizophrenic, or paranoid; the roads and electricity had come, but it hadn't been the end of the world for them. They had been able to adjust to and still had some control of their own lives, in spite of government decisions that were reducing their traditional territory, such as the tourist projects around Tulum.

One event really stuck out in my mind. In Chumpon, in 1974 I was told about a village woman who was sleeping in her hammock and woke up to find a dog licking her private parts. She screamed and tried to beat the dog but it ran. Some of her neighbors chased and shot it, but when they reached the spot where the body should have been, they only found a pool of blood.

The villagers knew they were dealing with a witch—someone who could change into an animal. They searched for a man who was wounded. When they couldn't find one, they went to the soldiers and police in Carrillo Puerto for help to rid themselves of the witch.

I found this story amazing. On one hand, the Cruzob were still talking about getting guns and ammunition to revive the war, while on the other, as soon as they had a problem, they asked for help from the very soldiers and police they were planning to fight. This sort of cultural schizophrenia couldn't help but be divisive to the Cruzob.

At one point the Cruzob even approached Hilario to become one of their leaders. They valued his knowledge of the outside world and trusted him because he was a North American—whom the Cruzob knew had been the victors of both World Wars. Hilario wisely declined this honor, remaining a friend rather than becoming a general.

Unfinished Conversations, a recent book by Paul Sullivan, is excellent reading for anyone interested in learning more about the Cruzob. Sullivan reveals the archeologist Sylvanus Morley spied on them as a U.S. intelligence agent, and shows how the Cruzob's distrust of outsiders is often well-founded, as well as affected by their own complex politics.

Brunhouse, Robert L. *Pursuit of the Ancient Maya.* Albuquerque: University of New Mexico Press, 1975

Coe, Michael. *The Maya.* Fourth edition. London and New York: Thames & Hudson, 1984.

Davis, Keith F. *Désire Charnay Expeditionary Photographer.* Albuquerque: University of New Mexico Press, 1981.

Desmond, Lawrence Gustave, and Phyllis Mauch Messenger. *A Dream of Maya.* Albuquerque: University of New Mexico Press, 1988.

Gómez-Pompa, A. "Tropical Deforestation and Maya Silviculture: An Ecological Paradox," *Tulane Studies in Botany and Zoology* 26 no. 1 (1987): 19–37.

———. "On Maya Silviculture." *Mexican Studies/Estudios Mexicanos* 3, no. 1, University of California (Winter 1987).

Gómez-Pompa, A., J. S. Flores, and V. Sosa. *"The "Pet Kot": A Man-Made Tropical Forest of the Maya."* *Interciencia* 12, no. 1 (Jan.–Feb. 1987).

Gómez-Pompa, A., and A. Kaus. "Traditional Management of Tropical Forests in Mexico." In *Alternatives to Deforestation: Steps Towards Sustainable Use of the Amazon Rainforest,* edited by Anthony Anderson. New York: Columbia University Press, 1989.

Gómez-Pompa, A., and J. J. Jiménez-Osornio. "Some Reflections on Intensive Traditional Agriculture." In *Food and Farm: Current Debates and Policies,* edited by Christina Gladwin and Kathleen Truman. Lanham, Md.: University Press of America, 1989.

Gómez-Pompa, A., H. L. Morales, E. Jimenez, and J. Jimenez. "Experiences in Traditional Hydraulic Agriculture." In K. V. Flannery, *Maya Subsistence.* New York: Academic Press, 1982.

Harrison, Peter D., and B. L. Turner, editors, *Pre-Hispanic Maya Agriculture.* Albuquerque: University of New Mexico Press, 1978.

Jones, Grant D. *Anthropology and History in Yucatán.* Austin: University of Texas Press, 1977.

Joseph, Gilbert M. *Rediscovering the Past at Mexico's Periphery.* Tuscaloosa: University of Alabama Press, 1986.

Pearce, Kenneth. *The View from the Top of the Temple.* Albuquerque: University of New Mexico Press, 1984.

Redfield, Robert, and Alfonso Villa Rojas. *Chan Kom, A Maya Village.* Chicago: University of Chicago Press, 1962.

Reed, Nelson. *The Caste War of Yucatán.* Stanford: Stanford University Press, 1964.

Riding, Alan. *Distant Neighbors.* New York: Vintage Books, 1986.

Roys, Ralph. *The Book of Chilam Balam of Chumayel.* Norman: University of Oklahoma Press, 1967.

Sabloff, Jeremy A. *The Cities of Ancient Mexico.* New York: Thames & Hudson, 1989.

———. *The New Archaeology and the Ancient Maya.* New York: Scientific American Library, 1990.

Schele, Linda, and Mary Miller. *The Blood of Kings.* Fort Worth: Kimbell Art Museum, 1986.

Stephens, John L. *Incidents of Travel in Yucatán,* volumes 1 & 2. New York: Dover Publications, 1963.

Sullivan, Paul. *Unfinished Conversations.* New York: Alfred A. Knopf, 1989.

Thompson, Edward Herbert. *People of the Serpent.* Boston and New York: Hougton Mifflin Company, 1932.

Tozzer, Alfred M. *Landa's Relación de las Cosas de Yucatán.* Papers of the Peabody Museum of American Archaeology and Ethnology 18, Harvard University (1941).

Villa Rojas, Alfonso. *Maya of East Central Quintana Roo.* Washington, D.C.: Carnegie Institute, 1945.

Willey, Gordon Randolph. *Essays in Maya Archaeology.* Albuquerque: University of New Mexico Press, 1987.

Afterword

𐤂𐤂𐤂𐤂𐤂𐤂𐤂𐤂𐤂

A Family Portrait

CHARLES DEMANGATE

I first met Macduff Everton in Cruzob Maya country in 1971. My circus truck was stalled on the road to Chacchoben—shut down by simultaneous flats on each side of its overloaded rear. I crawled into the shade of the disabled vehicle and slung my hammock amidst the boxes of snakes and chained monkeys while one of the lead cars went off in search of a tire repairman.

An excited voice disturbed my slumber. *"Otros gringos,"* it blurted. "Americanos!"

I peeked outside and saw Hilario. A couple of trapeze artists were addressing him and gesturing toward me. Macduff, meanwhile, was walking off toward the afternoon sun. Not one to miss a picture, he was assessing the best angle to capture this garish caravan strung out along the narrow, rocky road cut through the Quintana Roo jungle.

We introduced ourselves. I had come to Mexico as a student of Maya ruins, hopping freight trains and second-class buses until I reached the Yucatán. At the end of my money and the Mexican mainland, I became the Human Torch with a local, family-owned circus.

Hilario had fallen in love a few years back and was raising a family in Chichimilá, Yucatán. He compared the Maya to the Hindus and Muslims he'd lived with in his travels. "Yucatan—where East meets West," he liked to say, a phrase Columbus would have been proud of.

Macduff grew up intrigued by the world's cultures, a curiosity

189 *Circo Magico Modelo is a family-run regional circus. Norma, Kandi, Luis, Carlos, Alejandro, Darko, and his girl friend Janet pose while children are drawn to the town plaza to watch the* circeros *pitch the big top. Yobain, 1971.*

253

fostered by the foreign students his missionary father often brought home. He began traveling the world on money earned as a high school student. He'd gotten his first camera in Denmark and sold his first photo story in Japan. He had come to Yucatán on assignment. While documenting the relics of pre-Columbian America, he had become fascinated by the modern Maya.

Macduff loved the circus. He visited often, sometimes traveling for days and weeks with us to towns and villages throughout the peninsula. It was comfortable being a camera-wielding stranger in a small town and not having to explain yourself. He was an artist—he worked with the circus!

We spent our days hunting for ruins and *cenotes,* and photographing the people of Yucatán. We were luckiest when the circus played a town too small to support a hotel or restaurant. We'd hang our hammocks in a Maya hut and enjoy an intimate view of village life, not to mention some genuine home cooking.

One autumn day we left the circus for a few days to explore the villages of the Puuc hills. The trip reminded Macduff of a tour through the English countryside. Each family's yard was bounded by a low white-washed stone wall and planted neatly with fruit and calabash trees. Their thatched homes were oval in shape, made of stone and lashed poles caulked with earth. We stopped frequently to photograph.

190 *The arrival of the circus in town is a major event even though in many villages, electricity is bringing competition in the form of television, cinemas, and dances. Yobain, 1971.*

190

254 *Charles Demangate*

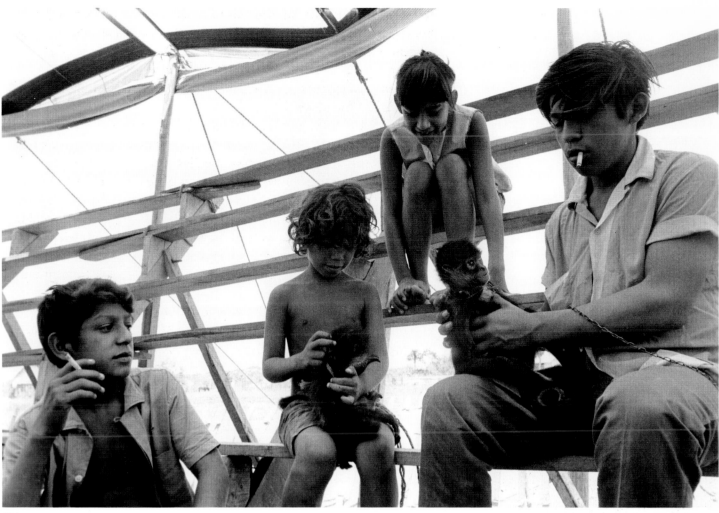

191

I was practicing my language skills on street corners and shopkeepers but was apprehensive about bursting in on the intimate lives of the villagers. Macduff would hear nothing of that.

"There's a pretty girl," he would say, stopping in front of a house that looked exactly like one chiseled long ago into the stone arch of Labna, a nearby ruin. "Go talk with her."

It was a request I couldn't refuse. The young mestiza was tending the elevated garden in front of her home. She carried water from the well and poured it over seedlings planted in a pair of hollowed logs raised upon crossed poles to protect from prowling pigs and chickens. Dressed in her embroidered huipil, she had tied her hair with colorful combs and ribbons in the style of local girls coming of age. Macduff wanted the picture.

"*Baax ka hual ic,*" I said, approaching the yard. "What do you say?"

"*Miix baa,*" came the standard reply. "Nothing."

"*Hach utz a pakal,*" I encouraged. "Very nice garden. What are you growing?"

She glanced away, momentarily flustered. Then she turned to me with a big smile. "*Pak,*" she announced. "Tomatoes."

By now we were drawing a crowd. Her younger brothers came out of the house to see the strangers, followed by her grandfather and mother. Our conversation grew into an animated discussion of cilantro, lettuce,

191 *Marta Elena, the family's youngest daughter, shows Robert Everton the circus monkeys while two employees, Chipitongo and Grillo, offer to teach him interesting phrases in Maya and Spanish. Limones, 1971.*

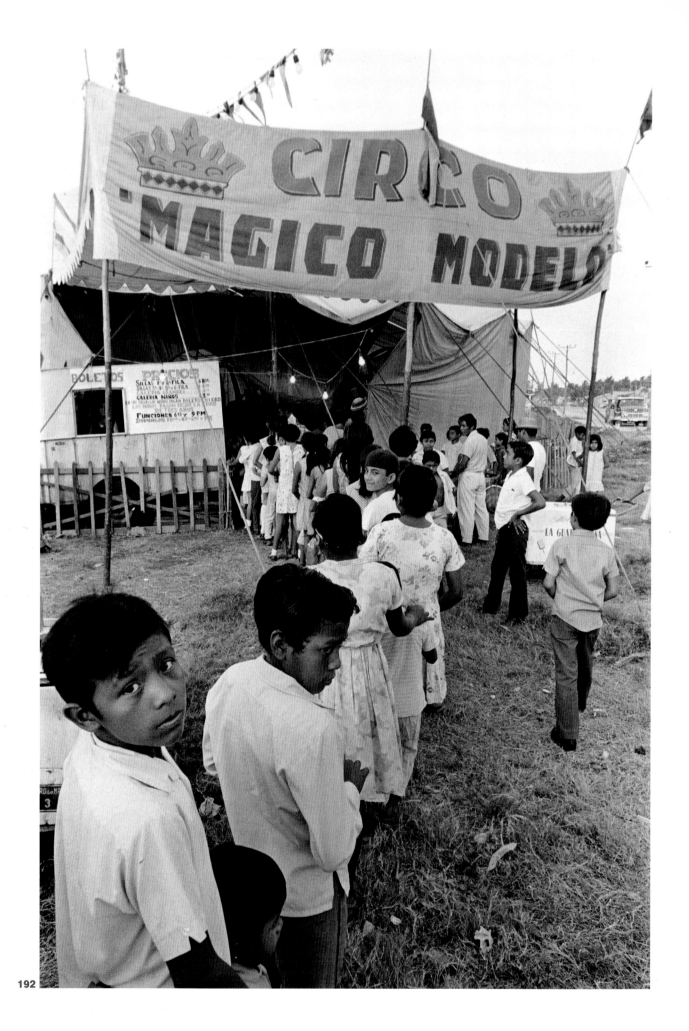

256 *Charles Demangate*

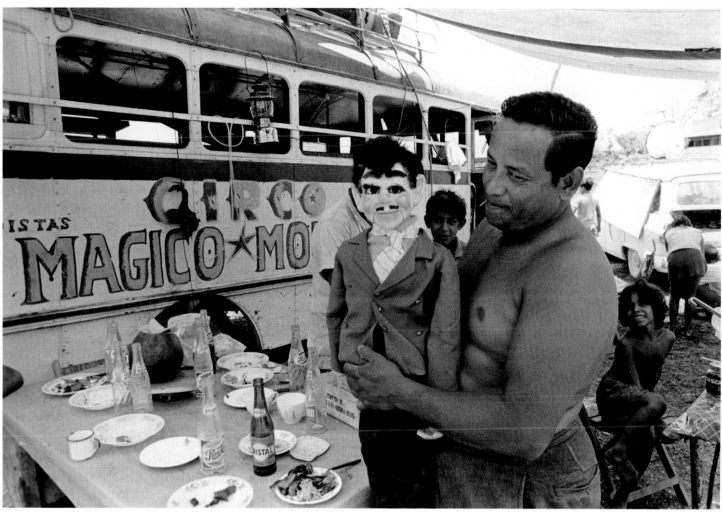

193

and chilis, with Grandpa finally inviting us into the backyard to see the kilos of hot red peppers he had laid out to dry.

We were all enjoying ourselves. Macduff, meanwhile, was busy snapping away, catching his subjects in relaxed, candid poses. Unfortunately, we'll never know whether his portraits captured the intimacy of our exchanges. Later, in the capital city of Mérida, we found his car broken into on a downtown side street where he had parked. The cameras and all of his film were gone.

Macduff overcame that setback and carried on. Over the years, he managed to peek into every corner of a changing Yucatán. He saw roads built where he had walked through the bush. He saw children leave their fathers' homes. He saw T.V.s and pop culture touch a people of the past. He saw tourists populate a virgin coast.

"What keeps you coming back," I asked him.

"I've started something and I'm going to finish it," he laughed, "even if it takes a lifetime." The Yucatán project was his photographic opus—he was clear about that.

Later, as he struggled to impose a theme on his manuscript, I questioned Macduff again. "Is this work really about an endangered people, about disappearing rain forests and lifestyles, about . . ." (as he had written) "'one of the most globally relevant issues of our time—the choice of an ancient culture either to change or face annihilation?'"

192 *Children line up for an afternoon matinee. Chetumal, 1971.* **193** *Don Luis confers with one of his actors. Limones, 1971.*

194

He thought for a long time. "No," he finally answered. "It's about my friends."

And about Macduff Everton. Over a span of two decades, I had seen him move from documenting a people to portraying human beings. When he viewed their photos it was not just as an artist, but with the joy of a person viewing old snapshots of someone he loved. He bundled packets of portraits as if they were the Christmas photos to be sent to a sister or grandfather. And he visited Yucatán time and time again to present them to the Don Chuchos, Doña Vevas, Darios, and Eluts who had become a part of his life. No grants or field studies supported his work—it was a self-imposed assignment. he was shooting his family album.

This work is not done. Life continues in Yucatán. A young girl cuts her hair and steps out of her native dress. A farmer stows his machete and takes a job building roads. They are eager to prosper from the new opportunities that have arrived at their doorstep.

Others are not so sure. They weave their hammocks and watch from the periphery of the burgeoning resorts with a patience that will remain long after the luster fades from the shiny facades—and the tourists move on to newer playgrounds.

Macduff and I revisited the Puuc Hills long after our first trip with the circus. He commented that, of all the Maya of Yucatán, the people of that area seem to have changed the least over the past two decades. They were colonized in centuries past, when civilization marched at a slower pace. Recent change has almost passed them by.

By contrast, others are hurtling into modern times with the speed and intensity of the late-twentieth-century world. Cultures are clashing and, of course, people are changing. Even so, many young men and women are still out there in the jungle—living assurances that their Maya way of life will survive for at least another generation or two.

That's plenty of time to get to know them.

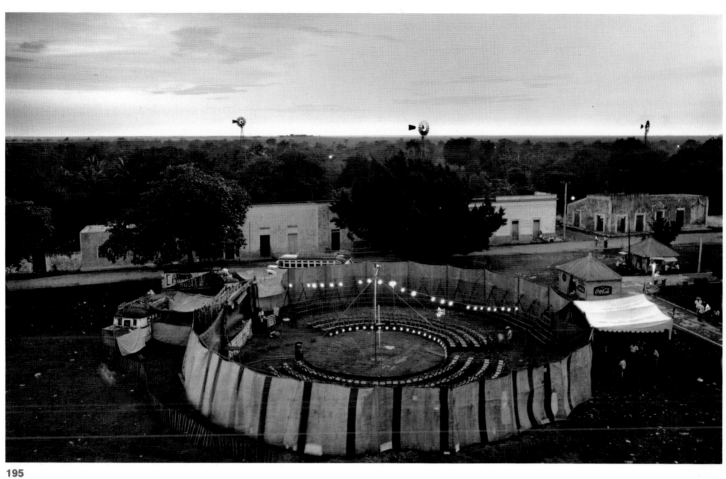

195

195 *The circus would play the henequen zone during the hurricane season,*
refraining from putting up the big top as it had once blown away.
Sinanche, 1971

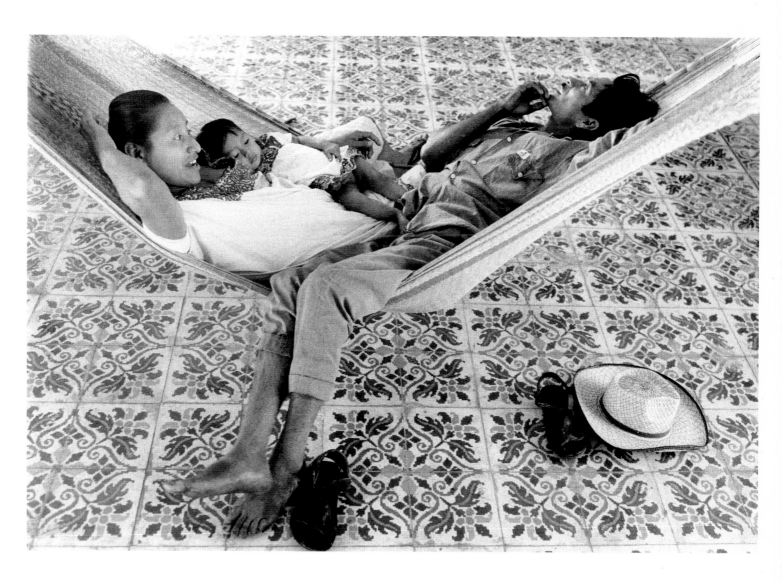

Fernando Puc Ché and his wife and child share a hammock.
They will spend much of their life in a hammock—it is
ideally suited for a tropical climate. Chichimilá, 1976.

The Modern Maya

DESIGNED BY KRISTINA E. KACHELE

*Typography in Sabon with Galliard and Helvetica display by
Vangie Mares with production by Don Leister at the
University of New Mexico Printing Services.*

Printed and bound by Dai Nippon Printing Company, Ltd.
PRINTED IN JAPAN.